# CHINESE PAINTINGS

# OF THE

# MIDDLE QING DYNASTY

JUNG YING TSAO

# CHINESE PAINTINGS OF THE MIDDLE QING DYNASTY

[SF GS] San Francisco Graphic Society, San Francisco, California
1987

CHINESE PAINTINGS OF THE MIDDLE QING DYNASTY
FIRST EDITION

Published by San Francisco Graphic Society, Inc., San Francisco, 1987

# CONTENTS

# MAP OF CHINA 1775 AND 1911

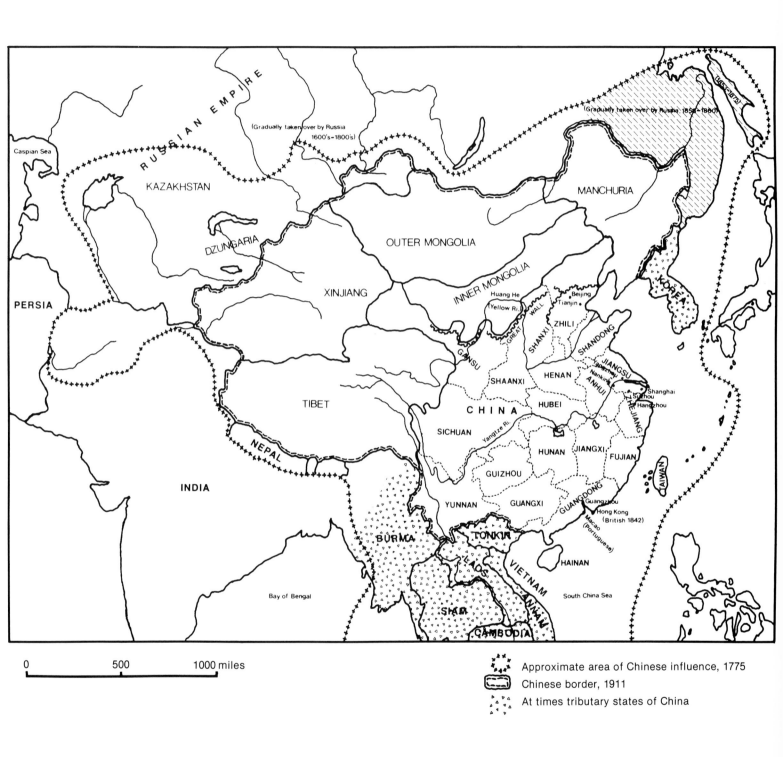

0    500    1000 miles

# CHRONOLOGICAL TABLE

| | |
|---|---|
| XIA DYNASTY | 21st c.-16th c. BC |
| SHANG DYNASTY | 16th c.-1st half 11th c. BC |
| ZHOU DYNASTY | 1st half 11th c.-256 BC |
| Western Zhou | 1st half 11th c.-771 BC |
| Eastern Zhou | 771-256 BC |
| Spring and Autumn period | 722-481 BC |
| Warring States period | 480-221 BC |
| QIN DYNASTY | 221-206 BC |
| HAN DYNASTY | 206 BC-AD 220 |
| Western Han | 206 BC-AD 9 |
| Xin | 9-23 |
| Eastern Han | 25-220 |
| THREE KINGDOMS | 220-280 |
| JIN DYNASTY | 265-420 |
| Western Jin | 265-317 |
| Eastern Jin | 317-420 |
| SOUTHERN AND NORTHERN DYNASTIES | 386-589 |
| Southern Dynasties | 420-589 |
| Song | 420-479 |
| Qi | 479-502 |
| Liang | 502-557 |
| Chen | 557-589 |
| Northern Dynasties | 386-581 |
| Northern Wei | 386-534 |
| Eastern Wei | 534-550 |
| Northern Qi | 550-577 |
| Western Wei | 535-557 |
| Northern Zhou | 557-581 |
| SUI DYNASTY | 581-618 |
| TANG DYNASTY | 618-906 |
| FIVE DYNASTIES | 907-960 |
| LIAO DYNASTY | 907-1125 |
| SONG DYNASTY | 960-1279 |
| Northern Song | 960-1127 |
| Southern Song | 1127-1279 |
| JIN DYNASTY | 1115-1234 |
| YUAN DYNASTY | 1279-1368 |
| MING DYNASTY | 1368-1644 |
| QING DYNASTY | 1644-1911 |

QING DYNASTY
Reign periods:

| | |
|---|---|
| Shunzhi | 1644-1662 |
| Kangxi | 1662-1723 |
| Yongzheng | 1723-1736 |
| Qianlong | 1736-1796 |
| Jiaqing | 1796-1821 |
| Daoguang | 1821-1851 |
| Xianfeng | 1851-1862 |
| Tongzhi | 1862-1875 |
| Guangxu | 1875-1908 |
| Xuantong | 1908-1912 |

# Preface

In 1977, just after the close of the exhibition of "Chinese Paintings by the Four Jens (Rens)" at the Far East Fine Arts Collection in San Francisco, plans were laid for an exhibit of Chinese painting of the 18th and early 19th centuries. An extensive collection of works from this period had already been gathered together, and I felt that it would be a pity to allow such fine examples to pass through my hands without sharing them with the public by means of an exhibition and illustrated catalogue. Much attention has been given in China as well as in the West to the sublime masterpieces of the 17th century and recently to the fresh vision of late Qing and contemporary paintings; but the intervening hundred and fifty years have been largely overlooked as a low point in Chinese art that is unworthy of investigation. Yet, whether or not these works appeal to our tastes today, an understanding of middle Qing painting holds the key to a comprehension of the moving forces behind subsequent developments in Chinese pictorial art.

While we hold the illuminating advantage of retrospection in viewing art of past ages, we also have a responsibility to consider the full context of its historical origins. And just as history can be an aid in appreciating the creative production of any given time span, so art itself can be a guide to uncovering valuable insights into the essential character of an era. If painting of the middle Qing appears unexpressive and derivative to us, what does this tell us about the artist, his world view, and his social, political, and economic circumstances? And if we look deeper, behind the plain exterior and allusions to antiquity, what hidden beauty might we find?

In writing this book, I have attempted to address these questions and hope that, in doing so, I can begin to close the gap in information on this phase of Chinese art. My original plan was to hold an exhibition of these one hundred and six pieces and to publish this volume as an exhibition catalogue. However, the paintings were gradually sold, so that before the research was completed, the almost total dispersal of the collection made such a showing impossible. Nevertheless, I felt strongly that this research was worthwhile, so I persevered in my efforts and finally gathered the art together in photographic form and wrote this book. My purpose, then, is not of a commercial nature; rather, it is the promotion of culture and art.

Because I believe that the art of any country or civilization should be considered within the context of its own cultural background, I have observed in this text and its illustrations a number of conventions that differ from those of many western books on Chinese art. First, when referring to artists or other individuals, I have without exception indicated the full name; that is, the surname followed by the given name, as is customary in China. For example, Su Shi (also known as Su Dongpo) should not for the sake of convenience be called simply "Su." Due to the small number of Chinese surnames (just over a hundred), using the surname alone after an initial introduction can become seriously confusing, as can be seen in the contents of this volume, wherein three artists are surnamed Zhang and four are from different families named Wu. An even graver mistake occurring in some books in English is the truncation of the names of monk painters. Since upon taking his vows a monk relinquishes the use of his family name and takes an appellation of usually two syllables, such as Hongren, his name cannot be shortened, as in this case to just "Hong."

Another rule I have followed is to provide translations for all inscriptions by either artist or collector appearing on the paintings, as well as transliterations of artists' and collectors' seals, unless they are undecipherable. The writings and seal imprints on Chinese works of art not only record valuable historical documentation; they are also integral parts of a visual whole. For this reason, I have also taken care to reproduce the paintings in full, without cropping out "empty" sections or areas taken up by inscriptions or seals. The artist conceived of his work on a piece of paper or silk of particular dimensions, and so the pictorial image is reproduced here in full, for in the Chinese aesthetic, unpainted portions are not dead intervals but rather live space equal in importance to the painted forms. This holds true even if a landscape's "sky" has been obliterated by wordy eulogies by later collectors.

The Chinese viewer is accustomed to beholding a painting on two levels, or as two layers. On one level he takes in the picture together with any calligraphy or seals that appear on the surface of the paper or silk. On another level, he is able to see "through" the written comments, signatures, and seals, like markings on a window pane, to the scene portrayed beyond. This is something that westerners must learn to do also, in order to fully appreciate a Chinese work of art as its creator intended.

Finally, I have not followed the frequent practice in books on Chinese art printed in both East and West of appending detail blow-ups of signatures and seals. In my view, such appendices only reinforce the common misconception that the mere recognition of signatures and seals is a quick way of acquiring expertise in separating the fakes from the originals. Actually, artists sign their names in different ways on different occasions. Not only would a painter's handwriting vary with his moods, but the circumstances surrounding the creation of his picture would also have their effects. Moreover, certain script types and manners of writing are purposely chosen to go with particular themes and styles, especially in 18th century painting. As to seals, most artists had ten, twenty, or sometimes many more. Therefore, without denying the value of calligraphy and seals as evidence of a painting's genuine or forged nature, I do not wish to perpetuate the emphasis on using them for this purpose.

What this book does emphasize is art. The primary basis of authenticating a piece lies in its intrinsic artistic worth; and in evaluating its worth, or lack thereof,

the connoisseur must keep his mind open to unexpected possibilities. Upon examining a painting for the first time, he begins by observing its merits, proceeding on the assumption that the work is an original. Should no outstanding positive qualities be found, he then notes the painting's failings. If these are not apparent, the reason must be that the painting reaches somewhere beyond his current level of knowledge. If he gives up his inspection here, he will have learned nothing new from this viewing experience. At this point, the connoisseur can improve his own expertise by plunging into a second, more probing exploration of the work to seek out artistic feats of a kind not previously observed. Only by continuing his search until he discovers the true significance of the painting will he be qualified to draw conclusions about its content. This type of analysis is especially applicable to middle Qing art because of the artists' deliberate veiling of personal expression.

Although this collection encompasses a broad sampling of middle Qing painting styles, not every school or approach is represented. For instance, the Changzhou School, consisting of Yun Shouping's followers, is not included. On the other hand, unlike the preoccupation with the "Eccentric" art of Yangzhou that characterizes the little notice that has been made of this period, "Orthodox" art and other trends over a larger geographical range are additionally treated in this study. The paintings selected here conform to a certain standard of quality and more or less typify their makers' artistic achievements. As far as I know, none of these works has ever before been publicly exhibited or published. Thus not only does this book offer the general reader a brief introduction to Chinese painting of the 18th and early 19th centuries; it also provides specialists in this field with new examples for comparison to those that are repeatedly reproduced for publication. The illustrations, historical facts, and ideas in the pages that follow are meant to serve not as a complete treatise on middle Qing art, but as reference material to complement what I hope will be a growing corpus of research in this area in the future.

*ACKNOWLEDGMENTS*

I would like to express my appreciation to all those who helped to make this book possible. The text was written by my dictation to a number of people, including Cathy Curtis and Elna C. Tsao. But mostly, I thank Carol Ann Bardoff for her assistance with the text. Additionally, I am indebted to John Service for his valuable editorial help. I am deeply indebted to all of these individuals for their assistance.

The artworks discussed and illustrated in this volume were all at one time in the collection of Far East Fine Arts. However, as the majority were acquired by various collectors during the time this book was in preparation, I wish to extend my thanks to the current owners who permitted me to use their paintings for this study.

# Introduction

The quest for beauty is a universal human endeavor. Whether manifested in our natural surroundings; harmonious personal relationships; or sounds, words, or visual forms arranged so as to illuminate some aspect of human experience, beauty attracts us and arouses in us a deep love and reverence for life. It has the power to relieve the strain of everyday living, to dispel sorrow and despair, to kindle in us hope for the future and confidence in the value of our very existence. Of fundamental importance to all societies, then, are man-made products possessing the quality of beauty; such works are what we call art.

The potential of art to enrich our lives is realized only through the beholder's capacity to respond to and penetrate beyond a work's subject matter or formal beauty and focus on the pure energies within. Such energies are the distillation of the forces behind civilization; thus art embodies the essence of the culture from which it springs.

Chinese art has evolved over five millennia, and out of each stage of its unfolding have emerged creations of fresh vitality. With such a rich heritage, it is little wonder that the Chinese revere their ancestors, value time-honored customs, and treasure native artifacts of past ages. This vivid awareness of their cultural origins has instilled in China's people a strong sense of identity, which has continuously directed them toward goals and ideals first voiced by their forebears thousands of years ago.

One of the earliest important concepts in the development of the Chinese world view was *dao*.[1] As the spiritual principle behind all concrete matter, *dao* is the supreme objective of Chinese art, surpassing mere decorative or didactic purposes. Revelation of *dao* through creative expression cannot be attained unless the artist is attuned to *dao*. So consideration of the artist's moral and spiritual cultivation is just as essential as technical skill in measuring the extent of his artistic achievement.

The aim of Chinese art has never been simply to copy the appearance of things. Patterned decorations on ceramics from the late Neolithic Yangshao culture testify

to an early appreciation for abstract form. Shang bronzes bear linear designs remarkable for their balanced rhythms and stately grace. In these ancient societies, pictures used to record events were gradually transformed into conventionalized graphs, culminating in the sophisticated writing system that China still uses today.

Meanwhile, pictorial art advanced toward realism. By Han times, painting had come into its own as an art form, and the power of the painted image to influence thought was exploited for didactic purposes. Depictions of figures enacting righteous deeds, such as Gu Kaizhi's "Admonitions of the Instructress to the Palace Ladies," inculcated members of the nobility with prescribed rules of morality and propriety; and portraits of deities and illustrations of sacred stories propagated the teachings of Buddhism. Over the next few centuries subject matter broadened to include flowers and animals, while landscapes, previously appearing as background in figure paintings, began to blossom as an independent theme, starting around the time of Zong Bing (375-443). The social function of art also expanded to include paintings created by and for the enjoyment of scholars. Poetry inspired the landscapes of Wang Wei, the learned official and poet of the late Tang period who is esteemed as the forefather of the literati tradition of painting.

The brilliant achievement of painting from the 10th to 13th centuries may be largely credited to the Song emperors' personal devotion to aesthetic activities. Imperial sponsorship of an art academy was not unique to this dynasty, but the rigorous scholastic standard required for entrance into the academy, and the high honors and rewards bestowed upon painters of merit, stimulated artistic production of unprecedented magnitude and range. The elevation of the painter's educational level and therefore social standing was a major turning point in Chinese art history, for it raised painting (both professional and amateur) above the category of craft once and for all, and placed it on a par with poetry and calligraphy, where it has remained through modern times.

In addition to their literary pursuits and official duties, Song scholars practiced "ink play" in pictures that were meant to be "read" much like a poem. This approach was taken up by artists employed in the service of the court, who in turn influenced the amateurs. During this era, religious and narrative themes, now classed under the general category of figure painting, took on a more decorative quality. The rise of rationalistic Neo-Confucian thought, with its inquiry into the universal principle (*li*) in all things, exalted landscape as a symbol of the all-pervasive *dao*. It also fostered interest in a broader variety of subjects, including rocks and various plants, such as bamboo and orchids, which signified certain moral ideals. Buddhist monk artists, too, enlarged the scope of their imagery to embrace these motifs. Northern Song landscapists paid homage to the majesty of the natural world in awe-inspiring panoramas wherein man was but a tiny part. Advancements in brush technique and ink effects characterize Southern Song art, but its crowning accomplishment lies in the prominent place accorded to unpainted portions of the silk or paper, both as an atmospheric device and as an evocation of eternity.

The sweeping changes imposed on Chinese society by the conquering Mongol regime of the Yuan Dynasty initially dealt a harsh blow to the flourishing artistic tradition of the Song. The art academy was abandoned, while scholars bemoaned their demotion to the lowest ranks of the populace. Either declining to serve in the administration of their foreign rulers or retiring after a short term in office, many intellectuals retreated to the countryside where they immersed themselves in

literature and art. For them, painting was an outlet for personal feelings, a leisurely pastime, and a vehicle for communication with other sensitive and cultivated minds.

Whereas the Song emphasis on objective observation of the world had retained a strong thread of realism in painting, the more subjective attitude of the Yuan artists had an abstracting effect on their images. Besides conveying the painter's relationship with nature, art now also presented his interpretation of culture; and the free exploration of the plentiful possibilities implicit in this mode generated a high point in quality. Inscribing a verse or comments in addition to a signature on pictures became common practice during the Yuan Dynasty. This firmly established the integration of poetry, calligraphy, and painting into an aesthetic whole as a distinctively Chinese form of creative expression.

The revival of the painting academy by the Ming Dynasty was politically rather than humanistically motivated. Under the strictures of an imperial patronage that favored Song styles and held innovation in suspicion, court art sank into empty formalism. Independent artists of various schools, drawing on their proficiency in calligraphy, concentrated on brush technique. Many sought to impart a sense of inner tranquility and scholarly refinement to depictions of gardens as well as of nature in the wild.

Political corruption and social decay plagued late Ming China, with extensive criticism launched against the idle philosophical deliberations in which intellectuals indulged. In art circles, interest in reassessing historical developments and categorizing past styles and schools spawned diverse theories, each prescribing a particular approach to painting. Of these, the ideas and artistic creations of Dong Qichang (1555-1636) had the greatest influence on later generations, supplying the theoretical basis for the supreme achievements of both the Orthodox and Individualist masters of the 17th century.

Art historians frequently divide the Qing period into three stages, the first spanning the inception of Manchu rule in China through the death of the Kangxi emperor (r. 1662-1723), and the third proceeding from the Opium War (1839-1842) until the close of the dynasty. The second stage commenced, after a transitional interval during the short-lived but harsh reign of Yongzheng (r. 1723-1736), with the ascendency to the throne of Qianlong (r. 1737-1796), and continued to the beginning of the Xianfeng (r. 1851-1862) period. It is the painting of this "middle Qing" epoch with which this book is concerned. A prerequisite to any study of the art of a given era is an examination of the historical forces that worked to mold the minds of creative individuals of that time. Essential to an understanding of middle Qing painting, is a brief survey of the political, economic, and social conditions that prevailed in China under the Manchus.

In the early 17th century, deterioration in the Ming administration as well as its inability to quell widespread internal revolts opened the door to invasion by a foreign power. To the northeast, Manchu tribes were building military strength and, through increased contact with China, making considerable strides in their economy, technology, and social organization. Under the enterprising leadership of

the chieftain Nurhaci (1559-1626), most of the separate tribes were united, becoming in 1616 the sovereign state of Jin. Now emperor, Nurhaci proceeded to declare war on China, and the ensuing struggle brought a series of victories for the Manchus in their encroachment into the northern regions of China. Nurhaci's eighth son and successor, Abahai (1592-1643), continued the campaign, winning new territory for his empire; he also changed the dynastic name Jin to Qing. His death brought his six-year-old son, crowned Shunzhi (1638-1662), to the throne, although power throughout his reign was wielded by his uncle and regent, Dorgon.

In 1644, when the army of the rebel Li Zicheng (1605?-1645) captured Beijing and the Ming emperor Chongzhen committed suicide, the Chinese commander (Wu Sangui) who had been staving off the Manchu forces at the Great Wall found no other recourse but to ask his foreign adversaries to aid him in saving his country from the rebels. His plan worked, but once in Beijing the Manchus refused to leave. The Qing capital was moved from Mukden to Beijing in October of 1644, inaugurating another era of alien domination in China, which was to last almost three hundred years. Chinese resistance to the new regime, however, was fierce, and only in 1683, with the defeat of Ming loyalists in Taiwan, was China's territory completely taken under Manchu command.

Ten Manchu emperors reigned in China from 1644 (the first being Shunzhi) to the fall of the Qing in 1911 (the last being Xuantong). As descendants of Nurhaci, their surname was Aisin Gioro, meaning "Gold Clan"; hence the dynastic title Jin, the Chinese word for gold. In order to avoid confusion with the former Jin Dynasty (1115-1234) as well as to project an image that would appeal to Chinese sensibilities, the name Jin was replaced with Qing, or "pure." Still, despite the Manchus' claims of having rescued the Chinese from the hands of the rebels, and despite their adoption and even promotion of Chinese culture, anti-Manchu feelings persisted among the Han Chinese throughout the duration of Qing rule. Noting such opposition, the Manchu emperors found it expedient to exert strict control over the Chinese by numerous means, one of which was the literary inquisition. Still, 17th and 18th century China enjoyed peace, prosperity, and cultural resplendence on a par with contemporary Russia under Peter the Great and France under Louis XIV.

The second Qing emperor, Kangxi, based his 60-year rule on the Neo-Confucianist thought of Zhu Xi (1130-1200). Both in administrative affairs and in personal conduct, Kangxi was guided by this Song philosopher's rationalism and the conviction that politics are inseparable from ethics. Designated a sage with the title of Shengzu, this potentate took very seriously his duty to set a moral example for the people, engaging in a strenuous daily schedule of study and attention to the myriad matters of state. He was inquisitive and diligent in his pursuit of knowledge, and lavished his patronage on traditional scholarship as well as western science and mathematics. True to his Manchu heritage, he was also physically strong and an able huntsman. Nevertheless, he was not immune to the corrupting effects of his exalted position, for his attempts to appear the morally upright and benevolent "servant of the people" covered driving ambition for glory and unlimited power.

Out of admiration for this Manchu sovereign's apparent dedication to Confucian ideals, many Han Chinese literati softened their hard-line opposition to the regime and offered themselves to public service. One outstanding scholar-official in Kangxi's court was Tang Bin (1627-1687), who took office after passing the

examination for the *jinshi*[2] degree. To win the allegiance of even those men of advanced learning who did not hold degrees, Kangxi established the prestigious title of *boxuehongci*. The bestowal of extensive recognition and rewards for academic achievement prompted a new surge of intellectual activity that encompassed a broader spectrum of subjects than ever before. But all official studies, including essays submitted in the civil examinations, were obligatorily permeated by orthodoxy in Neo-Confucianist thought. This climate was reflected also in the literature and art of the period, notably in the landscape paintings of the Orthodox School.

Outside the court a number of vocal scholars dared to take issue with Song and Ming thinkers' interpretations of classical texts, and openly attacked ancient and recent monarchs as despots and thieves. These critics were themselves divided into two camps. One group, upholding Western Han Dynasty (206 B.C.-A.D. 9) versions of the classics as authentic, saw Confucius as a statesman whose doctrine was the key to ideal government. The other, utilizing texts transmitted from the Eastern Han (A.D. 25-220), beheld Confucius as a historian and advised learning from the past to determine the proper course of action for the future. Both of these practical approaches to classical scholarship were in contrast to the metaphysical bent of Song and Ming Neo-Confucianism, with its borrowings from Daoism and Buddhism.

Three outspoken figures in this controversy were Gu Yanwu (1613-1682), Huang Zongxi (1610-1695), and Wang Fuzhi (1619-1692). In his *Rizhilu (Record of Daily Knowledge)*, Gu Yanwu observed two possible types of extinction: that of dynasties and that of China itself. The first, he reasoned, is the responsibility of the ruler and his administrators; the second, by far the more important, is in the hands of every single individual in society. Clearly referring to the threat of extinction of Han Chinese culture posed by the current Manchu dynasty, he urged his countrymen to constantly scrutinize their own history for the purpose of correcting mistakes and preserving their culture—in other words, restoring native rule to the throne. He was also reacting against the nonproductive speculation carried on by late Ming scholars while they watched their country crumble; thus, he advocated a return to study of the classics and the practical application of knowledge gleaned from them. His insistence on the systematic verification of every item under investigation, along with his pioneering research in such diverse fields as geography, agriculture, and phonology in addition to the classics, had a profound impact on later Qing scholarship.

Huang Zongxi was primarily a historian who promoted the utilization of historical lessons in governing. The writings of Wang Fuzhi, not published until the 19th century, decried the dualistic opposition of *li*, "principle," to *qi*, "material force," as specified by Neo-Confucianists. He rejected the existence of an abstract "principle of nature" *(tianli)*, which had dominated Chinese philosophy for centuries. All of these men considered domination of China by an alien people intolerable and in itself justification for revolution.

The anti-Manchu content of their ideas was for the most part tolerated by Kangxi. But after his death, his son, the Yongzheng emperor, dealt harshly with dissent. Tens of thousands were executed in his literary inquisitions, and the pens of innumerable free-thinking scholars who survived were censored. One famous case involved Lu Liuliang, who was already dead when his writings were found to be

seditious. Nevertheless, hundreds of his relatives were seized and executed, and his body was unearthed, beheaded, and put on public display. Some intellectuals met similar consequences through the inadvertent misuse of a single word or phrase. With the coronation of Qianlong, inquisitions became even more frequent. In fact, the compilation of massive encyclopedias under his direction was a means to amass an enormous collection of written materials, destroy those that were deemed undesirable, and call in their authors for punishment.

During his reign, Nurhaci had sponsored the creation of a Manchu writing system, but the comparative literary richness and more widespread use of the Chinese written language made it more rewarding for Manchus to learn Chinese. Shunzhi enacted a law prescribing a course of Chinese studies for all members of the Manchu nobility. Many Confucian scholars and artists of the Qing period were of Manchu stock, and all of the emperors since Nurhaci had found considerable advantages in informing themselves on Chinese language and traditions. But their objective was never assimilation of the two races; on the contrary, it was mastery of a means to subjugate the Chinese and firmly establish the superior standing of their own people. Manchus were forbidden to intermarry with any other ethnic group, and a system of double occupancy—one Manchu and one Chinese—for civil posts perpetuated separation and racial prejudice. Except for Buddhist monks and Daoist priests, the Chinese were forced to wear Manchu-style attire with their hair in a queue.[3] Chinese officials were required to kneel not only to the emperor but also to Manchu officials of equal rank. The Qing sovereigns' endorsements of obedience to authority and the ruler's heavenly mandate were time-honored Confucian institutions against which China's sons could hardly argue. By at once embracing Chinese culture and yet restricting its free development, the Qing leaders employed an effective stratagem for controlling their subjects.

Although Qianlong carried on his father's oppressive policies of harsh punishments and absolute power, he also emulated his grandfather's erudition and cultivated refinement. Qianlong wrote poetry and practiced calligraphy and painting.[4] His appetite for collecting art in all forms was insatiable, his esteem for antiquity and its artifacts obsessive. Reflecting his penchant for ostentation and luxury, his taste in porcelain and other palace furnishings inaugurated an era of highly elaborate designs and sometimes gaudy color schemes. Kangxi's belief in frugality and administrative efficiency had been enforced with periodic tax cuts along with relatively low spending on palace personnel and supplies. As opposed to the nine thousand female attendants and ten thousand eunuchs in the court of the later Ming emperors, Kangxi enlisted only 134 servants and 500 eunuchs, with palace expenses totaling only one percent of those of the Ming. Qianlong's disposition, however, was altogether different from his grandfather's. He reveled in conspicuous wealth and extravagant living. His six sojourns in the Jiangnan region were not for the purpose of observing local residents' problems, as Kangxi had done; rather, they were holidays set up purely for the emperor's enjoyment of leisurely sightseeing and feasting in the company of a retinue of thousands. The imperial art collection, which reached unprecedented proportions under Qianlong, was assembled through purchase as well as outright extortion. All this flaunting of opulence and power inevitably resulted in the imposition of renewed financial burdens on the population, along with divisiveness between the ruling elite and the ruled.

By patronizing only those arts and letters which conformed to orthodox

ideology, and by instilling fear through violent inquisitions, Qianlong stifled creativity and pursued a policy of keeping the people in ignorance in order to ensure their docility. Instead of encouraging innovative thinking and progressive action, he extolled the virtues of personal moral perfection and education geared exclusively to the convention-bound literature required for the civil examinations. Preparation for these exams, the single avenue to success for Chinese men, required decades, sometimes a lifetime, of intensive study, which diminished the men's physical hardiness and in the end left them with no useful skills other than the ability to comply with the official line as bureaucrats. Chinese women were kept in their place through continuation of the Ming practice of foot-binding—a practice from which Manchu women were exempt—while the illiterate millions were taught to submit to authority and accept as fate their lot of political and economic deprivation.

Thus at the same time that the West was advancing in the great strides made possible by industrialization and the American and French revolutions, China closed the door to change and laid herself down to sleep. Dreaming a glorified vision of her own past as something ordained by heaven which should be preserved intact and perpetuated without modification, she became oblivious to the stagnation and eventual degeneration of her cultural vitality. Some 17th century intellectuals, such as those discussed above, had foreseen the dangers of the path their country was treading and advocated a critical reassessment of historical trends.

Another thinker, Fang Yizhi (1611-1671), called on his countrymen to strive for society's renewal by combining the assets of China's heritage with western science and technology. Enlightened by the accomplishments of European civilization, he wrote numerous books on astronomy, mathematics, geography, mineralogy, botany, zoology, physics, medicine, and philology. The intent of his scholastic efforts was the acquisition of practical knowledge for use toward reform and progress in Chinese society.

Like Gu Yanwu, Fang Yizhi eschewed speculation and sought concrete facts from all available sources for the purpose of arriving at the truth. This inductive method of research came to be known as *kaoju* or textual research.[5] During the early Qing period, this approach was used to authenticate ancient documents, as in the dispute over Western and Eastern Han texts, and to corroborate historical events. In search of the earliest possible sources of evidence (which were not restricted to written materials but also included cultural artifacts of varied types), the very beginnings of Chinese civilization were examined with unprecedented depth and objectivity. The scientific spirit of textual research exposed the falsehood of many long-accepted premises of traditional learning; it also expanded the scope of subjects considered acceptable for scholarly inquiry. But thwarted by Qianlong's mistrust of the provocative or unorthodox, this initially productive research method was soon reduced to little more than a pacifier for allaying the nationalistic impulses of the educated.

As the quest for far-reaching truths narrowed into pedantry, scholarship of the middle Qing was typified by such items as the painstaking analysis of the phonological etymology of a single word. Knowledge was now pursued for its own sake, and the learned man dabbled in a wide variety of academic fields in addition to the classical studies of calligraphy, painting, and the appreciation of antiquity. Since they had failed at driving the Manchus out of their country, the Chinese literati could only hold on to the vestiges of cultural identity that were permitted to them.

Under these conditions, a general mood of nostalgia and introspection set in. Preoccupied with his own moral, scholastic, and aesthetic cultivation as well as the amenities of affluent living afforded by his elevated position in a prosperous society, the Chinese gentleman of the 18th century found in his own capacity for patience the best means of dealing with his foreign overlords. After all, the Manchus had adopted Chinese culture as their own, and they were a subgroup of the Chinese race. Moreover, they had extended China's borders to include all of Mongolia, Xinjiang, Tibet, Taiwan, and Hainan Island, a feat surpassed only by the Mongols of the Yuan Dynasty. The governments of Korea, the Ryukyu Islands, Annam, Burma, Siam, Nepal, and other surrounding countries acknowledged China's supremacy with regular payments of tribute. The third golden age in Chinese history (the first two being the Han and Tang periods) was in progress, and, indeed, the Chinese had much to be proud of. Limitations on the development of more noble literary forms gave rise to the popularity of novels, the most famous of which was *Dream of the Red Chamber (Honglou meng)*. Unequalled in all of Chinese fiction, this novel in its protracted length and careful attention to every subtlety of character and setting is testimony to the refined sensibility of the day.

As Qianlong approached old age, he could look back with satisfaction on the glory and splendor of his long reign. But whether due to an excess of confidence or deteriorating mental faculties, his judgment suffered an impairment which contributed to the swift demise of his golden age. One of his bodyguards, a young man named Hoshen, became a favorite of the emperor, and, through this advantage, rose rapidly in rank until he came to occupy the most powerful offices of government, including Grand Councillor. He used his authority to elevate his own supporters to influential posts, and, assured of their cooperation and the monarch's unquestioning approval, proceeded to amass an immense fortune through flagrant extortion. After Qianlong had withdrawn into retirement, his unscrupulous right-hand man took up the reins of power over all China. Meanwhile, upright ministers dared not protest, and those of lesser virtue took Hoshen's example as license to practice graft themselves.

It took the sovereign's death in 1799 to put an end to Hoshen's crimes, through imprisonment and execution. When the total value of his estate was tallied, it showed he had robbed the state of the staggering equivalent of ten years' gross revenue. The drain on the treasury caused by such corruption, in addition to expensive military campaigns and the repression of internal rebellions, was one of many major problems that Jiaqing (r. 1796-1821) inherited but was incapable of solving, and the situation only worsened during the twenty-five years of his rule. His successors, Daoguang (r. 1821-1851) and then Xianfeng, proved to be no more effectual. The remaining history of the Qing Dynasty is fraught with administrative inefficiency and corruption, a decline in military strength and economic growth, and increasing social unrest and foreign encroachment.

An outstanding achievement of the middle Qing period derived from the focus on antiquity that was prompted by textual research. This was in the field of *beixue* or the "study of stone tablets." Supplementing the books and other documents on silk or paper used as sources of data in textual research were inscriptions carved in

stone or wood, or modeled in brick or pottery. These inscriptions appeared in the form of commemorative tablets and monuments such as tombstones, steles, and the celebrated ten Stone Drums (8th-3rd century B.C.), and also tiles and other architectural fixtures.

The authentication and interpretation of these inscriptions comprises the branch of learning known as *beixue*. Ink rubbings of *bei* were highly valued, not just for their historical significance but for the beauty of their calligraphy as well. While *bei* rubbings had been collected by specialists since Tang times, the more common type of calligraphic reproduction used throughout history was *tie*, whereby samples of master calligraphers' writings on silk or paper are traced and transferred onto a stone or wooden surface. The writing is then carved out and an ink rubbing is taken on paper. The primary purpose of *tie* is to produce a facsimile of a calligraphic work that was written with a brush in ink on paper or silk. The making of these facsimiles was usually sponsored by collectors who wanted to distribute reproductions of their treasures for friends to enjoy or students to copy as practice. Since this technique became popular in the Tang Dynasty, *tie* calligraphy appears in the scripts most widely used from that time on; these scripts were regular, running and cursive. In contrast, because of their earlier origin (approximately 10th century B.C. to 6th century A.D.) the *bei* monuments and other objects tend to display the older seal and official scripts, and occasionally the regular script.

Interest in *beixue* inspired a revival of the archaic seal and official styles of writing in the middle Qing period. As it brought calligraphy full circle back to its historical beginnings, the creative force of writing as an art form was thus recharged. Calligraphers had long been trained by emulating *tie* models. But the several steps involved in making *tie* result in some discrepancies in the copy's fidelity to the original. Often, when originals had been lost or were no longer available, secondary *tie* were fashioned on the basis of the first *tie* prints, resulting in copies of copies that were even less true to the original. These problems, along with the limited number of different *tie* in circulation, eventually contributed to a decline in the general quality of handwriting.

The inscriptions on *bei*, on the other hand, were not derived from paper or silk originals, but rather were only intended to be engraved or molded objects. Consequently, *bei* rubbings are a direct and accurate image of the original in comparison to *tie*. Furthermore, the creators of *bei* objects were anonymous craftsmen whose chief task was to present a commemorative text in a dignified manner; their personal artistic expression, therefore, was only a secondary matter. The fresh naivete of *bei* writings and their freedom from self-conscious effort were features that were admired by middle Qing viewers. The fluid brushwork and intimate tendency of *tie* differs from the austere stateliness and robust power found in the chiseled inscriptions of *bei*.

Sophisticated connoisseurship gradually evolved around *bei* rubbings. Besides the problem of authenticity, they were also judged with regard to techniques used in the rubbing process: the richness of ink tones, the weight and rhythm applied to the ink-soaked wad of cloth as it was patted against the paper laid over the surface of the *bei* object. These considerations were evaluated in addition to the quality exhibited in the engraving itself: the sharpness of outline and the stylistic character of the forms. Calligraphers began to imitate *bei* inscriptions and, in doing so, an

attempt was always made to capture the carved effect of the model. The merits of practicing from *bei* rubbings as opposed to *tie* became the topic of ongoing debate. Numerous treatises on *beixue* were published, including *Yizhoushuangji* by Bao Shichen (1775-1855). His teacher, Deng Shiru (1743-1805) was a leading authority on *beixue* and the greatest calligrapher in *bei* writing modes of the 18th century. With time, the *beixue* movement broadened to embrace even metal artifacts, particularly bronze, moving the historical span under investigation all the way back to the Shang period. The study and appreciation of the inscriptions as well as artistic designs on metal and stone objects, falling under the heading of *jinshixue* ("study of metal and stone"), gained momentum in the Qianlong era and reached a peak of interest in the 19th century.[6] The new aesthetic taste which developed out of *jinshixue* stimulated a new phase in the art of seal carving while it exerted a transforming influence on styles of both calligraphy and painting.

The seal and official scripts continued to be utilized occasionally by some calligraphers even after other styles had become the principle means of communication. But the middle Qing period was exceptional for the inclusion of these early scripts in the repertoires of great numbers of calligraphic artists. Prior to the 18th century, the practice of the seal and official styles had been modeled on *tie*, which in themselves were based on late transcriptions of ancient engraved writings; calligraphers of the Tang through Ming periods were rarely exposed to original pre-Tang examples of the seal and official scripts.

The seal or *zhuan* style[7] is a denomination covering several of the earliest stages in the evolution of Chinese characters. One stage, not discovered until 1899, dates to the Shang Dynasty. It is engraved on shells and animal bones, and so is designated shell-and-bone script (*jiaguwen*). No specimens on wood or cloth have survived over the ages, but Shang writing has also been preserved in the medium of bronze where, again, the characters appear in intaglio (with some exceptions in relief). Texts cast in bronze, known as *jinwen*, become more frequent and lengthy in the Zhou Dynasty (1027-221 B.C.). The style exhibited on Zhou bronzes, somewhat altered from that of the Shang, is called large seal (*dazhuan*), and is also seen on the famous Stone Drums of this epoch.

In the Warring States (480-221 B.C.) and Qin (221-206 B.C.) periods, China's written language was simplified and standardized. With the Qin administration's adoption of the small seal (*xiaozhuan*) script for formal occasions, variations in stroke patterns were eliminated and each character was proportioned to fit into a square. Concurrently, the official (*li*; also translated "clerical") script evolved out of government officials' need to record legal matters quickly with the brush. This style further streamlined the character, squaring its inflections and allowing for modulation of brush strokes. During the four hundred years of the Han Dynasty, the official mode was employed for all state documents, while a shorthand form called cursive (*cao*; "grass") afforded great speed for more casual or personal communications.

In the Three Kingdoms period (A.D. 220-280) *bafenshu* or "eight parts of the official script" developed and led to the emergence of the regular (*kai*) style, the form of Chinese most commonly used through modern times for publications of all types. Running script (*xingshu*) is a cross between regular and cursive. These six major forms of writing—large seal, small seal, official, regular, running, and

cursive—are thus the outcome of a systematic evolutionary process and have all been used continuously to the present century. Throughout its long history, the Chinese character has accommodated itself to changes in life style as well as in writing technology. Yet, except for the reforms enacted since 1949, stylistic alterations and additions to this calligraphic tradition have never sprung purely from utilitarian incentives, but have always involved, to a greater or lesser degree, the criterion of aesthetics.

The greatest calligrapher of all time was Wang Xizhi (303?-361?), whose work is observable today only in *tie* copies. Although he is remembered for his regular, running and cursive scripts, an important part of his training was transcribing *bei* inscriptions in the seal and official styles. After attaining expert facility in all six scripts, he formulated a personal style remarkable for its lofty air and richly expressive movement. Under orders from the Tang emperor Taizong (597-649), *tie* of Wang Xizhi's writing were made and distributed widely, contributing to the rise during this dynasty of numerous talented calligraphers, among them Yu Shinan (558-638) and Zhu Suiliang (596-658), and later Yan Zhenqing (709-785) and Liu Gongquan (778-865). All of these men approached the act of writing as a process of self-cultivation, a serious discipline demanding precise technique and a high standard of quality. The legacy of Tang is disclosed in Song calligraphy, which evinces thorough assimilation of historical achievements embellished with a flavorful dramatic flare. Song writing was distinguished by the work of Mi Fei (1051-1107), Cai Xiang (1012-1067), Su Shi (1036-1101), and Huang Tingjian (1045-1105); the latter two were especially revered throughout the Ming period. With the rise of Literati art in the Yuan and Ming, most scholar-painters excelled in calligraphy.

In the 17th century, out of enthusiasm for Dong Qichang's (1555-1636) elegant hand as well as his landscape paintings, the emperor Kangxi sponsored the making of *tie* versions of his work in large editions. With the consummate finesse and profound erudition of this late Ming artist's brush, calligraphy returned once again to the heights it had reached in the Song Dynasty. The universal fervor with which Dong Qichang was imitated in the early Qing was matched only by the zeal demonstrated toward the small regular script of Zhao Mengfu (1254-1322) in Qianlong's court. The emperor's devotion in this case may possibly have been induced by this Yuan Dynasty master's willingness to serve in the Mongol court.

Zhao Mengfu's script clearly suited the imperial taste for polished decorum and daintiness, but it was not conducive to artistic spontaneity. Instead, it was trends outside the court, inspired by textual research and *beixue*, which engendered the calligraphic renaissance of the middle Qing. Inasmuch as an individual's handwriting was the mark of his character and scholarly refinement, the well-bred gentleman of this era engaged in the same diversity in calligraphy as he did in his multifarious academic endeavors. Given the length and resplendence of calligraphic history up to that time, the process of mastering previous forms and styles posed a ponderous task. Furthermore, the contemporary viewer faced the equally arduous challenge of evaluating a calligrapher's achievement by identifying each step in his personal training. Connoisseurs, usually calligraphers themselves, savored a fine work of writing for its historical derivations as well as for its unique transcendence of precedent. Calligraphic artists were in turn incited to ever greater heights of virtuosity by such a sensitive and well-informed audience. From the standpoint of a single script, the accomplishment of 18th and early 19th century calligraphers may

fall short of other epochs; however, considering its consistent quality in a broad range of scripts and styles, the middle Qing is a summit in the tradition of Chinese calligraphy.

The intellectual aura surrounding calligraphy did not prevent it from functioning as a decorative motif. It was displayed prominently in living quarters as well as scholars' studies in any number of different formats, from a single hanging or horizontal scroll to couplets (a form introduced in the late 17th century) and sets of four, eight, or twelve panels. Porcelain wares and other items of daily use, furniture, wooden screens, and architectural structures often incorporated the written word in their designs. Calligraphy as a visual art now entered into numerous aspects of cultural life; particularly in the realm of painting, it became increasingly instrumental in the development of new styles.

By the middle Qing period, China's artistic tradition spanned a long history replete with diverse schools and methods. The student of painting had always been expected to acquire a certain level of proficiency in the gamut of previous masters' accomplishments before embarking on a personal style. However, to the 18th century novice, the past presented a corpus of art that was awesome in volume, breadth, and achievement. Technique was transmitted from one generation to another in several ways: by painters' taking of pupils, by first-hand observation of master-pieces, and by viewing hand-painted copies of masterworks. One more means of study was the use of the woodblock print copy. Based on the idea of an engraved seal, the woodblock printing process was first employed in the Tang Dynasty for the purpose of disseminating Buddhist doctrine. Printing technology advanced a step in the Song period with the advent of movable type. Illustrated books of various sorts circulated at this time, and in the late Song and Yuan, painting manuals such as the *Catalogue of Plum Blossoms (Meipu)* and *Catalogue of Bamboo (Zhupu)* were published. The *Catalogue of Painting from the Studio of Ten Bamboos (Shizhuzhai huapu)*, the first edition of which dates to the end of the Ming Dynasty, had a considerable effect on painting, as did the *Mustard Seed Garden Manual of Painting (Jieziyuan huazhuan)*, produced in the Qing.

The arts of printing and wood engraving meshed especially during the 17th century, when a number of inventive painters designed pictures meant for reproduction by the woodblock method. Printing activities were stimulated in the middle Qing by the popular demand for illustrated novels and the imperial obsession with massive compilation projects. Not only did widespread distribution of painting manuals and printed reproductions do much to simplify the beginning artist's training, it also exposed the whole of China to specialties of technique and approach that had formerly been confined to certain regions. The printed picture brought art to all levels of society. People from every walk of life now tried their hand at painting, while the rising merchant class joined the ranks of art collectors, once the exclusive domain of scholars and nobility. With such a broad-based patronage, artists enjoyed relative ease in making a living with the brush. Moreover, the abundance of leisure time afforded by a healthy economy and stable government, along with easy access to printed copies of paintings and art handbooks, enabled painters to achieve a high degree of technical skill and versatility.

But the creative impact of woodblock prints on painting in the previous century was replaced in the 1700s by the effects of popularization and commercialization. The limitations inherent in using printed materials to learn the intricacies of handling brush and ink, compounded by the emphasis of many teachers on conventional methods, led many artists into the dead end of formalism. Intent on following all the rules and mastering all the styles presented in their manuals or by their instructors, aspiring painters often received little direction in realizing their potential for inventing something new. Even those who might have surmounted this obstacle were discouraged from openly transgressing the bounds of convention by the looming threat of imperial inquisitions. In addition to the veneration in which they held antiquity, the prevailing political climate was an important factor in the middle Qing artists' adherence to earlier modes. Painters had acknowledged ancient masters as their source of inspiration in their paintings' self-inscriptions for centuries; however, in this period the practice became more common than ever. For, by crediting the deceased with masterminding the overall concept of their work, painters of this age shed all personal responsibility for any content that might be interpreted as offensive to the ruling powers.

Notwithstanding these strong forces which suppressed innovation in painting in the middle Qing, individual expression did make itself known, if only to the cultivated eye of the connoisseur. Screened behind a facade of unnoticeable brushwork and preconceived compositions, the artist's unique statement could be detected in his modulation of ink values, in the nuances of his brushstrokes, in his unobtrusive departures from established designs. This concentration on the fine points of an art work had contemporary parallels in the preoccupation with detail in textual research as well as in the trends of connoisseurship in calligraphy, *beixue*, and antiques of all types. Half-concealed inner qualities were admired in all things and even in people; overt expression was considered immodest and uncultured. A term often used to praise paintings and human personalities alike was *pingdan*—literally, "bland" or "plain."

The attitude that the creation and appreciation of paintings required erudition was part of a kind of social exclusivism by which the upper segments of Chinese society maintained their superior standing. Unfortunately, this bias also extended to foreign peoples, to whom most Chinese intellectuals granted little attention. Limited trade had been carried on between China and Europe since Ming times; problems of security along the coast led to a ban on trade at the beginning of the Qing period, but Canton and a few other ports were reopened after Ming loyalists in Taiwan were finally subdued. From 1685, a broad range of goods including tea, silk, herbs, paper, and spices flowed out of China. Along with these material commodities, ideas between the disparate cultures were exchanged to some extent. Missionaries had been importing both Christianity and western science to China since the mid-16th century, and some Europeans took an interest in Chinese-style gardens and household furnishings. However, no attempt was made by the Chinese themselves to introduce to the West that which they prized perhaps the most: painting. Convinced that outsiders lacked any capacity to comprehend their aesthetic values and that no benefits were to be gained by sharing them, the custodians of Chinese tradition reserved their art, the essence of their noble civilization, for themselves. The paucity of modern westerners' awareness of China's brilliant artistic heritage bears witness to the persistence of such thought today, and to the continuing need to topple cultural barriers to gain mutual understanding.

Because calligraphy and painting were inextricably linked, the Chinese viewer could rely on certain common grounds for judging both art forms. The free movement and evocative distribution of lines in space constitute the fundamental objective of calligraphic aesthetics. Any work of writing is evaluated first on the basis of the structure and proportion of each individual character, then on the balance and continuum achieved in the relation of one character to another, and finally, on the unity and creative vision perceivable in the whole.

Although paintings are not strictly segmented into separate components as is calligraphy, they nevertheless may be appreciated for the same qualities. This was especially true in the middle Qing period when the major substance of a painter's expression was invested in his calligraphic brushwork. The novice calligrapher began his training with *kaishu*, the most conventionalized of the six basic scripts, and gradually familiarized himself with the others until his competence afforded him the means to evolve an individual style. The education of the painter followed a parallel pattern: only after mastering the accurate representation of form in the precise *gongbi* or fine brush method could he qualify to reveal his own personality in more abstract terms such as the *xieyi* mode.

Just as the connoisseur could trace a calligrapher's entire course of study in his handwriting, so could he recognize clues to a painter's process of development in his pictures. But in the latter case, this method of analysis was notably more complex, for the painter nourished his artistic growth from a multitude of disciplines besides paintings of the past; as suggested previously, these included calligraphy, engraved writings and designs (*bei*), woodblock prints, philosophical and literary trends, and his own observation of the world around him. The problem of identifying all the complementary and opposing forces that merged in the making of his personal style was further complicated by the eclecticism practiced by many artists of this era. In addition, unprecedented variety in his choice of format and subject matter offered the painter opportunities to either specialize or expand the scope of his art as he pleased.

Most of the painting formats used in the middle Qing have ancient origins, with the exception of the horizontal hanging scroll (*hengpi*), which was probably introduced around this time. This was a slightly modified version of the traditional handscroll or table scroll, a form dating back to the 4th century or earlier. A painting mounted as a handscroll is unrolled and viewed section by section. The resulting moving focus and sequential unfolding of the image characterize the spectator's experience as an "indoor journey."

Because the handscroll could hold vast panoramic vistas, a painting in this format is usually considered a major work in an artist's oeuvre. Hanging scrolls are designed for display on a wall, so paintings of this type possess decorative as well as artistic value. Besides the *zhongtang* (a large-scale work functioning as a centerpiece for a reception hall or other spacious room), variations of the hanging scroll are the long, slender *tiaofu* and the small, square *doufang*.

Small round, square, or rectangular paintings predate the Song period, when they were used as round fans or as inserts in standing screens. Some collectors preserved such paintings by mounting them in albums, but series of small pictures by a single artist meant for presentation in album form were only rarely produced

before the Ming Dynasty. While round fans are known to have existed in the late Han, the folding fan was introduced into China from Japan in the Northern Song. The oldest extant examples of folding fans decorated with painting and calligraphy are by 15th century masters such as Zhou Chen (active ca. 1472-ca. 1535) and Shen Zhou (1427-1509). Later, both fan shapes were sometimes mounted as hanging scrolls. All of these painting forms were used by artists of the 18th and early 19th centuries to satisfy the versatile tastes of their patronage. However, the popularity of certain formats over others depended on changes in architecture and life style, along with socioeconomic factors. *Zhongtang*, or large hanging scrolls, fell into a slight decline because a sizable object of bronze, porcelain, or other material could rival it as an impressive adornment in the great hall of the wealthy merchant's home. The nouveau riche also showed a predilection for sets of hanging scroll paintings consisting of four, six, eight, or twelve panels, either representing separate scenes or joining to form one continuous scene. Scholars, on the other hand, preferred the intimacy of the small hanging scroll or album, which they could enjoy in the privacy of their own studio. Often a simple composition of bamboo, a stone, or a flowering symbol of purity such as narcissus or plum blossoms graced the wall of a literatus' study.

The decrease in the dimensions of the hanging scroll was also related to the diverse collecting habits of merchant and scholar alike: painting was but one art among many, including bronzes, porcelain, jade, *bei* rubbings, woodblock prints, calligraphy, bamboo and wood carvings, ink, and ink stones. But far from lightening his load, the diminution of the hanging scroll posed new challenges for the painter. The connoisseur's sophisticated eye demanded a sense of free movement and spaciousness as well as expressive subtlety in every touch of the brush. Thus even in compositions of the most limited size, whether the artist chose to depict an extensive view of mountains and streams or a single branch of bamboo, he always endeavored to sustain an equilibrium between the weight and force of solid objects and the expansiveness and lightness of the surrounding space.

Silk, satin, and various kinds of paper have long been the standard types of support used in Chinese painting. Song works survive mainly on silk, while Yuan artists preferred paper for its capacity to impart a fuller spectrum to the range of ink values. Not until the Ming period were paintings created on gold-flecked paper. Beginning in the 15th century, pictures rendered on a solid gold ground appeared exclusively in folding fan form; larger formats in this decorative medium were an innovation of the middle Qing period. Although Ming painters found paper and silk almost equally desirable, toward the end of the dynasty paper was restored to favor, establishing a trend which continued until modern times.

Along with paper, brush, and inkstone, ink is one of the four treasures of the scholar's studio. A painting in ink alone has always been considered as chromatically complete as one employing colors, for ink has traditionally been said to possess five colors in itself. The tonal scale of ink in painting narrowed somewhat after the end of the 17th century. This was due to the influence of *bei* rubbings as well as textual research with its finely drawn distinctions, and reflects the middle Qing scholar's preference for plainness in art. At the same time, critics of this period enumerated not five but six colors in a successful monochrome ink painting, pointing out that their predecessors had neglected to mention the vitally important unpainted portions as a positive element and therefore "color" in a picture. The new

emphasis on unfilled areas of a painting revived the eloquent spatial effects achieved by Song artists, and followed the Individualists of the 17th century with their bold juxtapositions of solid and void.

Artists' signatures were rarely presented conspicuously on paintings until after the close of the Song Dynasty. Many painters of early periods did not excel in calligraphy and so did not wish to mar their pictures with poorly written inscriptions. Those who did sign their name hid the small characters within the contours of a tree trunk or in the crack of a rock. Zhao Mengfu was among the first to accord a prominent place to his signature on most of his works. He sometimes recorded a title, date, or commentary as well, appending the whole with one or more seals. After later Yuan Literati painters, all of them expert calligraphers, confidently embellished their art with similar texts and seals, Ming artists followed suit—and in the process refined the close relationship between the arts of painting, calligraphy, and poetry. But from the Song through the early 17th century, painters as a rule used a single script type consistently in their self-inscriptions, imprinting their seals directly below their signature at the end. Moreover, the written text was added as an afterthought, and was usually blocked out in the form of a neat square or rectangle in an unpainted corner of the composition.

Shitao (1641-ca. 1710) may be credited with revolutionizing a primary aspect of painting: his original conception of his creations encompassed the inscription and seals as integral parts of the whole design. The immediate heirs to this approach, the Yangzhou masters, often constructed their text into an irregular shape so as to relate it dynamically to the pictorial image. Subsequently, artists of the modern Jinshi School took this idea to its logical conclusion by also using seals as a compositional device. Along with the spread to other regions outside Yangzhou of this new flexibility in the spatial arrangement of calligraphy on paintings, middle Qing art is also characterized by the appearance of a variety of script styles within an individual artist's oeuvre. Again, this is derived from the art of Shitao.

The poems, poetic essays, and explanatory remarks that make up the main body of middle Qing inscriptions are notable for their lack of profundity. This is understandable, given the tight parameters set on the written word by the scourge of repeated literary inquisitions. To avoid risking punishment for seditious statements, the average artist was content to dwell on harmless flowery images and nostalgic sentiments in his self-inscriptions.

Observations noted by collectors on paintings in their possession or by other beholders have varied throughout China's history in the quality of the calligraphy itself and its placement on the work of art. Ideally, the writer selected a script and ink tone that were compatible with the style of the painting, and positioned his comments and seals in a discreet corner of the composition. Before the 17th century, the reality too often fell short of the ideal, but the Chinese spectator became accustomed to looking "through" inscriptions and seals to the painted scene beyond. Dong Qichang, a prodigious collector as well as calligrapher, painter, and art theoretician, practiced restraint and superior judgment in adding inscriptions and seals to works by other artists. His high standards did much to improve the treatment of paintings after his time, excluding those that passed through the collection of Qianlong. As an expression of his approbation, this emperor felt compelled to cover a large area of a painting with comments in his peculiarly monotonous hand, or to impress large

imperial seals in a prominent place on the work. The extent of his appreciation for a picture could be estimated by the number of seals he impressed on it, those bearing his maximum of five seals referred to as *wuxiquan*, or "complete with five imperial seals."

Ever since the Tang Dynasty, collectors have declared their pride in treasured works of art by imprinting their seals on them. The use of collectors' seals therefore predates artists' seals. Carving seals was taken up with fresh enthusiasm not only by craftsmen but also by scholars and painters in the 18th century. Studies in antiquity in general and in *bei* carvings in particular focused attention on this ancient art, which shares many common features with engraved stone monuments. The compact nature of the seal poses a special challenge for the maker: he must modify the conventional structure of the characters to fit within the confines of a small area so that the words are arranged in a visually pleasing manner and yet remain decipherable.

Different types of stone as well as jade, wood, and ivory are the most common materials for seals, and characters are carved in either relief or intaglio within a square, rectangular, circular, or other shape. Seal ink or paste is normally cinnabar red in color, but blue or black is sometimes used by artists or collectors in a state of mourning. In examining a seal on a work of art, the connoisseur considers the quality of the stone, the style and design of the characters, the carving technique, and the seal ink. In addition, he notes the care and dexterity with which the seal was handled, from the act of dipping it in and removing it from the seal ink to that of impressing it on and taking it up from the art work. The pressure and speed involved in this process are crucial, as is the tasteful positioning of the seal within the painting format. Numerous schools of seal carving thrived in the 18th and 19th centuries, and this fact, along with the middle Qing proclivity for precision and detail, brought the level of aesthetic sophistication in the making and application of seals to new heights.

Despite the splendor of Qianlong's golden era, painting of the 18th and early 19th centuries is not usually considered outstanding for either creative brilliance or technological strides within the greater scheme of China's artistic heritage. However, understood within the context of historical factors peculiar to the time and as but one brief episode in a venerable chronology of aesthetic production, the middle Qing emerges as an important transitional stage during which past achievements were explored anew and the seeds for later developments were sown. In the pages that follow, examples of the works of 62 artists are presented. These are meant to constitute not a comprehensive survey of the approximately 125 years that spanned the reigns of Qianlong through Xianfeng, but only a brief introduction to the painting of this period. Besides serving as portraits of the individual personalities that fashioned them, these images are indicators of the human values that prevailed during the middle Qing. Linking aged traditions with modern innovations in creative expression, they also disclose essential insights into Chinese civilization as a whole.

<div style="text-align: right;">

Jung Ying Tsao
Berkeley, California

</div>

*NOTES:*

1. Interpreted variously by innumerable schools of thought throughout China's history, *dao* commonly refers to the "way" of nature, or the great cosmic order.

2. The civil service examinations conferred three degrees: *xiucai, juren* and *jinshi*. The first degree examinations were conducted approximately every two years in each district (*xian*). Those who passed were given the title of *xiucai*. The next major set of examinations led to the title of *juren*. These were held in the capitals of the provinces (*sheng*), at intervals of approximately three years. In order to hold office, one had to pass the third set of examinations. These were held in the capital which, during the Qing Dynasty, was Beijing. Those who were successful were awarded the title of *jinshi*.

3. However, throughout the Qing Dynasty, figures in paintings (aside from portraits of specific individuals) were portrayed only in Ming or pre-Ming-style robes. That this practice was initially a quiet venting of anti-Manchu sentiments is demonstrated in more direct terms by Beijing opera of the period, in which the hero and his supporters always wore Ming fashions regardless of the time setting of the story, while the villains invariably appeared in Manchu costume. Gradually the racial innuendo of this device faded, and eventually artist clothed their subjects in ancient dress merely as an observance of convention. This custom has been continued by many traditional painters even to the present day.

4. His calligraphy has never been cherished by art connoisseurs; however, it was praised in his day as representative of the "imperial style" with its even lines, regular rhythms, and formal elegance. Paintings actually created by this emperor are rare; many bearing his signature were in fact painted by court artists at his request.

5. Literally meaning "search for evidence," this term has also been translated as "textual criticism" and "the School of Empirical Research."

6. The study of metal and stone objects from past ages began in Han times. During the Song Dynasty, Ouyang Xiu (1007-1072) and other scholars pursued this field of research and designated it *jinshixue*. It saw a decline in the Yuan and Ming periods before its revival in the Qing Dynasty.

7. *Zhuan*, originally meaning "name" or "title," denotes a seal that bears an individual's name in either intaglio or relief. The seal script is so named because early inscriptions in this mode are known mainly in intaglio or relief form.

# The Loudong School

While the task of the artist has always encompassed the acquisition of technical proficiency and the emulation of past masters, its most noble aspect is the element of creativity. During the 17th century, the creative impulse of painters all over China surged in the wake of political turmoil and moral crisis. For the most part, however, their 18th century successors, settling into a new life of prosperity, order, and enforced ideological conformity, prudently contented themselves with continuing their teachers' styles. Consequently, artistic production of the middle Qing lends itself to categorization in terms of schools, despite the eclecticism that characterizes much of the output of this period.

A leading school was formed by the followers of Wang Yuanqi (1642-1715). The name of this group of painters, the Loudong ("East of the Lou River") School, is a reference to Taicang (in Jiangsu Province), the hometown of Wang Yuanqi as well as of his teacher and grandfather, Wang Shimin (1592-1680), and Wang Jian (1598-1677). These three landscapists were partial to the painting modes of Huang Gongwang (1269-ca. 1354) and Gao Kegong (1248-ca. 1310), and interpreted them according to the orthodox theories of Dong Qichang (1555-1636), Wang Shimin's friend and teacher.

Wang Yuanqi's brilliance in recreating the outstanding qualities of old paintings was acknowledged even by his elders, as when Wang Shimin remarked to Wang Jian: "Of the Four Yuan Masters, the one I most admire is Huang Gongwang. The later master who best captured Huang Gongwang's spirit is Dong Qichang. As to capturing his formal style, I dare say that no one has surpassed me. But as to capturing both his style and spirit, we must step aside and give credit to my grandson." The Kangxi emperor rewarded Wang Yuanqi with an appointment to the post of director of authentication of art works in the imperial collection. The fame and prestige that accompanied his high position naturally attracted great numbers of students and followers who shared a common interest in promoting his approach to painting.

The Loudong painters saw themselves as the direct heirs to a long line of

Literati artists which reached as far back in history as Dong Yuan (ca. 900-1062) and also included Mi Fei (1052-1107), Huang Gongwang, Gao Kegong, the Wu School, Dong Qichang, and the three of the Four Wangs just mentioned. Although adherents of this school came from all parts of China, with some working in the capital city, many were from Wang Yuanqi's native region, a prosperous and long-established haven of intellectual society. Some were actually related to Wang Yuanqi; however, these were descendants of the second generation or later, and had studied under his pupils without benefit of guidance from the master himself.

Due to this broad geographical base and gap in family ties, Wang Yuanqi's style was not preserved intact, but absorbed the influence of other trends from which his students felt free to draw. Under the beneficent patronage of the Kangxi emperor, who prized Dong Qichang's art very highly, Wang Yuanqi had enjoyed the freedom to apply this late Ming artist-theoretician's ideas in the most liberal sense, with stress on his enjoinder for the creative transformation of past styles.

By practicing the methods of Huang Gongwang repeatedly in numerous works, Wang Yuanqi succeeded in inventing a revolutionary vision of his own. The Loudong artists, on the other hand, were obliged to confront the harsh realities of a suspicious administration and often the need to earn a living by the brush. To appeal to imperial taste, they expanded their focus to embrace Song landscape modes as well as styles of other Yuan artists besides Huang Gongwang. Wang Yuanqi's forceful, rough-hewn brush manner and abstracted images were now softened to the quieter voice of the times. Modestly (or discreetly) declining to outwardly assert their own individuality, these men credited their forebears with the genius of innovation and confined themselves to venting their own personalities in the exacting nuances of their unassuming brushwork. Still, even if their advancement of the Literati Tradition consists of only small, cautious steps forward, their contribution is nonetheless worthy of attention at least as a link between preceding and subsequent artistic developments.

*HUANG DING (Zungu, Duwangke), 1660-1730*

**Landscape**

Hanging scroll, ink on paper
41 x 15¾ inches

> *Inscription:* Awareness of the innermost recesses of the mind is not (to be found) in the depths of mountains and woods. Imitating the style of Yunlin (Ni Zan) on an autumn day in *guimao* (1723), the Yongzheng period. Huang Ding from Yushan.
>
> *Artist's seals:* *Ding yin*, square, intaglio
> *Zungu*, square, intaglio

Private collection, La Puente, California

"Lonely Traveler" (Duwangke), as Huang Ding called himself, was a fitting name for this artist who spent almost three decades wandering throughout China. A native of Changshu, Jiangsu Province, he began studying painting under Qiu Yuan, an artist from the same district. Huang Ding lived for a time in Beijing and spent his last years in Suzhou. His merits as a scholar won him an offer of a high-ranking official position under the Kangxi emperor; however, he declined in order to travel. As he climbed famous mountains and traversed valleys and gorges, he frequently stopped to paint the scene before him. This firsthand observation of nature, along with the spirit of inquiry that motivated him to surmount even the most rugged peaks are manifested in the novel compositions and compelling brushwork of his landscape paintings.

By journeying extensively Huang Ding was fulfilling Dong Qichang's dictum that an artist should travel 10,000 *li*. Huang Ding adhered to this late Ming artist's aesthetic doctrine also in his use of Yuan paintings as models. While residing in Beijing, he befriended Wang Yuanqi, who gave him some instruction in painting. Another of the Four Wangs, Wang Hui (1632-1717), with whom Huang Ding shared a common hometown, also influenced his style. Thus through direct personal experience he was thoroughly steeped in the Orthodox attitudes and techniques of the 17th century. It is this link to the movement's origins that distinguishes Huang Ding from other Loudong School painters, most of whom never knew Wang Yuanqi himself.

The transitional nature of Huang Ding's role in late 17th to early 18th century pictorial art is apparent in the conception and execution of his landscapes. The imposing grandeur of the previous generation's paintings is toned down in his work by a somewhat reserved manner and replaced by an emphasis on subtle brushwork. This trait is confirmed in this river scene in the style of Ni Zan (1278-1368). Water, represented by blank paper, covers the greater portion of the painting, with the near and distant shores conforming to Ni Zan's famous "one river, two banks" scheme. Huang Ding's use of dry ink and the leisurely air of his brush movements were inspired by this Yuan Literati artist. Evocations of Ni Zan's mode are further demonstrated in the spare, abstract description of form and in the attainment of a pure, serene atmosphere.

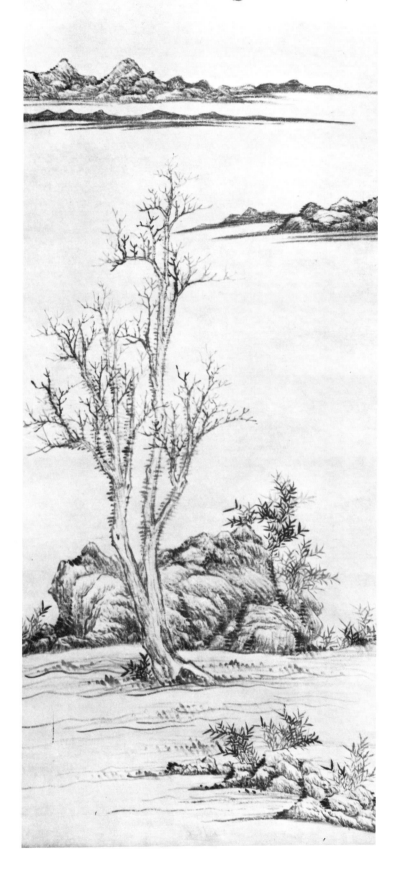

乃知心跡
遠不在山
林深
雍正荼郊
秋日倣雲
林筆
虞山黃鼎

Huang Ding
*Landscape*

25

The most remarkable aspects of Huang Ding's picture are the dynamic relationship between painted and unpainted areas, and the vivid suggestion of deep space within the framework of the traditional *pingyuan* ("level distance") perspective. The latter effect is achieved in great part by the single tree growing from the foreground, for the viewer peers through the network of dry branches across the water's surface to the receding hills beyond. On a two-dimensional level, the tree provides both a vertical thrust to an otherwise wholly horizontal design, and a formal connection between the nearby and remote segments of land. Solidity and weight are supplied for the foreground by rocks, and a sense of fresh growth by small leafy bamboo plants. Fluid calligraphic brushwork animates all of these elements and integrates them into a harmonious whole. Dong Qichang's presence may be noted in the slightly tipped groundplane of the stretch of hills entering the picture from the right. Other than this detail, however, Huang Ding holds all eccentricity in check, for his brand of orthodoxy marks the beginnings of the 18th century disparagement of blatant individualism.

The verse quoted in the artist's inscription implies a question: If "Awareness of the innermost recesses of the mind is not to be found in the depths of mountains and woods," then where is it to be found? Huang Ding offers the answer to this mystery in his landscape's flatness, for *ping*, flat or level, also means peace, and is used to describe a calm, composed state of mind. The source of proper human behavior, then, lies in the inner workings of nature, and in both his choice of composition and brush manner, Huang Ding portrays himself as a devoted observer of this principle.

## *ZHANG ZONGCANG (Mocun), 1686-1756*

### Landscape in the Style of Wang Meng

Hanging scroll, ink and light color on paper
56 x 21½ inches

|  |  |
|---|---|
| *Inscription:* | In mid-winter of the year *jiaxu* (1754), I suddenly became paralyzed. I returned south to cure my illness in my quiet and beautiful home. My brush and inkstone had been covered with dust for a long time. As I gathered my boxes, I found an old work in the style of Huanghaoshanqiao (Wang Meng). The outlines and composition were nearly completed, so I used my left hand to finish the painting, adding dots and light colors. I am so old now, I do not want this piece to be thrown away and forgotten. Year of *yihai* (1755), Moon Festival; recorded on behalf of Huangcun, Zhang Zongcang (by another). |
| *Artist's seals:* | *Zhang Zongcang yin*, square, intaglio<br>*Mocun*, square, relief |
| *Collectors' seals:* | *Changchuzhai*, rectangular, relief<br>*Xizhai*, square, relief |

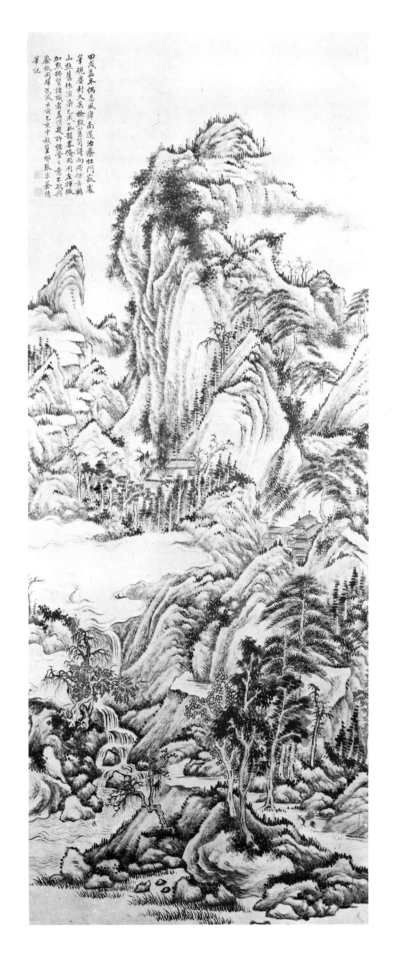

Zhang Zongcang
*Landscape in the Style
of Wang Meng*

27

Among numerous artists during the 18th century who followed in the Orthodox footsteps of Wang Yuanqi, Zhang Zongcang is notable for his landscapes, showing a highly developed brush technique and rich ink effects. A native of Wu District (Suzhou), he studied under Huang Ding, who had learned from the creator of the Loudong School, Wang Yuanqi. In 1751, when the Qianlong emperor traveled south, he viewed Zhang Zongcang's album entitled "Sixteen Views of Wu." So impressed was the emperor that he immediately summoned the artist to the capital to paint in the court. In 1754 Zhang Zongcang was appointed to a post in the Board of Revenue, but shortly thereafter became paralyzed (as he states in the inscription on this painting). After two years of retirement, he died at the age of 70.

The imperial favor bestowed on Zhang Zongcang stemmed from his application of the principles and techniques of past masters to pictures that display virtuoso skill and the exquisite taste of a true connoisseur. Ever since Wang Yuanqi had served as advisor to the Kangxi emperor on art collecting, his paintings had set the standard for the Literati mode of depicting landscapes. Qianlong, an avid collector and a would-be artist himself, continued to foster this new orthodoxy, which required comprehensive knowledge of history, an advanced level of proficiency in imitating ancient styles, and the incorporation of these styles into compositions of elegance, subtlety, and grandeur. Such paintings, resplendent with an air of antiquity, represent the culmination of centuries not only of artistic development, but also of the evolution of Chinese civilization as a whole.

Few artists among the proponents of the Loudong School were able to achieve a new creative vision while following the basic tenets of the Literati Tradition. That Zhang Zongcang was one of these is attested by this landscape in the style of Wang Meng (1308-1385). Using a dry brush to apply layers of ink and pale colors, the artist has set a scene of wooded mountains to a rhythmic buildup of calligraphic lines and luxuriant tonal variation. While the complexity and density of the composition serve as allusions to Wang Meng's paintings, the main peak with vegetation growing on its crest is particularly reminiscent of Fan Kuan (active ca. 990-1030). The works of this and other Northern Song landscapists are also evoked by the monumental scale employed here. The progression from low hills to towering bluffs as a series of round or conical forms arranged one behind the other follows the ancient convention of *longmo* or "dragon veins," which was practiced by Wang Yuanqi and other 17th century Orthodox masters. The brushwork also relates to that of Wang Yuanqi in its "raw" or outwardly unrefined quality, which, if not striking with the first viewing, affords rich rewards upon closer examination. It is this kind of cultivation and "taste" that was so admired by connoisseurs of the 18th century.

But there is yet another influence at work here, one that is a result of widespread interest during that era in ancient carvings in stone and metal. Such carvings were reproduced as rubbings which were collected, studied, and copied by scholars who hoped to obtain the same structural force in their calligraphy and paintings. With this objective in mind, Zhang Zongcang has here set aside Wang Yuanqi's advancements in indicating volume and space in favor of stressing linear movement, stroke patterns, and ink values. Earth forms are defined by heavy contours, with the convex and level areas left as blank paper, to stand out in high relief. However, rather than carry this sense of depth on the specific level over to the scene

as a whole, the artist intentionally uses the same range of ink tones for the middle and background as for the foreground. With the distant elements thus brought up to the same plane as those in front, surface texture and patterning become major aspects of this piece. The result is a strong resemblance to rubbings taken from landscapes carved in stone many centuries ago. The abstract qualities of this rubbing effect lend unity and harmony to the painting, and mark a step toward the reunion of pictorial representation in China with its ancestor, writing. In these ways, Zhang Zongcang attains the ideal balance from the Orthodox standpoint: the use of traditional styles to present a personal statement that is inextricably bound up with the spirit of antiquity.

## WANG CHEN (Zining, Pengxin), 1720-1797

### Landscapes in the Manner of the Yuan Masters

Two album leaves, ink on paper
12 x 9 inches each leaf

Leaf One:

> *Artist's seal:*   *Wang Chen*, square, intaglio

Leaf Two:

> *Inscription:*   After sitting for a long time at a rainy window playing idly with my brush, the methods of the Four Masters of the Yuan period suddenly entered my mind.

> *Artist's seal:*   *Wang Chen*, square, intaglio

Collection of Dr. and Mrs. Robert Magrill, San Marino, California

Wang Chen, great-grandson of Wang Yuanqi, was a leading figure in the Loudong School of the 18th century. He is also considered one of the "Four Little Wangs." (The other three were Wang Yu, active ca. 1700; Wang Su, active mid-18th century; and Wang Jiu, active late 18th century.) After passing the exams for a *juren* degree in 1760, Wang Chen accepted a post as prefect of Yongzhou in Hunan. During his residency there, he grew to love the scenery of Hunan, especially in the region of the Xiao and Xiang Rivers. Following in the footsteps of such 13th century artists as Ying Yujian, he portrayed scenes of this area in his paintings. Though heir to his family's distinguished artistic tradition, Wang Chen preferred to draw directly upon the achievements of Song and Yuan masters for his stylistic sources. Chinese critics have praised his work for its transcendence of "form-likeness" and its affinity to the past, attained through the delicate application of generally dark ink with a dry brush.

The artist's colophon on one of these two landscapes implies that they once made up half of a set of four album leaves, each painted with one of the Four Yuan Masters in mind. On the inscribed leaf, circular earthen formations are built up into a massive eminence that dominates the right side of the composition. The rhythmic sweep in the delineation of these hills and the vegetation dots that accent them are more reminiscent of Wu Zhen than of any other Yuan painter. Tracing Wang Chen's methods back even further in history, however, Dong Yuan and Juran (ca. late 10th century) become the most obvious points of reference. Still other influences are notable here as well: Fan Kuan might have inspired the gnarled trees; the monumental scale within a diminutive format recalls Southern Song landscapists; the fade-out of distant hills in mist recaptures the spatial effects of Ma Yuan (active ca. 1190-1224) and Xia Gui (active ca. 1180-1230). In his use of empty space here Wang Chen proves himself bolder than any Orthodox master of the previous century.

As in the first leaf, sensitive brushwork is the highlight of the second, with every line and dot revealing extensive training in traditional brush methods. The arrangement of land and water may have had its origins in Ni Zan or Cao Zhibo (1272-1355), while the restrained brush technique is based on various Yuan models. The narrow range of ink tones is maximized through careful grading of values. The central tilting axis, which unifies the overall design, is formed by a meeting of the rocky cliffs hanging over three low buildings on the near shore and the rugged peaks in the distance.

The combination of historical borrowings, along with the sense of intimacy pervading the essentially monumental scale, make these pictures typical of 18th century Orthodox art. Like other Orthodox artists of his time, Wang Chen saw painting as a vehicle for both paying homage to the past and expressing his own poetic ideas and feelings. From this standpoint, these two small monochrome landscapes keenly reflect the sensibility of an individual scholar-artist, as well as certain values of his contemporary society.

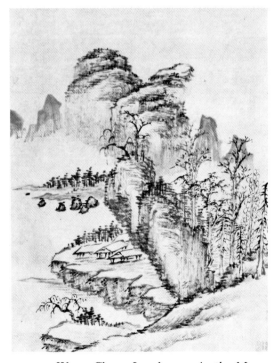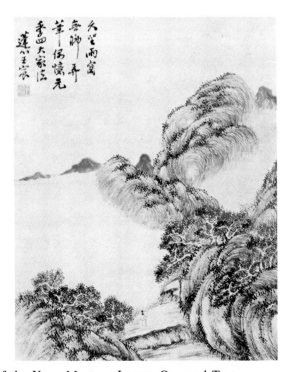

Wang Chen. *Landscapes in the Manner of the Yuan Masters*: Leaves One and Two.

*ZHAO XIAO (Yaori), active late Kangxi period*

**Landscape**

Hanging scroll, ink and light color on paper
34¾ x 17¾ inches

> *Inscription:* A spring day in *yiwei* (1715), in the manner of Ke Danqiu (Ke Jiusi). Lou River, Zhao Xiao.
>
> *Artist's seals:* *Zhao Xiao*, square, intaglio
> *Yaori shi*, square, relief
> (Upper right) *Zi you shanshui*, rectangular, intaglio
> (Lower right) *Weizhong qiuhao*, rectangular, relief
> (Lower left) *Yuanli*, square, relief

Private Collection, La Puente, California

A native of Wang Yuanqi's hometown, Taicang in Jiangsu Province, Zhao Xiao received instruction in painting from this great Orthodox master. Most of Zhao Xiao's depictions of bamboo and landscapes are small in size and quietly graceful in manner. He was determined and perfectionistic in his study of art, at times stopping abruptly in the midst of a painting and refusing to finish out of dissatisfaction with his work. It is said that when he was 40 years of age, he declined to sign his completed paintings, explaining that he still needed another 30 years of practice. Chinese art historians praise his work for its "plain" (*pingdan*) style and elegant antique flavor. These features, along with his development of Wang Yuanqi's brush methods, have won a place for Zhao Xiao as a dominant figure in the Loudong School of the early 18th century.

Had this bamboo landscape, dated 1715, been left unsigned, even a connoisseur might mistake it for the work of Wang Yuanqi, who died that very year. The artist cites the influence of Ke Jiusi (1312-1365), the Yuan period Literati master of bamboo painting, while the "one river, two banks" composition is an obvious reference to Ni Zan. From these early sources, Zhao Xiao derived his notably dry brushwork. Nevertheless, unlike some Loudong painters who turned directly back to Song and Yuan models for inspiration, Zhao Xiao used what he had learned from his teacher. One aspect of this is the clean edges of the beginning and ending of each stroke. Another is the somewhat stiff quality of his bamboo stalks and leaves, and of the dry branches on the near shore. This deliberate avoidance of refinement and technical bravura characterizes Wang Yuanqi's pictures. Also common to both artists is the rich layering of texture strokes and modulation of ink tones to construct rocks and hills. With certain facets of each formation left blank, remarkable bulk and solidity are achieved.

Notwithstanding Zhao Xiao's pursuit of Taicang tradition, the change in perspective ushered in at the turn of the century contributed substantially to his artistic priorities. For all its structural integrity and reserved manner, the intent of this bamboo scene is less to evoke in the spectator a sense of awe before the grand natural order than to amuse him with a demonstration of the painter's own aesthetic cultivation.

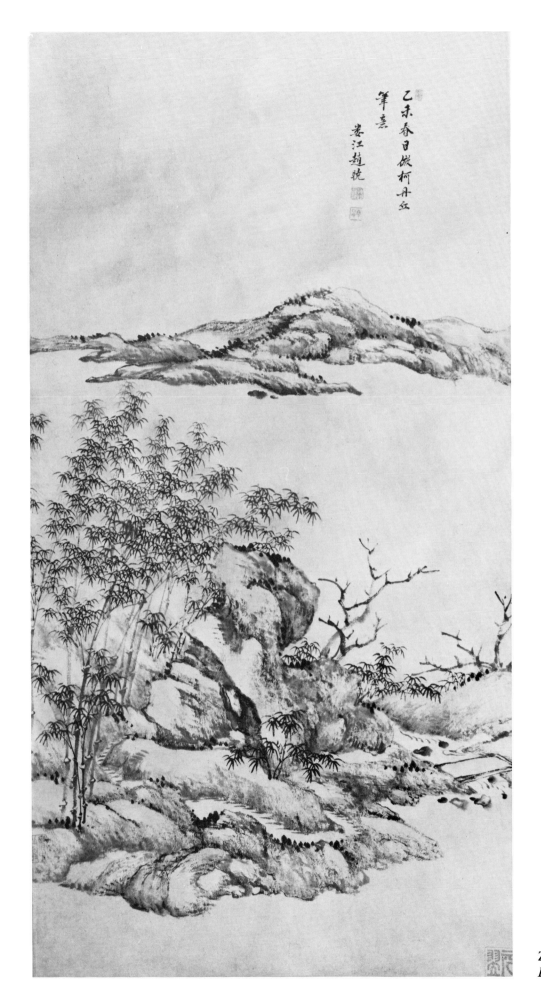

乙未春日倣柯丹丘
筆意
苕江趙曉

Zhao Xiao
*Landscape*

*FANG SHISHU (Xunyuan, Xiaoshidaoren), 1692-1751*

**Landscape**

Hanging scroll, ink and light color on paper
31½ x 12 inches

*Inscription:* The landscapes of Dong Yuan are wild, cool and natural. When viewed at close range they don't look like anything, but from a distance the trees and rocks appear natural. I once saw his long handscroll "Summer Mountains in Mist" (*Xiashan yan'ai*). The fluent brushstrokes follow an order all their own, so that their beginning and ending cannot be traced. In this painting of dotted sandy shores and trees I have tried to imitate his ideas. Painted in the summer of *yiwei* (1739) in the Qianlong period, as a guest at the residence of the mayor of Xunyang, while discussing art with my "second younger brother" Zhongju. Xunyuan.

*Artist's seal:* *Shishu*, square, intaglio

Private Collection, La Puente, California

The artist's comments written at the top of this painting provide some insights into the circumstances surrounding its creation. The mayor of Xunyang, to whom Fang Shishu refers as his "second younger brother," was Xu Jiaju, also known as Zhongju. A native of Haining in Zhejiang, he was a noted calligrapher and seal carver. It is not surprising that the two friends' discussion of art inspired a painting modeled after Dong Yuan, for his style continued to serve as an essential point of reference for all artists working within the Orthodox framework at that time. Some aspects of this 10th century master's method are present in this mountain scene by Fang Shishu. However, a number of other influencing factors are also at work here, some of which relate to the painter's artistic background and some of which may seem coincidental.

Fang Shishu was a native of She District in Anhui, but resided primarily in Yangzhou. The famous art critic Zhang Geng commended his ingenious use of the brush and the apparent ease with which he obtained "spirit resonance." Such was Fang Shishu's modesty, however, that when he completed a painting that pleased him he often affixed a seal on it reading "attained by chance" (*ouran shide*). As a student of Huang Ding, he was schooled in the Orthodox Tradition of art as interpreted by Wang Yuanqi, and therefore can be placed within the Loudong circle. Still, he preferred not to employ the techniques of the latter master—that is, rough strokes and bold color washes; nor did he convey the feeling of Wang Yuanqi's spontaneous and carefree hand. Instead, Fang Shishu is known for his employment of fine smooth strokes and dots and soft hues in a manner more akin to that of Wang Hui. Like many followers of Wang Hui, he excelled mainly in fluid brushwork, resplendent textures, and harmonious arrangement of form and color.

Painted when the artist was 49 years old, the present example is a view of

wooded banks and sandy shoals alternating with sheer cliffs and towering peaks. The long hemp-fiber strokes that give shape to the rounded mountains in the far ground are a classic revival of the Dong Yuan mode and represent Fang Shishu's attempt at capturing this Jiangnan master's "wild, cool" (*huanghan*) atmosphere. At the same time, the soaring height of the massif relates it to compositions by the northern painters of the early Song period. The subtle calligraphic delineation of the foreground elements discloses extensive practice of Huang Gongwang's techniques. The results of such a combination of Dong Yuan and Huang Gongwang as stylistic sources are usually reminiscent of Wang Yuanqi, but under Fang Shishu's brush the outcome is closely aligned with Wang Hui. The richly woven texturing of various land surfaces as well as the application of very pale brown over large areas, confirms this affinity between the Yushan master and this 18th century landscapist.

Nevertheless, in a significant departure from past orthodoxy, Fang Shishu's rendition of nature emphasizes entertainment for the viewer. He appeals directly to his contemporaries' taste for light-hearted enjoyment of adroit workmanship, refined expressiveness, and allusions to familiar prototypes. In this way his paintings are reflections of the middle Qing tendency toward introspection and reverence for antiquity.

Fang Shishu
*Landscape*

*HUANG JUN (Guyuan), 1775-1850*

**Landscape**

Hanging scroll, ink on paper
40½ x 13 inches

> *Inscription:*  Streams and Mountains in Leisurely Diversion. In the style of
> Ni Gaoshi (Ni Zan). Huang Jun.

> *Artist's seal:*  *Guyuan*, square, relief

Private Collection, La Puente, California

Huang Jun, painter of landscapes and flowers, was a native of Jiangsu Province, where he studied the methods of Huang Ding and Wang Yuanqi. For this reason he can be counted among the followers of the Loudong tradition in the early 19th century, although he also excelled in the styles of the Northern Song masters. In fact, in his middle years he reached such heights that critics declared him to be the greatest exponent of the Northern Song style since Tang Yin (1470-1524) and Wang Hui. Huang Jun was a professional artist; having refused a government position he lived in poverty. Despite difficult circumstances, he preferred to keep his work or make gifts of it rather than to sell his paintings.

Here Huang Jun refers to Ni Zan as "Lofty Scholar Ni," a name given to this Yuan master during the Ming Dynasty by admiring painters. Ni Zan is famous for saying, "When I paint I do not do so to make a living, show my skill, or create beauty. When I paint I just convey my sense of leisurely diversion." His aesthetic ideal reflects the Chinese scholar-painter's concern with motivational purity; the artistic impulse is not to be channeled into material or egoistic ends. The artist must paint for the sheer joy of the activity itself, and a beautiful result is the product of spontaneous spiritual outpouring rather than conscious design. The title of this landscape refers directly to Ni Zan's famous saying and to the mood in which Huang Jun himself painted this picture.

Those qualities that clearly mark the painting as an early 19th century work are Huang Jun's own contributions, quite apart from the legacy of the ancients. Raised perspective with a panoramic view and naturalistic depiction of distance and dimension characterize the landscape painting of this era, as does the calligraphic brushwork with its strong, unbroken lines. Huang Jun's mastery of monochrome ink composition is apparent in his suggestion of depth and color by layering different shades of gray over one another.

Despite Huang Jun's varied brushwork, with wet and dry, fine and broad, as well as dotted and sweeping strokes, the painting looks deceptively simple. This reflects Ni Zan's emphasis on unassuming beauty. Actually, behind the simplicity lies a complex orchestration of movement and an adept working of perspective. Chinese painters, often said to "love their ink like gold," value masterful restraint and economy of line. In consonance with this ideal, no stroke or dot in Huang Jun's painting is superfluous. The delicate, straying lines that trail off the cliff at left midground, for instance, break the stiffness of the rock and place the boat in

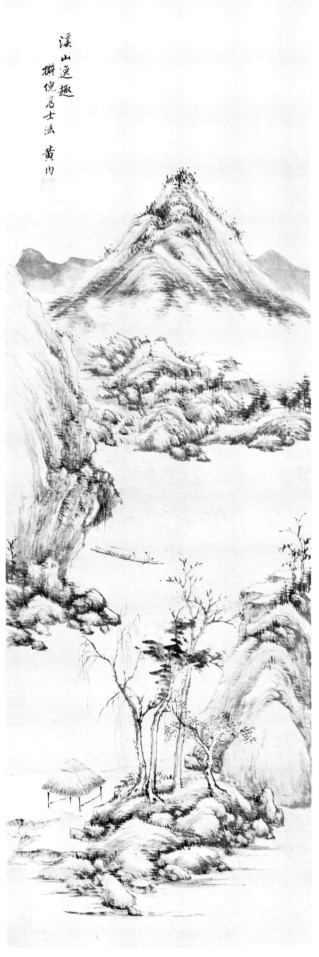

perspective. Seemingly unimportant, these lines are actually essential to the perception of distance in the painting.

The foreground trees begin the movement into the distance; they are of different species, and while keeping each of them distinct, the artist builds them into a sensitive and dimensional composition. The trees pull the eye into the midground, where the vertical thrust is relieved by a boat and overhanging cliff. Beyond the boat is a stream bubbling over rocks; Huang Jun suggests the water's flow most effectively with just a few strokes. This stream is important both in adding movement and in connecting the middle ground to the background. The circulation of air in this work is also a significant indication of the painting's compositional subtlety. The atmosphere in the foreground is clear, but moving farther back into the center the air becomes mistier, and in the background it turns into a bank of rain clouds around the base of the main peak.

"Streams and Mountains in Leisurely Diversion" embodies all the tenderness of touch and feeling so highly valued by Huang Jun's predecessors. Considering his impoverished condition, this work becomes especially valuable as an expression of Huang Jun's abiding love for beauty in the face of hardship.

Huang Jun
*Landscape*

# The Yushan School

The scenic district of Changshu in Jiangsu Province was the birthplace of Wang Hui (1632-1717), whose following is designated the Yushan School after the famous mountain in that vicinity. (Although another great artist of the early Qing, Wu Li [1632-1718], was also from Changshu, his art did not generate repercussions of sufficient magnitude during or immediately after his lifetime to consider him a co-founder of this school.) From his youth, Wang Hui dazzled accomplished painters and connoisseurs alike with his genius in making accurate copies of old paintings of all kinds. Like Wang Yuanqi (1642-1715), he received the lamp of Orthodoxy from Wang Shimin (1592-1680) and Wang Jian (1598-1677), but refused to limit his historical models to the Literati or Southern School and exclude the so-called Professional or Northern School, as Dong Qichang (1555-1636) had prescribed. Wang Hui's technical wizardry and his love for the picturesque scenery of his home district led to his preference for painting luxurious, richly colored landscapes in virtuoso brushwork. Elegantly decorative, yet based on vast artistic erudition, his art is a celebration of nature's abundance and graceful charm, and of a gentleman's life of joy and refinement.

The same emperor who bestowed his favor on Wang Yuanqi also commissioned Wang Hui to paint the official pictorial record of his travels through southern China. The enormity of this task required the assistance of a number of other painters who in this way came under the direct influence of Wang Hui. As the imperial project spread Wang Hui's name far and wide, hundreds of eager admirers from all over China flocked to his door seeking instruction. Adopting his "great synthesis" of divergent trends in art history, these followers approached their study of ancient masters with objectivity and open-mindedness. If none of them could surpass their teacher's prodigious talent and technical prowess, they did update his unbiased eclecticism to encompass even the styles of Wang Yuanqi and other recent artists. Moreover, some Yushan painters, such as Yang Jin, excelled not only in landscape, but in other subjects—flowers, birds, animals, and figures—as well. Rather than exercising individualism through the abstraction of form or idiosyncratic mannerisms, they immersed themselves in the full spectrum of artistic precedent in order to pay homage to the splendor of their entire cultural heritage.

Developing alongside of, and sometimes merging with, the Loudong School, the Yushan School thrived for generations, exerting significant influence on painting down to the present century.

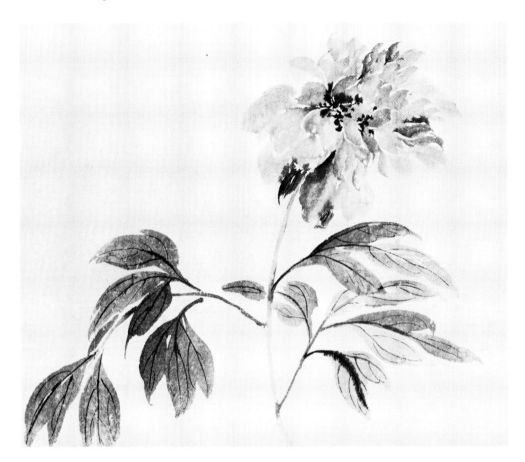

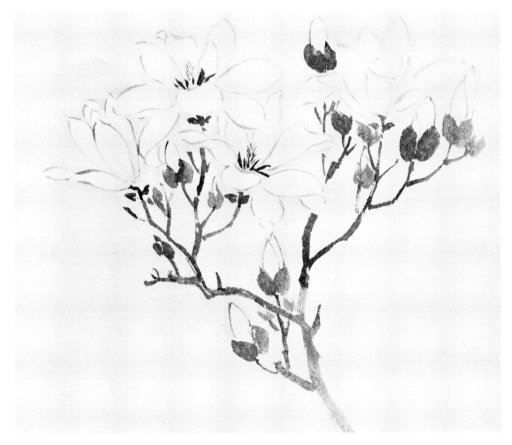

Yang Jin
Handscroll of *Flowers,
Birds, and Cat*:
Peony and Magnolias

*YANG JIN (Zihao, Xiting), 1644-1728*

**Flowers, Birds, and Cat**

Handscroll, ink and light color on paper
11 x 287¾ inches
Total of eighteen individual studies, with five poetic inscriptions interspersed

|  |  |
|---|---|
| *Sixth inscription* (left end of handscroll): | (Dated) *wangchun* (January) of *jiaxu* (1694). Director Kuiyuan (Xia Zhouyang, 17th century flower painter) painted this kind of handscroll. Though it was in the style of the school of Zhao Mengfu (1254-1322) or Qian Xuan (ca. 1235-1300), the brushwork is so superior and the use of ink so harmonious, it truly surpasses anyone's imagination. It is not something that later students like us can imitate. This imitation of mine would make a connoisseur laugh. A fellow student from Haiyu (Yushan), Yang Jin. |
| *Artist's seals:* | *Yang Jin siyin*, square, intaglio |
|  | *Yehao*, square, relief |
| *Collectors' seals:* |  |
| (Lower right) | *Zhangyi zhi yin*, square, intaglio |
|  | *Wanli zhencang*, square, relief |
|  | *Ma Jizuo yin*, square, intaglio |
| (Upper left) | *Ji Shanzhai yin*, square, intaglio |
| (Lower left) | *Jizuo*, rectangular, relief |
|  | Illegible, square, relief |

Collection of Dr. and Mrs. Robert Magrill, San Marino, California

Yang Jin, from Wang Hui's native Changshu (Jiangsu Province), was a prominent figure in the Yushan School. Not only did he receive instruction from Wang Hui, he also was frequently asked to fill in certain details of his teacher's landscapes, particularly figures, animals, buildings, and vehicles. In these subjects, as well as the flower and bird genre, Yang Jin actually surpassed the capabilities of Wang Hui. His earliest recorded work, a portrait of Wang Shimin dating to 1674, was executed jointly with Wang Hui. When the latter was summoned to the capital in 1691 to direct the painting of the "Southern Trip of Emperor Kangxi," Yang Jin traveled with him and assisted with this famous project. Back at Yushan, as the demand for the works of Wang Hui became too heavy for the master to fill himself, the pupil was asked to produce complete pictures under his teacher's name. Yang Jin is best known for his tranquil pastoral scenes with water buffaloes. His landscapes display the fine brushwork, soft, cheerful colors, and refined taste of Wang Hui, while his free renderings of plants with birds or insects draw upon the Changzhou masters Yun Shouping (1633-1690) and Wang Wu (1632-1690).

The series of monochrome studies in the present handscroll attests to Yang Jin's accomplishment in modes of expression outside the limits of the Yushan tradition. Opening with a single peony bloom, this work also includes depictions of magnolias, narcissus, and other flowers; bamboo, insects, birds of various types, and a cat.

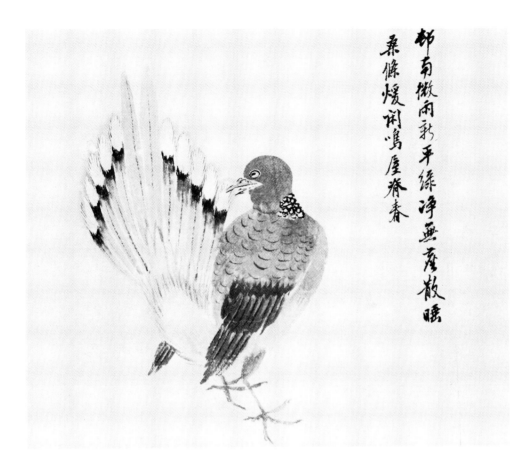

郊原微雨新平綠淨無塵麼散睡
桑條煖釣鳩屋脊春

Yang Jin
Handscroll of *Flowers, Birds, and Cat*:
Dove and Cat

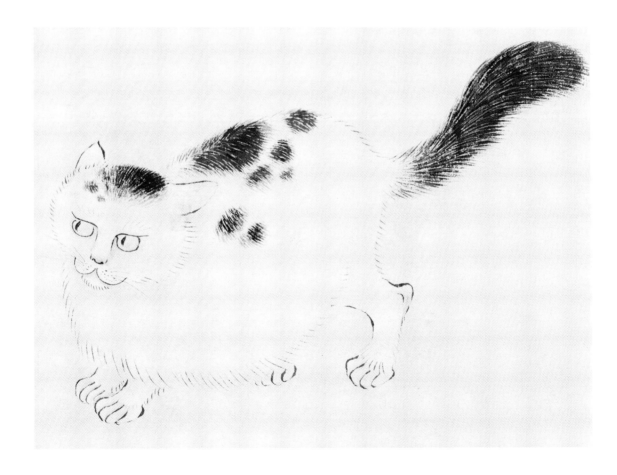

Each item or grouping is painted in succession, with brief poems at intervals. Though alternating from outline to "boneless" to suit each subject, the style is consistent throughout the scroll in its fluidity of delineation and classicism of design. Through sensitive application, the ink is modulated with such rich variety that the colors characteristic of each plant or animal are strongly suggested.

This chromatic diversity is featured particularly in the peony, which consists of light washes, a few dark lines for the veins of the leaves, and black dots in the flower's center. Both absolute control and ease of execution are evident in every touch of the brush. Each of the soft, feathery-light petals is distinct from the next, while no trace of the brush's path is visible in the washes of the foliage. Implicit in the selection of techniques and in the conveyance of the vital and supple qualities of this plant is the influence of the Ming period flower painter Chen Chun (Daofu, 1483-1544).

In contrast, the spray of magnolias is an evocation of graceful linear movement. These flowers are contoured in strokes that thicken and thin out in accordance with the petals' natural curves. By means of light ink washes around the outer edges of the blooms, their pure whiteness is made to seem even lighter and brighter than the colorless ground on which they are drawn. This same device also serves to accentuate the magnolias' bulk and elegant formations.

The versatility of Yang Jin's brush is further demonstrated in his representation of a dove. The bird stands oddly posed with its head turned back to groom its tail feathers, which are spread in full array like a peacock's. In a show of masterful grading of ink tones, the artist returns to the boneless manner with linear detailing to capture the soft weightless feeling of the creature's plumage.

A comical touch colors the portrait of a cat, which crouches on its forelegs, its tail extended, and its glaring eyes betraying the workings of some mischievous intent. Except for its lined-in facial features and paws, the animal's body is simply rendered with a single row of short light strokes suggestive of fur, while a few black spots on its head and back and its bushy tail consist of masses of delicate brushstrokes.

Taken as a whole, the eighteen ink studies comprising this lengthy handscroll make up a sampler of Yang Jin's technical repertoire and aesthetic sensibilities at about the midpoint of his long artistic career. Every section, like a poetic vignette, is phrased with remarkable economy of means and unadorned clarity so as to elicit in the viewer an appreciation for the charm and grace inherent in the character of each subject.

**Landscape**

Hanging scroll, ink and color on paper
51 x 25¼ inches

*Inscription:* The late works with color painted by my teacher Gengyan (Wang Hui) attained the sublime; each tree and rock is carefully designed, fusing the merits of all past masters. Here I have utilized his methods to paint this, but I have not achieved even one ten-thousandth (of his excellence). *Yiwei* (1715), midwinter, as a guest at Shuiyunjingshe (Wang Hui's studio), Yang Jin.

*Artist's seals:* *Yang Jin siyin*, square, relief
*Zihao*, square, intaglio

*Collectors' seals:*
(Lower right) *Zhang shi Keyuan shoucang xinshang juepin zhi yi*, rectangular, relief
(Lower left) *Zhang shi  ?  ?  shoucang shuhua yin*, square, intaglio

Private Collection, La Puente, California

As he declares in his inscription, Yang Jin's landscape of 1715 is a tribute to his teacher. The fact that the artist was staying at Wang Hui's studio at the time this piece was done is an indication of the long and close association between the two. (Wang Hui died just two years later, in 1717.) From the picturesque quality of the setting and the structural soundness of the composition to the refinement of each brushstroke, this painting sums up all that the student had learned from the master. At the same time, even though a point-by-point study of the individual aspects in Yang Jin's work reveals fidelity to the elder painter and his blending of the Northern and Southern Schools, certain subtleties of technique as well as the underlying artistic purpose of this painting are clearly identifiable as 18th century innovations.

A fine brush was used throughout this complex arrangement of mountains, a river, trees, houses, and figures. Viewed from a foreground hilltop out of which willows and a giant *Taihu* stone rise, a group of cottages in a garden setting is nestled beneath a towering pine and bamboo grove on one shore of a river. A footbridge leads the eye across the water to more houses and trees on the opposite bank. Following the river's winding course into the distance, a dense forest cushioned in low mists edges up against the foot of sheer rocky cliffs, the soaring height and solidity of which provide a monumental scale for the scene. This gradual progression to tall mountains at midpoint is an instance of the *shenyuan* ("deep distance") perspective. The main peak, based near the painting's center, is built of rectangular formations. After a slight drop in altitude and a waterfall, the mountain range continues in more rounded slopes to the right and toward the front, creating a semicircular enclosure around the lowlands. Faint silhouettes of lofty spires in the background add a sense of far-reaching space, while confirming the remote location of the retreat.

Many qualities in this work are manifestations of middle Qing Literati values.

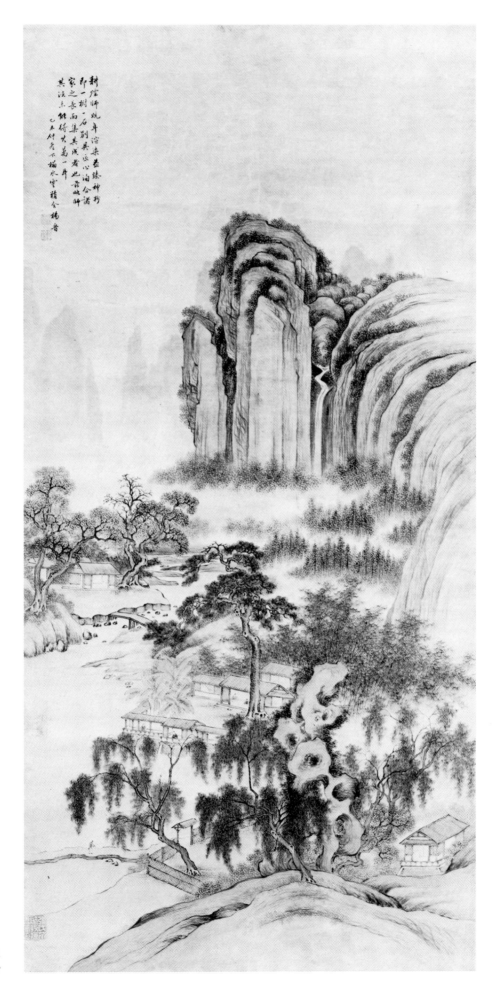

Yang Jin
*Landscape*

43

By the end of Kangxi's reign the qualifications expected of the scholar-artist placed a new emphasis on encyclopedic knowledge of art history and a high degree of connoisseurship. Whereas late Ming and early Qing painters used the past as a vehicle for self-revelation and treated landscape as a pictorial symbol of the mind, Yang Jin and his Orthodox contemporaries took up the brush with the aim of giving voice to their scholarship and powers of aesthetic discrimination.

With this picture of a scholar's country residence, Yang Jin interprets a theme first favored by Yuan amateur painters and continued by succeeding generations. A sophisticated 18th century spectator would recognize the grandeur in Yang Jin's spatial construction as an allusion to Song landscapes; he would also savor the sensitivity of the brushwork as a reflection of Yuan taste. The detailed decorative rendering of each component follows many works of Wang Hui. Moreover, the colors, now faded but once vivid shades of blue, green, and light ocher, are derived from the latter's famous *qinglu* (blue-green) scenes. On the other hand, the uniformity of ink tone, moisture, and stroke width mark a break from precedent. Any rugged or wild aspects of the natural elements are subdued by the soft fluid elegance of their lineation. Such a homogeneous manner eliminates all tension from the painting and characterizes Yang Jin's vision of the world with a quiet grace, suggesting a relationship of harmony and unity between man and his environment.

**Landscape**

Hanging scroll, ink and light color on silk
44½ x 15¾ inches

>   *Inscription:*   Autumn Woods in Secluded Heights, in the manner of Jiang Guandao (Jiang Can, active first half 12th century). A summer day in *bingwu* (1726), Yongzheng period. Xiting, Yang Jin.
>
>   *Artist's seals:*   *Xiting Yang Jin*, square intaglio
>   *Zihao*, square, relief
>
>   *Collector's seal:*   *Yu'nan Zeng Xiangting zhencang*, square, relief

This late work by Yang Jin, completed when he was 82, exhibits a loose, cursive hand. Again the composition opens with a cluster of trees growing on raised land in the foreground. Unlike the front hill in the valley scene of 1715, this one is jagged and the trees are mostly barren. Cut off sharply on the left side, this cliff serves as a point of embarkation for the eye's journey through the picture. This creates an illusion of a third dimension within the deeply carved canyon that winds its way back into the distance, and also accentuates the soaring height of the topmost peaks in contrast to the low riverbed.

On a level area beside the water, a servant boy gestures to a scholar who, seated on his donkey, gazes at trees clinging to steep slopes and a simple pavilion perched

high on an overhanging ledge. Just above this point a looming bulky eminence thrusts powerfully up to the left. Washed in light brown with a slight greenish tinge, only the fissures are described in straight parallel strokes known as *nilibading*. This technique, meaning literally "spikes pulled out of mud," was utilized for shading concavity by the early 12th century painter Jiang Can, to whom Yang Jin credits his inspiration in his inscription on this piece. The use of vegetation dots along the contours, and the peculiar rhythmic build-up of land mass, also relate to this Song master. But the angular turnings and rocky hardness of Yang Jin's hills are akin to those of Tang Yin (1470-1523) as well.

By these means the impression of volume is obtained, while the layering of woods and mountains that project from either side of the painting funnel the field of vision through the ravine to pale peaks far in the depths of space. Compared to earlier works, the range of nuances in the ink is broader here; in combination with lively brush movements, this affords a feeling of the clear fresh atmosphere of a crisp autumn day. By venturing into this greater measure of spontaneity, Yang Jin expands the scope of the Yushan School, proves himself more than just the pupil and main assistant of a major early Qing master, and earns his reputation as an artist meriting attention in his own right.

Yang Jin
*Landscape*

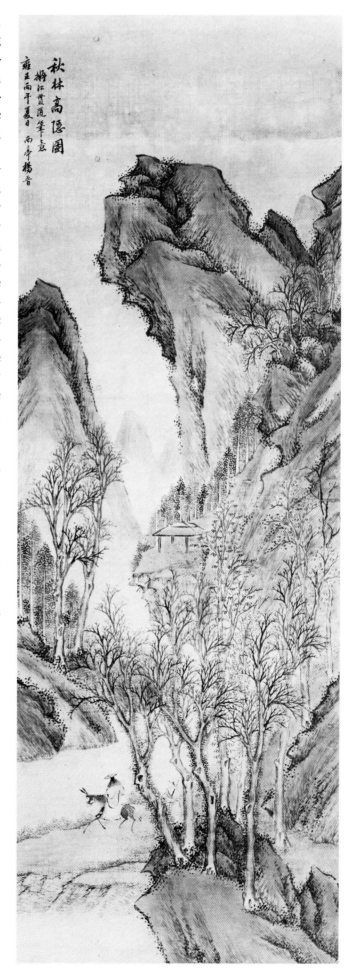

*XU RONG (Shanting, Baiyangsanren), active 1713-1727*

**Landscape**

Hanging scroll, ink and color on paper
57¼ x 30½ inches

> *Inscription:*  Rivers and Mountains Without End. Painted in the style of General Li at Moling. Baiyangsanren, Xu Rong.

> *Artist's seals:*  *Xu Rong zhi yin*, square, intaglio
> *Baiyangsanren*, square, intaglio

Private Collection, La Puente, California

A lesser-known student of Wang Hui was Xu Rong from Wujiang, Jiangsu. While few biographical facts on this scholar-artist survive, three of his paintings are recorded for the years 1713, 1716, and 1727, the second work being a collaboration with Wang Hui. Xu Rong's paintings are extremely rare today, and his identity has been cast into obscurity by the fame of a 19th century artist with the same name. This later Xu Rong was also a native of Jiangsu and an artist in the Literati tradition. He may be distinguished from his earlier namesake by his style name, Yuting, and by records which indicate that he took up residence in Japan in 1862. Still, many art historians have unwittingly deprived the 18th century Xu Rong of recognition by attributing his work to Xu Yuting.

In his inscription on "Rivers and Mountains Without End," Xu Rong acknowledges his indebtedness to General Li (Li Sixun, 651-716), a Tang period painter. However, the more obvious sources of this large-scale landscape are Xiao Zhao (active 1126-1134) and Xu Rong's teacher, Wang Hui. Xiao Zhao was sometimes called Xiao Banbian ("One-sided Xiao") for his compositions, which were divided down the middle, with one half occupied by mountains and the other left unpainted. Xu Rong combines this schematic formula with the fine brush technique and delicate hues of Wang Hui.

Just beyond a rocky bank in the foreground, a tiny figure sits at the window of a cottage gazing up toward a group of trees surmounting the bank. The remarkable height of one of the pines in this grove anticipates the lofty pinnacle towering above and leads the viewer's eye up along the vertical progression of subordinate peaks. This exemplifies the type of perspective known as *gaoyuan* ("height and distance"), wherein nearby high peaks are juxtaposed with faraway stretches of land. Built up of layer upon layer, the solid rocky mass is modeled with a dry brush and occasionally washed with pale brown. The viewer feels the same awe toward nature as he does when admiring the monumental landscapes of the Northern Song period, but here the mood is brightened by the sense of verdant growth provided by the rich ink of the "moss dots" and the light blue, green, and brown coloring of the foliage on the trees.

Half-hidden in a wooded gorge among the crags are two buildings, perhaps temples; and on a small plateau, clinging precariously to the right side of the giant peak, is a pavilion from which miles of water and hills can be viewed. The rows of

46

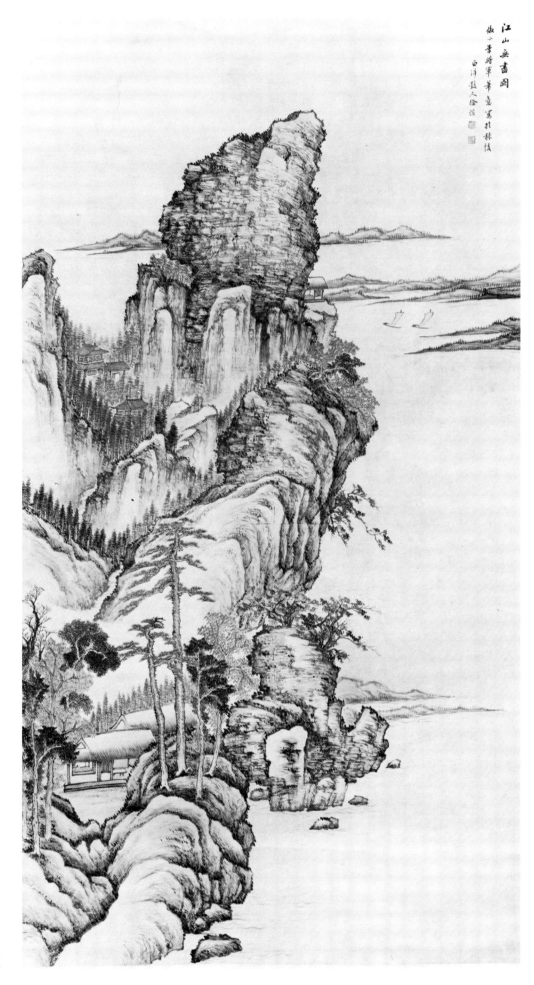

江山無畫圖
倣小李將軍筆意寫於秣陵
白洋散人徐溶

Xu Rong
*Landscape*

hills stretching across the water serve to break the almost entirely blank right portion of the painting as well as the powerful verticality of the composition. Finally, the pinnacle that reigns over all other elements in this piece, appearing fantastic in form yet sound in structure, points its summit to the upper right-hand corner, which bears the title and the artist's remarks, signature, and seals. Although the title invokes visions of a panorama full of rivers winding their courses through myriad mountains and valleys, in this work Xu Rong offers only a suggestion of such a scene. The monumentality of the awesome precipice at close range poses a sharp contrast to the small scale of the distant hills. This juxtaposition of height and depth combines with the use of blank space as a representation of both water and sky (unbroken by a horizon line) to imply a sense of the infinite grandeur of the natural world.

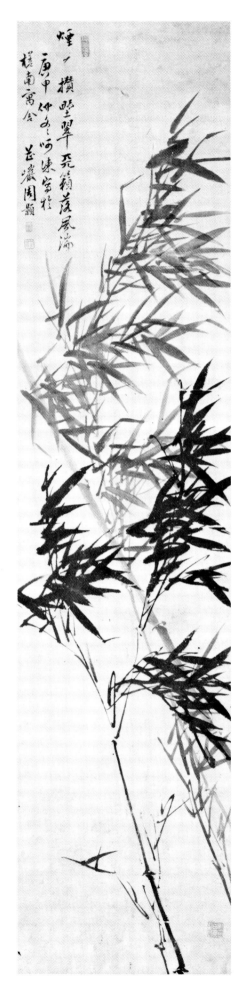

Zhou Hao
*Bamboo in the Wind*

## ZHOU HAO (Zhiyan), 1675-1763

### Bamboo in the Wind

Hanging scroll, ink on paper
47½ x 11¼ inches

| | |
|---|---|
| *Inscription:* | Mist penetrates the verdant growth,<br>The whirring wind falls over the creek.<br><br>Painted by warming my hands with my breath in midwinter,<br>*gengshen* (1740) at Cha'nan Studio by Zhiyan, Zhou Hao. |
| *Artist's seals:*<br>(To right of<br>inscription)<br>(Lower right) | *Chen Hao*, rectangular, intaglio<br>*Zhiyan*, square, relief<br><br>*Ying ? xuan Jiangnan*, rectangular, intaglio<br>*Buke yiri wu ci jun*, square, intaglio |

Collection of Annelies L. Langenbach, Lucerne, Switzerland

The artist's seal in the lower right corner of this painting, "I cannot live one day without this gentleman," quotes a remark once uttered by the Northern Song scholar, poet, and artist Su Shi (Dongpo, 1036-1101), who also wrote:

> I would rather not eat meat than live without bamboo;
> A meatless diet makes one thin, but life without
>     bamboo makes one vulgar.

Su Shi was famous for his paintings of monochrome ink bamboo, which he is said to have studied under his relative Wen Tong (ca. 1019-1079). Depictions of this plant date back to pre-Tang times, when it usually was painted in outlines filled in with color as a background motif. The beginnings of ink bamboo are attributed to the Tang emperor Minghuang (Xuanzong, 685-762), who noticed the silhouette of this plant on his window shade on a moonlit night. Today, however, no paintings in this mode earlier than Wen Tong remain in existence.

In addition to its natural beauty, countless uses of bamboo in Chinese daily life, including chopsticks, paper, writing brushes, musical instruments, and even food, explain the fondness with which it has been regarded since antiquity. Bamboo has also long been an emblem of the gentleman. The rhythmic quality of its segmented stalks symbolizes proper Confucian behavior. As an evergreen it signifies fortitude, and its hollow center is compared to the scholar's open mind when engaged in discussion or research. Long training in the art of calligraphy is required to paint bamboo, since the depiction of the stems, branches, and leaves each calls for a specific calligraphic technique. The character of an artist's mind is thought to be reflected in his renderings of bamboo. Thus, central to the tradition of Chinese bamboo painting is the demonstration of scholarly cultivation. Following the realistic renditions of bamboo in the Song Dynasty, Yuan artists employed the more abstract *xieyi* ("write the meaning") method, while most Ming painters concentrated on bravura brush technique.

Zhou Hao, a native of Jiading in Jiangsu Province, received instruction from Wang Hui in landscape painting, a subject in which he often imitated the manner of Wang Meng (1308-1385). He was a poet of note as well as a carver of bamboo; that is, he carved sections of bamboo into brush holders, arm rests, and other objects. His paintings of bamboo are classic in approach, but their brushwork shows spontaneity and exuberance. Few of his works survive today, partly because he would not part with a painting unless he felt it satisfied a high standard of excellence.

This standard is most certainly met in a picture of wind-swept bamboo completed in 1740. The earliest work by Zhou Hao known to this author, it exhibits superior command of the subject and technical virtuosity backed by decades of rigorous training in calligraphy. Two general layers of depth are described by the use of dark ink for the bamboo in front and diluted ink for that growing some distance to the rear. As a bamboo carver, Zhou Hao was frequently in intimate contact with the plant; because of this, assiduous observation of its physical properties and appearance in various types of weather are evident in his bamboo paintings. For bamboo tossed about by a swift wind, he appropriately wields his brush quickly and fluently over the paper. The slender shape of the stalks originates in the style of Wu Zhen (1280-1354).

Tang Yin, the versatile early Ming painter, may have inspired the dense clustering and apparently haphazard arrangement of the leaves and the sweeping brushstrokes, derived from the running (*xing*) and cursive (*cao*) scripts. Some of these turn in and out on themselves to render a series of leaves with one prolific zigzag. Others twist askew like an engraved line in which the carving tool is lifted abruptly at a sharp angle. In isolation, some sections of the painting are wholly abstract, more like writing than representational art. Viewed overall, however, the image is remarkably true to the look of a few stalks of bamboo shaken by a sudden gust. Rather than the resilience of the stems, the movement of the small branches and of the foliage is emphasized, and this is carried out with such sensitivity that the rustling of the leaves is almost audible.

During the 18th century, scholars throughout China aspired to manifest their refinement of taste and nobility of character in monochrome depictions of bamboo. While many who ascended to fame did so on the basis of unconventional compositions and highly personal styles, Zhou Hao followed established rules to voice his deep appreciation for the plant's numerous qualities. In view of the consummate skill of his execution and poignancy of his statement, he is without question one of the leading masters of bamboo painting of the middle Qing period.

*WANG JIU (Cifeng, Erchi), active 1760-1780*

**Landscape**

Hanging scroll, ink and color on paper
34½ x 12½ inches

*Inscription:*   Cloudy Ravine in Autumn Skies, in the manner of the Yuan masters. Erchi, Wang Jiu.

*Artist's seal:*   *Wang Jiu zhi yin*, square, relief

Private collection, La Puente, California

By the 18th century, landscape painting as a scholar's pastime had been irreversibly altered by the influence of Dong Qichang and Wang Hui. Within less than a hundred years after the former's theory of a fundamental dichotomy in Chinese art history had become firmly established as the Orthodox approach to aesthetics, Wang Hui succeeded in breaking down the barriers between the Northern and Southern Schools through his reunification of the two opposing trends. His scholarly interpretations of the *qinglu* style in landscapes became a new model for court as well as amateur painters. Unfortunately, among his countless followers not even a handful were able to strike Wang Hui's subtle balance of Literati and decorative elements in their work. Many imitators failed to attain the grace and ease of the master's brush, while others tended to lapse into superficially attractive images lacking in force. At Wang Hui's death, aside from his student Yang Jin, no other artistic figure appeared capable of carrying on the "great synthesis" with high standards and creative power that approached those of the founder of the Yushan School.

It was not until three generations after Wang Hui that the true spirit of his vision was revived once again. In the 1760s and 1770s Wang Jiu depicted nature with a richness of surface texture and refinement of technique that echoed similar effects in the works of his great-grandfather, Wang Hui. Using a dry brush based on the methods of various historical schools, Wang Jiu avoided the common pitfalls of sweet or stilted forms that had brought quality in Yushan art to its current low level. As a student of Wang Yuanqi's noted follower Huang Ding, Wang Jiu learned something of the Loudong version of orthodoxy as well as that which was passed down to him through his own family. Yuan painting exerted a strong influence on the talented and proud young Wang Jiu, who so admired and emulated Huang Gongwang (also known as Dachi, "Great Fool"), that he took on the nickname Erchi, "Second Fool."[1] It is said that he declined any offers of official rank that came his way, wishing to devote himself fully to his art. In his old age Wang Jiu passed his days in Suzhou where he surrounded himself with other scholars and monks. Thus steeped in the breadth of his Literati artistic heritage, Wang Jiu developed his own stylistic synthesis, which eventually won him a place in history as one of the "Four Little Wangs."[2]

This painting, true to the title inscribed by the artist in the upper left-hand corner, conveys the cool, clear atmosphere of autumn in the mountains. Here, Wang Jiu displays his mastery of his great-grandfather's tour-de-force, that is, the organization of an intricate combination of pictorial elements into a luxuriantly textured and dynamic composition. In its journey through this landscape, the viewer's eye begins at a wooded riverbank in the foreground. The vigorous turnings of the tree trunks and branches, together with the variant wealth of foliage patterns, assert such power as to balance that of the towering bulk of massifs to their rear. A small brush, inked with little moisture, was used to delineate the outline and "wrinkles" of the peaks, with some convex areas left blank. The "dragon vein" movement of these hills follows a steady if winding course up the right edge of the picture and then

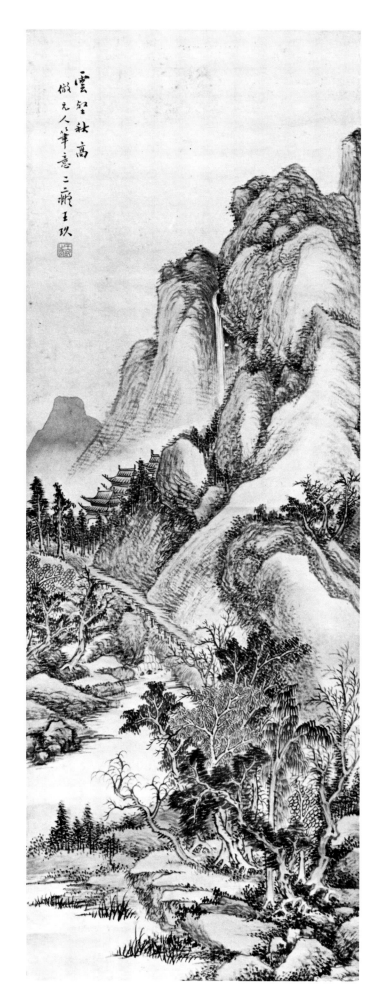

雲壑秋高
倣元人筆意
二瞻王玖

Wang Jiu
*Landscape*

down to the left, ending in a single lightly washed mountain suggestive of remote distance. As if to emphasize this diagonal thrust of earth formations, a pathway built up on stakes borders the foot of the hills as well as the stream. Its destination, a secluded temple, is only partially visible from behind the forested mountainside. Across the river, the rocky land with knotted old trees hints of great stretches of wilderness beyond the borders of this scene. A delicately woven fabric of lively brushstrokes endows this work with a quality of shimmering resonance and numerous layers of depth. Even the water and sky, rather than being simply blank spaces, are integral parts of the whole landscape, breathing life into the forms that surround them.

Like many of his contemporaries, Wang Jiu looked deep into the past for artistic inspiration, taking up the techniques of the Yuan masters while seeking to attain the spirit of Song monumentality. The mixture of these preferences was further modified by the 18th century appreciation for a small intimate format and virtuoso brushwork. In this way, "Cloudy Ravine in Autumn Skies" is a masterpiece of middle Qing Orthodox art, a mode that continued to thrive for generations.

*NOTES:*

1. Another *hao* or sobriquet of Wang Jiu was Cifeng, or "Second Peak," again a reference to a *hao* of Huang Gongwang: Yifeng, or "First Peak."

2. The other three were Wang Yu, active ca. 1700; Wang Su, active mid-18th century; and Wang Chen, 1720-1797.

# The Manchu Nobles

From the beginning of the Qing Dynasty, the Manchu nobility was enjoined by the ruling power to learn the Chinese language and to acquire knowledge of Han Chinese culture. This was in part a stratagem for controlling the Chinese population; however, by this time, due to generations of intermarriage (even though the law forbade it), the great majority of Manchus were ethnically part Chinese. Some of these nobles achieved high stature as men of letters in the Chinese tradition. Nalanxingde, son of the prime minister Mingzhu, was an accomplished poet, essayist, and calligrapher of the 17th century. His contemporary Bo'erdu was a famed art connoisseur and collector who befriended Wang Yuanqi (1642-1717) and the great Individualist painter Shitao (1641-ca. 1710). All of the Qing emperors involved themseles in Han learning to a greater or lesser degree. Kangxi became a scholar of notable merit in Chinese literature and art, devoting his attentions in the latter mainly to calligraphy and painting. His successor, Yongzheng, is best remembered for his exquisite taste in porcelain. The versatile Qianlong extended his interest to all art forms and honored all those whose creations earned his appreciation.

As men of leisure, many Manchus dabbled in art, taking instruction from Chinese painters attached to the court. Since court painting from the 17th century on was dominated by the Orthodox styles of Wang Yuanqi and Wang Hui (1632-1717), most Manchu artists absorbed this influence. Their status as members of a privileged class gave them access to the imperial collection, an opportunity granted to very few Chinese. This direct exposure to rare and important masterpieces no doubt made a deep impression on them and played a major role in determining their artistic outlook. Although not attached to the Loudong or Yushan circles, Manchu painters of the middle Qing period took up the brush in the same spirit of preserving and extolling the treasured traditions of China's artistic past.

*HEYI (Danshi, Biyanxiaoshi), active 1702-1728*

**Landscapes**

Album of twelve leaves; ink, and ink and color on paper
13½ x 9¾ inches each leaf
Leaf Five: Ink and light color on paper

> *Inscription:* Biyanxiaoshi.
>
> *Artist's seals:* *Heyi*, square, intaglio
> *Danshi*, square, relief

Leaf Twelve: Ink on paper

> *Inscription:* Twelve leaves in the styles of the Yuan masters, eighth month
> of *wushen* (1728), Heyi.
>
> *Artist's seals:* *Heyi zhi yin*, square, intaglio
> *Danshi*, square, relief
> *Quanshiqu*, rectangular, intaglio

Collection of Merlin Dailey, Victor, New York

Heyi was one of many Manchu noblemen who followed the emperor's example of pursuing literary and artistic endeavors. A member of the imperial clan Aisin Gioro and a close relative of Kangxi, Heyi is remembered as an outstanding intellectual and painter of the early 18th century. He distinguished himself in poetry and calligraphy, basing his style in the latter on Dong Qichang's (1555-1636) renditions of the writings of ancient masters. In pictorial art, under the tutelage of Wang Yuanqi, Heyi cultivated facility in Yuan landscape methods and advanced the cause of his teacher's predilection for rough-hewn brush strokes and rejection of showy displays of technical polish. Heyi imitated the Song and Yuan paintings that he had the opportunity to view in the bountiful palace collection, but his transmittal of these early modes is obviously filtered through the artistic vision of Dong Qichang. While the imposing grandeur and structural power of Heyi's compositions link him closely to the 17th century Orthodox School, the veil of "blandness" (*pingdan*) laid over such power marks the transition to the aesthetic values of the 18th century.

The twelve leaves in this album dated 1728 exemplify Heyi's version of Yuan styles. Rather than citing in his inscriptions the specific masters who inspired him, he simply remarks on the final leaf that he is painting in the "Yuan masters' styles," as if hinting acknowledgment of the intermediary influences of Dong Qichang and others. Wang Yuanqi's manner is clearly present in these leaves. The major difference between master and pupil lies in Heyi's use of a broader, more worn brush, drier ink, and relatively muted color. With this technique, Heyi manages to arrive at the mood and carefree spirit of Yuan art. The monochrome ink river scene in the last leaf, for instance, revives Wu Zhen's (1280-1354) moist dots, blunt strokes, and simple shapes. But, not merely mimicking his model's methods, Heyi succeeds in obtaining the Yuan painter's characteristic quiescent atmosphere as well as his appreciation of beauty in uncomplicated forms and subdued expression.

The fifth leaf in this album alludes to the early Yuan landscapist Gao Kegong (1248-1310), who painted in the tradition of Mi Fei (1052-1107) and his son Mi Youren (1072-1151). Gao Kegong loosened the close ties to nature of Mi father and son in favor of stylization through delicate fusions of ink and color distributed in patterns of layered dots. Such an abstracting tendency has remained an essential feature of Literati painting from Yuan down to modern times. Here, Heyi takes up Gao Kegong's approach in his depiction of mountains, piling ink of varied tones with dark green color until the individual dots are no longer distinguishable. Through these means, the peaks appear at once solid in structure and rich in tonal nuances. A very pale wash covering both sky and water intensifies the whiteness of the unpainted cloud bank encircling the base of the hills. By deftly carving out blank space on the surface of the verdant slopes, the artist renders the clouds not just as light, rounded forms but also as rising, swelling mass. Their convincing tangibility suggests the existence of land behind them and so achieves a continuous ground plane from front to rear.

That Heyi never received deserved recognition for his accomplishment in painting may be in part attributed to his amateur status. He probably painted only when the fancy struck him, occasionally presenting his creations to relatives and close friends. His obscured brushwork represents the proper modesty and reserved statement expected of the gentleman scholar-artist, and results in a type of beauty that demands a like mind to fully comprehend. Still, the underlying freedom inherent in his work, the outcome of technical mastery and deep insights into his country's artistic past, ultimately satisfies the discriminating eye.

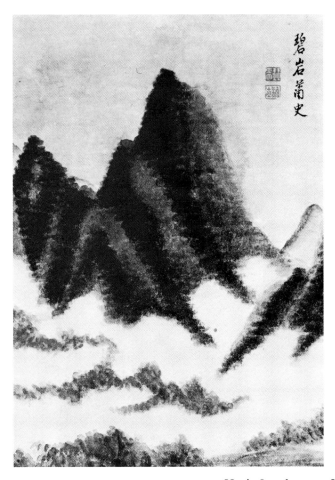 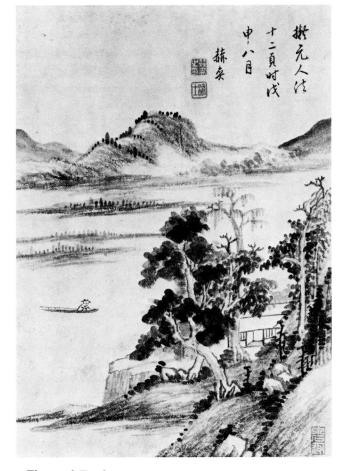

Heyi. *Landscapes*: Leaves Five and Twelve.

*HONGWU (Yaohuadaoren), active 1751-1800*

## Snow Landscape

Hanging scroll, ink on paper
79½ x 22¼ inches

| | |
|---|---|
| *Inscription:* | The waves on the sea come in a line. |
| | Look where I point in front of the house—how the snow piles |
| | up! |
| | From now on you should come up often, |
| | And gaze at the silver mountains again and again. |
| | |
| | In the third month of the fifth year of the Jiaqing period |
| | (1800), (I) painted this to patch my east wall. Yaohuadaoren. |
| | |
| *Artist's seals:* | *Yaohuazhuren*, square, intaglio and relief |
| | *Jile yu hua* ("My happiness lies in painting"), square, intaglio |

The 18th century was a period of renewed interest in ancient Chinese culture among both native intellectuals and Manchu nobility. Central to this trend was *beixue*, the study of stone tablets with carved inscriptions. Calligraphers and artists attempted to imbue their works with an antique flavor as characterized by these ancient carvings.

Among the Manchus who followed this trend was Hongwu, a close relative of Qianlong. Hongwu painted landscapes in the style of Dong Yuan (ca. 900-962) and Huang Gongwang (1269-ca. 1354), and was noted for flowers in the manners of Chen Chun (1483-1544) and Lu Zhi (1496-1576). The dates of Hongwu's birth and death are unknown; however, the *Song Yuan Ming Qing shuhuajia nianbiao (Almanac of Calligraphers and Painters of the Song, Yuan, Ming, and Qing Dynasties)* records three of his paintings dated 1751, 1770, and 1792.

This snow landscape, dated 1800, is the last known work by this artist. Its large-scale composition reflects the monumental quality of Song landscapes by such masters as Fan Kuan (active ca. 990-1030). In fact, this work by Hongwu may be compared to Fan Kuan's "Lonely Temple in Snow-Clad Mountains."[1] In both paintings, rocky mountains with trees begin at the lower edge of the composition and pile up, one behind another, almost all the way to the top edge. The build-up of each follows a natural logic and ascends as an integrated whole. The scene by Hongwu consists of ink washes and brushstrokes, with unpainted areas holding spatial value as a representation of snow. A sense of counterpoint is created in the interplay of lines, dots, and ink wash. The striking yet balanced contrasts are suggestive of a rubbing taken from a landscape carved in stone. This reference to antiquity provides another dimension of interest, and also indicates Hongwu's involvement with China's past. The vitality of nature emerges from beneath the blanket of snow in this landscape, and even the flow of the waterfall and its resurgence as mist show the fresh clear atmosphere of winter.

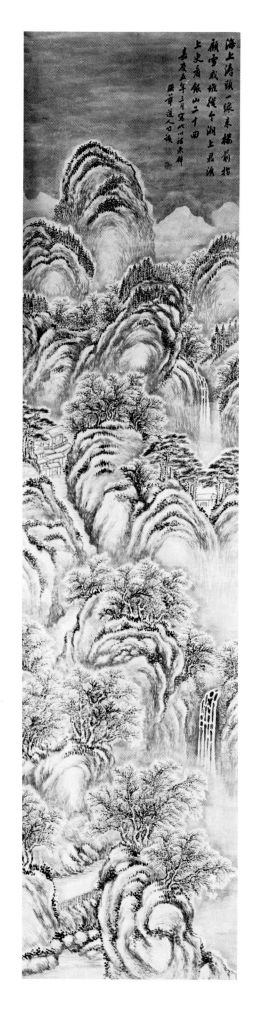

海上潮頭一線來橫前指
顧雪成堆徑小湖上君海
上史有銀山二千田
嘉慶五年二月寫此揭東軒
碧華道人万塚 印

Hongwu
*Snow Landscape*

58

*NOTES:*

1. Now in the National Palace Museum, Taiwan.

*YONGRONG (Xingzhai, Jiusizhuren, Zhizhuangqinwang), 1744-1790*

**Landscapes**

Album of eight leaves; ink, and ink and color on paper
7 x 9¾ inches each leaf

Leaf One:

   *Collector's seal:*   *Qianlong yulan zhi bao*, oval, relief

Leaf Eight:

   *Inscription:*   Respectfully painted by your servant (*chen*), Yongrong.

   *Artist's seals:*   *Chen*, square, relief
                       *Yongrong*, square, intaglio

Private Collection, La Puente, California

Yongrong was the sixth, and by some accounts the favorite, son of Qianlong. Despite his death at an early age, this talented prince attained a high level of proficiency in the arts of poetry, calligraphy, and painting. Selections of his poetic writings survive in his *Jiusitang shichao*. Although his painting instructor is not known, his work shows affinities to the styles of such official-artists as Qian Weicheng (1720-1772) and Dong Bangda (1699-1769). The Ming painter Lu Zhi influenced Yongrong's depictions of flowers and birds, while his landscapes are often based on originals by Song masters.

The audience for Yongrong's art was confined mainly to nobles and officials within the palace. He was no doubt spurred on in his painting by his father's encouragement, and most of his pictures bear the mark of the monarch's approval, either in the form of colophons in Qianlong's own hand or imperial seals (or both). This album is no exception, for the large oval seal centered at the top of the first leaf indicates that this work was viewed by this emperor.

The opening leaf consists of a rocky bluff of diagonally disposed encrustations studded with trees of various types. Similar trees grow from the lower right corner of the picture, their bases enclosed in mist. A vast body of water, its turbulent movements delineated in long, gracefully undulating ink strokes, stretches back to hills far in the distance. The precedent for this painting could be Jiang Can (active first half 12th century), a Song follower of Dong Yuan. In fact, all eight leaves in

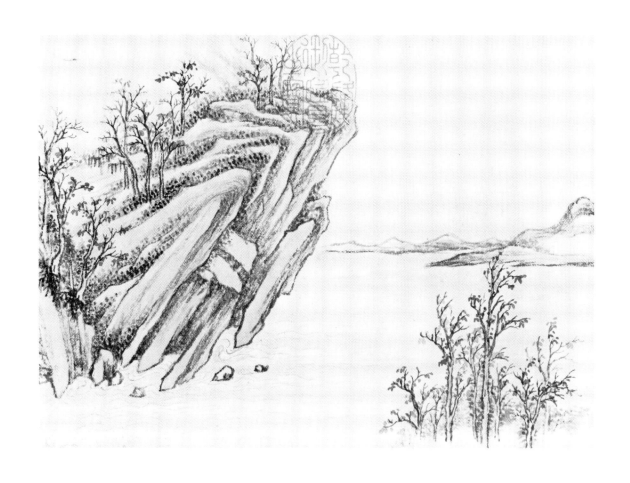

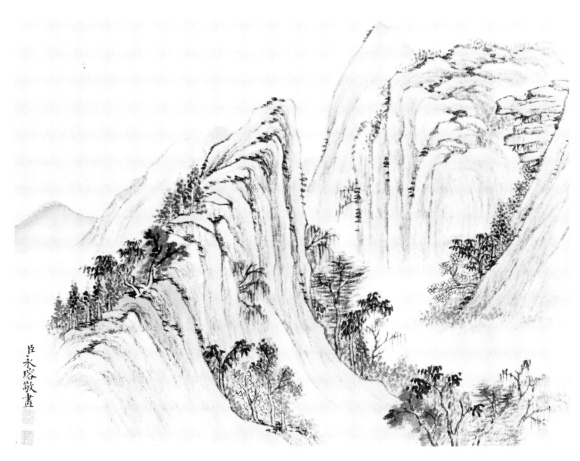

Yongrong. *Landscapes*: Leaves One (above) and Eight (below).

this album embody the Song objective of art as the illumination of nature's essential principles, or *dao*, by rendering vast panoramas of wondrous splendor within small formats. A sense of precision and order pervades Yongrong's work, while clarity and chromatic freshness provide charm. Like the "boneless" landscapes of the Tang period, Yongrong's color is handled with carefree ease (note particularly the trees), lending a lively, spontaneous air to the composition.

Two massive groups of mountains dominate the pictorial space of the eighth leaf. With impressive weight and volume, the peaks seem to bulge out from the paper, and this effect is augmented by the presence of lightly washed blue hills in the remote distance. The monotony implicit in the repeated forms of the mountains is remedied by the differentiated woods that creep up the steep slopes. The care taken in dotting every leaf on each tree discloses Yongrong's mastery of the brush. He does not succumb totally to the 18th century connoisseur's penchant for the un-dramatic and "bland"; his straightforward designs and lucid brushwork identify him as an independent spirit within this era, a sensitive artist whose lyrical images reveal the grace he found in nature and in life.

Yongrong precedes his small signature in regular script on the final leaf with the word *chen*, and follows it with a seal offering this same term of respect. Used by court artists and officials when painting for the emperor or other members of the court, the presence here of this character confirms the artist's expectation that Qianlong would inspect the album.

# The Court Painters

Art held a special appeal for all of the Qing emperors. In addition to dedicating considerable time and expense to the collection and appreciation of art, several were artists in their own right. Qianlong pursued connoisseurship with unequaled fervor, and prided himself on his own abilities in calligraphy and painting. Yet, in spite of the high priority assigned to art by the throne throughout Qing times, the one component of Ming government structure that the Manchus discontinued was the painting academy (*huayuan*).

During the Ming Dynasty the painting academy, modeled on that of the Song period, supplemented the salaries of accomplished artists with the honor of high rank and a certain degree of expressive freedom. In the Qing, however, artists in the service of the court were attached to a bureau of art called the *Ruyiguan*, which offered the artists only the unimpressive title of *gongfeng*, and rigid restrictions on the content of their work. Even the selection process for court artists differed from the open painting competitions and examinations of former times. Now, they were handpicked by the emperor after the recommendation of an intermediary, or occasionally by coming directly to the monarch's attention during an imperial tour of the provinces. Moreover, the Ruyiguan encompassed not only painting, but also such fields as porcelain, jade, household furnishings, and architecture. This comingling of fine art with the production of decorative and utilitarian items further detracted from the court painters' prestige, since in effect it reduced their status to that of mere craftsmen.

These policies were designed to keep the bureau's personnel under the tight reins of the Manchu rulers, since the latter were well aware of the potential of art for stimulating thought and communicating ideas, including ideas that might question or criticize the political status quo. Absolute orthodoxy of style was therefore required of bureau artists; and rather than being allowed to delve into the eternal *dao* in their paintings, these artists were obligated to limit their creative energies to emulating the ancients. Just as scholars engaged in the literary arts were steered into flowery metaphors and narrow pedantry to avoid provoking imperial wrath, painters attached to the court could but rework time-worn methods into eye-pleasing

images replete with technical polish, but for the most part devoid of spiritual conviction.

Qianlong's taste for ostentation and extravagance called for dazzling displays of intricate ornamentation and virtuoso showmanship superimposed on old formulas that were derived mainly from Song and certain Yuan period masters. Some painters were commissioned to apply their talents to other media as well, such as the decoration of porcelain objects, and architectural and interior design. Their chief task was to provide the premises of the imperial palaces with a visual splendor befitting a vast, rich, and peaceful empire. Official portraitists were enlisted to paint the likenesses of nobles, officials, and historical personages. Court artists' copies of ancient masterpieces were often presented by the emperor to meritorious officials as an act of recognition. These imitations served to preserve and disseminate traditional culture in a society with no public museums or art academies.

The strictures imposed on painters of the art bureau, and the want of honors or opportunity for advancement, discouraged most truly talented artists from catering to its demands for very long. Li Shan (1686-1762), who later became known as one of the Yangzhou Eccentrics, was one of many who withdrew from the bureau after only a short term. Still, despite its suppression of individuality and innovation, official art of the middle Qing period is worthy of consideration for its decorative qualities as well as its value as a symbol of a civilization at the summit of power, prosperity, and sophistication.

*YU SHENG (Zengsan, Luting), active 1736-1757*

**Flowers and Rock**

Hanging scroll, ink and color on paper
22¼ x 15½ inches

> *Inscription:* Respectfully painted by Yu Sheng, an official.

> *Artist's seals:* *Chen Sheng zhi yin*, square, intaglio
> *Gonghua*, square, relief

Collection of Mr. and Mrs. William M. Spencer, III, Birmingham, Alabama

Yu Sheng was the son and pupil of Yu Xun, an artist who specialized in portraits and paintings of flowers and birds. He was noted for his detailed renderings of flowers and insects. Unfortunately, Yu Sheng's other teachers are unknown, and even his birth and death dates are shrouded in obscurity. This circumstance is due to the snobbism of Chinese art commentators, who often do not accord court painters the attention they give to the nonprofessional Literati artists. We do know that Yu Sheng served in the court during the first year of Emperor Qianlong's reign (1736), along with other famous artists, among them Tang Dai (active 1708-1750). Yu Sheng carried on the family heritage by specializing in flower, bird, and insect paintings. He was noted for his naturalistic treatment of dragon flies and his rendering of orchids, bamboo, chrysanthemums, and plum blossoms (the "four gentlemen").

It is said that Yu Sheng's paintings were so accomplished that the emperor asked to see each one as it was completed in order to comment on it, often in the form of a poem inscribed directly on the painting. Although the court records do not mention Yu Sheng before 1736, it is known that paintings by his hand are dated each year from 1736 to 1757. Several of Yu Sheng's works are recorded in the *Shiqubaoji (Descriptive Catalogue of Paintings of the Imperial Collection of Emperor Qianlong)*: a handscroll in the style of Lin Chun (a Song master), dated 1741; a hanging scroll of chrysanthemums (1744); a handscroll depicting hundreds of different butterfly varieties (1755); and plum blossoms in the style of Wang Mian (1752). Yu Sheng's last recorded painting departs from the traditional Chinese mode in that it is an album of twelve leaves depicting all the western flowers he had seen. He may have painted these flowers from life—as the result of trade with the West—or possibly from the influence of hand-tinted prints in western herbals.

Interestingly, this painting of flowers (coxcomb, amaranthus[1], and small blue flowers) and a rock is reminiscent of an 18th century western botanical book illustration, despite its Chinese characteristics. The flowers and leaves are meticulously arranged to show each part of the plants clearly. The little mound of earth is more tightly limited and smooth-surfaced than is customary in Chinese paintings. On the other hand, the texture strokes in the rock are purely Chinese, as is the single, twisting brushstroke of the lowest stem with the flower bud. The showy coxcomb flower above carries a special meaning of "promotion" for the Chinese viewer. This symbolism suggests that the work may have been intended as a reward for a court official.

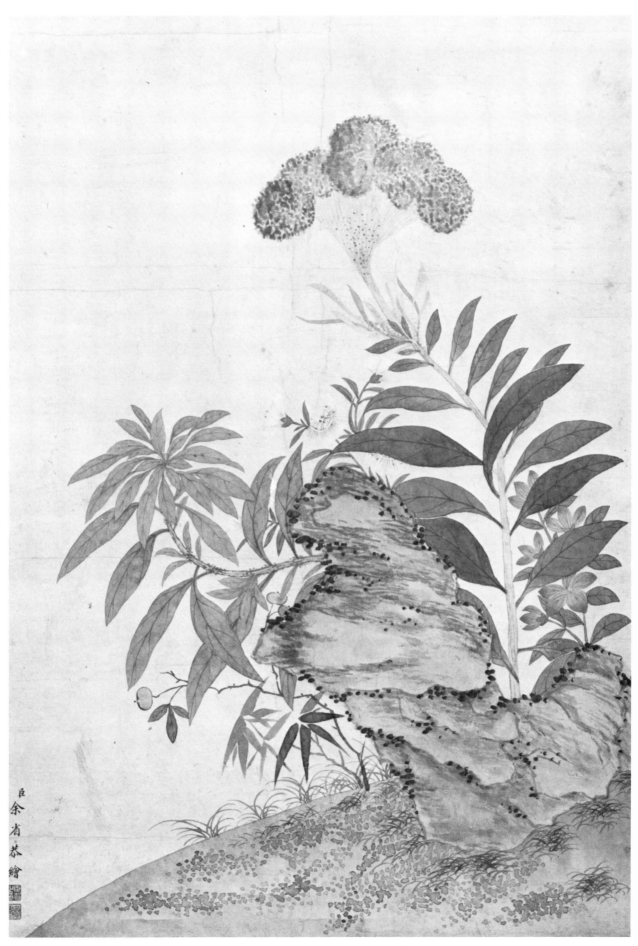

Yu Sheng. *Flowers and Rock*.

To appreciate this painting fully, the viewer needs to perceive the "naive" arrangement of the plants as part of the same sensibility that inspired the jungle paintings of Henri ("Douanier") Rousseau. Both artists share an almost childlike delight in the shapes, patterns, and colors of the natural world. Yu Sheng plays the different rhythms of the various repeated shapes against each other, from the large coxcomb leaves to the spiky amaranthus leaves and the feathery grasses below. The repetition and variation of the shapes give a lively feeling to the painting and reflect the ordered diversity of the natural world.

In the interest of liveliness, Yu Sheng has allowed one errant leaf on the left side of the coxcomb plant to stray from its carefully spaced and graduated fellows. This bent leaf and the blue flowers behind the leaves on the other side of the plant help to give a three-dimensional quality to the composition. The slight curve of the flower stem hints at the flexible way it turns in the breeze. Yu Sheng employs a similar technique to give a natural quality to the amaranthus. One leaf falls across the others on the left side; the leaves on the right are covered by the undulating contours of the rock. Although the flower petals are painted in the three primary colors (which would normally contrast strongly with each other), Yu Sheng has chosen subtle shades of these hues that balance and harmonize with each other. In this mixture of techniques from western printmaking and Chinese painting, Yu Sheng has portrayed natural forms with the freshness of someone seeing them for the first time.

*NOTE:*

1. Also known as love-lies-bleeding, and called in Chinese *yanlaihong*, meaning "turns red with the coming of the wild goose."

## QIAN FENG (Nanyuan), 1740-1795

### Eight Horses

Hanging scroll, ink and light color on paper
56½ x 32¾ inches

> *Inscription:* Qian Feng.
>
> *Artist's seals:* *Nanyuan*, square, relief
> *Feng yin*, square, intaglio

Qian Feng, a native of Kunming in Yunnan Province, was noted both for his excellence as an artist and as the foremost calligrapher in the court of Qianlong. The latter skill, derived from the manner of Yan Zhenqing (709-785), had considerable bearing on his painting style, since calligraphy represents an artist's basic training in brushwork. In 1771, Qian Feng passed the examination for the *jinshi* degree. His earliest recorded painting, of a running horse, is dated 1778. Horses were to be Qian Feng's most distinguished subject. His characteristically slender horses demonstrate

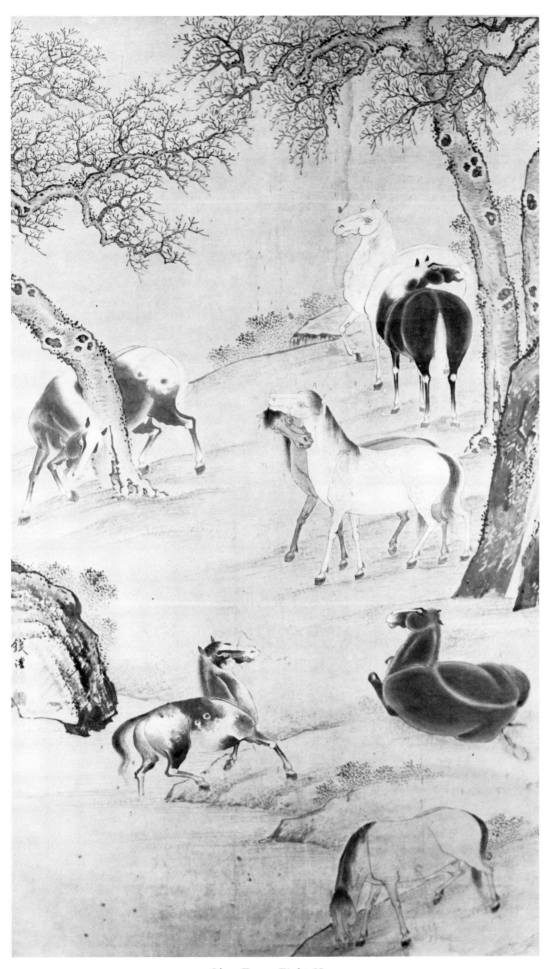

Qian Feng. *Eight Horses*.

his thorough understanding of the animal's bone structure and prove him a true master of the theme. These lanky horses best display the natural beauty and spirit of the species. Qian Feng is sometimes confused with Qian Li (active ca. 1800; a flower painter in the school of Yun Shouping), whose name in Chinese differs from Qian Feng's by only one stroke.

The horse, an emblem of speed and endurance, has been a favorite subject of Chinese artists since the creation of tomb wall paintings in the Han Dynasty. Depictions of this animal reached a high point in the Tang Dynasty, due to contacts with Central Asia and the importance of horses to the military as well as to the polo-playing upper classes. Cao Ba (ca. 8th century) and Han Gan (active 742-756) were two major painters of this genre in the Tang period. The Yuan Dynasty artists Gong Kai (1222-1307), Zhao Mengfu (1254-1322), and Ren Renfa (active early 14th century) brought the tradition into a new phase of excellence, aided by the Mongol invaders' partiality to horses. During the Ming Dynasty, however, few artists portrayed equine subjects; in particular, the Literati school avoided military themes. In the wealthy and leisured era of the Qing Dynasty, sport again came into favor, and the influence of visiting Italian artist Castiglione (Lang Shining, 1688-1768) injected new life into horse painting. He combined Western techniques with the traditional Chinese media of ink, brush, and paper or silk.

Qian Feng's style differs from Castiglione's in that the Chinese artist used only Chinese methods of horse painting. He has been said to have studied the plain outline (*baimiao*) technique of Li Gonglin (1040-1106); however, the full, rounded bodies of Qian Feng's horses in the painting presented here are more reminiscent of Zhao Mengfu. The 18th century painter did not make a point of flaunting his knowledge of the Yuan master's art, as did many scholar-artists of the time. In fact, despite his prominent standing as a calligrapher, he has chosen not to add any writing to the painting except his signature, so as to create a purely decorative composition based on the natural aesthetic of the horse's body, rather than an elaborate balance of art, calligraphy, and poetry in the usual Literati manner. Qian Feng has even placed his signature and seals most inconspicuously on the rock at the left, in the modest way of the Song Dynasty painters. (The colophons on the mounting were written by important 19th century collectors and calligraphers.)

Generally, Chinese artists choose to paint an odd number of objects or animals because it is easier to arrange them into a pleasing, not overly symmetrical composition. Horses, however, are often depicted in a group of eight to commemorate the eight horses that served Mu Wang (1001-746 B.C.), the fifth sovereign of the Zhou Dynasty. Of course, it is difficult to distribute this number of horses in a natural-looking group so that equal attention is portioned to each without violating the unity of the whole design. In this painting, Qian Feng has managed to position each animal differently. Above, one stares proudly off into the distance, with the back of its darker companion facing the viewer. Nearby, one kneels on the ground while two others either emerge from bathing or drink from the water. Each horse is unique in its coloring and markings—from deep velvety black to auburn to pure white, with dappled variations in between. The softly curving contours of their bodies are painted by a master hand with careful attention to proportion. Qian Feng brushes hair-thin outlines to contain his seamless application of wash. The textures of the mane, tail, and body are each indicated with lifelike precision.

So that nothing detracts from the horses themselves, Qian Feng has included

only enough of the surrounding trees and rocks to suggest a setting of a wooded landscape. His decision to show none of the trees in its entirety is governed by the desire to focus attention on the subjects and to provide ample space for their movements. The airy branches that meet in the sky are delicate and weightless, a well-chosen contrast to the solid, three-dimensional animals below. Each horse, a beautiful specimen in itself, joins with the others in a composition alive with the rhythm and harmony of nature. "Eight Horses" is an excellent example of Qian Feng's work and of the refined achievement of 18th century horse painting.

## DING GUANPENG, active 1740-1770

### Buddhist Figure: Guanyin

Hanging scroll, ink and color on silk
36 x 17½ inches

> *Inscription:* *Dingyou* (1777), Buddha's Bath Day (*Yufojie*). Respectfully painted by Ding Guanpeng, a Buddhist.
>
> *Artist's seal:* *Ding Guanpeng*, square, relief
>
> *Collector's seal:* (Lower right) Illegible

Collection of Mr. and Mrs. George T. McCoy, Hillsborough, California

Not many biographical facts are known about Ding Guanpeng except that he was a court painter during the middle of the Qianlong reign and that he depicted Daoist and Buddhist figures in the style of, and perhaps superior to, the famous Ding Yunpeng (ca. 1575-1638). Ding Guanpeng also painted landscape and genre scenes, such as "Peaceful Spring Market Landscape" (1742), "Minghuang Playing Polo" (1746), and "Fisherman in the Snow" (1747). He completed two handscrolls of Lohans in the style of Ding Yunpeng in 1749 and 1752. This Guanyin of 1777 is an important example of his later work.

Guanyin (Sanskrit: Avalokitesvara; Japanese: Kannon) is one of the most popular of the Buddhist deities, saving those in distress with mercy and compassion. Literally, the name means "One Who Hears All." This Bodhisattva came to be associated with mother-love and the protection of children in China. Even though the Bodhisattva is supposed to be neither masculine nor feminine, the sexual representation varies throughout the history of Chinese painting. Guanyin is usually depicted with a man's body and a woman's face. It was believed that it was easier for this Bodhisattva to work in the role of a woman within the framework of Chinese society. The benevolent deeds of Guanyin are outlined in the *Lotus Sutra*. The last chapter of the *Huayan Sutra* described Guanyin's residence as being Mount Putuoluojia, thought to be an island off the shore of Ningbo in China; therefore, this Bodhisattva is often shown sitting amidst rocks near water. It is recorded that Zhou Fang (780-810) painted Guanyin in a landscape setting of water, rocks, and

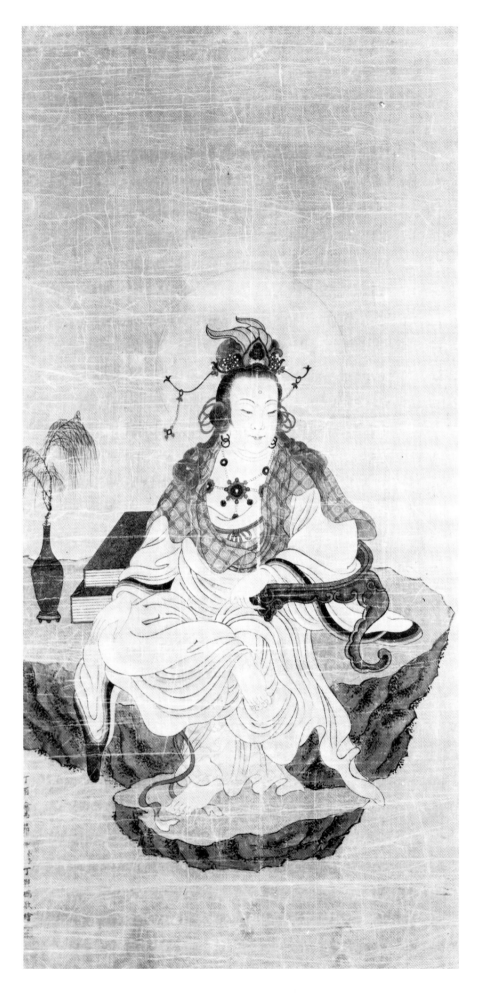

Ding Guanpeng
*Buddhist Figure:*
*Guanyin*

bamboo, thus creating the type that would be repeated for centuries.

The earliest extant representations of Guanyin are to be found in the caves of Dunhuang. These examples exhibit the characteristically expressive Chinese line in combination with influences from Central Asia such as the Greco-Indian sculptures of Gandhara and the Persian tradition with its flattening of forms. All of these traits converged in the classic Tang figural type. During this period the full face, double chin with lines beneath, ears elongated nearly to the shoulder, and elegant straight nose became ideal features. Literary references relate that Wu Daozi (active ca. 720-762) used uneven thick and thin lines that created a dynamism in his Buddhist and Daoist wall paintings and solidity in his figures. In the Tang Dynasty and earlier, Guanyin was often pictured in the guise of an Indian prince; however, in the Song Dynasty a more feminine countenance prevailed. Under Li Gonglin's brush, Guanyin became less Indian and took on more Chinese characteristics. This artist painted his figures in the *baimiao* technique, which employs a very delicate and restrained line with no added color. With its close affinity to calligraphy, *baimiao* became the favored mode for figure painting among the Song Literati.

Toward the close of the Ming Dynasty, painters of Buddhist and Daoist beings began to look back to Tang and Song models. An outstanding master of the genre during this period, along with Wu Bin (1568-1626) and Chen Hongshou (1599-1652), was Ding Yunpeng. His elegant application of color in combination with Wu Daozi's free lines and Li Gonglin's graceful *baimiao* method laid the basis for the dominant school of Buddhist and Daoist figure painting in the late 16th and early 17th centuries. This style can be seen in his "Watching the Washing of the Elephant" in the National Palace Museum (Taiwan). In this Buddhist scene, fresh, bright colors are applied evenly and carefully. Another example of his work is part of a handscroll entitled "The Dragon King Paying Homage to Guanyin," which blends the ideas of Daoism and Buddhism within a fantastic composition. Both paintings display a lively interaction among the subjects.

With the Manchu takeover in 1644, many scholars and artists became monks. This led to an emphasis on the religious over the secular aspects of Buddhist and Daoist images. Such paintings were considered objects of devotion to be worshipped like sculptured pieces in temples. In contrast, 18th century art portraying immortals and deities stressed the temporal, with the incorporation of updated Literati attitudes into both technique and representational details. Ding Guanpeng painted sensitively within this Literati approach; thus his religious works have artistic as well as spiritual value. This Guanyin exhibits a mixture of styles. The delicate diadem and high coiffure with ornaments extending out to both sides, along with the hair cascading past the shoulders, are indications of a characteristically 16th century Guanyin. The rosary medallion with its radial arm acting as a clasp for the garments is of 17th century origin.

The figure sits in the *labitasana* or casual pose with the right knee over the left and the right arm holding the right knee, barefoot as usual and seated on a rock, symbol of the island Putuoluojia. Sutras and a fancy armrest are shown on either side. A blue vase holds a willow branch, Guanyin's attribute and emblem of mercy and compassion. Even though the subject is placed exactly in the center, as in most paintings of Guanyin, one is aware of a change of attitude in what this Bodhisattva represents. Ding Guanpeng has attempted to take a Buddhist deity and paint it in the

Literati manner, for this Guanyin looks more like a scholar in an ideal but believable environment. The rocks conveniently form a chair, but they still resemble natural formations. The arrangement typifies the 18th century idea that nothing should be unsuitable or out of place. No flying dragon kings or supernatural images are seen here, as they are in Ding Yunpeng's pictures. Also, Ding Guanpeng's color tones are much softer and more harmonious, characterizing the 18th century golden mean or "middle way." The result is a more serene and subtly appealing style that lacks harshness and extremes.

An important point for consideration when studying Ding Yunpeng and Ding Guanpeng is that they both were sculptors as well as painters. Therefore the vitality and substance revealed in their figures is not surprising. Here, Ding Guanpeng paints in the *baimiao* technique with great linear movement. The folds of the robes display this freedom of line, tempered with restraint. The shawl flows gently across the shoulders of the figure and is painted with accuracy, detailing the diamond pattern and, at the same time, the transparency of the material. The hair is painted with this same attentiveness, yet the careful delineation does not destroy the feeling of life in every strand. Respect for Guanyin is expressed by the artist's control and idealization of the subject's form and environment.

This work represents a synthesis of Buddhism, Daoism and Confucianism with a scholarly approach that is indicative of the 18th century orientation. Drawing on Tang and Song models, and using the freedom associated with Daoism along with the restraint and idealization of Confucianism, Ding Guanpeng succeeds in creating a religious image that is a work of art as well.

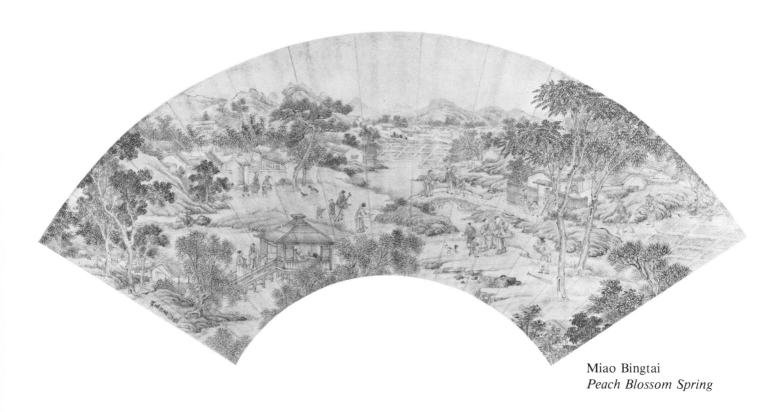

Miao Bingtai
*Peach Blossom Spring*

*MIAO BINGTAI (Xiangxian, Qitang), 1744-1807*

**Peach Blossom Spring**

Folding fan, ink and color on paper
6¾ x 21 inches

    *Inscription:*    Humbly painted by Bingtai.

    *Artist's seals:*    *Bing*, square, intaglio
                           *Tai*, square, intaglio

Collection of Dr. and Mrs. M. Bruce Sullivan, Birmingham, Alabama

A portrait painter in the court of the Qianlong emperor, Miao Bingtai was a native of Jiangyin in Jiangsu Province. The circumstances of his artistic training are unknown, but he was influenced by Qiu Ying (active 1506-1522) and Zhou Chen (active 1472-1535), as evidenced by a number of his works in the National Palace Museum (Taiwan) and in private collections.

A portrait by Miao Bingtai of an official in Qianlong's court was left behind when the official retired from service. On discovering the painting one day, the emperor was astonished by its vitality and its remarkable resemblance to the subject. When the emperor asked the artist to paint for him, he was further delighted to learn that Miao Bingtai was also a literary scholar of great merit. Thereupon he was conferred with the rank of *xiaolian* and appointed to a position as a court artist. His most famous painting was completed in 1785 in honor of the fiftieth anniversary of the reign of Qianlong, and is recorded in the *Shiqubaoji (Descriptive Catalogue of Paintings in the Imperial Collection of Emperor Qianlong)*. From that time on any court official whose deeds merited recognition was honored by a portrait sitting with Miao Bingtai. But this painter's talents were not limited to the human figure; he often depicted landscapes as well.

The story of "Peach Blossom Spring" (*Taohuayuan ji*) originated with Tao Qian (Yuanming), a great scholar of the Jin Dynasty in the Six Dynasties period (265-316). According to the story, a fisherman was boating up a river when he was attracted by beautiful peach blossoms growing along the shores. Tracing the forest's end to the source of the river, he saw light gleaming from a crack in a mountain. He passed through this tunnel into a new world where everyone lived peacefully like brothers and sisters. These people had never heard of the different dynasties in the outside world. They lived in harmony with one another with no government, no taxes, and no soldiers because they had never heard of war.

Tao Qian's utopian vision of a world of perfect peace and simplicity is fully illustrated in the small-scale format of this fan painting by Miao Bingtai. The fisherman has placed his oar on the ground and bows reverently to the people of the village. He exhibits both delight and awe at his discovery of this new world. A studio is prominent in the foreground; houses cluster among the trees and low hills throughout the painting. Figures are grouped on either side of the river that winds its way around the scene. Even with the additional elements of a bridge, rice paddies, two chickens, and a dog, the composition does not appear too busy or crowded. The

arrangement of all seems natural as it recedes layer by layer to distant mountains. Each figure is an individual engaged in a particular activity. The tranquil life and the fresh atmosphere of the countryside are conveyed through the artist's delicate yet lively brush strokes and fresh, harmonious colors. Miao Bingtai has compressed a complete village scene into a small space by painting every detail with painstaking care. Every blade of glass displays a sensitive touch, and every color, natural elegance.

As a portraitist, Miao Bingtai was adept at rendering the subject before him realistically but without the stiffness that too often mars the styles of painters concerned with accurate representation. This refined realism so imbued with life may be traced back to the Ming painter Qiu Ying. An artist of the Kangxi period, Jiao Binzheng (active 1662-1726), employed techniques of western perspective in his famous Gengzhitu, an album of forty-six leaves that shows scenes of land cultivation and the manufacture of textiles. Jiao Binzheng's influence on Miao Bingtai is evident in the diminishing size of scenic elements as they recede into the distance.

In addition to painting from live models, Miao Bingtai also did *zhuiying* ("chase-shadow") portraits in which a likeness of a deceased person is based solely on descriptions of their facial characteristics by family members and friends. He succeeded in mastering the difficulty of following verbal directions to create an image that closely resembles a particular individual and that also shows the subject's personality with a sense of life. Thus he was well-qualified to translate Tao Qian's literary creation into pictorial terms. Indeed, any reader of the famous poetic essay who views this fan painting would not only immediately recognize the connection between the two works but would most probably also agree with every detail of Miao Bingtai's interpretation. Under his lively brush the entire scene is so animated that it is no longer just a dream-world but a real world somewhere yet to be discovered, just as "Peach Blossom Spring" was discovered by Tao Qian's fisherman.

# The Yangzhou Masters

Ever since construction of the Grand Canal from Beijing to Hangzhou in the Sui Dynasty (581-618), Yangzhou, situated at the intersection of the canal and the Yangtze River, has been a major commercial center and a point of great strategic importance. Called Guangling during the Han period (206 B.C.-A.D. 220), it was one of nine large metropolitan regions under the direct administration of the central government at that time. The man-made waterway through Yangzhou provided easy transport not only for several emperors on pleasure tours of the southern portion of the country, but also for the flow of merchants and their wares in and out of town. In the early Qing, Yangzhou was designated the official seat of the distribution of salt, which was a government monopoly. The salt trade, as well as the fortunes amassed by the salt merchants living there, helped to stimulate the local economy, making Yangzhou one of the most prosperous urban areas of China by the 18th century.

Commerce and wealth were not all that Yangzhou had to boast of in the middle Qing period; along with the salt and other merchant families who dwelled in this ancient city was an extensive population of scholars and artists. The rapid growth of the intellectual sector in Yangzhou beginning in the late 17th century was a phenomenon arising not only out of the economic boom but, more significantly, out of the massive influx of non-natives to this city to replace the populace that was reduced to barely fifty following a disaster in 1645.

This disaster was the outcome of the bitter battle fought by the Ming army to save Yangzhou from takeover by the Manchus as they pushed south after conquering northern China. The Ming commander-in-chief, Shi Kefa, also a noted scholar and calligrapher, put up a fierce defense of the city with only a small number of troops. His desperate pleas to the capital for more men brought General Liu Zhaoji with an additional force, but they were still no match for the huge enemy army. After several days of hand-to-hand combat, all of the Ming loyalist fighters had either been killed or had committed suicide, and Yangzhou fell under Qing imperial control. Despite his victory, the Manchu commmander Duodeli was so enraged by the dauntless perseverance of the Chinese resistance that he ordered his soldiers to slaughter every man, woman, and child remaining in the city. This merciless

massacre, remembered as the Ten Days of Yangzhou, left the once-bustling streets of this metropolis a wasteland, with the indigenous people virtually wiped out.

In the years that followed, residents of surrounding areas, particularly northern Jiangsu and the Huangshan (Yellow Mountains) region of Anhui, migrated to Yangzhou. Since Anhui had long been a major producer of ink, paper, and other artists' supplies, as well as the home of numerous literati and artists, its scholarly tradition was imported to Yangzhou by these newcomers. So it was that of all the notable artists working in Yangzhou during the middle Qing period, only a few were natives of that locale. The others were immigrants from various parts of China, each of whom brought along his own home-bred artistic sources and predilections. Thus the art of Yangzhou during this era does not constitute a single stylistic school; even those painters who associated closely each maintained a distinctive individuality in their work.

One unifying factor with a lasting impact on these painters, however, was the art of Shitao (1641-ca. 1710), who lived in this commercial center off and on in the late 17th and early 18th centuries. Many Yangzhou artists also looked for inspiration to Zhu Da (Badashanren, 1624-ca. 1705), whose paintings were enthusiastically collected and copied there. Another common denominator in Yangzhou art was the popularity of flower-and-bird themes in the *xieyi* mode. (This method was an effective, simplified technique of drawing with the aim of capturing the subject's spirit rather than outward form, but without disregarding outward form. Unlike Ming-period *xieyi* painters such as Xu Wei [1521-1593] and Chen Chun [1483-1544], however, Yangzhou artists painting in this mode featured brushwork with a strong flavor of *jinshi* or *bei* inscriptions.) This stood in contrast to the *fanggu* (imitation of the ancients) landscapes that dominated painting elsewhere at this time.

Among those who developed highly personal approaches to painting was a group known as the Eight Yangzhou Eccentrics, a name referring to both their personalities and their brush methods. Variously numbering anywhere from eight to thirteen, the Eccentrics or "strange" masters took advantage of the liberal intellectual atmosphere of Yangzhou to express themselves through boldly unconventional techniques and compositions. Such practices placed them in opposition to the Orthodox principles of painting, which were firmly entrenched in the capital and other artistic centers of the period. While they deemphasized (but did not eliminate) landscape in favor of the "four gentlemen" (plum blossoms, orchids, chrysanthemums, and bamboo) and in some cases, figures, it was not subject matter that made the Eccentrics so different but rather their innovative treatment of traditional themes. Meanwhile, revivals and other stylistic trends were pursued by other painters in Yangzhou, such as Yuan Jiang (active ca. 1698-after 1724), Yuan Yao (active 1744-1755), Ni Can, and Zhang Shining.

Whether retired officials or professional artists, most of these men had been schooled in Literati methods and values but were now in the position of painting for commissions. Yangzhou's heterogeneous culture fostered diversity in aesthetic tastes and so provided a receptive climate to painters of widely ranging backgrounds, especially those with an independent and adventurous spirit. This abundant artistic activity continued well into the late Qing period, for when the modern master Huang Binhong (1864-1955) went to that metropolis as a young man of 21, he observed that more than three thousand artists and scholars were residing there.

*HUA YAN (Qiuyue, Xinluoshanren), 1682-1762*

**Scholar with Little Boy**

Album leaf, ink and light color on paper
9½ x 13 inches

       *Inscription:*   (A Tang period poem) Among sparse trees in the fresh autumn air, chanting alone against the wild waters.

       *Artist's seal:*  *Hua Yan*, rectangular, intaglio

       *Collector's seal:*
       (Lower left)  *Yishan zhencang*, oval, relief

Private Collection, Sydney, Australia

In general surveys of flower-and-bird painting of the Qing Dynasty, Chinese connoisseurs often follow up a discussion of the 17th century masters Yun Shouping (1633-1690) and Wang Wu (1632-1690) by mention of Hua Yan. While placement of this later artist on a par with the earlier two is not unwarranted, his identification with this single subject has unjustly limited recognition of Hua Yan's broad versatility. His consistent achievement in rendering landscapes, figures, animals, vegetables, and insects as well as plants and winged creatures, uncommon throughout history, was even more remarkable in the context of 18th century Yangzhou where the predominance of the Eccentrics encouraged narrow thematic specialization. Whether because of this factor, because of a lack of heterodox tendencies in composition and technique, or both, Hua Yan is not traditionally included among the Yangzhou Eccentrics, although he lived in that metropolis for much of his adult life.

Born the son of an impoverished family in Linding, Fujian Province, Hua Yan benefited from only a few years of schooling before he had to join his father at work in one of the local paper mills. Even as a young boy he spent his spare time practicing calligraphy, painting, and reciting poetry. According to some sources, at one point early in life he was employed painting ceramic objects in a porcelain factory in Jiangxi Province. If true, this experience would explain two facets of his artistic development. First, since, from the reign of Yongzheng through that of Qianlong, decoration on porcelain wares was heavily influenced by Yun Shouping, this vocation may well have been the stimulus for Hua Yan's adoption of certain features of this master's style in his own paintings on paper and silk. Second, it was probably the abundant talent he showed at the factory that won Hua Yan invitations to view a number of notable art collections. By studiously copying the masterpieces that he saw, he gradually acquired technical proficiency.

An anecdote relating an incident that took place when Hua Yan was nineteen provides a colorful characterization of the youth as a precocious and determined aspiring artist. When an ancestral temple for the Hua clan was being erected in his home district, the elders in charge decided to have its walls adorned with painted scenes. Hua Yan eagerly volunteered his services, but his offer was rejected because of his lowly origins. Disheartened by this rebuff, he resolved to leave home, hoping

for opportunities to prove his creative abilities elsewhere. On the night of his departure, he stopped by the new temple, took out his painting implements, and proceeded to execute four murals depicting landscapes with figures and animals. By daybreak he had completed the task, whereupon he quietly stole from the place without waiting for the reaction of the local people. Surprised delight was evidently their response, for the murals were preserved intact on the temple walls for all to see.

Hua Yan's travels took him to Hangzhou where he joined a group of artists and scholars that included Jin Nong. In his middle years he moved to Yangzhou, the city that held the promise of success for so many painters of the time. The circumstances of Hua Yan's later life are largely unrecorded, although it is known that he returned to Hangzhou sometime in his early sixties and remained there until his death.

Most of this artist's paintings are signed either Hua Yan or Xinluoshanren, Xinluo being the ancient name for his place of birth. He also called himself Buyisheng, literally "Scholar with Cotton Clothing," a reference to the attire worn by men not holding an official title, as well as an attempt to affiliate himself with Yun Shouping, who used the nickname Caoyisheng, "Scholar with Straw Clothing." Hua Yan's poems were collected and published posthumously under the title *Jietaoguan shiji*, or *Collection of Poems from Jietaoguan*, naming the studio at his Hangzhou retirement home.

Contemporaries of Hua Yan knew him not only for his pictures but also for his calligraphy and poetry. Many 19th century artists considered themselves his followers, including the individualist monk painter Xugu (1824-1896) who frequently cited his indebtedness to this 18th century master on his depictions of squirrels.

In addition to Yun Shouping, Hua Yan drew on a number of other disparate styles. Living in Yangzhou for as long as he did, he was bound to absorb Shitao's influence, which had pervaded the city since that master resided there. For both landscapes and figures, Hua Yan looked to Tang Yin (1470-1523), while his flowers show an affinity to those of the Ming painter Chen Chun. Assimilating selected aspects of each of these artists' methods, Hua Yan devised his own distinctive voice, which spoke to the new generation under Manchu rule with fresh vitality based on naturalism and tempered with quiet grace and humanizing wit.

Small landscapes inhabited by scholars and their servants were one of his favorite subjects, represented here by an album leaf portraying a scholar resting under a tree, with a boy sitting before a large stone and cooling his hand in the flowing waters of a stream. The focal point of this picture is the gentleman's face, a gem of characterization accomplished with a minimum of brushwork. With slanted eyes and prominent eyebrows, strong nose and chin, and a sweeping long beard, this is the physiognomy of the poor yet contented scholar, aloof to the cares of the dusty world, his thoughts filled with poetry and the lofty contemplation of nature. His amused expression and leisurely demeanor are reinforced by the gentle lilt of the strokes that define his robe. The sideways arc of his posture is echoed by the gnarled tree that supports him, and which, along with the main branch of a moss-laden tree to the rear, frames his upraised head. These trees, metaphors for an upright, tenacious spirit, join with the rock, emblem of constancy, to set the entire figure off in a spherical enclosure of its own.

Screened by the boulder from the gentleman's view, the young servant crouches down on the shore, the form of both his head and body imitating the low oviform shape of his stony backdrop. The pure water flowing across the foreground completes this evocation of scholarly virtue. This theme also runs through every touch of the artist's brush, from the dry texturing of the trees and rocks to the fluid, undulating lineation of the figures' garments. Obviously executed with absolute control, each stroke nevertheless displays a light-hearted spontaneity that instills the painting with a mood of carefree relaxation. The inscription reiterates the poetic note of this intimate scene.

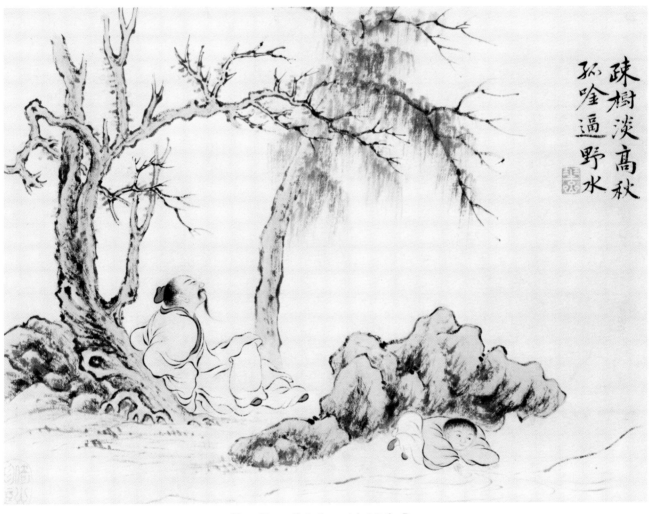

Hua Yan. *Scholar with Little Boy.*

## Horse Drinking by Wintry Trees

Leaf from an album, ink on silk
11 ¼ x 13 ½ inches

*Inscription:*   A deep breath to take in the long river.

*Artist's seal:*   *Hua Yan*, square, intaglio

Collection of Dr. and Mrs. Robert Magrill, San Marino, California

That the animal kingdom held a special appeal for Hua Yan is demonstrated in numerous surviving works depicting a wide variety of birds and beasts. In every case, anatomical fidelity is coupled with conveyance of the creature's individuality, at times with a touch of whimsy. This is exemplified in an album leaf showing a horse drinking from a river on a narrow bank with a few tall leafless trees and rocks. Across the water, lightly washed mountain peaks recede into deep distance. Tonal gradations in ink wash model the horse as a solid round form, convincingly foreshortened in its nearly frontal pose. The swish of its mane and tail in the wind and its limpid staring eyes bring the animal to life as its gulping redirects the water's course toward its mouth. To its right, four tree trunks grow straight up and then branch out into boughs and twigs, a web of gracefully poised lines reaching out to all sides and up even beyond the border of the painting. As with all of Hua Yan's animals, this horse elicits the viewer's sympathy and even mild amusement without sinking into sentimentality or ridicule.

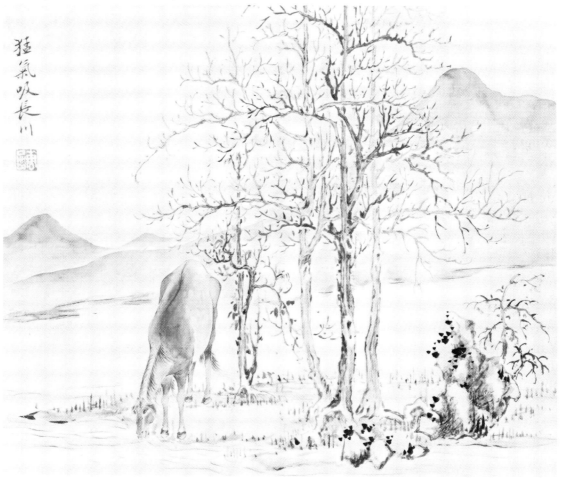

Hua Yan. *Horse Drinking by Wintry Trees.*

*HUANG SHEN (Gongmou, Yingpiao), 1687-after 1768*

**Landscape with Figure and Donkey**

Hanging scroll, ink and light color on paper
26¾ x 21¾ inches

      *Inscription:*  Painted by Huang Shen.

      *Artist's seal:*  *Huang Shen*, square, intaglio

Private Collection, La Puente, California

When Huang Shen was young his father died, leaving the family impoverished. To care for his mother personally, Huang Shen refused the opportunity of an official position, remaining in his native Fujian Province to paint professionally. His mother, fearing that without further education he would remain a mere craftsman, encouraged her son to become a scholar so that his painting would reflect deep insight in addition to technical skill. Following her advice, Huang Shen began studying day and night while painting for a living. Unable to afford oil for a lamp, he had to study at a nearby Buddhist temple where lamps burned all night. Still studying continuously, Huang Shen traveled to Jiangsu, Anhui, and Zhejiang provinces to sell his paintings. In 1727 he moved with his mother to Yangzhou, where he met the other painters who with him became dubbed the Yangzhou Eccentrics, and where he also came into contact with many influential literati.

Huang Shen is known as the "three sublimes" because of his mastery of painting, calligraphy, and poetry. In calligraphy he is particularly noted for his cursive script (*caoshu*); in painting he was adept in virtually all genres—landscape, figures, birds, flowers, and religious subjects. His discovery of a personal style is said to have resulted from his playfully drawing a picture while practicing cursive script. Realizing the intimate connection between the two arts, he began substituting bold calligraphic strokes for fine-lined renderings.

Although his landscapes are mainly influenced by Yuan masters, in this painting Huang Shen derives his composition from the "Ma-Xia" style (referring to Ma Yuan, active 1190-1224, and Xia Gui, active ca. 1180-1230) of the Song Dynasty. The larger tree's branches are drawn from Ma Yuan, as is the triangular design of the whole. The simple slashes of light strokes, which so effectively indicate the looming mountain behind the mist, are also a contribution of Ma Yuan or Xia Gui.

The artist's signature translates literally as "Written by Huang Shen" because in this painting he achieves calligraphic ideals in pictorial form. Like the other Yangzhou masters, Huang Shen finds his aesthetic challenge in a descriptive use of the brush, and through brushwork alone he describes space, dimension, and climatic conditions. In this sense this work may be defined as one of "pictorial calligraphy."

Huang Shen endows the trees with life calligraphically through the momentum of the strokes, which shoot up from the ground so swiftly toward their outermost extension that we seem to view the trees in the very process of their growth. Without use of shadow or modeling, he makes the branches turn in space; indeed, he defines

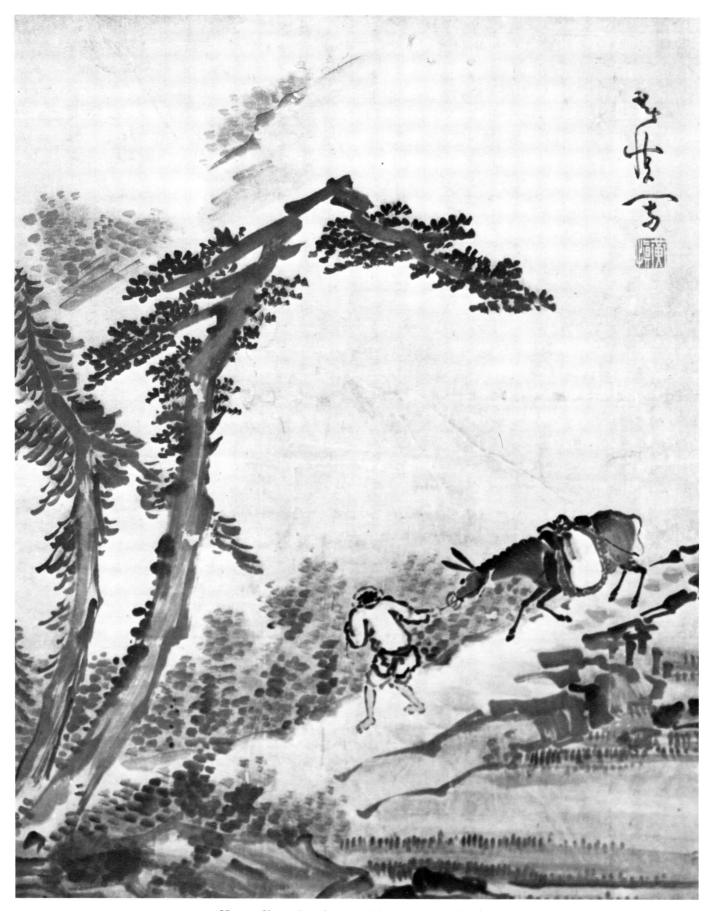

Huang Shen. *Landscape with Figure and Donkey.*

the space of the composition as a whole in terms of the top branch of the larger tree, which extends back into the distance. The artist's vividly descriptive use of the brush asserts mass in the road with its shale sides, as well as volume in the man's body. Even the decreasing depth of the water in the foreground is indicated by the few deft strokes representing supports for the bridge at right. He uses tonal variations as pleasing abstract values in themselves as they appear in calligraphy, in addition to exploiting their function as suggestions of distance and mist.

Within this hazy mountain landscape, Huang Shen presents an everyday drama: a man pulls his stubbornly resisting donkey along the road in an attempt to overcome the animal's fear of the water. The representation of this scene in emphatic calligraphic terms typifies the Yangzhou masters' high regard for personal idiosyncracy in creative expression. The donkey, perhaps the most naturalistic element in the work, is executed in wash without outline. Details of the animals' body are all designed to show its fright and ambivalence. The ears pushed forward and the eye separated from the face convey fear, while the lines of the neck and position of the legs show resistance; even the tail indicates energetic obstinance. The nervous line with which Huang Shen renders the man's body manifests the tension resulting from his physical exertion. Moreover, the relation of his arms to his body is an especially subtle rendition of the caution he must exercise to maneuver the donkey across the bridge.

In this composition, the arrangement of abstract values is as important to note as the naturalistic representation. The counterpoint of forward and backward movements; jutting, free lines and thick, stable surface; accentuated brush strokes and light dotting—all these elements reflect the calligraphic medium through which Huang Shen expresses his imagination.

**The Lady Immortal Magu**

Hanging scroll, ink and color on paper
63¾ x 21½ inches

> *Inscription:*   Eighth year of (the reign of) Qianlong, autumn, ninth month, painted at Wangcheng Studio by Yingpiao, Huang Shen.

> *Artist's seals:*   *Huang Shen*, square, relief
> *Yingpiao*, square, intaglio

Collection of Mrs. Anna Moore, Bangkok, Thailand

Chinese figure painting emphasizes elegant drapery, proper physical proportions, and the essential character, rather than the outward glamour, of the subject. These principles hold true in Huang Shen's portrayal of the heavenly attendant Magu. Her sturdy frame and tall stature revive Tang period ideals of femininity, a refreshing deviation from middle Qing court trends, which featured anemic young maidens of exceedingly delicate build.

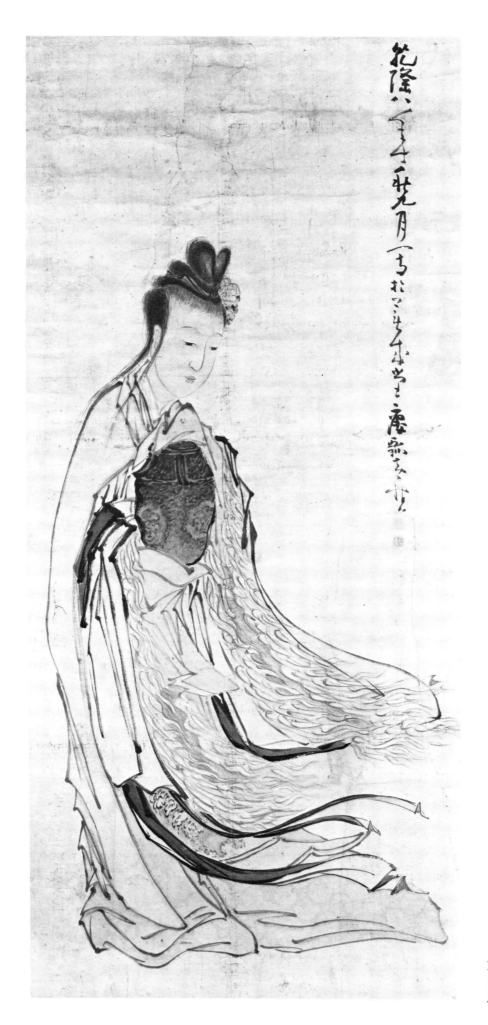

Huang Shen
*The Lady
Immortal Magu*

84

From the figure's right shoulder to her lower sleeve edge extends a single stroke executed at an even speed with the brush held upright. Her left sleeve is rendered in the same calligraphic style, which displays the expressive freedom based on masterful skill seen also in the "wild cursive" script of the 8th century monk Huaisu. The fur lining of the lady's sleeves consists of a lively and rhythmic patterning of short strokes, while the brocade panels and ribbons suspended from her gown float gracefully as though lifted by some celestial breeze. Although the concealment of her entire body, including her hands, adds an aura of mystery to her being, it is evident from the structure of her clothing that two human hands firmly hold the jar from inside the sleeves. The outlines of her face and nose are perfectly proportioned, while her soft eyes and dainty lips are poised with dignified yet human beauty, despite her immortal nature. Irregular lines of varying widths and ink tones make up her hair, which is adorned with a peony. This touch of pink and green, along with the pink of her cheeks and lips, and the yellow, green, and aubergine hues embellishing the brocade panels, enliven the composition without detracting from the superb effects of line and ink in this highly successful and mature work.

**Flowers, Figures, and Landscapes**

Album of ten leaves; ink, and ink and color on paper
9⅝ x 10¾ inches each leaf

Leaf Three: ink and light color

   *Artist's seal:*   *Yingpiao*, square, intaglio

Leaf Nine: ink

   *Artist's seal:*   *Huang Shen*, rectangular, relief

Collection of Dr. and Mrs. Joseph Goldyne, San Francisco, California

Ranked among the greatest painters to emerge from Yangzhou during the 18th century, Huang Shen was one of the few artists of this group to excel in landscapes. In fact, the height of his spontaneous brush style may be observed in his landscapes after Yuan masters, especially Ni Zan (1301-1374) and Huang Gongwang (1269-ca. 1354). Using his trademark linear technique of cursive script brushwork applied with the brush held perpendicular to the painting surface (*zhongfeng*), he could produce either full, dense compositions or sparse, airy images. But characterizing all his landscapes in this mode is the strong personal statement of his brush movements.

The limited number of such movements in one album leaf showing a lone fisherman in a boat serves to intensify the effectiveness of each line, dot, and patch of wash. From the tree's branches and simple boat to the figure's garments, face, and hair, each touch offers just an intimation rather than a literal description of the object it represents. Ni Zan's quiescent river scenes were obviously inspirational in the creation of this work. This influence is notable not only in its spare layout but

Huang Shen. *Flowers, Figures, and Landscapes*: Leaves Three (above) and Nine (below).

also in the "severed band strokes" (*zhedaicun*) of the willow tree. Yet even here, Huang Shen's penchant for free-flowing cursive script prevails over the Yuan master's extreme reserve. In the weeds growing around the tree, the artist sheds all constraint with brisk, seemingly aimless brushstrokes in pale, alternately wet and dry ink. The presence of a sandy bank beneath the weeds and tree is indicated by nothing more than a faint whisper of light ink wash. Thus the bank, the plants, and the river itself appear as if half obscured by heavy fog. The boat and its occupant are similarly rendered in diluted ink, the boat composed of but four pale lines, its bulk hidden beneath the surface of the water.

Although the seated gentleman is equipped with fishing pole and basket, his main purpose clearly lies in the serene enjoyment of his tranquil surroundings. Beyond the figure in his vessel, all is blanketed in fog, which is depicted as a vast void stretching across more than half the picture. In this dreamlike world where tangible forms dissolve into nothingness and empty space reaches into infinity, Huang Shen exposes his own realization of the ephemeral nature of all things. He aptly illustrates this truth by means of a few brief gestures of the brush, yet the mature brushwork, masterful application of ink, and ingenious distribution of un-painted paper provide ample justification for the lasting appeal and influence of his art.

Another leaf in this album retains the casual brushwork of the former land-scape while broadening its scope to encompass a monumental vista in the *gaoyuan* ("high and distant") perspective. Piled, jagged boulders make up the nearby river-bank in the lower right corner of the painting. Constantly twisting the shaft of his brush, the artist delineates these rocks with meandering lines that conform only in their buoyant rhythms. Clusters of pine trees on the shore recede diagonally into the distance. This recession is accentuated by an intervening mist, which manifests itself through the grading of ink tones from black in the front two trees to very light grey in the back. Near the base of the third group of trees the tiny, faint form of a monk seated in meditation barely distinguishes itself from the surrounding terrain. The sheer cliff that rises beyond him is made the more imposing by the presence of this lone figure. Both the trees' fade-out and the light, translucent quality of its own ink push this stony mass back in depth. Although somewhat more loosely knit than that of the closer formations, the sketchy linework here imparts the convincing impres-sion of a rugged mountain veiled from foot to summit by a thick mist. Despite the pale ink values and sensitive brush manipulations, each line, whether short or exten-sive, is fully articulated and functional as a defining feature of an impenetrable rocky structure. Immediately to the right of this towering edifice, a narrow pinnacle shoots straight up in a single stroke made with the brush held at a slant (*bianfeng*), a symbolic reference to still more remote mountains.

These heights contrast sharply with the left half of the picture, where sandy shores and low-lying hills jut into the river as far as the moisture-laden air allows the eye to see. This division of a composition into two halves appears frequently in the works of other Yangzhou painters, particularly Zheng Xie and Jin Nong. That the long horizontal brush strokes on the left are light-toned even near the foreground in-dicates the presence of heavier fog over the surface of the water. Balancing the em-phasis on height and stepped recession in the right half, the left portion of this land-scape presents immense spaciousness and confirms the remoteness of the monk's meditation site.

Both of these album leaf paintings employ diluted ink and loose, spontaneous brushwork to transport the onlooker into an intuitive mode of awareness. Through the abbreviated delineation and hazy definition of the images, the various landscape elements and figures exist less in a physical sense than in the artist's ideal vision of perfect peace and natural harmony. In such a world, reality sheds its dependence on rational thought and material objects in order to focus on the inner workings of creation and the ultimate oneness of evanescence and eternity. Yet, even as he aspires to the universal, Huang Shen asserts his own individuality in no uncertain terms. Aside from the philosophical implications of his work, his unique "handwriting" technique engages attention on the level of aesthetic abstraction. The enormous energy and power that run through even the lightest touches of his brush place his personal style firmly above mere novelty or eccentricity. Indeed, the depth of his vision and the remarkable simplicity with which it is realized place Huang Shen among the outstanding masters of the middle Qing era.

Unlike most of Huang Shen's paintings, these two examples are not inscribed with poetry, remarks, or signatures. Each bears only one small seal, placed unobtrusively in the lower right corner of the picture.

## GAO FENGHAN (Xiyuan, Nancun, Nanfulaoren), 1683-1748

### The Peach and Willow Contend in Spring

Hanging scroll, ink and color on paper
59¼ x 18⅜ inches

| | |
|---|---|
| *Inscription:* | Glory compares to flowers, |
| | The myriad things are but a dream. |
| | All matters are like peach blossoms, |
| | Just as they fade, fresh willows sprout again. |
| | |
| | Three days after the Mid-Autumn Festival (8th month, 18th day), *dingmao* (1747), Qianlong period. Left-handed Nanfu. |
| | |
| *Artist's seals:* | *Gao Fenghan yin*, square, intaglio |
| | *Nanfu*, square, relief |
| | |
| *Collector's seal:* | |
| (Lower right) | *Chen Yufu cang shuhua*, square, intaglio |

Private Collection, Philadelphia, Pennsylvania

Gao Fenghan is sometimes associated with the Yangzhou Eccentrics because of his residence in that city, his friendship with some of the Eccentrics, and the unconventional manner of many of his paintings. However, the intermittent and brief character of his stays in Yangzhou has prompted most critics to exclude him from this convenient grouping. Nonetheless, the influence of Shitao figures prominently

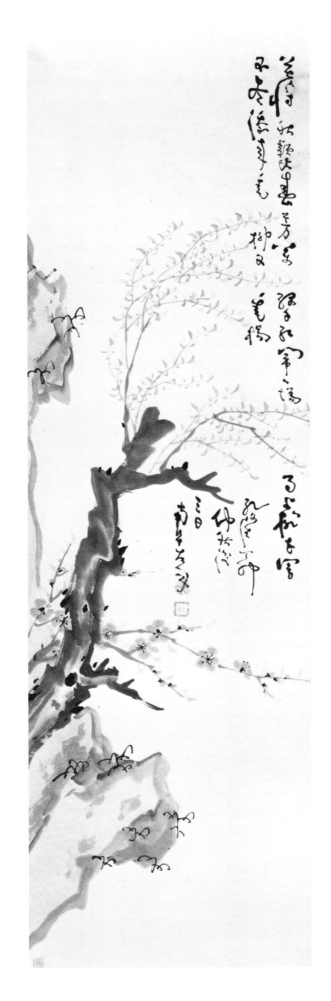

Gao Fenghan
*The Peach and Willow
Contend in Spring*

in his works, which in turn played a role in the evolution of the styles of some of the Eccentrics, especially that of Li Shan.

The locality of Jiaozhou in Shandong Province was Gao Fenghan's place of birth. He gained recognition for his poetry as a young man, and, after passing the examinations for a *xiucai* degree, at the age of 45 he was awarded the title of *xiuzhilang* by the Yongzheng emperor. Gao Fenghan subsequently held a number of civil posts, including magistrate of She District in Anhui and salt commissioner in Taizhou. His career was rudely interrupted when a jealous senior bureaucrat falsely charged him with a crime and had him imprisoned and tortured. (Later, Gao Fenghan's honor was restored with official acknowledgment of his innocence.) In the same year, *dingsi* or 1737, he lost the use of his right arm. Sometime after this malady struck him he carved a seal for his own use which read *dingsi canren* or "one who was handicapped in *dingsi*."

Besides carving his own seals, Gao Fenghan is said to have accumulated an assortment of old seals, one of which had been made for the brilliant Han Dynasty scholar Sima Xiangru. The value that this seal held for the artist is illustrated in an incident involving Zhu Wenzhen, a powerful official who owned the seal of Sima Xiangru's celebrated wife, Zuo Wenjun. At a banquet in the home of a mutual friend of Gao Fenghan and Zhu Wenzhen, the latter revealed to the host his hope of reuniting the two seals of the famed lovers—by an addition to his own collection. Upon hearing this Gao Fenghan bowed in a gesture of departure and addressed his friend in a serious but polite tone, "I have cherished friendship all my life, and I am willing to share any of my possessions with a friend except for two things: one is this seal, and the other is my humble wife." This act of defiance, as well as his unrelenting refusal to admit any guilt to his prison torturers, discloses the indomitable spirit that enabled the painter to succeed in the formidable task of relearning the use of the brush with his left hand following his paralysis.

Gao Fenghan's fascination with seals was matched by his zeal in collecting ink stones. His *History of Ink Stones (Yanshi)* was published in 1738. As a calligrapher he first emulated Wang Xizhi (303?-361?) and Mi Fei (1051-1107), and then used as his models ancient carved inscriptions in the *zhuan* (seal) and *li* (clerical) scripts. Owing to this practice of archaic calligraphic forms, his paintings are replete with the subtle flavor of antiquity. Adroit in depicting plants and birds in addition to landscapes, in the latter he recaptured the power and grandeur of Northern Song pictures while attaining the sensitive expression of the Yuan masters. In his early flower-and-bird paintings he drew on the Changzhou tradition as exemplified by the works of Yun Shouping. Still, he remained essentially independent of any single school or method, applying his well-rounded artistic training to his own vision of nature, and occasionally even using his fingers instead of a brush.

"Peach and Willow Contend in Spring" was painted within one year of Gao Fenghan's death. It consists of three simple elements: a large stone or cliff, an old willow tree with young leaves, and a few branches of blossoming peach, all of which issue from the left edge of the paper toward the right. No ground plane or background particularizes the setting of these subjects, yet the power of their structure and the vitality of their delineation render them complete and convincing as tangible natural forms occupying three-dimensional space. On the other hand, the incorporation of the inscription into the overall design, with some characters set in

between branches of the trees, provides still another dimension through which this work may be viewed. Moreover, the absence of additional elements reinforces the symbolic force of these motives, the meaning of which is articulated in the inscribed poem.

The left-handed execution of the brushwork is confirmed by the movement of the brush in individual strokes. However, the unique qualities of this painting are due less to this handicap than to Gao Fenghan's inventive application of calligraphic technique to pictorialization. His study of Han period stone engravings is demonstrated here in the rendering of the rock, willow trunk, and branches, and the boughs of the peach tree. These are based on strokes of the type known as "silkworm head, wild goose tail" (*cantou yanwei*) for their initial swellings and terminal flourishings. The wiry lines representing grass on the stone and the curving young willow leaves reflect the artist's facility in *zhuan* script. His writing, in a combination of the *xing* and *cao* styles, follows a compatible rhythm with its accents of heavy ink, suggestive of the *li* mode.

Gao Fenghan's success in injecting the aesthetics of Han and pre-Han engravings into his paintings sowed the seeds for major future trends in Chinese art. Through his rediscovery of the bold beauty of archaic carvings and his dynamic integration of the three gentlemanly arts of poetry, calligraphy, and painting, Gao Fenghan brought the achievements of his recent predecessors up to date and infused Chinese pictorial art with new life. Such rejuvenation is the theme of the present work, wherein the fleeting elegance of peach blossoms is juxtaposed with tender new growth on the aged willow.

## ZHENG XIE (Kerou, Banqiao), 1693-1765

**The Four Gentlemen**
Album of ten leaves, ink on paper
8½ x 11¼ inches each leaf

Leaf One: Plum Blossoms
    *Inscription:*  In the Gushe Mountains[1] snow-white fairies
                Accompanied the Queen Mother of the West to Jasper Pond.
                On her return she brought longevity wine,
                Now alone in the spring wind, she is slow to awaken.

                Painted by Banqiao.

    *Artist's seals:*  *Laohuashi*, square, intaglio
    (Lower right)  *Zhegu*, persimmon shape, relief

    *Collector's seal:*  *Dong ? guoyan*, square, relief

Leaf Four: Chrysanthemums and Rock
    *Inscription:*  Yellow leaves in the autumn wind by an old wooden bridge,

This is just the spot for poets to chant and chat.
Yuanming[2] is long gone without any news,
Only a few cool flowers are company for my loneliness.

*Artist's seal:*   *Banqiao*, square, intaglio

Leaf Six: Rock
    *Inscription:*   A rock painted in Zheng's style,
                   Moss dotted in Chen's;
                   Tut-tut, two marvels form a rocky crag,
                   And no one knows from whence it flew.[3]

                   Banqiaolaoren, Xie.

*Artist's seals:*   *Zhegu*, persimmon shape, relief
(Lower right)   *Lauhuashi*, square, intaglio

Leaf Ten: Bamboo
    *Inscription:*   Painted by Zheng Xie, a 73-year-old man.

*Artist's seals:*   *Shusan*, double gourd shape, relief
(Lower left)   *Xie he li zhi you yan*, rectangular, intaglio

Collection of Dr. and Mrs. Robert Magrill, San Marino, California

Born in Xinghua, Jiangsu Province, Zheng Xie was a poet, essayist, calligrapher, and painter, and is considered a leading master among the Yangzhou Eccentrics. His father, Zheng Zhiben, earned a meager living by taking students to supplement his scholar's stipend from the government. After both of Zheng Xie's parents died while he was still a young child, he was raised by his nursemaid. His appreciation of her selfless devotion to him later became the subject of a number of his poems. He was extremely outgoing, and many of his friends were Buddhist and Daoist monks and skilled craftsmen. Naturally bright, he formed definite opinions on all he read and loved to engage in lengthy, heated discussions with his companions. His own impoverished condition provoked the independent-minded youth to speak out against society's injustices. Thus even in his early years many thought him *guai* (strange or eccentric).

In 1736, at the age of 43, Zheng Xie passed the civil examinations for a *jinshi* degree. He was then appointed to the post of magistrate of Fan District in Shandong Province. There he involved himself deeply in the residents' problems, investigating all litigation thoroughly in order to judge each case fairly. After he was transferred to Wei District, famine struck the area. Out of sympathy for the starving people, Zheng Xie opened the municipal granaries to them and ordered wealthy landlords to provide the hungry with rice gruel. His charity saved many lives and won for him the enduring gratitude of the poorer segments of the population; however, it also kindled the wrath of the local nobility as well as of his superiors in officialdom. Under their pressure he saw no recourse but to retire on a pretext of failing health, whereupon he returned once again to Yangzhou.

Back in this fast-developing commercial center, Zheng Xie was able to make a

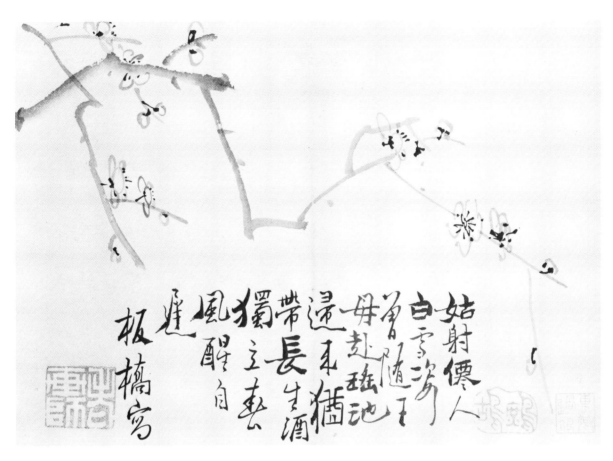

姑射偎人
白雪姿
曾不隨王
母赴瑤池
逞未猶
帶長生酒
獨立春
風醒自
遲
板橋寫

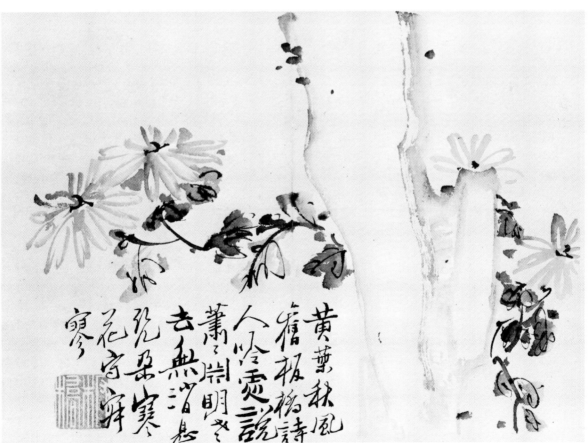

黃葉秋風
瘦板橋詩
人吟憊
蕭蕭崇明冬
去無消息
况是
花宜爭
寒

Zheng Xie. *The Four Gentlemen*: Leaves One (above) and Four (below).

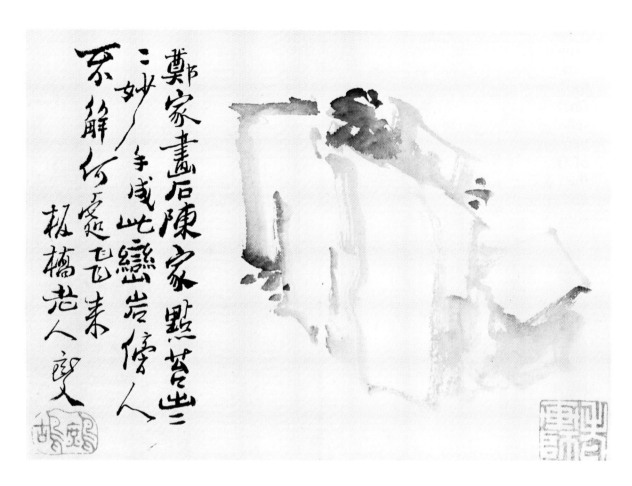

鄭家畫石陳家點苔些些妙
手成此戀巖傍人
不解何意葛來
板橋老人燮

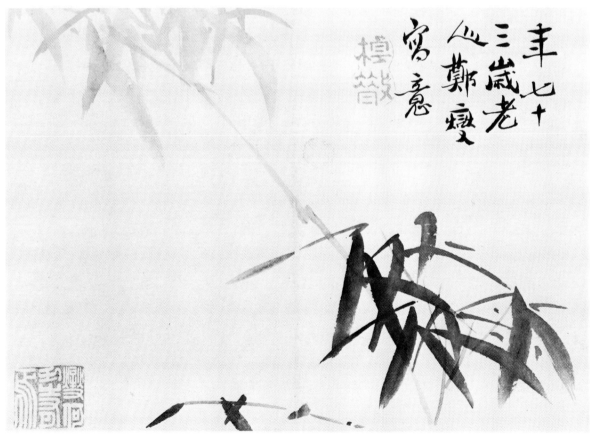

年七十
三歲老
人鄭燮
寫意

Zheng Xie. *The Four Gentlemen*: Leaves Six (above) and Ten (below).

94

living through the sale of his literary compositions, calligraphy, and paintings. He usually chose to depict plum blossoms, orchids, bamboo, and chrysanthemums, the "four gentlemen," perhaps as an invocation of true scholarly virtues as opposed to those he encountered during his government service. It is said that although his financial situation was hardly secure, he valued his art works highly and would not sell them to just anyone. He always considered the character of the potential buyer before parting with one of his creations. In his view, art should be for the enjoyment of farmers and laborers after a hard day's work rather than for the amusement of the nobility with their long hours of idleness. Still, he held no literati qualms about accepting money for his art; in fact, he even posted a price list on his door, which concluded with the comments,

> Gifts and food are never as wonderful as white silver. Your honorable gifts may not necessarily be favorable to me. If cash is given, I will be truly pleased and my calligraphy and paintings will be excellent; gifts are just a nuisance. Those who buy on credit often don't pay; I am old and easily tired, and can't engage in unprofitable discussions with everyone.

Like his temperament, Zheng Xie's paintings show assertive individuality and an undaunted spirit. He was not formally trained in pictorial art; once his calligraphy had developed into a mature style, he began to apply his writing skills to making pictures. Therefore, expressive brushwork rather than realistic description functions in his paintings to reveal the essence of the subject. An admirer of the later Ming artist Xu Wei (1521-1593), Zheng Xie held in common with him the ability to break out of convention and paint in a highly personal and often sketchy, almost abstract mode. While poetry, calligraphy, and painting had since Song times been considered complementary forms of artistic expression among the literati, for Zheng Xie they were interrelated as parts of one whole. His poems communicate in the same unconventional, spontaneous, and terse manner as his paintings, and his pictorial images are constructed of brushstrokes that are indistinguishable from those in his calligraphy. Furthermore, poetry and calligraphy are not merely embellishments added after completing his paintings, but are incorporated into the scheme of the entire composition, at times appearing within the contour of a rock or between the branches of a plant.

Zheng Xie's calligraphy was inspired by Su Shi (Dongpo, 1036-1101) and by early Han stele engravings in the official style. He fused this script with the regular and running styles, a technique which he called the "six-and-one-half-tenths of the official style." To artists who write in this elegant manner today it is simply known as the Zheng Xie style.

According to the inscription on the tenth leaf of this album, it was completed when the artist was 73 years old (sui). As this was his age when he died, this may have been among his last works. Although no poem accompanies this final picture, the seal in the lower left corner reads "What power do I have?" Zheng Xie asks this rhetorical question with reference to his frustration at his thwarted efforts as a public official to serve the needs of people suffering from poverty and natural disasters. The text of his seals is often a pithy phrase, whether an eloquent lamentation as in this example, or a humorous remark or humble statement about himself. As an important element in his paintings, Zheng Xie's seals supplement the visual and poetic content as a statement of the man's mind. Although some sources claim

he carved his own seals, there is evidence that they were made for him by other artists such as Gao Fenghan.

The spontaneity and boldness of the plum blossoms, bamboo, chrysanthemums, orchids, and rocks shown in these leaves demonstrate Zheng Xie's talent for "ink play" and novel compositions. On some leaves the subject is positioned to one side with the calligraphy on the opposite; on others, the poem occupies the upper half, with the painting appearing below. Still others invert this arrangement, while one of the depictions of bamboo (Leaf Ten) displays a diagonal design. On every leaf the painted subject, inscription, and seals carry equal importance, and each is thoughtfully placed so that the exclusion of one would leave the whole composition unbalanced.

Characteristically, the poems in this album were all composed by the artist himself. As a poet Zheng Xie spoke in a lively, informal voice after the spirit of Tao Qian and Li Bo (701-762). Drawing on images from everyday life and using common language, he often wrote of companions, including a number of other Yangzhou masters, of the hard lot of the farmer, or of his own life experiences, touching the reader with his poignant warmth and compassion. The witty, eccentric side of his personality is also reflected in his poems, such as that on Leaf Six, which pokes fun at artistic imitation and eclecticism. By thus relating the poem to the picture, which in itself is technically one with the calligraphy, Zheng Xie joins these three arts in a cohesive unity that is unmatched in the history of Chinese art. Rejecting the formalistic and derivational approach of the Orthodox School and working within a limited thematic range, he developed a refreshing new mode in which poetry, calligraphy, and painting interact in a single aesthetic presentation.

**Bamboo**

Hanging scroll, ink on paper
54 x 20 inches

*Inscription:* Biting tightly the green hills, never letting go,
Its roots cling to wild cliffs.
Swishing and swaying incessantly, it still stands firm,
No matter which way—north, south, east, or west—the
wind blows.

Banqiao, Zheng Xie.

*Artist's seals:* *Banqiao shuhua*, square, relief
*Zheng Xie zhi yin*, square, intaglio
(Lower right) *Suonanwenghou*, irregular, relief

Private Collection, La Puente, California

Because it requires mastery of calligraphic brush methods, bamboo has long been a preferred subject among scholar-artists in China. Zheng Xie was the last

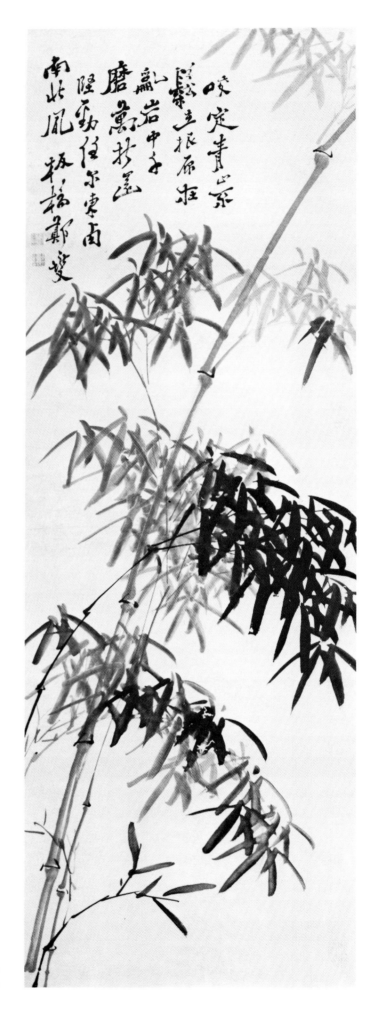

Zheng Xie
*Bamboo*

97

painter to specialize in this theme, and he attests to the value he placed on his renditions of this evergreen in a poem appended to his price list:

> Paintings of bamboo cost more than real bamboo,
> For six feet the price is 3,000.
> Sweet words of past connections and friendship
> Are only as the autumn wind blowing past my ear.

In this painting of rain-drenched bamboo, a tall stalk sweeps diagonally from the lower left to the upper right edge of the picture. The bottom and top extremities of this stalk are beyond the paper's border, emphasizing the patternlike effect of the foliage. The latter is divided into four main groupings, arranged in perpendicular lines across the main stalk. The blunt leaves are weighed down by rain and jostled in all directions by a light wind; yet even where densely clustered, they are mutually distinguishable. The three-dimensional quality of the strokes representing the leaves imparts a sense of movement, while striking contrasts of light and dark ink suggest varying degrees of depth.

Zheng Xie's bamboo is meant to be appreciated not so much for its affinities to real bamboo as for its calligraphic beauty. In fact, the entire course of the artist's training in calligraphy—what styles and whose manners he took as models—may be detected in this bamboo painting. Living as he did in an era when the study of *bei* and *tie* was prevalent, he also discloses his connoisseurship in this field in his pictorial art.

Here, unlike in many of his other paintings, Zheng Xie refrains from employing eye-catching compositional devices or bravura brushwork. Nonetheless, out of this seemingly ordinary design and subdued manner, deepset power and vitality emerge. Such outward plainness with inner forces is an outstanding feature of works by Shitao. It is not known whether or not Zheng Xie knew this artist, but he did associate with Gao Xiang (1688-1753), who had been a friend of Shitao and so had absorbed some aspects of his style. Zheng Xie's relationship with Gao Xiang may well have bolstered the influence of the earlier master that he would have been exposed to as a resident of Yangzhou; such influence is clearly manifest in this painting.

The inscription, written in the artist's typical hand in dark ink, complements the layout and ink tones of the picture. The poem, which also appears elsewhere in his painting oeuvre, speaks not only for the hardy character of bamboo, but also for the resolute temperament of Zheng Xie.

*NOTES:*

1. A range of mythical mountains recorded in the *Shanhaijing*, a book of fables that describes legendary regions and their indigenous flora and fauna.

2. Tao Qian (372-427), one of China's greatest poets. Rather than compromise his scholarly ideals in the civil service, he retired from public life after a brief career and retreated to his home in the countryside. There, he lived a simple life of farming, composing poems, and raising chrysanthemums. This autumnal flower came to symbolize the man and his lofty character.

3. This poem may refer to the giant rock known as Feilaifeng ("flown in by the wind") in Hangzhou. It towers conspicuously alone on flat terrain, appearing to have dropped from the sky.

*JIN NONG (Shoumen, Dongxin, Jiliushanmin), 1687-1763*

**Pine Tree and** *Lingzhi*

Hanging scroll, ink and light color on paper
17¼ x 11 inches

*Inscription:* Strange rocks have long heard (of this tree),
And, crowded together, bow down.
Evil vines cannot strangle it,
If you ask how old this pine tree is,
The Yellow Emperor slept in it.

Painted by Jiliushanmin, Jin Nong in Guangling
(Yangzhou) as a house guest.

*Artist's seals:*
(Upper right
corner) *Dongxin xiansheng*, square, relief
(Following
inscription) *Jin Nong yinxin*, square, intaglio and relief
*Shoumen*, square, relief

Collection of Dr. and Mrs. Robert Magrill, San Marino, California

Like Zheng Xie, Jin Nong was an accomplished scholar, poet, and calligrapher before he ever took up the brush to paint. In addition, he was a connoisseur of *bei* and *tie* as well as paintings. He published his colophons (poetry and authentications) in a four-volume edition.

This Eccentric grew up in Hangzhou and traveled extensively in early adulthood. Probably sometime in the late 1740s, after his wife had died and his daughter married far from home, he took up residence in a Buddhist temple in Yangzhou, where he remained until his death.

Generosity to friends and free spending on his collection kept Jin Nong poor for much of his life; to publish his colophons he had to obtain financial aid from his friend Zheng Xie. In middle age he tapped his knowledge of art and mastery of calligraphy to fashion pictures with the brush. His initial attempts to sell his paintings, however, were cooly received. On one occasion he painted lanterns to sell, although he was embarrassed at having to produce a minor craft, and asked his childhood friend, Yuan Mei (Zicai, Shuiyuan Laoren; 1716-1797), to sell them. At that time Yuan Mei was mayor of Jinling (present-day Nanjing). He wrote in reply to Jin Nong's request, saying, "Your paintings are outstanding, but unfortunately the people here in Jinling only know how to eat duck. They don't even know what a painting is in broad daylight, so how can they hope to at night [i.e., on a lantern]? As mayor, I cannot go walking around, peddling your things on the street." Such blows were common to Jin Nong, and his life was a constant struggle.

In 1736, the year Zheng Xie earned his *jinshi* degree, the court nominated Jin Nong for the honorary title of *boxuehongci*. Contrary to some accounts, Jin Nong

did not fail the qualifying examination for this honor. Rather, he refused even to take the test. Despite straitened circumstances, he turned down the official recognition that would have made his life considerably more comfortable, for to accept the title would have been to compromise his personal ideal of free and disinterested scholarship.

Writings in the *li* script engraved in stone tablets dating to the Han Dynasty were Jin Nong's primary models in his study of calligraphy. After prolonged practice of this style, he turned to the *li* script of the Three Kingdoms period as found on the *Tianfa shenqian* stele, and also to Northern Wei (386-534) tablets. By his mid-thirties, his imitation of these ancient modes had merged with his own characer and evolved into a style that was neither *li* nor Wei, but a new script of his own creation. In this form, Jin Nong used his brush to exert the same robust force of ancient carved characters in a formalized, precise, and squared manner. His calligraphy figures prominently in his paintings, with inscriptions filling much or sometimes nearly all of the blank space. Moreover, his highly developed calligraphic style is the basis of the brush technique in his pictorial works.

Jin Nong's earliest subjects, bamboo and plum blossoms, remained his favorites. His first recorded painting, dated 1746 when he was living in Nanjing, depicts bamboo in the manner of Guan Zhongji (1262-1319). Later, he added horses and Buddhist figures to his repertoire. His years of study and connoisseurship shone forth in his works from the outset, and to the end of his life he endowed his creations with great originality and vigor. This artist's major aesthetic concern is to convey the effect of stone engraving with the brush. Consequently, he renders his subjects in a notably abstract mode that emphasizes the same powerful line found in his calligraphy. In this way, he makes obvious the integration of painting and calligraphy that is central to Chinese art. As this integral relationship first occurs in the evolution of the Chinese written language from pictographs into the abstractions of modern characters, Jin Nong's style represents a return to the roots of Chinese culture. This stylistic aspect of his creations, along with the ingenious novelty of their compositions, played a significant role in the formation of the Jinshi ("Engraving") School of the 19th century.

These qualities are featured in "Pine Tree and *Lingzhi*," wherein almost half the space of the work, along a diagonal line, is devoted to the inscription. The diagonally divided composition is an 18th century Yangzhou innovation. Four lines of bold characters in Jin Nong's distinctive hand, filling the upper right-hand corner, are no less a subject in this work than the plants below. The artist supposedly cut off the tips of his brushes for the squared-off, chiselled effect of his brushwork. The strokes do not play on the surface of the paper, but seem to dig into it, as though the painting were a rubbing of a stone or metal engraving. At the same time, the lines of the calligraphy are so clear, their texture so evenly controlled, that they seem to jut forward in relief. Touching us with their deliberate vigor, the characters bespeak a force like the slow, steady deepening of mountain gorges, or the impress of a cultural tradition on the heart of every age. Jin Nong celebrates this timeless energy, balancing strictly the elements of each character and the spaces between them.

Counterpoised to the calligraphy are an aged pine tree, a Confucian symbol of constant moral virtue, and the Daoist *lingzhi*, legendary fungus of immortality.

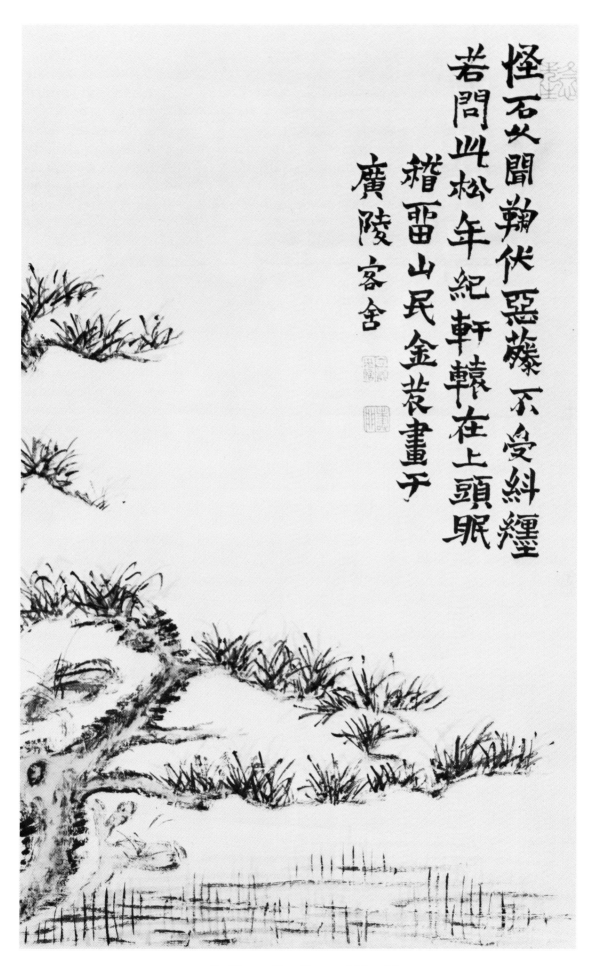

怪石如火聞翰伏惡藤不受斜纏
若問此松年紀軒轅在上頭眠
稽雷山民金農畫于
廣陵客舍

Jin Nong. *Pine Tree and Lingzhi.*

These two philosophical strains are woven compositionally as they are conceptually. In the first sense, their relation provides movement back into the picture, the *lingzhi* giving the tree back and side facets, while on the conceptual level, the combination of the two plants suggests the notion of enduring virtue. The tree, with its branches spread in an elegant frame, is a showcase for the calligraphy, with the poetic text reciprocating as a literary reference for the pine. The powerful, blunt brushwork of the needles and the reeds below mirrors that of the writing. Like the calligraphy, the reeds and pine needles resemble a rubbing of an engraving. To further this feeling, Jin Nong applies the pale color of the new growth of needles and the water of the marsh in brush strokes rather than in wash, and he treats the tree's trunk with a dry brush to evoke the rubbed impression of a bevelled surface.

This painting communicates great stability without stiffness as well as a sense of the living force of the pine tree. The artist achieved these feats by imbuing his forms with movement in almost every direction, a movement so subtle that it seems to emanate from an inner stratum instead of the surface of the paper. In keeping with the themes of life and growth implied in the brushwork and composition, Jin Nong in his poem sheds the conventionally solemn contemplation of the past and, on a fanciful note, imparts the vitality of this tree, and, by analogy, of antiquity itself. Pine trees are traditionally depicted with rocks, but here, in a unique twist, the presence of rocks is implied in the poetic text in place of a physical rendition.

For Jin Nong, recapturing the essense of antiquity is never the imitation of ancient styles; to him, like the other Yangzhou masters, the value of individual expression is paramount. The fusion of old and new as presented in this painting represents a cogent statement on the relevance of the spirit of the past to every age, and the validity of a subjective interpretation of that spirit.

**Plum Blossoms**

Hanging scroll, ink on paper
46 x 15 inches

> *Inscription:* I received a letter yesterday from a monk friend in Sichuan. He asked first about the plum blossoms, then about my crane. I answered that the wild plum blossoms are fine, and the skinny crane also; only this old man is sick in his feet and back. The pain has caused me to keep my door closed, but because I did so, I was able to purify my spirit and paint the plum blossoms. I painted them in the moonlight while my crane danced beside me. The dancing crane made me as pure in spirit as the plum blossoms. I needed to paint them in order to have rice to eat; it was a very ordinary thing to do. Few intellectuals are so highly spiritual as to give me rice for nothing. Since no one delivers rice to me, I am always hungry and my crane is skinny for lack of food. What can I do? I just hold the crane in my arms all the time. On the first day in the

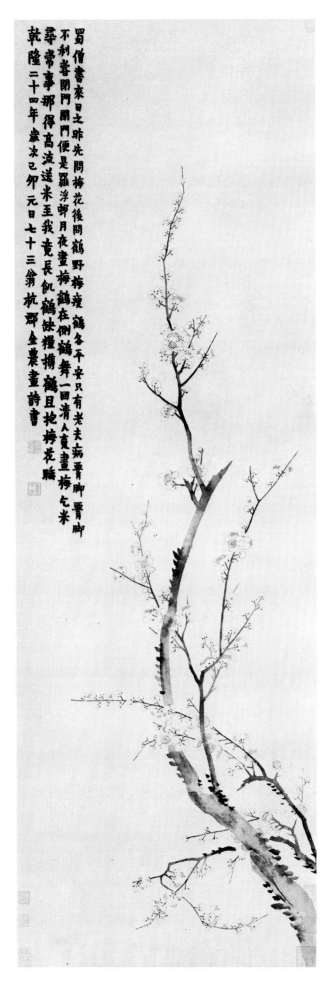

蜀僧書來日之昨先問梅花後問鶴野梅瘦鶴各不安只有老夫喜晉腳晉腳

不剌誊閉門閉門便是羅浮卻月夜畫梅鶴在側鶴舞一回清人賣畫梅乞米

尋常事那得高流送米至我竟長飢鶴俵糧搆鶴且抛梅花睡

乾隆二十四年歲次己卯元日七十三翁杭郡金農畫詩書

Jin Nong
*Plum Blossoms*

103

year of *jimao*, 24th year of Qianlong (1759), Jin Nong painted this painting, and composed and inscribed this poem.

*Artist's seals:*   *Jin Jijin yin*, square, intaglio
                    *Sheng yu dingmao*, square, relief
(Upper right)   Illegible

*Collectors' seals:*   Six seals in the lower right and left hand corners, not transcribed

Private Collection, Sydney, Australia

Jin Nong's plum blossoms express that originality of vision characteristic of the art of Yangzhou. Plum blossoms, one of the "four gentlemen," bloom in spite of winter's harshness, and their ability to withstand the bite of the cold season is likened to the scholar's ability to maintain his integrity under the pressures of poverty. Thus, to Jin Nong, this subject had special personal significance.

The viewer's vantage point in this work deviates from the common one wherein a branch enters the picture from the upper or side border; here it moves from below in an almost straight path to the top. Interest is shown in upward growth through the intermingling of diverse rhythms. Delicate twigs weave in front of and behind the main branch in a naturalistic manner, providing depth and variation without impeding the sense of the growth's strong thrust.

The sturdy characters in dark, wet regular script perform a more important compositional task than just filling in the upper left-hand space. Their glittering lacquerlike quality results from the same even brushstrokes used for the branches. The calligraphy offers support for the tree, allowing the delicate uppermost twig to occupy its somewhat precarious position without seeming about to topple over to the left. The long narrow overall design of the inscription also reinforces the vertical pull of the tree, enlivening the composition and directing the spectator's eye back down the branches so that it does not linger awkwardly suspended in the upper blank space.

Because the tree has just begun to blossom, Jin Nong focuses attention on the tremendous energy of the branches. This aspect is clearly manifested in the main bough, which splits open at the lower right. Forceful brushwork conveys this inner power throughout, without sacrificing the delicacy and grace of the whole. The branches are executed, each in a single stroke masterfully controlled, with light and dark alternations produced by varying the angle and pressure of the brush. By these means, both volume and the uneven texture of the bark are achieved. Although the tonal spectrum is more pale than the uniformly dark calligraphy, the boughs and twigs consist of the same clean-cut, smoothly flowing lines as seen in the inscription.

The curvilinear plum blossoms, with heads turned in every direction in every stage of bloom, soften the linear tensions set up by the branches. The fine-lined petals are cast in cheerful counterpoint to the controlled, wet brush of the boughs and twigs, and their rhythm parallels the movement of the black dabs on the branches which signify knots in the bark. The animation of these crisp flowers denotes their context, the sharp winter air blowing with frosty perfume.

To transform the blossoms' ethereal fragrance into a visually perceptible phenomenon is the chief task of the plum painter, and under Jin Nong's hand this is accomplished with exceptional finesse. This hand, deliberate and exacting, archaic yet straightforward, passes over the paper with a sprightly naive grace, impregnating empty space as it moves with an atmosphere of immaculate freshness. Drawn in by this ambience, the viewer is granted asylum in a world where fleeting beauty is frozen in time and where pristine vapors uplift the spirit by way of the eye.

## LUO PING (Danfu, Liangfeng), 1733-1799

### Figures: The Eighteen Lohan

Album of twelve leaves, gold on blue paper
9½ x 6¼ inches each leaf

Leaf Twelve:

> *Inscription:*  Liangfengshanren, Luo Ping.

> *Artist's seal:*  *Qiao'an*, square, relief

Collection of Mr. Walter Sedgwick, Cambridge, Massachusetts

The youngest of the Yangzhou Eccentrics was Luo Ping, who studied under Jin Nong. A native of She District in Anhui Province, Luo Ping moved to Yangzhou in 1766. Like Jin Nong, Luo Ping lived for a time in a Buddhist temple. Claiming to be a reincarnation of a former chief monk (*seng*) of Huazhi Temple, he called himself Huazhisi Seng. He was known for his poetry and calligraphy as well as his paintings. During his own lifetime, Luo Ping won fame as a painter of figures, particularly ghosts and demons, and a popular legend attributes his special talent in this area to an ability to see ghosts in broad daylight. Such an explanation, however, does not account for his equal facility in depicting other types of figures in addition to landscapes, plants, and rocks. In Jin Nong's old age, many orders for his work were actually filled with paintings by Luo Ping, his favorite pupil. Eventually, the student surpassed the teacher in the sensitivity and versatility of his brush. Famous examples of Luo Ping's work can be seen today at Hanshan Temple in Suzhou, where scenes based on his original paintings are carved into stone.

The eighteen individuals portrayed in this album of twelve leaves represent Lohan or Arhats, followers of Buddha who have transcended the cycle of transmigration. Only sixteen Lohan were transmitted from the Buddhist lore of India to China, where two more were often added to make up the grouping pictured here. However, the distinction of Lohan has been assigned to as many as 500 devotees. The depiction of these holy men in Chinese painting dates back at least to the ninth century, when the monk-artist Guanxiu (832-912) is known to have completed several series of Lohan portraits characterized by their non-Chinese and grotesque features. In the Song period, Li Gonglin (Longmian, ca. 1040-1106)

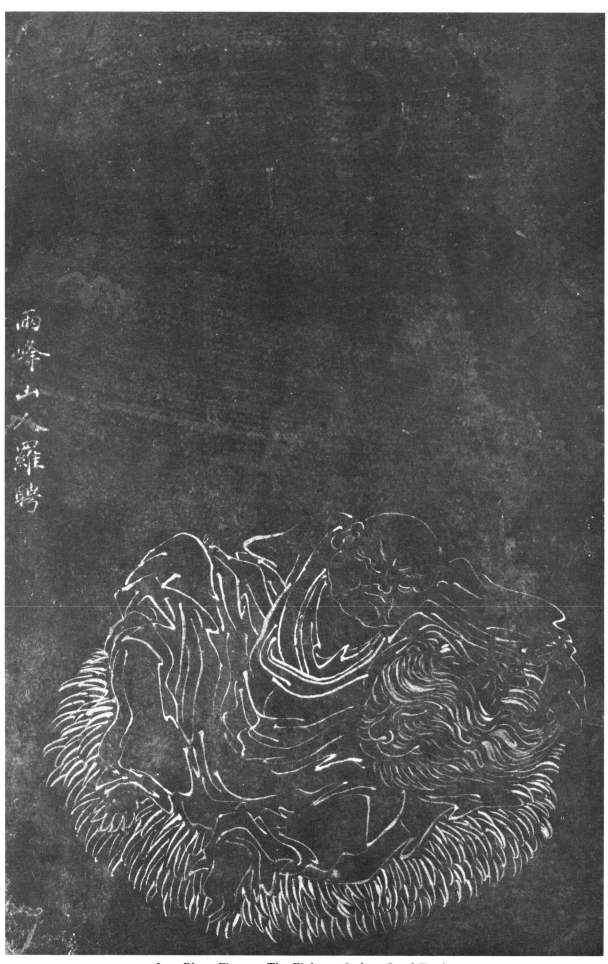

兩峰山人羅聘

Luo Ping. *Figures: The Eighteen Lohan.* Leaf Twelve.

pictured Lohan of a more naturally human appearance. The Li Gonglin tradition bore particular influence on later figure painting in general, with his *baimiao* or plain outline technique becoming the preferred method among Literati artists.

Much later, Chen Hongshou (1599-1652) reworked ancient modes to create figures, including religious subjects, composed of resilient curving lines with a decidedly archaic flavor. Luo Ping, too, delved deep into antiquity for his means of expression, and this album exemplifies the fruits of his search. But rather than striking allusions to the past through a somewhat affected awkwardness, as in the works of Chen Hongshou, Luo Ping transformed the ancient *baimiao* method into a style all his own. Such a transformation occurs in these twelve compositions through a combination of the artist's technical virtuosity, the carved appearance of the individual strokes, and a terseness of rendering. The result is a unified series of images so fresh and lucid that they speak to the pure character of the subjects themselves.

Even in his selection of materials for this work, gold on deep blue paper, Luo Ping continues a Chinese Buddhist practice and indicates his reverence for the venerable ideals represented by the Lohan. From an aesthetic point of view, the light shade of the lines on the dark paper imparts a negative or intaglio effect not unlike that of rubbings taken from inscriptions or pictures carved into stone during ancient times. The sole use of gold in depicting the figures, animals, and settings against the colored background also provides an aura of ethereality appropriate to this subject. Even so, these paintings are not merely decorative; the abstract beauty of calligraphic brushwork and rich tonal variations in gold would appeal to the tastes of the most discriminating connoisseur.

The album closes with a virtually round composition, portraying a sleeping Lohan leaning on a tiger and curled up on a mat. The drapery folds in generally horizontal direction upon the soft waves of the tiger's fur and the brief, almost vertical lines of the bushy straw mat. The six-character signature along the left edge of this final leaf is written in regular script, an indication of Luo Ping's attitude of respect and care in creating this work.

Luo Ping has been looked upon by many art historians as one of the last masters of China's traditional painting. While it is true that he lived during a decline in the Orthodox School of the Four Wangs, and that he was the youngest of the Yangzhou Eccentrics, his art marked less the twilight of an age than the dawn of a new one. His powerful "carved" brush strokes, featured in every leaf of this album, inspired the Jinshi School, which came to be the major movement of the 19th and early 20th centuries.

*LI SHAN (Zongyang, Futang, Aodaoren), 1686-1762*

Two album leaves, ink on paper
10½ x 14½ inches

Leaf One: Lotus, Dragonfly, and Frog

*Inscription:*     The ocean's vastness lets fish leap about,
The sky's spaciousness allows birds to fly.
All kinds of matter are the same;
even in such a small thing as this,
the nature of the universe may be seen.
Don't tell me there is no life in paintings!

Li Shan.

*Artist's seal:*     *Buzheyao,* oval, relief

Leaf Two: Bamboo Shoots, Mushrooms, and Cabbage

*Inscription:*     The pure aroma so satisfies the appetite,
Even a jade pot in an official's kitchen cannot compare.
Today I dwell leisurely on a ten-*mou* garden;
The door shut, I often read old farmer's books.

Futang, Li Shan.

*Artist's seals:*     *Shan,* square, relief
*Zongyang,* square, relief
*Shan,* round, relief
(Bottom right)    *Futang,* oval, intaglio
(Bottom left)    *? baishanren,* round, intaglio

Collection of Dr. and Mrs. Robert Magrill, San Marino, California

Li Shan is perhaps the most misunderstood of the Yangzhou Eccentrics, yet the most important in terms of his influence on later generations. While each of these artists had brief followings in the 18th century, it was Li Shan's wholly independent approach that was taken up and expanded by numerous 19th and 20th century painters. This approach used certain aspects of the academic tradition of realistic depiction, along with techniques of the more abstract, expressionist *xieyi* mode. Solid training in both of these forms qualified Li Shan to move freely from one to the other and ultimately to formulate a novel style based on a synthesis of the two.

With a family heritage of scholar-officials dating back to the Ming Dynasty, Li Shan was well versed in literature and art by an early age. As a young man he passed the examinations for a *xiucai* degree and went on in 1711 to obtain a *juren* degree. At this time he had already gained a name as a poet and calligrapher in the area of his hometown, Xinghua in Jiangsu Province. Soon after, he was granted admittance to the court of Kangxi, where he became the pupil of the flower-and-bird painter Jiang Tingxi (1669-1732). Under the guidance of this famous master, Li Shan learned the *gongbi* method of painting in which meticulous detail and close fidelity to natural appearance are the rule. As one of his duties as a court artist he accompanied imperial excursions to various parts of the country to make pictorial records of the scenery encountered along the way. It was probably while Li Shan was still serving in this capacity that he met and received instruction from Gao Qipei (1672-1734), for the latter held high-ranking posts in the Kangxi and Yongzheng periods. Although Li Shan did not acquire this artist's habit of using his finger to

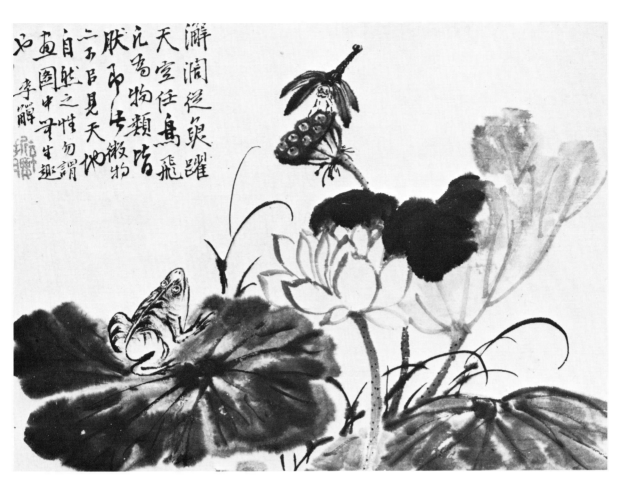

Li Shan. *Lotus, Dragonfly, and Frog.*

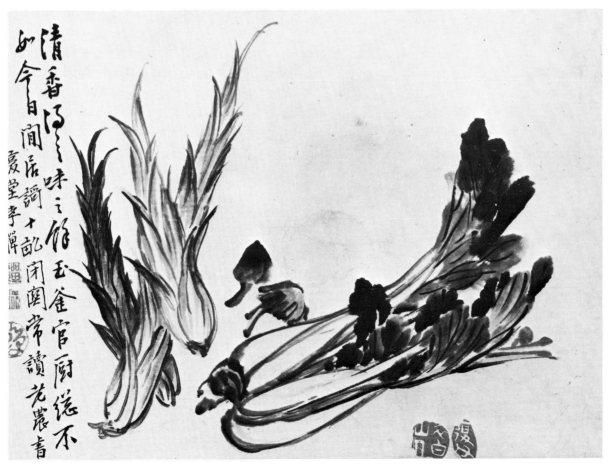

Li Shan. *Bamboo Shoots, Mushrooms, and Cabbage.*

paint, Gao Qipei's spontaneous, unrefined manner clearly made a deep impression on his student.

Li Shan's career was cut short when, implicated in an illicit plot, he was expelled from court. The third year of the Yongzheng period saw him back in Yangzhou, disillusioned and depressed, giving himself over to an aimless life of wine, women, and poetry. Gradually, however, his ambition was restored, in part through the encouragement of such friends as Zheng Xie and Huang Shen. At the magnificent Tianning Temple these artists practiced painting and studied rubbings of ancient engravings together. Since he had exhausted his inherited wealth, Li Shan now had to eke out a living through the sale of his art works.

Around the age of 52, he moved to Shandong Province as magistrate of Teng District. But after only a few years in office, he was forced to retire due to conflicts with his superiors. Li Shan acknowledged his unwillingness to submit to authority in one of his seals, which reads *buzheyao*: "(I) will not bow in obeisance." Again he took up painting in Yangzhou, this time meeting with more success.

His early mastery of calligraphy gave Li Shan a firm footing for his later success in pictorial art. Thorough familiarity with the writing of Huang Tingjian (1045-1105) is observable in his hand, as is that of Zhu Yunming (1460-1526). Older models are also revealed in Li Shan's calligraphy, particularly engraved inscriptions in *li* script and in the Northern Wei style. Like Gao Fenghan and Jin Nong, he transferred the carved effect and archaic flavor of such engravings to his paintings. There is no evidence that he carved seals, but the prominent sculpted character of line in his pictures suggests that he did engage in this art form.

In addition to the influence of his two teachers in Beijing, Li Shan absorbed Lin Liang's (active ca. 1450-1500) dramatic displays of technical virtuosity and much of Xu Wei's emotional intensity. The latter tendency caused some contemporary critics to dismiss Li Shan's art as too audacious. But discipline and subtlety of brushwork and color as well as the compelling vivacity that radiates from all of his pictures confirm the high standard of quality that this artist achieved.

Strong individualism, adherence to the *xieyi* tradition, and the joining of poetry, calligraphy, and painting in a united whole are traits that Li Shan held in common with the other Eccentrics, yet his paintings stand apart from those of the rest in several fundamental respects. Whereas most of these artists specialized in either the "four gentlemen" or figures, Li Shan's repertoire encompassed a wide range of plants, vegetables, insects, and birds, some of which were drawn from the academy rather than scholar-amateur painting. His colors also reflect his training at court, with their vivid hues and realistic usage. Thus broadening the scope of the *xieyi* mode, Li Shan laid the groundwork for the later advancements made in this field by the Four Rens and proponents of the Jinshi School such as Wu Xizai (1799-1870) and Zhao Zhiqian (1829-1884).

Even in his monochrome ink paintings, Li Shan renders his subjects in a style that is at once literary and naturalistic. Such an album leaf depicting lotus, a frog, and a dragonfly evokes the warm moist atmosphere of a summer day and the low murmur of a pond abounding with life. Three lotus leaves make up the basic design: one toward the upper right just half-unfolded, another to the lower left fully

opened, and the third, which partially extends beyond the painting's lower right corner, wilting in umbrella formation. Varying stages of growth and decay are also seen in the two lotus flowers, one in full bloom, the other, having shed its petals, now a pod ripe with seeds. Just touching down on the pod, a dragonfly prepares to sip the morning dew, unaware of the frog watching with intent interest. This small-scale drama is viewed from a low point as though the spectator were another frog sitting on a leafy perch at close range. Although the amphibian and the insect are poised motionless, movement is implicit in the action that is about to take place. Moreover, an inner vibrancy is generated through freely suffused washes, richly modulated ink values, and a cohesive interrelation of the various pictorial elements. With the relatively large block of calligraphy in the top left portion of the painting, most of the space is occupied, but this density is offset by the loose, apparently extemporaneous brush manner.

Li Shan's exploitation of ink's multiple "colors" in this work contrasts with another album leaf painting wherein line acts as the principal means of expression. Two mushrooms are set between a group of bamboo shoots rising vertically on the left and a head of cabbage laid at an angle to the right. Although these plants have been harvested and are here arranged as inanimate objects much as in a still life, their surviving vital forces are manifest in the moist, tender qualities of their forms and textures. The thick, firm stalks and crisp leaves of the cabbage, the fleshy substance of the mushrooms, and the lilting curves of the sheathes of the bamboo shoots appeal to the viewer's sense of taste as well as sight. Yet even as the vegetables are accurately rendered as solid, tangible items, they are animated by a rhythm built of the lines that define them.

This simple picture offers a telling study of Li Shan's ability to achieve realistic results using the paraphrasing language of the *xieyi* method. The three-line inscription and seals that fill the left edge from top to bottom shift the balance of the fanlike composition of the vegetables, but this is ingeniously remedied by the presence of the two seals just below the cabbage on the lower border. These seals, their rounded irregular shapes echoing the caps of the mushrooms, serve to anchor the weight of the overall scheme, although the calligraphy and seals may all be observed as on a separate plane that overlays the painted image and therefore does not disrupt the pictorial design. The placement and function of the two lowermost seals mark Li Shan as a master not only of the "three arts" but of the fourth, that of seals, as well.

### MIN ZHENG (Zhengzhai), 1730-after 1788

**Two Ducks**

Hanging scroll, ink and light color on paper
43 x 17½ inches

    *Inscription:*  Painted by Zhengzhai, Min Zheng.

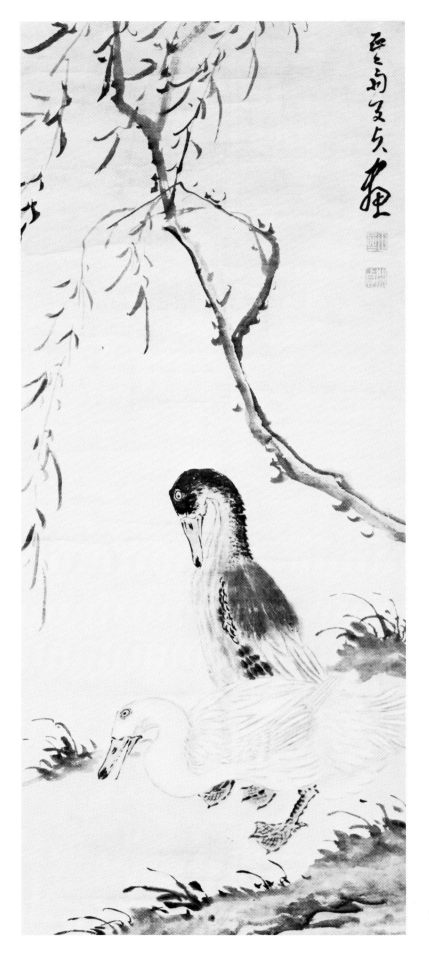

Min Zheng
*Two Ducks*

*Artist's seals:*  *Zhengzhai*, square, intaglio
*Min Zheng*, square, intaglio

Private Collection, La Puente, California

Min Zheng was a native of Jiangxi Province but lived in Hankou in Hubei for much of his life. It is said that as a young boy he wept at the sight of portraits of his friends' parents, for, orphaned at an early age, he had no memory of his mother and father, and so could not paint their likenesses. One day an elderly neighbor told him that he had seen a couple walking down the road who closely resembled Min Zheng's parents. So excited was the young artist at the prospect of seeing these people's faces that he immediately took off down the road in pursuit of them. After running for 300 *li* he overtook them, and invited them back to his home. They returned with the youth, but as soon as he had completed their portraits the man and woman mysteriously disappeared. From that time on, Min Zheng was known as Min Xiaozi, or "Min the Filial Son."

The date of Min Zheng's move to Yangzhou is not known, but his residence in that city in the mid-18th century and his unique painting style qualify him for inclusion in the Yangzhou Eccentrics. The apocryphal story related above has also been cited as evidence of this artist's uncommon character. Unlike the others in this group, his oeuvre is dominated by figure paintings, but the unconventional compositions of these live up to the provocative spirit of Eccentric expression.

Min Zheng also excelled in depicting landscapes, plants, and birds, the latter two of which are pictured in this hanging scroll painting of two ducks beneath a willow tree. This work emanates a feeling of quiet contentment. The ducks pause at the edge of a river; one, having just emerged from the water, cleans its breast feathers, while the other seems to be on the lookout for small fish that might swim by. This tone of tranquility is echoed in the predominance of curvilinear strokes and in the soft swirling leaves of the willow tree—a sign of early summer—the graceful contours of the ducks' bodies and the gently blowing grass on the riverbank.

There is an almost musical quality to the arrangement, with its avoidance of any stiffness or sharp contrasts. The darker silhouette of the duck to the rear merges harmoniously with the white one in front. The juxtaposition of the two, one in a horizontal pose and the other in a vertical stance, creates a strong focal point. Expert use of washes, dots, and long thin strokes brings out the natural texture of the feathers and even suggests the volume and firmness of the bodies underneath. Min Zheng's skillful brushwork reveals his mastery of calligraphy, especially as seen in the leaves and grass and in the powerful delineation of the ducks' bills. The artist's signature betrays the influence of the "wild cursive script" of the Tang monk Huaisu (737-after 798).

**Cranes and Banana Leaves**

Album leaf, ink and color on silk
8 x 11 inches

*Inscription:*   Min Zheng.

*Artist's seal:*   *Min Zheng zhi yin*, square, intaglio

Collection of Senator Jack Faxon, Michigan

Whereas Min Zheng's ducks are viewed close up in lifelike proportions, this small album leaf encompasses a spacious garden scene with eight cranes, giant rocks, and full-grown banana trees, all of which are reduced to miniatures. Varied tones of green were applied in the boneless technique for the leaves, and ink washes form the sculpture-like Taihu stones behind and beside the trees. The cranes, birds of considerable height, speak for the large scale of the landscape elements, while the creatures' placement and active postures establish spatial relationships and depth. The diminutive size of the format lends an aura of poetic intimacy to the painting. Banana trees are associated with scholars, who often plant them near their windows so that the pleasant patter of raindrops on the broad leaves may be heard from within their studios. The crane is known for its cleanliness and pure character; although often domesticated to grace gardens such as this one with its animated beauty, it is easily disturbed. Thus, the relaxed manner of the cranes here as they frolic in the shade of the banana trees conveys a mood of cheerful serenity.

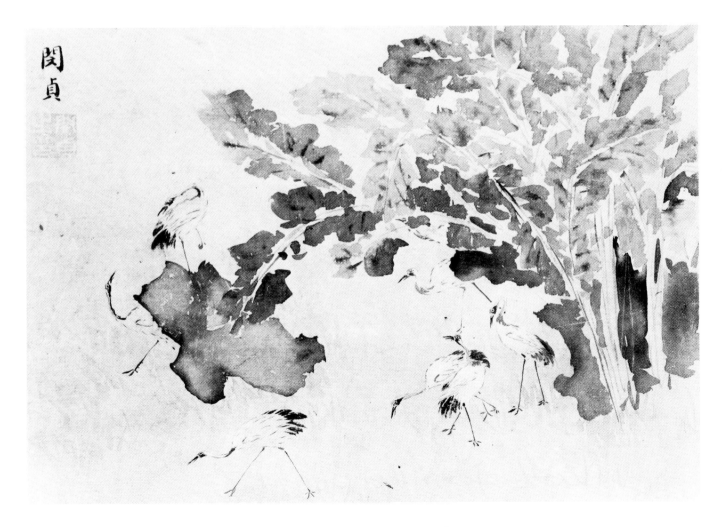

Min Zheng. *Cranes and Banana Leaves.*

## CAI JIA (Songyuan), active 1739-1782

Three album leaves, ink and color on paper
6½ x 10½ inches each leaf

Leaf One: Plum Blossom Studio

*Artist's seal:* *Danyang Cai Jia*, oval, relief

Leaf Two: Dwelling on a Lakeshore in the Mountains

*Artist's seal:* *Cai Jia*, square, intaglio

Leaf Three: City by a River

*Artist's seal:* *Songyuan Cai Jia*, square, intaglio

Collection of Scott and Mary Lynn Denne, Indianapolis, Indiana

The landscape and figure painter Cai Jia was a native of Danyang, Jiangsu Province, close to Yangzhou. His dates are unknown, but it is known that he was a friend of Wang Shishen (active 1730-1750) and Gao Xiang. Chinese critics differ in discussing Cai Jia's work. The *Zhongguo huajia renming dazidian*, for example, says he had a one-track mind in copying old masters and had little inspiration. However, another book on the art of the Qing period, the *Qingdai huashi*, says his landscapes show the most inspired talent and his figures are so alive that even their hair and eyebrows seem to move. Both books quote the same source, *Yangzhou huafanglu*, but the interpretations are completely different. Critical judgments, then, are useful only as a reference and must be taken with a grain of salt. For assessment of artistic merit, it is best to look at the paintings themselves.

Cai Jia is known for his paintings in fine lines and thin washes in the *baimiao* style. This leaf shows a gentleman enjoying the view from a two-story studio surrounded by blossoming plum trees. The twigs, branches, and rooftop are all painted in the finest of lines, but there is no weakness about them. The viewer's gaze moves from the intimate scene of the gentleman in the left foreground to the higher hills and a waterfall. A tall peak towers over a hamlet just visible through a veil of trees and mist. Distant peaks beyond, drawn in light wash, appear through gaps in the foothills. Throughout the painting there is a feeling of great spaciousness. By avoiding a high mountain over the man in his studio, the artist gives the illusion of the scholar commanding an enormous view of hills, water, and village. The cozy enclosed spaces of the figure in his house and the village in the trees contrast with their vast surroundings.

The painting is unified in composition and the mountains are convincingly solid. The brushwork is sensitive, yet not effeminate, while the pale blue, beige, and pink tones reinforce the feeling of a clear and transparent atmosphere. Each stroke, no matter how small, conveys energy and sureness, and the angles of the trees and the speed of the waterfall speak for the artist's sureness of hand and clarity of vision. Cai Jia has not needed to resort to roughness to present energy and power, but, by his elegant brushwork, achieves the same qualities.

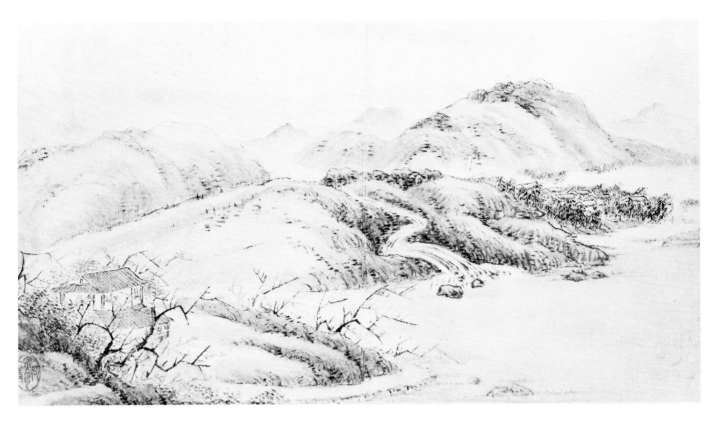

Cai Jia. *Plum Blossom Studio.*

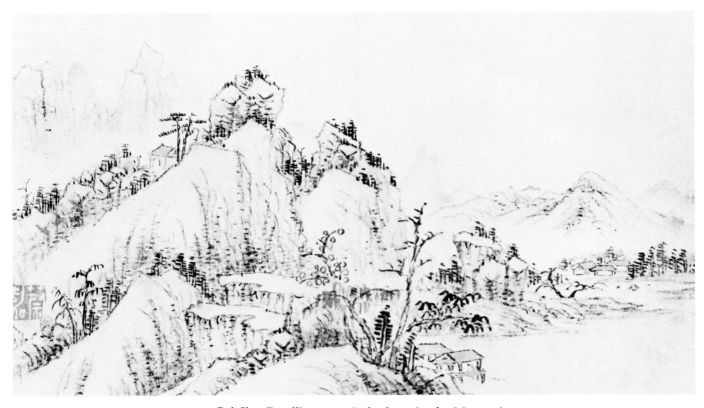

Cai Jia. *Dwelling on a Lakeshore in the Mountains.*

Very different in mood from the first leaf, the second draws us immediately with its resemblance to works of the 17th century master Hongren (1610-1664) who in the same spirit suggested the clear pure air of high mountains. The scene begins with trees in the foreground and a scholar in a little house overlooking a lake. Behind can be seen deeply eroded mountains with textured, rocky slopes topped by dark trees along the ridges. In the distance rise angular peaks painted in light blue wash. The artist leads the viewer to a quiet place far from the noise of the city, the ideal setting for a gentleman to purify his mind. The *cun* texturing of the mountain is like a web, binding the whole work together. Again the strokes are slow and sure, yet carefree. The challenge of this type of brushwork was taken up by Literati artists, and here Cai Jia shows that he has a consummate command of the brush. The various layers of depth in the painting are skillfully rendered by progressively lighter tones of ink and elimination of detail. The artist has successfully given us a vast world in a small format; such monumental feeling is rare in the 18th century.

The third leaf begins with rolling hills with small groves of trees in the foreground. The cheerful tones of the red autumn leaves establish the fresh cool atmosphere of fall. The trees seem ancient, yet their branches are lively and powerful. Beyond the trees a fisherman pulls in his net on a broad river that stretches the full width of the painting. The viewer looks down on a whole range of mountains that surround the houses of the city. In one open and impressive view we see both inhabited spaces and great mountains. A bridge leads to the gate of the city, and off to the right, on a separate horizon line, a crenelated wall can be seen curving off into the distance and lending a sense of security to this peaceful scene. The lines of the trees and *cun* defining the mountains are very fine, their delicacy enhanced by light brown, green, and blue tones. Such brushwork effectively gives a quality of clear air and dense, substantial mountains.

In the art of the 18th century, Cai Jia created a new phase of painting, and later Yangzhou artists were influenced by his arrangement of light wash and delicate line.

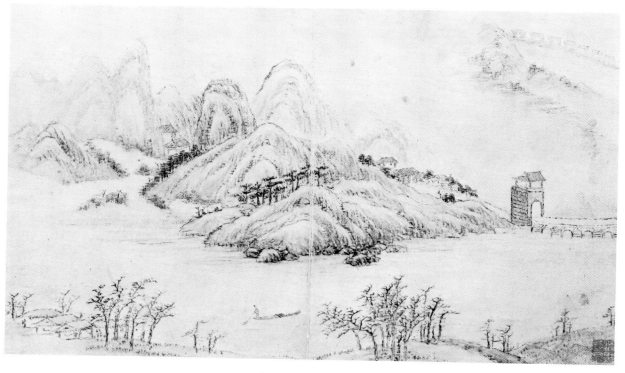

Cai Jia. *City by a River*.

But his work is striking in its refinement, in contrast to the more eccentric works of other Yangzhou masters. All of Cai Jia's leaves in this album are in one manner and of one identity.

We can also learn from Cai Jia's works that the strength of a painting does not depend on the boldness of the brushstrokes. Broad strokes, heavy ink, and a large format do not necessarily mean great strength in a painting. Similarly, small strokes and fine lines do not denote a lack of strength. It is apparent that Cai Jia's paintings have *yiqi*, inspiration, and his personality is expressed in an engaging and sophisticated manner.

## NI CAN (Yanshichufu), 1764-1841

### Landscape

Hanging scroll, ink and color on paper
45 x 12¾ inches

> *Inscription:* Spring Morning at Willow River, in the style of Zhao Zhongmu, third month, spring, *xinmao* (1831). Yanshichufu, Ni Can.

> *Artist's seal:* *Yantian*, rectangular, relief

Private Collection, La Puente, California

Important as the contributions of the Eccentrics were, their prominence in the annals of art history has unfortunately overshadowed the careers of painters who worked in Yangzhou at the same time or slightly later but who did not consider defiance of convention essential to their own creativity. One of the latter was Ni Can.

A native of Yangzhou, Ni Can painted landscapes with mountains and clouds that seem to continue through space without end. Neither local eccentricities nor the orthodoxy emanating from the capital were major factors in the formation of his style. While his teachers and other sources of artistic training are unknown, the techniques exhibited in his works indicate a thorough familiarity with those of the Song, Yuan, and Ming periods. Bustling scenes of figures in palaces and houses, fishing from boats, or traveling through hills toward a village, are common to Ni Can, who succeeded in striking a balance in his paintings between the human realm and the world of nature. Working with a fine brush in ink and subdued colors, he combined a monumental scale derived from the Northern Song with sensitive calligraphic brushwork based on the Yuan approach. Architectural structures are executed with consummate skill in Ni Can's pictures, an aspect in which the capabilities of most Literati artists of his day fell short. On this point his work relates to the "boundary" paintings of earlier eras. This type of landscape, mastered in the 10th century by Guo Zhongshu and in the 12th by Zhao Boju, features often elaborate pavilions and palatial dwellings drawn meticulously with the aid of a ruler. However, from the standpoint of artistic intent, a more worthwhile comparison

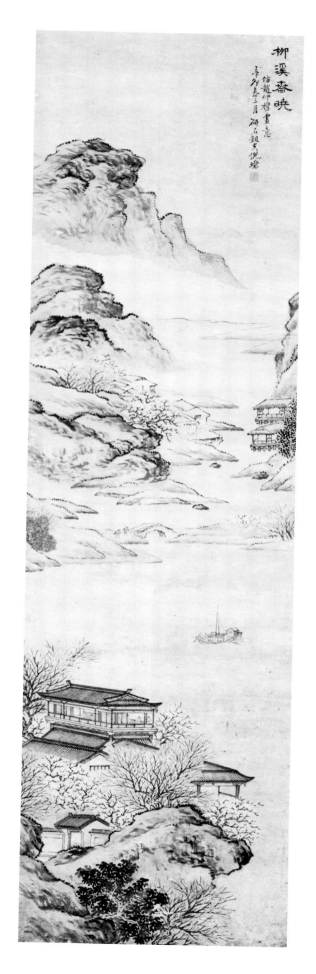

Ni Can
*Landscape*

would be with such Yuan masters as Zhao Yong (Zhongmu, 1289-?; son of Zhao Mengfu) and Wang Zhenpeng (14th century). Common to the works of all of these artists is the depiction of man-made constructions in a precise and detailed manner within landscapes employing the cursive, expressive brush of the Literati mode.

In the inscription accompanying "Spring Morning at Willow River," Ni Can acknowledges his emulation of the painter Zhao Yong. This stylistic affinity is illuminated particularly in the foreground setting of this piece. A rocky promontory partially encloses a walled garden wherein the radiating boughs of willows rise above the gnarled blossoming branches of plum trees. In contrast to this linear diversity are the straight angles and repetition of parallel lines in the palatial multi-storied building that towers over most of the trees. This skillful integration of architecture and natural elements, as well as the long, somewhat bold contours of the earth forms, constitute Ni Can's personal interpretation of Zhao Yong's method.

Open windows in the upper chamber of the palace afford the onlooker a glimpse into the activities of the people inside. From here, the viewer's gaze continues out and across the water to two fishermen on a boat and then beyond to a pair of travelers approaching a bridge. Each of these figures consists of only a few brief strokes of the brush, yet their liveliness matches that achieved by masters of the Song period. The vast area of blank paper at midground is clearly established as water by the simply defined boat that stirs but a few ripples as it moves over the calm surface.

The delineation of the riverbanks and mountains that completes the background portion of this scene was applied with a constantly twisting brush, resulting in the tensile strength of chiseled stone. These long wavering lines echo the "orchid leaf" (lanye) brush strokes of the Song master Ma Hezhi (active second half of the 12th century), with their varying thickness and light, fluttering character. Absolute control is evident in every touch, even in the delicately rendered foliage and branches of distant trees; still, a buoyant freedom runs through the brushwork here. The rich array of dark and light ink, quick and slow movements, and curving and straight lines is further complemented by warm shades of orangish brown and red.

The series of low hills, small houses, inlets, and soaring peaks that recede into the far distance counterpoint the splendor of the foreground environment, imbuing the entire scene with a sense of the grandeur of both human and natural creation. At the same time, the presence of tiny animated figures, whether engaged in work or leisurely diversion, anchors the picture in the reality of daily life in human society. The cheerful atmosphere pervading this landscape invites the viewer to walk through and experience each section in turn. Nevertheless, the numerous focal points do not detract from an overall compositional unity.

In terms of subject matter as well as method and artistic conception, Ni Can bridges a range of historical currents for purposes of communicating a fresh vision of the world around him. Sidestepping both the orthodox and unorthodox trends of his own time, this independent artist delved deep into the past for a classic directness of approach and purity of expression. As a demonstration of his powers of organization, versatility of technique, and refinement of taste, "Spring Morning at Willow River" represents one of the few extant examples of Ni Can's unique achievement.

## ZHANG SHINING *(Guiyan, Shisanfengcaotang), 1743-1817 or later*

### Landscape

Hanging scroll, ink and light color on paper
63 x 32¾ inches

> *Inscription:* Painted for Xiangyu on a winter day in *gengshen* (1800). Zhang Shining of Cangzhou.

> *Artist's seal:* *Guiyan hua yin*, square relief

A Yangzhou painter who provided yet another dimension to the artistic diversity that thrived in that city was Zhang Shining. A native of Cangzhou in Hebei Province, he rose to the rank of judge in the higher courts. Later in life he retired in Yangzhou. He began painting when young with the meticulous realism of the *gongbi* method. The subsequent change in his style was in part inspired by his mentor, Wang Chen, who praised his work highly and elucidated the six canons of painting to the budding artist. With this new understanding, Zhang Shining began to produce landscapes that showed remarkable spontaneity, movement, and vitality with an originality that prompted comparisons to those of Shitao.

During Zhang Shining's residence in Beijing his fame was on a par with that of Luo Ping. The close friendship he enjoyed with Ji Jun (Xiaolan), an editor of the *Sikuquanshu* and of whom Zhang Shining painted a portrait in 1807, no doubt enhanced his reputation in the capital. Ink bamboo and figures were familiar subjects to Zhang Shining's brush, but he is remembered more for the unsurpassed color effects of his depictions of flowers and birds. It was his paintings in this category that were to impress later 19th and early 20th century artists in Yangzhou, such as Wu Xizai, and in Shanghai, such as Zhao Zhiqian and Wu Changshi (1844-1927). These modern masters drew on his ingenious balancing of contrasting colors as well as his application of certain calligraphic script techniques to certain pictorial elements. Many of their works cite as their inspiration "the Master of Shisanfengcaotang," the studio name Zhang Shining often signed on his paintings. As a poet he authored *Huanghuayinguan ji* and *Shisanfengcaotang shichao*. His brilliant achievement in calligraphy, so essential to his painting style, was derived from Zhao Mengfu and Mi Fei, with emphasis on running script. The year of Zhang Shining's death is not known, but his "Chatting Among Autumn Cliffs" is dated 1816, and his contemporaries have written that at the age of 74 (1817), he was still active as a painter.

While Zhang Shining's landscapes impart a fresh vision and energetic rhythm in a vein similar to those of Shitao, the later painter did not strive to imitate this 17th century Individualist. At the same time, despite his association with the Loudong artist Wang Chen, Zhang Shining did not conform strictly to the tenets of orthodoxy. This immense hanging scroll landscape illustrates his independent approach, for here he disregards the device of a central peak (*zhufeng*) towering over smaller ones that has been prescribed since antiquity for this format. Instead, his composition has the casual air of a small album leaf, with only water and the tops of a few trees in the foreground, and a horizontal line of hills similar in size crossing the width of the picture in the distance. By thus presenting a glimpse of natural scenery

in the raw, without apparent manipulation of its elements to fulfill schematic formulas, the artist breaks from the past and renews the ageless thematic power of nature itself. That unity and monumentality are not lost in the unlikely combination of a large format and informal layout is all the more commendable upon consideration of the chosen brush technique. All of the components of this landscape—mountain, water, trees, and reeds—are rendered in the short tapered strokes of running script. Moreover, a minimum of brushstrokes are used, and the tones of both ink and light brown color are sensitive but subdued. If large-scale works of calligraphy in the running script are rare, paintings employing this technique exclusively as does this one are unknown. Rather than comparing this piece to Shitao, then, a more telling parallel may be drawn between Zhang Shining's painting and Dong Qichang's (1555-1636) fluid writing in the running script. The animation of the various elements of this landscape generated through deft brush movements imbues the surrounding space with a flowing atmosphere that connects the parts into a convincing whole. The engaging rhythms and abstract beauty of the calligraphic brushwork are the qualities that attracted late 19th century painters to Zhang Shining's landscape style, among them Hu Yuan (1823-1886) and Wu Tao (1840-1895).

This painting is dedicated to Jin Ruli (Xiangyu), native of Haining, Zhejiang. A scholar and seal carver of the 18th century, he wrote *Shouwen*.

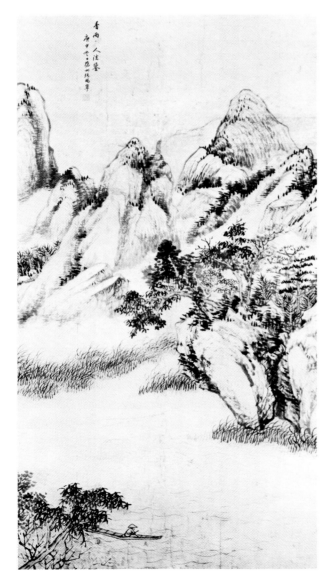

Zhang Shining
*Landscape*

# The Hangzhou Masters

The scenic beauty of Hangzhou's natural setting has inspired a prodigious line of artists for over a millenium. Blessed with a hospitable climate and picturesque mountains that ascend from the shores of the Qiantang River and West Lake, this part of Zhejiang Province has since ancient times lured retired scholars in search of a peaceful retreat. In the Sui Dynasty (581-618), the district of Qiantang was linked with outlying towns and suburbs to form Hangzhou, the term *zhou* referring to a metropolis under the direct control of the imperial administration. Situated within the rice and fish bowl of the Yangtze River delta and not far from the coast, this location was selected to be the southern terminus of the Grand Canal. The resulting boost to Hangzhou's economy joined with its other amenities to make it one of the more attractive metropolitan areas of China. Su Shi (Dongpo, 1036-1101), the illustrious poet, painter and statesman, resided there for a time, and some of the greatest painters of the Northern Song (960-1127), such as Ma Hezhi (12th century) and Liu Songnian (late 12th-early 13th century), came from Qiantang.

With its well-developed commerce and cultural life, this city was a likely choice for the southern capital of the Song court when it was forced to flee its northern invaders in 1127. Renaming the city Lin'an ("Temporary Peace"), the Southern Song emperors reestablished the imperial painting academy, to which were attracted numerous distinguished artists, both local and from afar. Among them, Ma Yuan (active ca. 1190-1224) and Xia Gui (active ca. 1180-1230) are credited with founding a school of painting. In their Ma-Xia style, the prominent use of unpainted silk or paper to indicate mist-filled space is actually an accurate representation of Hangzhou's moisture-laden atmosphere. This landscape mode evolved further under the brush of Dai Jin (1388-1462), the originator of the Zhe School. Victimized by malicious jealousy at the court, this brilliant painter saw his career cast into disrepute. He died in Hangzhou in poverty. Generations of devoted followers kept alive his exuberantly elegant style. Toward the close of the Ming Period, orthodox critics advocating the amateur ideals of Literati painting discredited Zhe School art as superficially attractive and lacking in scholarly basis. But in fact, Lan Ying (1585-after 1664), a late heir to the Zhe tradition, sought to emulate the model literati-artist Huang Gongwang (1269-ca. 1354); moreover, Lan Ying's brushwork

discloses an advanced level of calligraphic training to rival that of any gentleman painter.

At the same time, it should be recognized that there was a difference between the Zhe School, classified disparagingly as part of the Northern School, and the Wu School, placed in the orthodox Southern School. Broadly speaking, the art of Hangzhou preserved some of the functions and objectives of art that were born in the earliest stages of Chinese civilization, when painting was an integral part of architecture which in turn blended with its natural environment, and when depictions of mountains and rivers projected a dramatic splendor that elicits both awe and cheer. Close to nature and human society, Zhe paintings avoid the esoteric and elite. Meanwhile, in the same spirit as that of Yuan intellectuals who engaged in ink play to ward off their feelings of loss and humiliation after their homeland had been captured by the "barbarian" Mongols, the scholars of Wu used the brush to communicate their refined sentiments to minds of equally cultivated backgrounds. Unfortunately many later literati became so convinced of the inherent superiority of their viewpoint that they became blinded to the dazzling technical performance of many Zhe painters as well as to the virtues of their more direct expression.

By the beginning of the Qing Dynasty, the limelight had turned away from Hangzhou art circles to shine on proponents of orthodoxy and individualistic recluses. It seems this city was waiting, observing, searching for a new direction to revitalize its creative impulses. While in Yangzhou an economic boom was giving rise to a nouveau riche merchant class that supported the iconoclastic art of the Eccentrics, the old town of Hangzhou remained set in traditional social patterns. Schooled in the research method of textual research *(kaoju)*, men of letters residing in the latter city delved deep into the origins of their civilization. In the process, some accumulated vast knowledge of antiquity, particularly of archaic inscriptions carved in stone or cast in metal. For these scholars, the ancient art of seal carving held a natural attraction, and during the 18th century their enthusiasm gathered into a budding movement that eventually remolded the very character of the Zhe aesthetic.

From this time on, "Zhe School" referred to a group of seal carvers who were also called the Eight Xileng Masters, after a bridge by that name. The feats of these men were by no means limited to the carving knife; without exception connoisseurs of the written word in all its aspects, they were also superior calligraphers and even painters. If their independent temperament made some of them headstrong (for example, Ding Jing, 1695-1765, seal carver and painter of orchids and bamboo, was known to refuse to carve for wealthy patrons whom he didn't fancy), it also gave them a fierce dedication to their quest for their cultural roots. By incorporating their new insights into early Chinese civilization, along with their expertise in carving and calligraphy, into their painting styles, they integrated the arts of painting, calligraphy, and seal carving to an unprecedented extent and laid the groundwork for the most significant artistic movement of the 19th and early 20th centuries, the Jinshi School. In 1903 the Xileng Seal Society was founded in Hangzhou by followers of these Zhe masters, whose impact continues to make its mark today.

By no means were all notable artists in Hangzhou of the middle Qing period seal carvers. There were those who, proud of the past glories of the Zhe School of painting, carried on its legacy, injecting varying degrees and types of external

influences into their styles. Their personalities were divergent, as may be seen in the works of the eight masters presented here. But it is evident that all had absorbed the basic outlook of the early painting masters of Zhe, who pursued art not as an escape from the drudgery of life, but as a celebration of life's richness and beauty.

*XI GANG (Tiesheng, Mengquanwaishi), 1746-1803*

**Landscape**

Hanging scroll, ink and very light color on paper
32½ x 12¾ inches

*Inscription:* Behind the house is planted bamboo and beyond,
mountains,
Deep green moss dots the forest of stone.
This place befits a scholar like Ni Zan,
Intoning (verses) on the setting sun, and dragging his
cane back home.

Fifth month of *wushen* (1788), in the style of Nantian (Yun
Shouping). Mengquanwaishi, Xi Gang.

*Artist's seals:* *Xi Gang zhi yin*, square, intaglio and relief
(Upper right) *Weizhen*, square, intaglio

Collectors' seals:
(Lower right) *Huang Xiqi yin*, square, intaglio
(Lower left) *Yumo*, rectangular, relief
*Guishan*, square, relief
*Wan shi hao Lu zhencang*, rectangular, relief

Private Collection, La Puente, California

Xi Gang won fame along with Fang Xun as one of the Two Noble Scholars of
Western Zhe and as one of the Eight Xileng Masters, a group of seal carvers in
Hangzhou. Unfortunately, his ungentlemanly behavior during frequent bouts of
inebriation also brought him infamy. Born in Hangzhou, his family was originally
from Xin'an in Anhui Province. He is said to have been of a generous and open-
minded temperament, as well as an extremely talented artist from an early age. At
nine he was writing in the *xiaokai* (small regular) and *li* (official) scripts, and in his
teens he excelled in the *xing* (running) and *cao* (cursive) scripts. His practice of seal
carving after the style of Ding Jing eventually enhanced his calligraphy and paint-
ings. In the latter, flowers (particularly orchids), bamboo, and landscapes were his
primary subjects. Some art historians lament that lack of discipline prevented him
from capturing the spirit of former masters. Still, his pictures are praised for
possessing both "bones" *(gufa)* or structure, and "flesh" *(rou)* or ink effects. Dur-
ing his lifetime, his art was well received by collectors in Korea, Japan, and Okinawa
in addition to those in his homeland.

Despite his personal shortcomings in proper conduct, or perhaps because of
good intentions for self-reformation, Xi Gang admired the paragon of scholarly
behavior and purity of mind, Ni Zan (1301-1374). The poem on this landscape paint-
ing discloses the artist's admiration for this Yuan master and also reveals an attempt
to imitate his manner of writing. But more than Ni Zan, the calligraphy here
resembles that of Hongren (1610-1664). It is possible that Xi Gang was familiar with
the works of this Xin'an artist since Xi Gang's own roots were in that district.

126

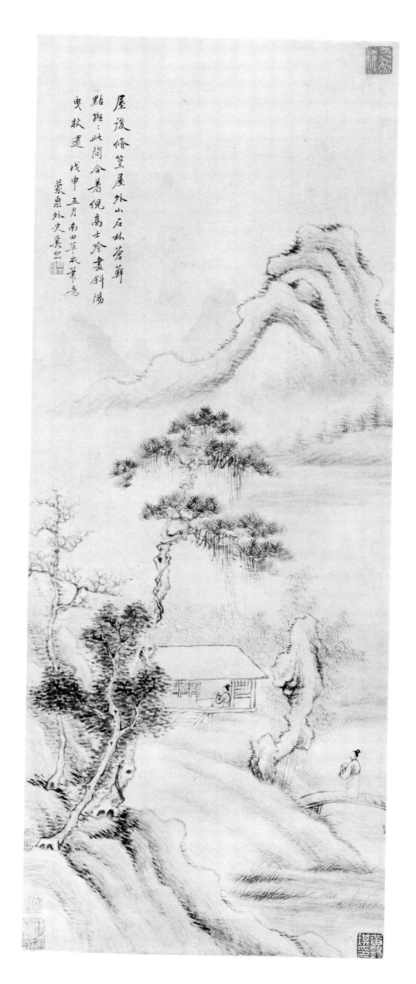

屋後脩篁屋外山石林蒼蘚
點綴之此間合著倪高士冷盡斜陽
曳杖遲南田草衣筆意
戊申五月
蒙泉外史奚岡

Xi Gang
*Landscape*

127

Following the verse he cites Yun Shouping as the source of his style in this painting, and this influence is evident in the delicate forms, light touch, and pursuit of a pure, clean atmosphere. In fact, the spare design and plain, unsullied quality of this composition evoke, once again, Ni Zan as much as they do Yun Shouping (1633-1690).

A figure carrying books over a bridge approaches a cottage where a scholar sits reading. A group of three trees on a rocky bank to the left hides part of the house from view, and the surrounding grounds are adorned with a large sculpture-like Taihu stone, banana trees, and bamboo. The tallest of the three trees, a pine, extends up into the center of the picture, providing a visual link from the foreground to the distant mountains across the river. This ideal scholar's retreat is depicted in varying shades of pale ink. Departing from Yun Shouping's softly curving terrain, Xi Gang constructs hills with rugged profiles, a preference resulting from his knowledge of seal carving and appreciation of Han steles. His trees are gnarled, and the leaves of the foremost tree consist of triangular dots that may be likened to chipped stone, giving the foliage a shimmering appearance. This technique of injecting a carved feeling into brushstrokes was further developed by 19th century artists of the Jinshi ("Engraving") School of Hangzhou and Shanghai. Under Xi Gang's hand the full power of this method remains latent, for, even if he could not control his own actions under the influence of liquor, in painting he was restrained and undemonstrative like the majority of his contemporaries.

## Orchids, Bamboo, and Rock

Hanging scroll, ink on paper
41¾ x 17½ inches

> *Inscription:* In the fifth month of *yiwei* (1799), the orchids and bamboo before my front hall flourish. Now, just as the rain stops and the sky begins to clear, I paint this from life. It is just ink play to express my feelings at this moment. Mengquanwaishi, Xi Gang.

> *Artist's seal:* *Tiesheng*, rectangular, intaglio

> *Collectors' seals:*
> (Lower right) *Qikan shending*, square, relief
> (Lower left) *De er bao zhi*, square, relief
> *Baiquan Cen Zhongtao cang shuhuayin*, square, relief

Collection of Mr. and Mrs. Bertil J. Högström, Stockholm, Sweden

In this rendition of bamboo and orchids, both symbols of the ideal scholar's character, and of rocks, emblem of constancy, Xi Gang observes the conventions and constraints of the mainstream artistic currents of his time. In this painting in ink only, he demonstrates the calligraphic techniques he had mastered as a child, particularly in the bamboo, which requires expertise in writing. The fantastic structure

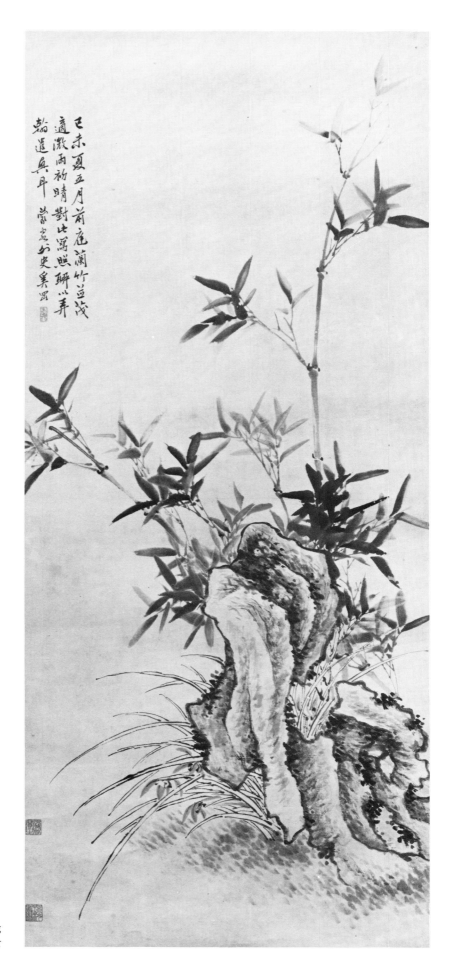

己未夏五月前庭蘭竹並茂
適澂雨初晴對此寫照聊以弄
翰遣與耳 崇容如史属寫

Xi Gang
*Orchids, Bamboo, and Rock*

129

of the Taihu rock, designed with the cultivated taste of a rock collector, is defined by bold contours and rendered three-dimensional with short texture strokes. The works of the earlier Ming artist Xia Chang (1388-1470) may have been the model for the bamboo, its foliage moist and resilient after a shower as related in the poem. The leaves, radiating vital energy as they dart in all directions, each consist of a single stroke that begins and ends in accordance with the principles of calligraphy. Growing behind the stone along with the bamboo are orchids, their leaves painted in *shuanggou* (outline). While this technique in itself is not uncommon, Xi Gang again draws on the aesthetic of seal carving to produce roughly-hewn lines executed with varying pressure and intermittent stops of the brush. Moreover, the two lines composing each leaf do not meet at the ends. The result is a blurring of form for the suggestion of vibrancy and movement.

As a whole this picture displays a studied, tightly knit composition conceived more as a flower arrangement than as growth in the wild. Every element is deliberately placed, every touch of the brush carefully applied. Whereas Shitao (1641-ca. 1710) and the Yangzhou Masters exploited spontaneous brushwork for individual expression, Xi Gang adheres to the more conservative aspects of the Literati artistic tradition.

It is not known why Xi Gang did not pursue a career as an official, but he was part of the beginning of a trend among scholar-artists to forego the rank and privileges offered by the civil service in order to devote themselves fully to art and literature. By the 19th century, distinctions between professional and scholar-amateur painters had virtually disappeared; Xi Gang was thus responding to the social and economic factors that contributed to the changing role of the artist in Chinese society.

**Wisteria, Roses, and Rock**

Hanging scroll, ink and color on paper
50½ x 11¾ inches

> *Inscription:* In the style of Wang'anlaoren (Wang Wu, 1632-1690), an autumn day in *gengshen* (1800). Menglao, Xi Gang.
>
> *Artist's seal:* *Mengdaoshi,* square, intaglio
>
> *Collector's seals:*
> (Lower right) *Yangyun shang zhuang Liu Zhitian cang,* rectangular, relief
> (Lower left) *Diwuzi Liu Shihang baoshou,* square, intaglio

Collection of James Cole, Ithaca, New York

This late work (completed just two years before the artist's death) departs from the aforementioned paintings in its use of vivid hue and loose brush manner. The blossoms and leaves of the wisteria are depicted in the *mugu* ("boneless") mode. By

dipping one side of the brush in water and the other in blue-violet, Xi Gang formed each flower petal with one dot of graded coloration. Although clustered on the vine, the flowerlets remain mutually distinguishable, bringing their early spring freshness into play. Below, the Taihu stone, this time washed in a light malachite green, is outlined in *feibai* strokes, wherein the hairs of the brush separate so that streaks of white paper show within the black line.

In contrast to the *mugu* technique of the wisteria and the colored wash of the rock, the rose blooms are delineated in fluid *shuanggou*. The leaves, like those of the wisteria, appear in pale blue-green wash with darker veins. The carefree flare of the brushwork and elegant charm of the colors characterize this painting as a decorative work, yet its calligraphic basis and sophisticated discrimination retain the high quality of the Literati tradition. The disparity between his earlier paintings and this one arouses speculation that at some point Xi Gang questioned the validity of time-worn categorizations of artistic styles. With this piece he seems to conclude that beauty need not be obscured by monochrome forms and veiled expression, nor does sensual appeal through rich colors, striking compositions, and flourishing brushwork necessarily negate the intellectual attractions of a painting. He takes a first step into the 19th century in this bold, if limited, rejection of the reserved austerity of Literati art of the Qianlong period, and, in doing so, helps lay the groundwork for modern developments in Chinese pictorial art.

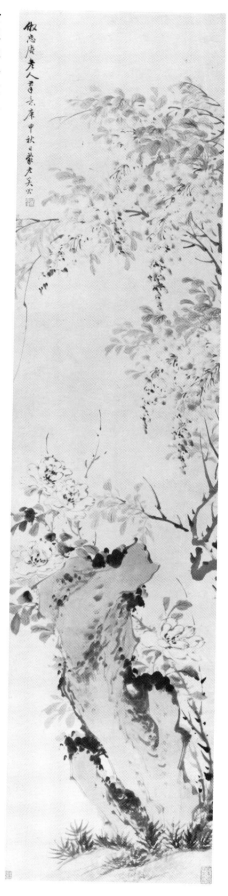

Xi Gang
*Wisteria, Roses and Rock*

*HUANG YI (Qiu'an, Xiaosong), 1744-1801*

*Landscape*

Hanging scroll, ink and very light color on paper
39 x 9¼ inches

> *Inscription:* In the early Ming period there was a monk who sent silk to Mr. Shitian (Shen Zhou), asking for a painting. Before he sent the silk, the monk wrote this poem along one edge of the material: "Send me a scroll of mountains, rivers, and twisting vines. I request that you paint four rows of green mountains ending in a cliff, with a monk sitting by the water looking up at the clouds." Mr. Shitian smiled when he read this. He painted such a scene and sent it to the monk. Huang Yi.

> *Artist's seal:* *Huang Yi zhi yin,* square, intaglio and relief

Collection of The Reverend Richard Fabian, San Francisco, California

In the second half of the 18th century many Chinese calligraphers turned from the trend of academicism that had dominated the last hundred years of art and devoted their attention to ancient engraved calligraphy. The styles of Dong Qichang (1555-1636), the Yuan masters, and even Song and Tang period artists had been copied over and over again. Now, some members of the Literati began to look back to the beginnings of writing itself, advocating the study of all types and phases of calligraphy and the freedom to incorporate such study into a personal artistic style.

Huang Yi was a pioneer in this new enthusiasm for ancient engravings. It is said that he spent much time in the wilderness hunting and digging for ancient carvings and steles. The son of Huang Shugu, a famous artist and poet, Huang Yi also wrote poetry and was an accomplished calligrapher and painter. Also known as Dayi ("Great Simplicity") and Xiaosong ("Little Pine"), he is considered one of the Eight Masters of Xileng (Hangzhou). His calligraphy in the *li* style is calm and well-controlled, while his landscape paintings display light, sensitive colors and a quiet mood, and have been compared to the works of Ni Zan for their high spirituality. Huang Yi painted flowers and birds in the manner of Yun Shouping, although he added a distinctive personal touch. *Xiaopenglaige jinshiwenzi (Engraved Calligraphy of Xiaopenglai Studio), Song Luo fang bei riji (Diary on Searching for Steles in Songshan and Luoyang)*, and *Daiyan fanggu riji (Diary on Looking for Antiques at Daiyan)* are just three of this artist's publications, the products of his research on Chinese antiquity and his love of excavating ancient artifacts. In 1786, when he was serving in an official post at Jinan in Shandong Province, Huang Yi discovered the Wu Liang Ci, the tomb of the Wu family at Jiaxiang. His passion even became the subject of many of his artistic creations; he painted a series of sixteen landscapes entitled "Searching for Ancient Steles." Each of these bears a colophon by Weng Fanggang (1733-1818), a famous calligrapher and authority on engravings. The inscriptions describe the steles shown in the paintings. Qian Zhuding commended Huang Yi in a poem saying, "I have never seen anyone with such a great hobby. If you would aspire to be an official, you should have a mother like Mencius'. Those who would accomplish something must have a pair of hard

shoes and a pair of sharp eyes. But Heaven created engravings just for this man." The Jin-shi School of painting and calligraphy developed out of the interest such artists as Huang Yi and Wu Dongfa took in ancient carvings. Unfortunately, Huang Yi did not live to witness the discovery of *jiaguwen*.

The painting presented here depicts a monk sitting on a riverbank within a deep gorge. Above him tower enormous cliffs enclosed in mist, which ends in empty space at the top of the composition. In this space is written, in Huang Yi's flowing hand, the story that is the theme of this painting. It is doubtful that Huang Yi actually saw the work by Shen Zhou to which he refers in this inscription, but his own interpretation of this anecdote is an example of his lively imagination and refined taste. Most noteworthy are his decisive brush strokes, subtle ink tones, and constructive use of "empty" space which, according to Buddhist philosophy, has substance equal to that of "solid" form.

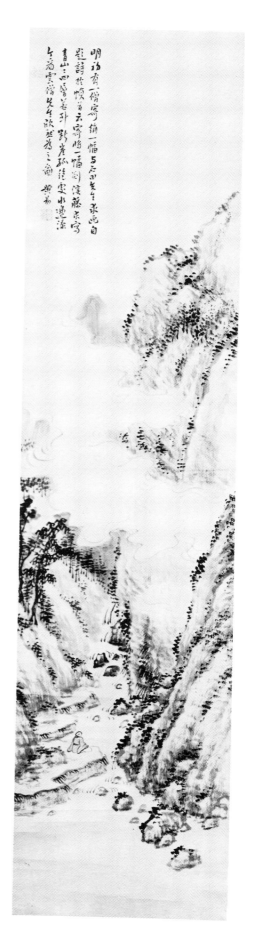

Huang Yi
*Landscape*

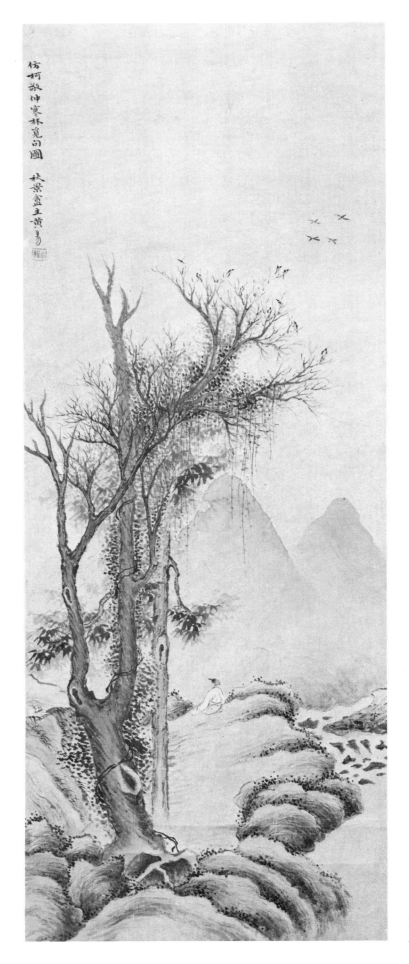

Huang Yi
*Landscape*

134

## Landscape

Hanging scroll, ink and light color on paper
26½ x 10 inches

> *Inscription:* In the style of Ke Jingzhong's (Ke Jiusi, 1312-1365) "Searching for Verses in the Wintry Forest." The master of Qiujing Studio, Huang Yi.

> *Artist's seal:* *Xiaosong*, square, relief

Private Collection, La Puente, California

Two tall old trees appear on the left side of the foreground of this painting, and a group of crows are either perched on the twisted branches or approach from the right. Just beyond the trees a man sits on the riverbank looking off to the right toward two conical peaks in the distance. Formed of thin color washes, the contrasting hues of these peaks, one in blue, the other in ocher, suggest the effects of the setting sun. The pale tones of these colors also indicate the remoteness of their location.

A painting by Shitao entitled "The Old Ginkgo on Green Dragon Mountain" depicts a hollowed-out tree rising up one side of the composition almost to the upper edge. The striking design of this 17th century master's work is similar to the one presented here, but to the earlier painter simplicity of form and boldness in brushwork seem to have been of prime importance. In this piece by Huang Yi, the emphasis is on subtle contrasts of color, as in the two mountains, and on textural variations. The wash of the ocher hill is smooth and even, but that of the blue one has slight breaks; this difference was probably the manifestation of Huang Yi's attempt to depart from the academicism of the day. Moreover, it illustrates his taste for engravings, for the surface of the mountain on the left appears to be chipped almost like a stone carving. The light washes and simplified geometric shapes of the background also make an interesting contrast with the profusion of dots and lines and the broad spectrum of ink tones in the foreground. In this work, then, Huang Yi's masterful application of Literati techniques combines with his creative imagination and knowledge of ancient engravings to produce this poetic yet very lively scene in the woods.

## Bamboo and Rock

Hanging scroll, ink on paper
36½ x 12 inches

> *Inscription:* Xu Chongsi (11th century, grandson of Xu Xi), said that masters who paint from life work spontaneously and capture both form and spirit. Sometimes they use light green and ocher to color objects, and empty space to add a spiritual quality. Even

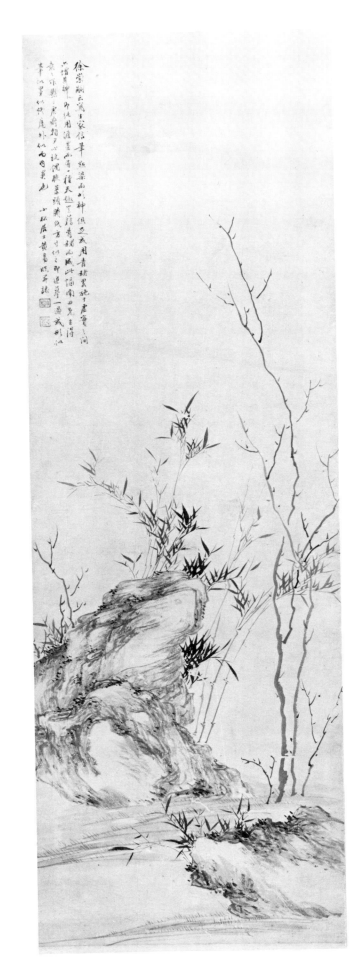

Huang Yi
*Bamboo and Rock*

136

when they use ink alone, they attain a natural feeling; it is not necessary to use green or ocher. This painting, a work by Master Nantian (Yun Shouping), with which he was extremely satisfied, hangs in my studio. Day and night I enjoy it. I have just come upon a piece of paper in my desk and used the same idea to paint a picture. In my copy, the form is similar, the strokes are similar, the ink is similar, and the outer appearance is similar, but the inside (i.e., spirit) is different.

*Artist's seals:*   *Xiaosong*, square, relief
*Qiu'an*, square, relief

Collection of William Warren Bartley, III and Stephen Kresge, Oakland, California

In this painting, Huang Yi demonstrates his control of the brush and the richness of subtle ink tones in a composition that is simple, yet as delicate as a flower arrangement. A few tall dry branches reach up along the right edge of the picture, while on the left, young bamboo grows from behind a rock. The synthesis of fine detail with a spontaneous style suggests some influence of the 17th century artists Yun Shouping and Shitao, although the pure, spare quality of the dry branches and bamboo is reminiscent of Ni Zan.

## CHEN HONGSHOU (Zigong, Mansheng), 1768-1822

### Lily and *Wutong* Tree

Hanging scroll, ink and color on paper
37¼ x 13¼ inches

*Inscription:*   The time when *wutong* leaves fall in sprinkling rain. Painted by Chen Hongshou at West Lake Painting Studio in Yuanjiang.[1]

*Artist's seals:*   *Hongshou zhi yin*, square, intaglio and relief
*Mansheng*, square, relief

Private Collection, La Puente, California

Many painters of the middle Qing period engaged in the related arts of poetry, calligraphy, and even seal carving; Chen Hongshou was involved in all of these in addition to one more: the making of teapots. Although the craft of ceramics was not generally considered a scholarly pursuit, an exception was the teaware of Yixing.[2] As early as Ming times, intellectuals collaborated with potters in this district to fashion small teapots of unglazed brown clay. These pots were often formed in the shape of fruits, flowers, and antique objects, and were decorated with carved inscriptions and pictures. As magistrate of Yixing, Chen Hongshou commissioned numerous teapots of his own design, thus reviving the high aesthetic level this ware had attained in the

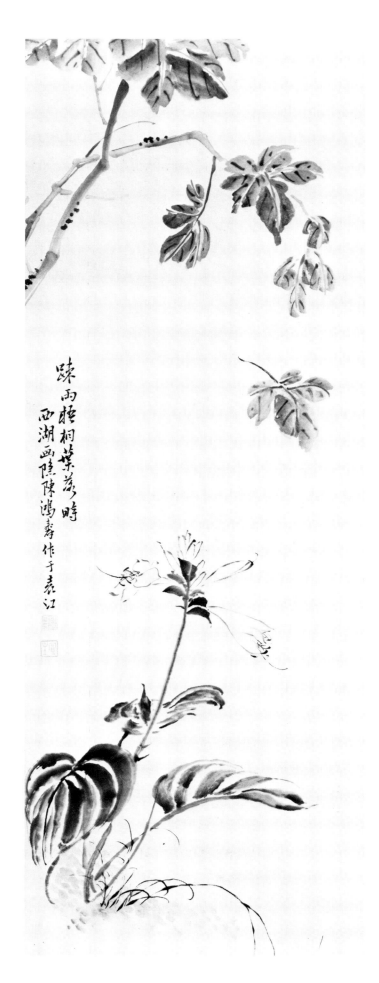

疎雨梧桐葉荻時
西湖画隠陳鴻壽作于袁江

Chen Hongshou
*Lily and Wutong Tree*

previous dynasty. The vessels made under his direction are known as *Mansheng hu* (Mansheng's teapots).

Chen Hongshou is known as one of the Eight Xileng Masters, a group of seal carvers based in Hangzhou in the late 18th to early 19th century. Unfortunately, his fame in this field has overshadowed his other talents. From an early age he excelled in poetry, literary composition, calligraphy, and painting. After passing the examination for a *bagong* degree, he became an assistant to Ruan Yuan (Yuntai, 1764-1849), a chancellor in the Grand Secretariat as well as a noted poet, calligrapher, and artist. During Chen Hongshou's subsequent term administering the government of Yixing (1811-1817), he was visited by many prominent literati, including Qian Du and Gai Qi. A handscroll entitled "Painting by the Host and Guests of the Hall of the Interlocking Mulberry Tree" *(Sanglianliguan zhuketu)* was the product of one of many literary gatherings held there. In spite of his popularity among men of letters, Chen Hongshou also befriended the common people of Yixing and worked to improve their education and livelihood. His personal interest in the indigenous ceramic industry stimulated economic growth in the area.

Throughout his life, Chen Hongshou never aspired to fame or wealth through his artistic endeavors; for him, poetry, teaware design, seal carving, calligraphy, and painting were pastimes rewarding in themselves. Thus it was not until after his death that his seals were published by a friend of his. Both seal carving and his study of *bei* and *tie* contributed to the formation of his calligraphic style. He mastered the *xing* and *cao* scripts, but his supreme achievement was his writing in *li* script, which is often compared to that of Yi Bingshou (1754-1815). With their outward delicacy and inner strength, Chen Hongshou's *li* characters might have been carved in stone or clay rather than brushed on paper. This feature also appears in his painting. His landscapes follow the spare manner of Cheng Jiasui (1565-1643), while his floral compositions are simple, elegant depictions akin to those he incised into the moist dark clay of unfired Yixing teapots. Although rare, his surviving pictorial works are unassuming monuments to this artist's diverse talents and sensitive nature.

In "Lily and *Wutong* Tree," Chen Hongshou strikes a poetic note by capturing a solitary leaf in mid-air as it descends gently to the ground. Poets have long sought out the shade of the *wutong* as a cool, tranquil spot for seeking the right phrase to complete a verse. Here the "poet" is a lily plant, its snow-white flowers in varying stages of bloom. An autumn scene, this painting speaks to the scholar contemplating the fleeting nature of time and the approach of the year's end. This theme is reiterated in the artist's inscription along the left edge of the picture. Two branches enter the scene just above this colophon. One continues upward beyond the upper border, while the other droops down toward the right, forming an arch over the lilies, which reach up as if to catch the falling leaf. Were the main stem of the lilies to continue its diagonal ascent, it would touch the lowest leaf on this branch. But these two elements remain far apart, and are related only by the strategic positioning of the stray leaf and the calligraphy in two staggered lines on the left. This spatial treatment, with the major motifs occupying the upper and lower extremes of space, is uncommon in painting. It is undoubtedly an outgrowth of the artist's expertise in organizing characters within the diminutive surface area of a seal, such a composition being conceived from the four borders toward the center.

The choice of technique pursues this same engraving aesthetic, with the forms

139

constituting a clear system of solids and voids suitable for carving in rock or clay. Moreover, Chen Hongshou's brush moves slowly and earnestly over the paper like a chisel driving a path out of stone. Linear contours seem chipped in their irregularity, while the evenly applied colors of the *wutong* foliage appear to be impressed on the painting as if by a seal.

Chen Hongshou cloaks his technical prowess in a reserved, artless style, the quality of which may defy recognition by the untrained eye. But to his educated contemporaries who had a highly developed appreciation for, and often competence in, the various arts, this veiled expression was as admirable in the artist as it was rewarding for themselves.

## NOTES

1. Also known as Xiujiang, in Yichun District, Jiangsu Province.
2. In Jiangsu Province.

## QIAN DU (Shumei, Songhu), 1763-1844

### The Monk of Dragon Gate

Hanging scroll, ink and color on paper
35 x 13 inches

*Inscription:* An autumn rain just fell at Dragon Gate;[1]
Now the fragrance of grass touches heaven,
The North Star hangs on a green cliff,
And white lotus blooms in the heavenly pond.
The enlightened one has meditated for a long time,
Sitting in the lotus position, his right shoulder exposed.
Then enter the bitter bamboo grove,
And draw some herbal spring water.
Pine cones fall around the stove,
The stone teapot clangs cool and clear.
I long to learn how to change my form,
Just as the cicada sheds its skin to fly with the immortals.

I have seen in Shangqiu,[2] in the Chen family collection, a painting entitled "Dragon Gate Tea Pavilion" by Ni Gaoshi.[3] It is the "Monk of Dragon Gate" painting, which has been handed down for many generations. On another occasion, in Yunnan province at the Lu home, I saw a painting by Zhao Mengfu in ink and bright colors in which his brushstrokes follow the manner of the Song masters. The spirit of that painting surpasses that of Ni Zan. I now paint this landscape

140

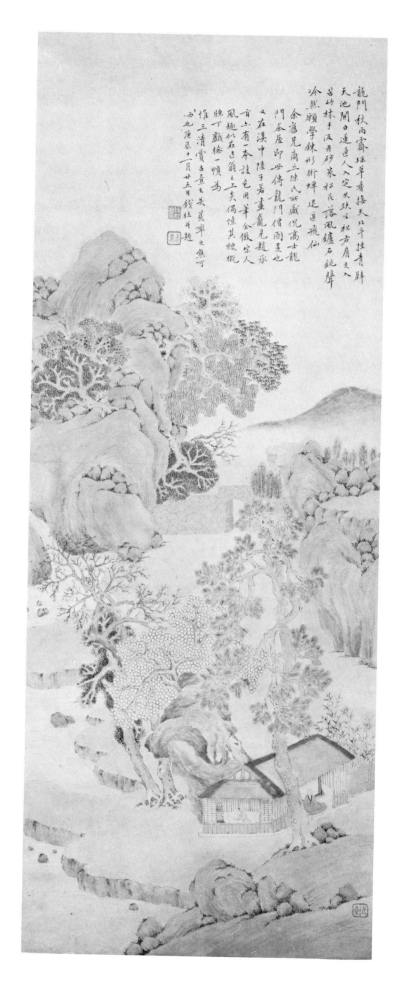

Qian Du
*The Monk of
Dragon Gate*

in admiration of these two works. Painted for Mr. Weisan. I am afraid that this painting displays little feeling of antiquity; such a careless manner is really a pity. Eleventh month, 25th day, *gengchen* (1820). Inscribed by Qian Du.

Artist's seals:  *Qian Du zhi yin*, square, intaglio
*Shumei*, square, relief
(Lower right)  *Songhu*, square, relief

Collection of Mrs. Howard Cook, Rancho Mirage, California

The paintings of Qian Du are distinctive in their small scale and delicate touch. Born into a wealthy family of artists from Hangzhou, this artist spent most of his life traveling throughout China, painting and writing poetry. He was the seventh son of Provincial Governor Qian Qi.

Qian Du was skilled in the methods of past masters, but his style was highly personal. A major source of inspiration in his landscapes was the Ming Dynasty artist Wen Zhengming (1470-1559), although he also drew on the Yuan masters Zhao Mengfu (1254-1322) and Wang Meng (1308-1385). His forms consist of fine, dry lines of a light, tensile quality, which create a rhythm throughout the entire composition. In addition to their exquisite technique, his paintings display a lively imagination. Their atmosphere of another world or age evokes a feeling of seclusion and innocence.

Such is the mood of Qian Du's rendition of "The Monk of Dragon Gate." The geographical setting of the recluse's cottage is ideal for a life of meditation and communion with nature. Viewed from a hilltop on which a lanky pine grows, the house is set by a large stone and a few trees on a riverbank. To the rear, rocky heights jut abruptly up on either side of the basin and are joined by a stone wall with an open gate leading out to a broad plain ending in a mist-enveloped mountain in the remote distance. Gnarled trees issue from the higher cliff on the left; some, their roots clinging to the steep sides of the precipice, hang inverted over the smooth valley floor. The contours that define form are so fine as to be scarcely noticeable, and the texture strokes that fill out the earthen elements are but faint traces of curvaceous line. Cool blues and greens modulate in almost imperceptible nuances and blend freely with light washes of tan. With consummate discipline, the colored foliage of the varied trees is rendered leaf by leaf, whether with minuscule dots, hair-breadth lines, or carefully shaped triangles, ovals, or circles. Every component of the landscape is presented in painstaking detail with consistent clarity and precision. Color's dominance over line here harks back to pre-Tang Dynasty art, and the delicate patterning of the trees' leaves adds to this note of primitivism. The artist's brush betrays no hint or motion of emotion, although an acute sensitivity pervades the work.

The poem that opens the lengthy inscription in the upper right corner of the picture reflects Qian Du's realm of tranquility and harmony. Even if the artist never achieved this supreme mode of being in his lifetime, he succeeds in illustrating his vision of it in vivid pictorial terms. Whereas for most of his contemporaries painting was a vehicle for exhibiting literary cultivation and aesthetic discrimination, for Qian Du it was also a means of approaching the divine.

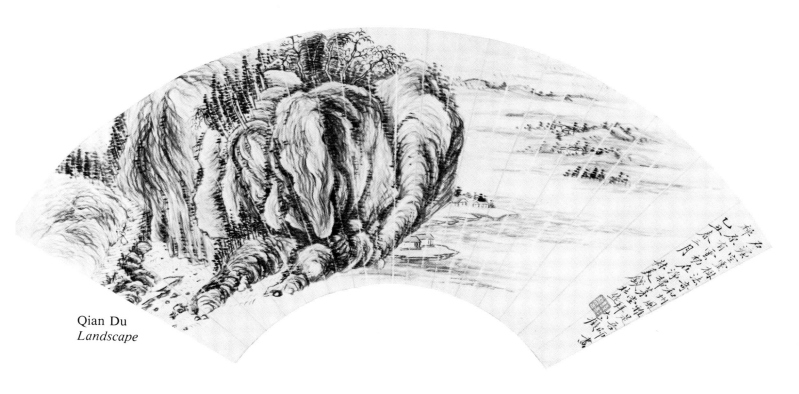

Qian Du
*Landscape*

## Landscape

Fan painting mounted as a hanging scroll, ink on paper
20½ inches maximum width

> Inscription: With rocks divine and trees uncommon,
> The landscape of Hezhou[4] is my teacher.
> The Zen of painting is clouded in mystery;
> I sweep clean my thatched studio to venerate
> Dachi (Huang Gongwang).
>
> Spring, third month, *yichou* (1805). Painted by Shumei, Qian
> Du.

> Artist's seal: *Qian Du siyin*, square, intaglio

Collection of Professor Michael Gallis, Jr., Charlotte, North Carolina

In the poem on this fan painting, Qian Du pays homage to Huang Gongwang and alludes to Dong Qichang, who, with his concept of the "Zen of painting," viewed art as an intuitive experience similar to the philosophy of Zen Buddhism. While the scheme of a body of water with low spits of land on the right and an imposing promontory on the left may bear some structural resemblance to Huang Gongwang's masterpiece, "Fuchun Mountain Villa," the main stylistic source of this painting is Yun Shouping. This may be observed in the fluid, rippling "hemp fiber" texture strokes *(pimacun)* that give shape to the massive bluff.

With this work, Qian Du reveals another side of his artistic character: here he is a brush virtuoso, applying long undulating lines in richly contrasting ink values accented by dark dots. Unlike the contemplative and meticulous "Monk of Dragon Gate," this landscape was executed spontaneously in a moment of carefree exuberance. Nevertheless, steady control tempers every stroke, including those in the characters written in regular *(zhengkai)* script along the right edge of the painting.

The rugged peaks extend up to or even beyond the top border of the picture; wind-blown trees appear on the lofty summits. To the left, a stream winds in its way down the mountain and empties into the lake, while a lone traveler ascends a pathway up the slopes. The left half of the picture, with its dense composition of swelling vertical earth forms and flowing water, is balanced on the right by sparse, horizontal bands of land spread out over still waters, fading into infinity. This sudden shift in terrain strengthens the volume and height of the mountain at the same time that it emphasizes the depth and atmospheric effects of the lake. Within the limited space of the fan format, a vast area is thus represented in a style remarkable for its resonance and untrammeled Literati spirit.

**Rocks and Flowers**

Hanging scroll, ink on paper
42 x 14 inches

*Inscription:*  With simple grace, pure and slender,
a few branches take form;
In the wind or under the moonlight,
always congenial.
Look—they show an elegance all their own,
And with carefree charm, take delight in
themselves.

In the manner of the Song masters; inscribed during the first ten days of the 12th month of *renyin* (1842) in the Daoguang period by Shumei, Qian Du of Quantang.

*Artist's seals:*  *Qian Du*, square, intaglio
*Shumei*, square, relief

Private Collection, La Puente, California

Many of Qian Du's flower-and-bird paintings bore the influence of Yun Shouping, who is known for his *mugu* method. In this work depicting plants and a rock, however, the artist employs the *baimiao* (plain outline) technique. Since five elements—the blossoming plum, camellia, narcissus, bamboo, and a rock—are included in this winter scene, it may be considered a variation of the "five purities." Yun Shouping also delighted in this theme, as a number of his paintings showing a pine branch, plum, bamboo, a rock and the moon testify. Qian Du's alternate

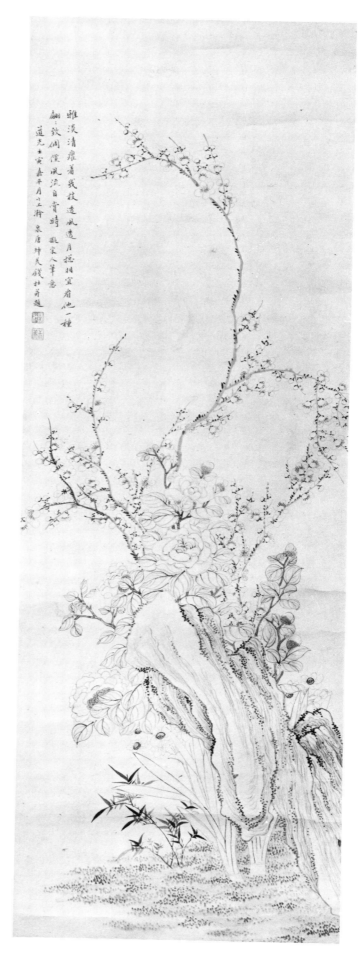

Qian Du
*Rocks and Flowers*

145

choice of subject matter retains the implied virtue of purity, for, as late winter bloomers, these flowers along with the evergreen bamboo and ageless rock signify endurance in the face of harsh conditions.

Rendered in ink line only, with no shading, coloring, or background setting, each of the five items in this piece displays exceptional clarity, a quality in keeping with the notion of purity. The plants impart a sense of fresh growth, while the rock appears solid and hard. Instead of disturbing the subjects over various areas of the picture plane, Qian Du has lined them up one behind the other in an ingenious arrangement that provides the third dimension for this linear composition. From its base just beyond the right border of the painting, the rock leans over to the left at the very front of the pictorial space, blocking parts of the plants off from sight. Yet, rather than overpowering the flowers and bamboo, the stone offsets the natural grace of their forms. From below the rock, two clusters of narcissus issue from the earth, their flowers like faces peeking around the sides of the stony screen. Slightly to the rear on the left a few tender branches of bamboo grow, their quiet manner elicited by the scholarly artistry of Qian Du's brush. Next in line is a camellia bush in full bloom, its rounded leaves and petals contrasting with the spear-shaped foliage of the bamboo and narcissus. The crowning glory of this floral group is the plum, with short branches fanning off to the sides and one tall branch curving up and then over to the left, leading the spectator's eye to the inscription. The refined linear technique provides the buoyant rhythm for this movement, which is accented by tiny moss dots on the ground as well as on the rock and plum branches.

Like the lofty character of the man who painted it, this work is tasteful and elegant in every detail. Herein lies the artist's expression of his scholarly view of nature as a gentle, harmonious creative force. His calligraphy, written in impeccable regular script, also bespeaks his sophisticated aesthetic outlook, as do the contents of the quatrain that accompanies the picture.

## Pine Tree, Nandina, Bamboo, Narcissus and Rock

Hanging scroll, ink and color on silk
44 x 21 ½ inches

> *Inscription:* Painted on a winter day in *dinghai* (1827) at Red Bean Studio.

> *Artist's seal:* *Songhuxiaoyin*, square, relief

Collection of Mr. and Mrs. Tom Berkley, Oakland, California

Another variation on the theme of the "five purities" appears in this colorful garden scene of a pine tree, nandina (heavenly bamboo), bamboo, narcissus, and a rock. All of the subjects occupy the left portion of the composition, with the exception of two large pine branches that sweep down to the right. Yet another facet of Qian Du's versatile artistic facility is illustrated in this work with its realistic delineation and hues. This fidelity to nature, along with the serious tone of the heavy colors

and formalized scheme, endows the painting with the classical splender of Song works. Virile calligraphic lines, as seen in the pine needles, narcissus leaves, and rocks, update this archaic tendency and inject the picture with a power that anticipates developments later in the 19th century. For Qian Du's contribution to his artistic heritage was more than nostalgic glorification of bygone ages; his paintings are a significant link between China's oldest traditions and her breakthrough into the modern world.

NOTES:

1. A place in Henan Province.
2. An ancient city in Henan Province.
3. Ni Zan.
4. "Peaceful Region," modern-day Liyang in Anhui Province.

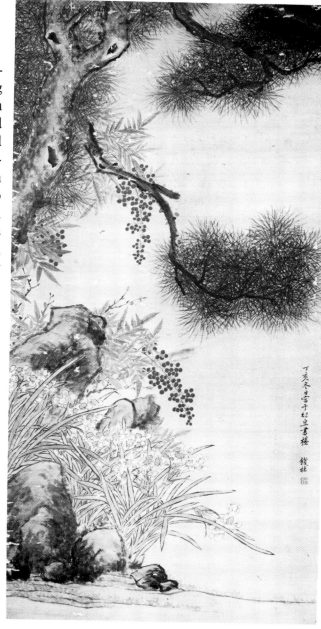

Qian Du
*Pine Tree, Nandina, Bamboo, Narcissus and Rock*

## WU QI (Yiju, Xueyai), 18th century

### Snow Landscape: Su Wu Herding Goats at North Mongolian Border

Hanging scroll, ink and light color on silk
56 x 15½ inches

*Inscription:* Painted by Xueyai, third month of spring, *xinhai* (1731). Wu Qi, at Yangeng Studio.

*Artist's seals:* *Wu Qi zhi yin*, square, intaglio
*Yiju*, square, relief

Collection of Mr. and Mrs. Randolph Lee Kihm, Richmond, California

Little is known about Wu Qi; even his birth and death dates have not come down to us. The artist spent his life in Hangzhou and is considered a late follower of the Zhe School. It is said that in his figure painting he followed the school of Chen Hongshou. Primarily, Wu Qi was influenced in his landscape style by the latter artist's teacher, Lan Ying.

147

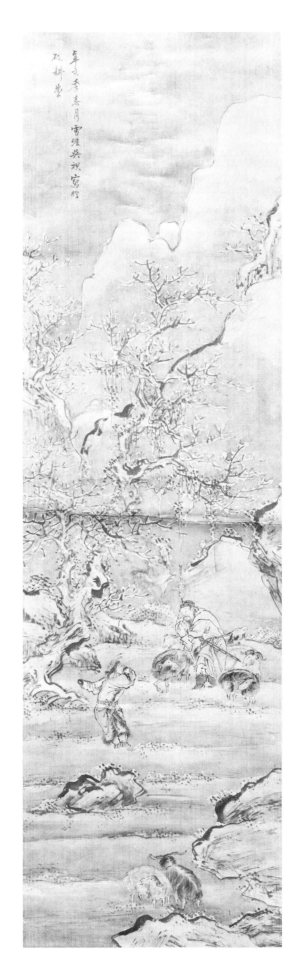

Wu Qi
*Snow Landscape: Su Wu Herding*
*Goats at North Mongolian Border*

Su Wu (139-60 B.C.), the subject of this painting, inherited his father's military rank of general, and was appointed by the Han emperor to make peace with the Mongolians. The Mongolian chief attempted to force Su Wu to serve under his command, but the patriotic general refused. In retaliation, the Mongolians imprisoned him in an underground cell, where he managed to stay alive by eating snow and his woolen blanket. Finally, annoyed at the resilience of the Chinese general, the Mongolian chief dispatched him to the frigid northern border. Still holding his Han *jie* (ambassadorial staff), Su Wu used it to herd goats in the frozen North, where he remained for nineteen years. Peace between the two lands finally came when the Han emperor married his daughter to the Mongolian chief. At this time the Chinese asked for the release of Su Wu, only to be told that he had died. Actually, the canny ambassador from the Han court had invented a tale to trap the Mongols. According to the story, the Han monarch, out hunting one day, shot his arrow at a goose with a message from Su Wu tied to its leg. The chief, outwitted, admitted that Su Wu still lived. A messenger was dispatched by the emperor to bring the general back to the Han court. There he was welcomed by the emperor, who was touched by the steadfast loyalty of his subject.

Wu Qi has chosen to depict the moment when Su Wu meets a messenger bearing the news that the long Mongolian captivity is over. The messenger, holding one hand up to his mouth in an effort to keep warm, represents the outside world that Su Wu is soon to rejoin. The general himself, surrounded by his milling goats, ponders the news of his freedom. He still holds the *jie*, symbol of his continued loyalty to the Han court.

Despite the straightforward way Wu Qi has illustrated this legend, it was chosen mainly as a vehicle for the artist's talents at painting a snow landscape. The picture consists of obliquely shaped, flat layers of sky, mountains, water, and land, which are unified by the calligraphically rendered tree that dominates the composition. Although the tree is leafless, Wu Qi has given strength and vitality to the thick, gnarled trunk and twisted branches. Other bold, sharp ink strokes separate the mountains and define the contours of the rocks.

This fluid treatment of line contrasts with the smooth areas of wet wash that indicate the sky and water. Reversing the usual procedure in Chinese painting, Wu Qi has used the unpainted surface of the silk for the mountains and the rocks protruding from the snow, the wash for the "empty" areas of sky and water. This contrast reflects the Buddhist concept that substance and void each contain its opposite. Even the two goats in the foreground play on this theme of the interplay of opposites: one is outlines only; the other two are given shaggy coats of ink wash. To give the impression of depth despite the pattern of flat areas and calligraphic brushstrokes, Wu Qi has left a series of horizontal spaces, softened by clusters of texture strokes, on the snowy land.

Wu Qi has created a composition that goes beyond illustration or the evocation of a specific type of landscape. The series of poetic contrasts gives the viewer the deeper satisfaction of considering the unity of harmonious opposites that constitutes the natural world.

*QIU SUI (Jifang), active late 18th century*

**Flowers and Insect**

Album leaf, color on paper
9½ x 12½ inches

> *Inscription:*   Qiu Sui.

> *Artist's seal:*   *Jifang*, square, relief

Collection of Carol Ann and David Bardoff, Oakland, California

Qiu Sui was born into a scholarly and artistic family in Hangzhou. His father, a collector of antiques, art, and old books, was also a well-known scholar and artist under whom Qiu Sui studied. Other family members were also painters, but Qiu Sui surpassed them all with his depictions of flowers and insects.

Qiu Sui painted in the boneless or *mugu* method, in which the subject is rendered in color without any ink outlines. The veins of the leaves are either left blank or executed in color. This style was created by Xu Xi (10th century) and it flourished from the Ming period through the late Qing. *Mugu* art achieved great popularity in the 17th century when famous masters such as Yun Shouping, Wang Wu, and Jiang Tingxi (1669-1732) favored it. By the end of the 18th century, this mode of painting flowers and birds had spread all over China and was used to decorate ceramics, furniture, embroideries, and other objects. Even some of the Yangzhou Eccentrics were exponents of this style.

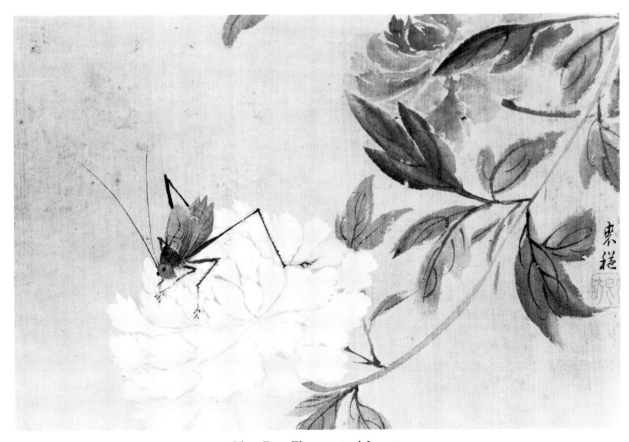

Qian Du. *Flowers and Insect.*

This flower painting displays great skill in shading and brushwork. Color is not merely washed on, but is applied in long, wet strokes similar to the technique of ink painting. The heavier color of the partly hidden red flower is masterfully counterpoised by a full white blossom that is subdued by a lively grasshopper perched delicately upon it. The contrast of the sharply focused insect and softer, more subtle flowers provides a three-dimensional feeling. Such balance and contrast are perhaps more difficult to obtain in color than in black and white. There is no date on this painting, but it is one of the best examples of Qiu Sui's work known to exist.

## GAN JING (Wenzhao), 18th century

### Landscape

Hanging scroll, ink on silk
70 x 37¼ inches

> *Inscription:*  In the style of Yunlin (Ni Zan). Wenzhao, Gan Jing.
>
> *Artist's seals:*  *Gan Jing zhi yin*, square, intaglio
> *Gan Jing*, square, relief

Collection of the Israel Museum, Jerusalem, Israel

Other than the fact that he was a native of Hangzhou, little is known about Gan Jing's life; this painting is the main source of information available on the artist. From a study of its style we can tell that he was a scholar, a follower of the great Yuan Dynasty painter Ni Zan, and probably part of the artist-intellectual circle of Hangzhou.

Ni Zan, an eccentric individual who abhorred any manifestation of untidiness or vulgarity, created landscape paintings unsurpassed for their purity and remoteness from worldly concerns. Large areas of unpainted paper and thin, pared-down forms give his small compositions a feeling of spaciousness and great clarity. A familiar compositional device of his was to show the passage of a river between two banks. For Ni Zan, the greatest challenge was to avoid making a direct likeness of nature; in his high-minded way, he sought to capture the deepest essence of his surroundings as reflected by a purified state of consciousness.

Certain elements of Ni Zan's style are evident in Gan Jing's painting. The great expanse of space, suggestive of clear atmosphere, the leafless trees, and the light application of ink with a dry brush are features of the older master's work. In Gan Jing's painting, however, the rigor of Ni Zan's style has yielded to a gentler view of nature in conformity with the leisured, comfortable social climate of 18th century China. Whereas Ni Zan rarely showed signs of any human presence in his paintings—even the occasional pavilion is very small—Gan Jing depicted a luxurious dwelling in the lower part of his landscape. He livened up the pale, dry brushstrokes with accents of darker ink in small strokes unlike Ni Zan's thin, sustained lines,

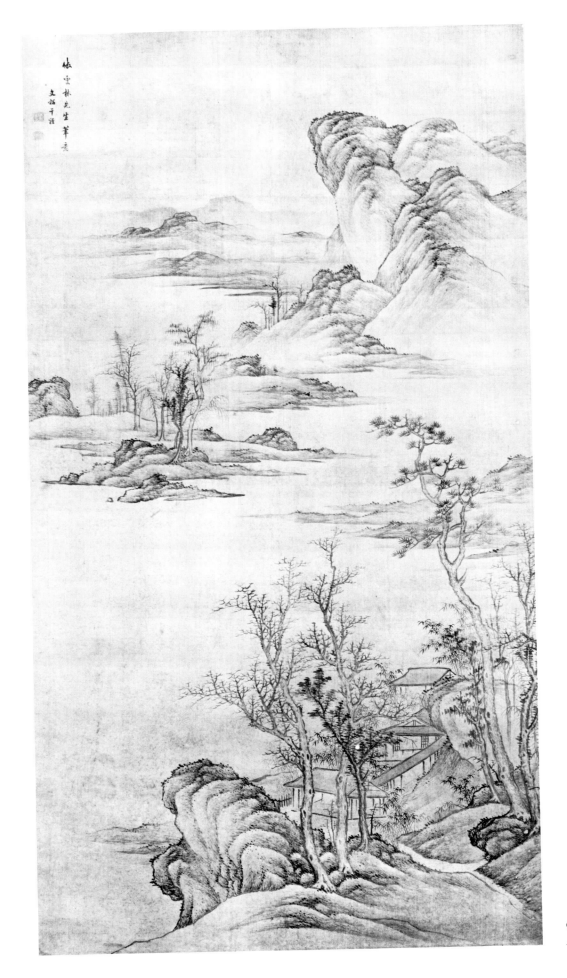

Gan Jing
*Landscape*

which suggest transparent air and a sensitive, even fastidious, response to nature. In Gan Jing's interpretation of Ni Zan's style, the natural features are much more realistically rendered with small dots and varied tonal accents. This lifelike depiction of the beauty of the natural world and the large size of the painting give it a decorative aspect quite removed from the intellectual discipline of Ni Zan.

Even though Gan Jing's work is less austere than the landscapes of Ni Zan, the middle Qing artist has achieved a monumental composition. By means of a sinuous curve into the distance, the various land masses are unified and made to seem part of an infinite chain. The cool air of late autumn or early winter is suggested by bare branches and the vast areas of empty space. The wrinkled hills, the varied brush-strokes used to differentiate the types of trees in the foreground—these are touches of realism in a spirit quite different from Ni Zan's spontaneous, impressionistic style. In many ways, Gan Jing's work is more closely related to a painting by Xu Daoning (first half of the 11th century), entitled "Fishing on a Snowy River."[1] In both Gan Jing's and this Song period landscape, the seemingly endless progression of peaks fading into the misty distance imparts a sense of awe and grandeur.

During the 18th century, proper appreciation of a painting involved a careful "reading" of the composition from detail to detail. Gan Jing's landscape stands up well to this kind of scrutiny. Each detail is carefully plotted so as to make the composition unified and the mood consistent. The pine tree on the far right, for example, binds together the foreground mass with the spit of land just beyond it. Of course, space in Chinese painting is not constructed from a single point of view, as in western perspective. Each land mass is seen from its own vantage point and the space between is unfixed, limitless. Gan Jing has taken the spacious air and made it the major feature of his painting. Here, the sense of limitless distance and crisp atmosphere is created by a judicious choice of landscape elements and a bold sweep of unpainted space.

*NOTE:*

1. In the collection of the National Palace Museum, Taipei, Taiwan.

*WU YUNLAI (Zhongyuan), active early 19th century*

**Landscape**

Hanging scroll, ink and color on silk
55½ x 15¾ inches

> *Inscription:* A pass penetrates windy pines,
> Springs emerge from cold valleys,
> Ascending to the top of the pagoda,
> One looks for waterfalls flying in the clouds.
>
> Painted at the end of autumn, *dingyou* (1837), for His Excellency Qiucha. Zhongyuan, Wu Yunlai.

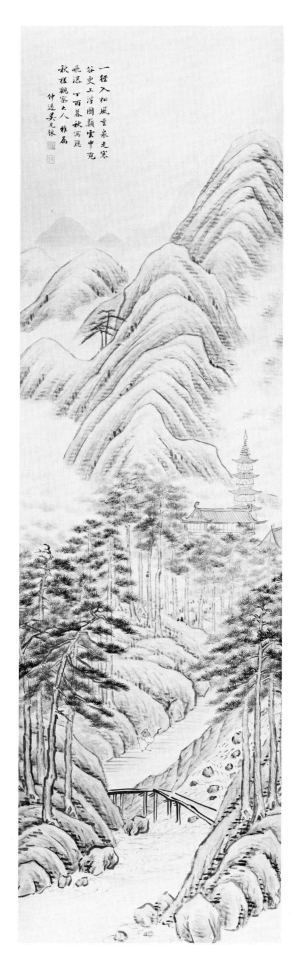

一徑入松風玉崟毫寒
谷史上淳圓顧雲中覓
飛深丁酉暮秋寫庭
秋槎觀察大人雅屬
仲遠吳元徐
[印]

Wu Yunlai
*Landscape*

154

*Artist's seals:*   *Wu Yunlai yin,* square, intaglio
                 *Zhongyuan,* square, relief

Collection of Mr. and Mrs. Min S. Yee, Bellevue, Washington

Wu Yunlai was a professional artist, poet, and calligrapher in the early 19th century. A native of Hangzhou, he carried on the Zhe School, which was born in that city during the Ming Dynasty. His landscapes are derived from the paintings of Lan Ying. A number of Wu Yunlai's works show an affinity to the style of Hua Yan (1682-1756), who retired in Hangzhou. However, whether or not this was the result of direct influence is unconfirmed.

This picture of a scholar walking beside a stream to a temple hidden deep in a pine forest, with a massive range of peaks looming in the background, depicts scenery that is typical of the area around Hangzhou. The path begins with a footbridge in the lower portion of the painting and zigzags back through a glen to the temple midway up the picture plane. The landscape is viewed from the vantage point traditionally known as "deep distance" *(shenyuan)*, looking from a raised spot over low hills and then gradually up a higher range of mountains. The sense of depth thus established is reinforced by gradually fading tones of ink and color in the trees as well as in the land forms, and also by the presence of mists that swell around the temple and up along the sides of the distant mountains. A series of frontal planes, the contour of each defined by a single long brushstroke, represents the far mass of peaks. To the left, more hills staggered with mist lead back to lightly washed mountains symbolizing infinite reaches of space. The mountains' diagonal recession repeats that of the stream and path in the foreground. Whereas the road and mountains lead the eye back in space, the rushing waters are a counterforce as they tumble forth into a broad pool at the lower edge of the picture.

In this work, Wu Yunlai demonstrates confident facility and spontaneity in his use of the brush, with a bold style dominated by lines and dots. These features, along with Wu Yunlai's convincing rendition of depth, are reminiscent of Lan Ying. The analogy, however, stops here, for the pale coloration—the green of the trees, the brownish-red of the temple—follows the prevailing taste of the middle Qing period for subdued hues, and suggests the lighter harmonies of Hua Yan's paintings.

**Landscape**

Hanging scroll, ink on silk
32½ x 11½ inches

        *Inscription:*   My leisurely brush dots moss;
                        Traces of moss break through the autumn rain.
                        I dream of the God of Clouds,[1]
                        As I face a thousand peaks and pines.

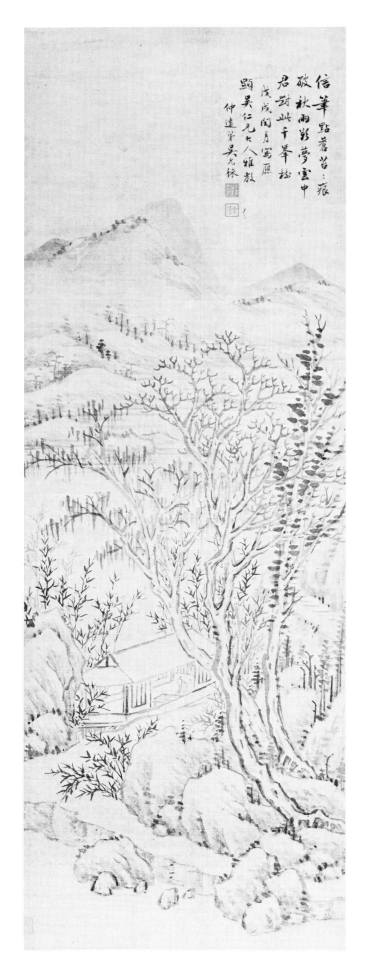

Wu Yunlai
*Landscape*

Painted for His Excellency Xianwu in the intercalary fourth month, *wuxu* (1838). Zhongyuan, Wu Yunlai.

*Artist's seals:* *Wu Yunlai yin*, square, intaglio
*Zhongyuan*, square, relief

*Collector's seal:* *Wu Nongsheng ? hushangguan,* rectangular, relief

This landscape illustrates the comment made by Chinese critics that Wu Yunlai succeeded in avoiding stylistic tendencies associated with professional artists. Its Literati approach may be seen in the lack of any color, the nondramatic composition (in contrast to Zhe School art), and the emphasis on subtle brushwork. A few tall trees in the foreground spread their branches over much of the painting's surface. Dry and sparsely foliated boughs and twigs radiate in all directions in a masterfully woven network of line. Below, a scholar sits reading in an open studio surrounded by bamboo and rocky terrain. Through the spaces between the trees' branches, an expanse of water and hills on the far shore is visible.

Despite the narrow range of generally light ink values used throughout the painting, each element is distinct in both structure and spatial situation. The near shore is rendered in moist strokes, while the remote hills, in addition to their horizontal disposition, are differentiated by drier texturing. With its fluid expression, this picture recaptures the spirit of landscapes by Yun Shouping, an artist much admired by Hua Yan. But Wu Yunlai's free manner extends beyond the brush to his conception of form: the trees tower above the pavilion and bamboo out of all realistic proportion. Nevertheless, as the picture's focal point, they merit such prominence. Moreover, the power of the individual strokes exhibits a taste for *jinshi* studies, which had recently begun to exert influence on calligraphy and painting. In these ways, Wu Yunlai's work testifies to the continuing vitality of the Hangzhou School well into the modern era.

*NOTE:*

1. Named Fenglong, from the *Nine Songs (Jiuge)* in *Chuci*.

# The Jingjiang School

Nanjing, China's "southern capital," has been a seat of government intermittently since the Three Kingdoms period when it was part of the state of Wu. Known in ancient times as Jinling, this city served as the capital of the Eastern Jin Dynasty (317-420). During the Ming Dynasty (1368-1644), many imperial palaces and administrative offices in Beijing had counterparts in Nanjing. Easy access to this metropolis in Jiangsu Province by way of the Yangtze River allowed commerce to flourish. In addition to its large merchant population, Nanjing was home to many a wealthy lettered gentleman, including the preeminent calligrapher Wang Xizhi (303?-361?). Gong Xian (ca. 1618-1689), Fan Qi (1616-1694), and six other noted painters who made up the group called the "Jinling Masters" drew artistic attention to this period in the late Ming and early Qing dynasties.

Nearby Zhenjiang (called "Dantu" from Han [206 B.C.-A.D. 220] to Tang [618-906] times) also boasted a long history. Because of its position close to the intersection of the Yangtze River and the Grand Canal, this city was not only a commercial center but an important naval base as well. By the Song Dynasty (960-1279), Dantu had become a prefecture named Zhenjiang (literally "to guard waterways"). A "fish and rice bowl" with convenient transportation and extensive commercial ties to Nanjing, Zhenjiang was a prosperous metropolis in the middle Qing period.

Active patronage of the arts developed in Nanjing and Zhenjiang during the 18th century, and this factor, as well as the presence of such prominent literary figures as Yuan Mei (1716-1797), stimulated a new local trend in landscape painting. This movement, dubbed the Jingjiang School (derived from a combination of the names of the two cities), sought an alternative both to the increasingly rigid formalism of the Loudong and Yushan Schools, and to the eye-catching devices used by the Eccentric painters gathered in Yangzhou at the time. Aligning themselves with their painting heritage, the artists of Nanjing and Zhenjiang revived the practice of studying nature directly instead of concentrating exclusively on the artistic models of the past. By looking at the world around them with their own eyes, they offered a variety of fresh conceptions frequently cast in a naturalistic vein. The Jingjiang School thrived from approximately 1750 to 1850, reaching its height during the reigns of Daoguang (r. 1821-1851) and Xianfeng (r. 1851-1862). A good number of paintings from this school have survived until today; moreover, this school's influence is still felt by contemporary artists from this area.

# PAN GONGSHOU (Shenfu, Lianchao), 1741-1794

## Landscape with Pine and Juniper Trees

Hanging scroll, ink and color on silk
73¾ x 12½ inches

| | |
|---|---|
| Colophon by Wang Wenzhi (Yuqing, Menglou), 1730-1802: | Zhao Danian's (active ca. 1070-1100) "Longevity of the Pine and Juniper." (Painted for) Roquan, (my) fourth brother, (on the occasion of his) sixtieth birthday. Pan Lianchaojushi pays sublime homage to elegant mountains. How can this even be discussed along with common invocations for longevity? With their antiquity, energy, and fluency, all of his brushstrokes cast off the narrow conventions of our time; this may be plainly seen. Inscribed by Menglou, Wang Wenzhi. |
| Artist's seal: | (Lower left corner) *Pan Gongshou yin*, square, intaglio |

Seals of Wang Wenzhi:
(After title) *Wang Wenzhi*, square, relief
(After colophon) *Wang Wenzhi yin*, square, intaglio
*Cengjing canghai*, square, intaglio

Collectors' seals:
(Lower left) *Zhang shi Jizi jianshang*, square, intaglio
(Lower right) *Cengjing guichi kaiyuanxiang nanshancun liushiwu song qi zhu jiu pu zhi zhai*
(Collected by the Studio of the Five Pines, Seven Bamboos and Nine Rushes of the Liu family of Nanshan Village in Kaiyuan District, Kaiyang [Guizhou Province]), square, intaglio

Three individuals were involved in the creation of this work: Pan Gongshou, who painted the langscape; Wang Wenzhi, who wrote the colophon; and Chu Kuangzu (called Roquan in the colophon), whose sixtieth birthday inspired this artistic collaboration.

Pan Gongshou was a student and friend of the calligrapher Wang Wenzhi. Both men were natives of Dantu (modern Zhenjiang) in Jiangsu Province. Pan Gongshou began his study of painting without a teacher. Later, after he asked Wang Wenzhi to instruct him on the use of the brush, his paintings showed swift progress. On one occasion, the Loudong artist Wang Chen visited Wang Wenzhi at his home when Pan Gongshou happened also to be present. Wang Chen praised Pan Gongshou's work and advised him on the proper methods of imitating ancient masters. It is said that Pan Gongshou practiced these methods day and night, and advanced even further in his artistic skills. His landscapes are modeled after those of Wen Zhengming (1470-1559), and his flower-and-bird compositions after Yun Shouping (1633-1690). He also painted Buddhist images in the manners of Ding Yunpeng (ca. 1575-1638) and Wu Bin (ca. 1568-1626).

Collectors have always prized paintings by Pan Gongshou, but particularly those bearing an inscription by Wang Wenzhi, who is considered one of the greatest poets and calligraphers of his time. His calligraphy is styled after the classical

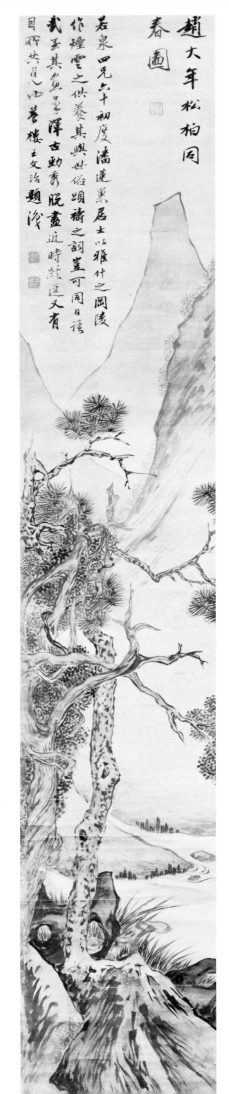

tradition of Wang Xizhi, Zhao Mengfu (1254-1322), and Dong Qichang (1555-1636).

The third artist associated with this painting, Chu Kuangzu, was a native of Cao District in Anhui Province. He lived in Nanjing and was known for his paintings of landscapes and of flowers and birds. The reference to him in the colophon as "brother" is a common form of address between close friends. The representation of these three men in this single work thus is of historical significance as well as artistic interest.

Upon being presented with this birthday gift, Chu Kuangzu would have appreciated the wishes for longevity symbolized by the pine and juniper trees, the rocks, and the *lingzhi*, fungus of immortality. First reading the title and colophon, and then viewing the mountain scene below, he would have been struck by the accordance between the brush styles of the written and pictorial aspects of the work. As a connoisseur, he would also have noted the allusions to Wen Zhengming's famous "Old Trees by a Cold Waterfall"[1] in the very long narrow format as well as in the technique of the twisted old trees.

The columnar shape of Pan Gongshou's composition places the viewer right up against the rocks in the foreground and directs the eye up to the trees, the main subjects of the scene. Beyond the Taihu stones and *lingzhi* at the base of the trees, a bending river gives rise to mist, positioning the high mountains far off into the distance. A cool atmosphere issues from the graceful lines of the winding branches and the faint blue and brown washes in the mountains. The smooth surfaces of the Taihu stones contrast with the rugged rocks, which display the same jagged effect as those constructed of "axe-cut" strokes in the landscapes of Ma Yuan (ca. 1190-1224) and Xia Gui (ca. 1180-1230). However, this brush technique was rarely used in the 18th century, and here the artist has employed the "nail-head" or "rat-tail" texture stroke, executed with the brush held upright in the manner of Shen Zhou (1427-1509). Yet, despite heavy influence from the Wu School, the emphasis on calligraphic brushwork and the striking format endow this work with a purely 18th century flavor.

*NOTE:*

1. *Gumu hanquan,* now in the National Palace Museum, Taipei, Taiwan.

Pan Gongshou
*Landscape with Pine
and Juniper Trees*

160

## ZHANG YIN (Baoyai, Xi'an), 1761-1829

**Landscape**

Hanging scroll, ink and color on paper
57¾ x 15½ inches

*Inscription:* When autumn comes to the deep mountains,
The ancient temple becomes cool,
And thick woods are dyed yellow by frost.
The *Lengyan Sutra* is set by the window,
But the monk has come to chat about the sunset.

Painted by Xi'an, Zhang Yin.

*Artist's seals:* *Zhang Yin zhi yin*, square, intaglio and relief
*Xi'an*, square, relief and intaglio

Private Collection, La Puente, California

Zhang Yin was a unique talent who spurred the development of the Jingjiang School in the early 19th century. Born to a family of wealthy scholars, artists, and collectors in Dantu (Zhenjiang in Jiangsu Province), he held the minor official rank of *gongsheng*. His family background exposed him to noted masterpieces of painting and calligraphy from an early age, and he quickly acquired a facility for depicting a variety of subjects in a broad range of styles. His repertoire included flowers and birds, bamboo, rocks, figures, and Buddhist images. But his wide acclaim was based mainly on his landscapes and renditions of pine trees. His basic artistic training emphasized the methods of the Yuan master Wang Meng (1308-1385) and the coarse brush technique of Shen Zhou. However, because he had absorbed the styles of so many past artists of various schools and periods, he was able to synthesize them into his own creative vision. This vision maintained strong ties to nature in compositions that were novel without indulging in eccentricity. Some of his landscapes feature an aerial view of a vast expanse, often laid out in two sections with towering peaks in the distance. Admiring contemporaries praised Zhang Yin's artistic achievement in poems and essays. During his lifetime, his paintings circulated for the most part within the area of Nanjing and Zhenjiang, but these literary references brought Zhang Yin even wider fame. His biography is recorded in *Zhang Xi'an xiansheng nianpu*, and his observations on art are published in his diary, entitled *Xi'an riji*.

This landscape illustrates the two-part arrangement with faraway peaks to which Zhang Yin was partial, in addition to his unusual success with pine trees. Two giant pines grow close together in the center of the foreground, while the foliage of a third is visible from behind a cliff beyond. While the artist has taken advantage of the pine needles' easy reduction to an ordered pattern, he has also achieved the difficult task of creating a poetic atmosphere wherein the soughing of the wind in the trees becomes almost audible. Other kinds of trees cling to surrounding boulders and offer a rich sampler of foliage techniques. A gnarled old plant just to the right of the twin pines exposes a few twisted branches among its bushy oval leaves. Defined in ink outline, each of these leaves turns in a predetermined direction to form a delicate shimmering mass.

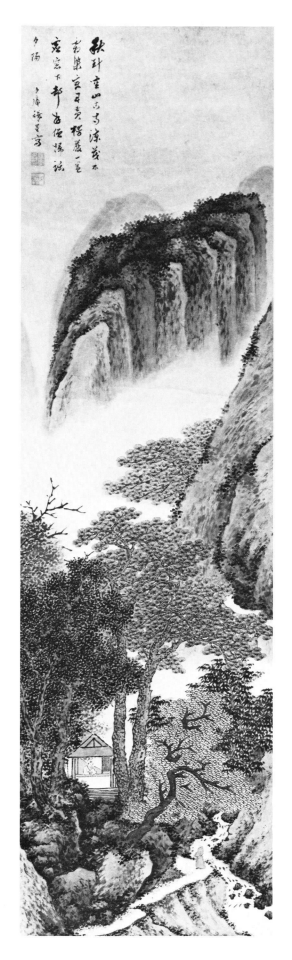

Zhang Yin
*Landscape*

162

On the left side of the painting a group of trees bears foliage composed of squared dots, executed after the manner of Shen Zhou with the brush held upright in the *zhongfeng* position. The various stroke patterns of the trees commingle as both decorative design and as a precise description of the forest's varied formations. The viewer may "walk" into this wooded area by way of a narrow trail leading from the picture's lower end, along the edge of a creek, to a studio nestled atop the rocky bank. A figure on the path gazes up at a man in the window who, from his secluded haven, takes in the view of the steep ravine. As the trail leads the eye into the scene, the winding creek leads it back out again, but not before it passes through a misty space to the eminence in the background. These peaks recall Shen Zhou again with their *nilibading* ("to pull nails out of mud") texture strokes, although this technique originated with Wang Meng. Applied in series that run down the sides of the multifaceted mountain, these strokes exhibit the fluid brush movements required for writing in *cao* (cursive) script. At times the artist barely lifted his brushtip off the surface of the paper between each brief touch, thus lending a spontaneous feeling to the rugged, lofty hills.

Rather than bringing the landscape to a sudden close with this screenlike formation, Zhang Yin indicates its continuation over further distances with lightly washed hills beyond. With this suggestion of enormous space, the location of the little studio in the foreground seems all the more remote from civilization, and we are the more moved by this image of nature's limitless grandeur.

## ZHOU GAO (Zijing), early 19th century

### Landscape

Hanging scroll, ink on paper
43 x 11½ inches

|  |  |
|---|---|
| *Inscription:* | Painted in winter, *yiyou* (1825), (in the reign of) Daoguang by Zhou Gao. |
| *Artist's seal:* | *Zhou Gao siyin*, square, intaglio |
| *Collectors' seals:* | *Donghai Wan Rilin shi xingshang*, square, intaglio<br>*Yangzhou Tai shi kaocang,* square, relief |

Zhou Gao was a little known landscapist active in the first half of the 19th century. Although his name does not appear in major art history texts, an example of his work is illustrated in *Zhongguo hua*.[1] According to this publication, his home was Dantu (Zhenjiang, between Suzhou and Nanjing), his *zi* Zijing, and he was active during the Jiaqing (1796-1821) and Daoguang periods. A listing for Zhou Gao, *zi* Huaixi, in *Lidai renwu nianli beizhuan zongbiao*[2] gives his dates as 1754-1823, describing him as a native of Jingui (Wuxi, Jiangsu) and one-time governor of Zhangzhou (in Fujian), but makes no mention of him being an artist. The dates of the two landscapes presented in this collection (1825 and 1838) render their

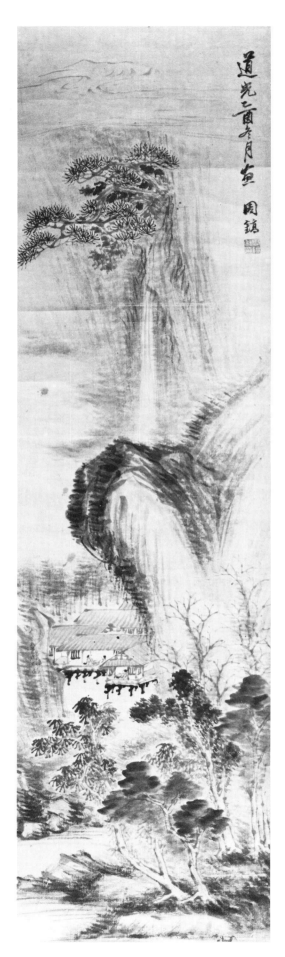

association with this Zhou Gao (Huaixi) improbable, while the work published in *Zhongguo hua* is consistent with these two paintings in terms of both date and style.

On the basis of these two monochrome pictures, Zhou Gao's style may be characterized by its sensitive application of washes and masterful modulation of ink into finely differentiated nuances. Echoes of Shitao's (1641-ca. 1710) landscapes and also those of the 17th century Jinling masters may be observed in this artist's paintings.

This example of 1825 is conceived in a three-step progression of height and depth. The upper and most distant segment consists of a thin layer of clouds outlined in pale ink and hovering over a gnarled pine, which grows out of the vertical wall of a cliff. Water cascades from a crevice, but its final destination is blocked from view by an outcropping of stony earth from the right middle ground. This mountain's leftward thrust breaks the sheer drop of the distant cliff as well as the long slim shape of the whole painting. A narrow opening to the left of this hill reveals a number of low buildings set on stilts, indicating the presence of water beneath. Inside, people sit at the windows enjoying the view through the same opening to the trees in the foreground, the lowermost portion of the scene.

The variation of species within these woods allows the artist to demonstrate his accomplishment in three types of brush techniques used for foliage: small dots, short blunt strokes, and plump watery dots. The graduated ink values of these leaves impart a shimmering effect suggestive of shadows and wind. A progression of generally light-toned ink to dark from top to bottom over the entire landscape underscores the sequential nature of its classic division into three distances. Finally, throughout the composition, both small and broad areas of blank paper, whether representing water, mist, or convex portions of natural forms, illuminate the painting with a softly glowing light that enhances the salient aspect of this work: the display of ink in its myriad "colors."

Zhou Gao
*Landscape*

164

**Landscape**

Hanging scroll, ink on paper
47 x 15½ inches

       *Inscription:*  Painted in winter, *wuxu* (1838) by Zhou Gao.

       *Artist's seal:*  *Zhou Gao siyin*, square, intaglio

Private Collection, La Puente, California

      Zhou Gao's mature style may be seen in this ink landscape of 1838. It shows a striking resemblance in brush technique to the painting of the same year in *Zhongguo hua*. An islet in the foreground consisting of semispherical mounds of earth is linked by a footbridge to a precipitous land mass that leads back to ever higher peaks along the left side of the picture. Geometric shapes, such as cubes and flat-topped cylinders, dominate this mountain range; these are neatly defined, first in light ink outline and then in successively darker contours. Several layers of short, blunt texture strokes are applied within these lines in a manner reminiscent of Gong Xian's voluminous hills. But whereas this 17th century master employed a relatively narrow range of light and dark, moist and dry ink, Zhou Gao freely modulates his ink in tone and wetness. These variations effect a crusty surface pattern with considerable tactile appeal at the same time that they achieve a sense of the weighted stability of the rocky heights. Dark wet dots both accentuate the contours of individual earthen forms and punctuate the reverberant quality of the overall texture.

      Trees both near and far are distinctive in construction. Evergreens are rendered in medium to light shades of ink rather than the usual dark tones, while dry branches and twigs are strokes that taper to a sharp point at the end. The last type of tree evokes a sense of the biting chill in the air; this is conveyed also by the clear delineation of remote mountains, by the lack of human habitants in the houses or anywhere else in the scene, and by the sharp contrast drawn between dry land and water. The great empty space that represents a river or lake is much more than merely unpainted paper; it asserts a presence, a volume and substance of its own. Stillness hangs heavy over this landscape, yet it stops short of the desolate, brooding mood of Gong Xian and Zhu Da (1624-ca. 1705). Stark and deserted though Zhou Gao's work may be, the elegant grace of his mountain formations, the buoyant stroke rhythms, and the engaging "colorist" use of ink express a more lighthearted frame of mind and therefore a personality nurtured by middle Qing attitudes and values.

      The similarity of Zhou Gao's style to that of Gong Xian offers evidence that this Nanjing master had a following as much as 150 years after his death. Moreover, the influence of Zhou Gao himself came to bear on such 20th century artists as Xiao Xun (1883-1944), whose animated brush manner produced luxuriant, cheerful scenes, and Xiao Junxian (1865-1949), who emphasized the serious note of Zhou Gao's work.

*NOTES:*

1. *(Chinese Painting),* Zhongguo gudian yishu chubanshe, Beijing, 1957.

2. *(Collection of Epitaphs of Historical Personages),* ed. Jiang Liangfu and Tao Qiuying, Zhonghua shuju, Hong Kong, 1961.

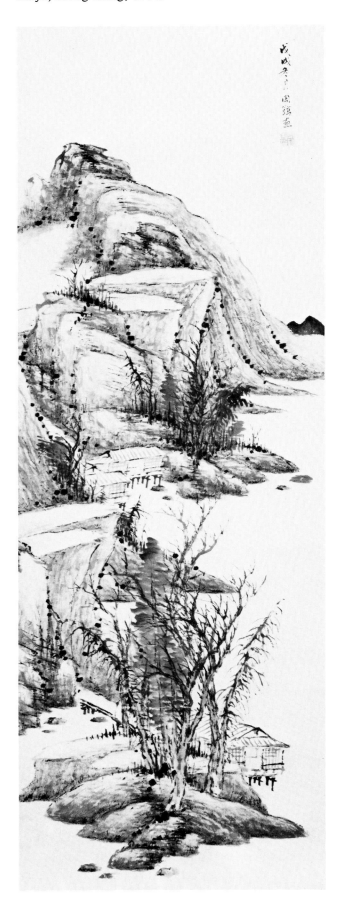

Zhou Gao
*Landscape*

*LI XIGUANG (Yueshan), active early 19th century*

**Landscape**

Hanging scroll, ink and color on paper
23⅝ x 15¼ inches

> *Inscription:* Reciting Verses of Loujin. Each time I pass through Loujin, I repeatedly recite Mr. Wang Yuanting's "Outside the gate the wild wind opens the white lotus." Xiguang.

> *Artist's seal:* *Xiguang shuhua*, square, intaglio

After he moved to Nanjing from his native Hebei, Li Xiguang met the master landscapist Tang Yifen (1778-1853). Although the former is sometimes remembered as the latter's student, the two were in reality peers who exerted mutual influence on one another. Li Xiguang was said to be so skilled in imitating the works of the Four Wangs that his copies could not be distinguished from the originals. He also admired Dong Qichang and Shitao, but his own work shows him to have been an independent thinker who could confidently dispense with the formalistic conventions that dominated the art of the day.

The artist's inscription on this late landscape refers to the revered early Qing poet Wang Shizhen (1634-1711). Also known as Yuanting and Yuyang, this literary giant was also a calligrapher, painter, and seal carver, as well as the president of the Board of Punishments during the reign of Shunzhi (r.1644-1662). A line from a poem he wrote about Loujin, a community with a temple of the same name in Gaoyou District, Jiangsu Province, is quoted here as the inspiration behind this picture.

Loujin's curious name, which literally translates as "exposed muscle tissue," is explained by an incident that took place during the Tang Dynasty. A young maiden, traveling with her sister-in-law in the countryside at dusk, refused to ask a farmer to take them in for the night. Instead, she spent the night in a swampy field that was infested with mosquitos. And there she died, her tender flesh bitten away by a swarm of hungry insects. A temple was erected on the site and named Loujin by the local people to honor the memory of this virtuous girl. A record of this story, in the handwriting of the great calligrapher and painter Mi Fei (1051-1107), was engraved on a stone tablet. Referring to the heroine as Xiao Hehua (Xiao the Lotus), this eulogy relates that the lake where she was buried produced an abundance of lotuses. Rubbings of this tablet circulated widely, and perhaps it was after a copy reached the hands of Wang Shizhen that he wrote his famous poem about Loujin.

Li Xiguang's painting shows Loujin to be a bustling fishing community as well as the site of a large temple, in a landscape of rivers, lakes, and hills. Observed from a high stance, the view covers a deep stretch consisting mainly of water which, represented as unpainted paper, links up with the sky somewhere beyond distant shores. Populated by laborers and fishermen attending to their daily work, the area surrounding the temple is nevertheless portrayed as a peaceful idyllic place with willow trees swishing in the warm summer breeze and ducks swimming on quiet waters.

The painting offers an unusual glimpse of the lives of common people in the

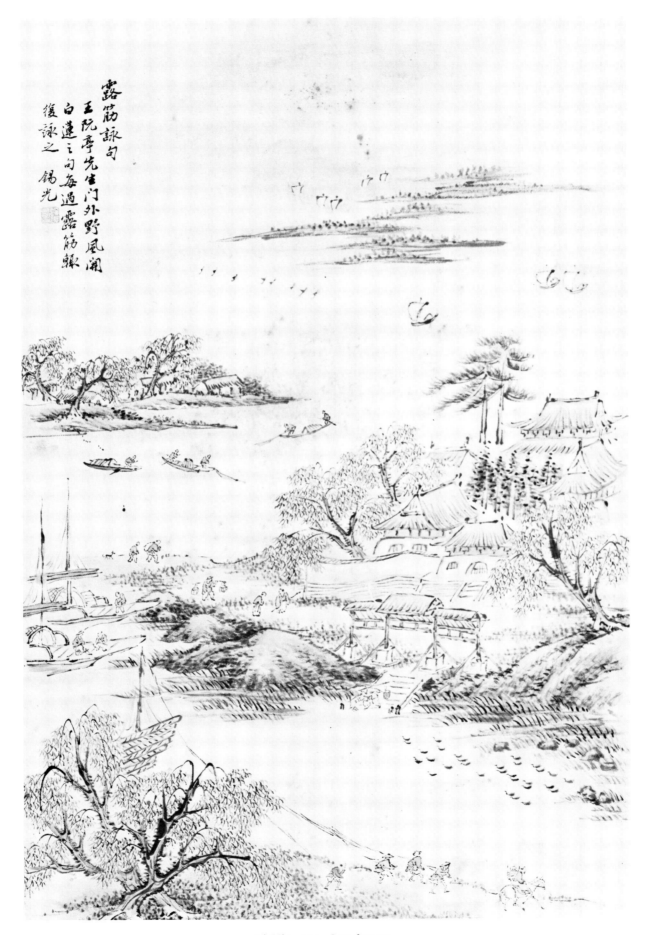

露筋詠句
玉阮亭先生門外野風闌
白蓮之句每過露筋輒
後詠之　錫光

Li Xiguang. *Landscape.*

168

countryside in a composition that is uncommonly informal for its time. The technique, too, strikes a casual note; despite the employment of a single small brush for the entire painting, the brushwork has the loose spontaneity of a freehand drawing. Long practice in writing *xingshu* (running script) accounts for the fluency of the fine strokes and the ease with which complex forms such as figures and animals are vividly described in abbreviated terms. Little use is made of that standard building block of landscapes, *cun*, or texture strokes, and patches of color wash conceal all traces of the movement of the brush on the paper.

Although the landscape abounds in small elements of different types, the individual parts are held together by a dynamic tension that allows for both cohesiveness and lively animation. Pale ochre, light grayish-blue, and brief passages of pale brick red filling in the ink-outlined form further enliven the scene, although the overall effect of ink and color together adheres to the middle Qing taste for uniform and subdued tones.

The light-hearted verve of the brushwork itself imbues the image with a strong sense of atmosphere that engages the senses. The slight undulations of the lines, as in the contours of the buildings, suggest the heavy moisture and heat in the air of a summer day. Considering its refreshing immediacy, its unique conception and layout, and the direct approach of its execution (without any preliminary sketching in diluted ink), this work provides valuable insights into what were then newly budding trends in Chinese landscape painting.

### *TANG YIFEN (Yusheng, Longshanqinyin), 1778-1853*

**Landscape**

Hanging scroll, ink and color on paper
23 x 15½ inches

>    *Inscription:*   Tang Yusheng.

>    *Artist's seal:*   *Laoyu*, form of two linked ovals, relief

>    *Collector's seal:*   *Jingyizhai zhencang jinshishuhua*, rectangular, relief

Private Collection, La Puente, California

Tang Yifen figures as an important late master of the Orthodox tradition in Chinese painting. A scholar with widely varied talents, he was born in Wujin, Jiangsu, but made Nanjing his home. He was a brilliant calligrapher, poet and essayist, and was learned in the fields of astronomy and geography. Besides excelling in the games of chess and go, he was an expert fencer, and played both the flute and the *qin*. Tang Yifen inherited his grandfather's official title and held posts in Guangdong and Zhejiang Provinces. Late in his career he was appointed deputy military commander of Wenzhou, but declined the position for reasons of ill health. After he

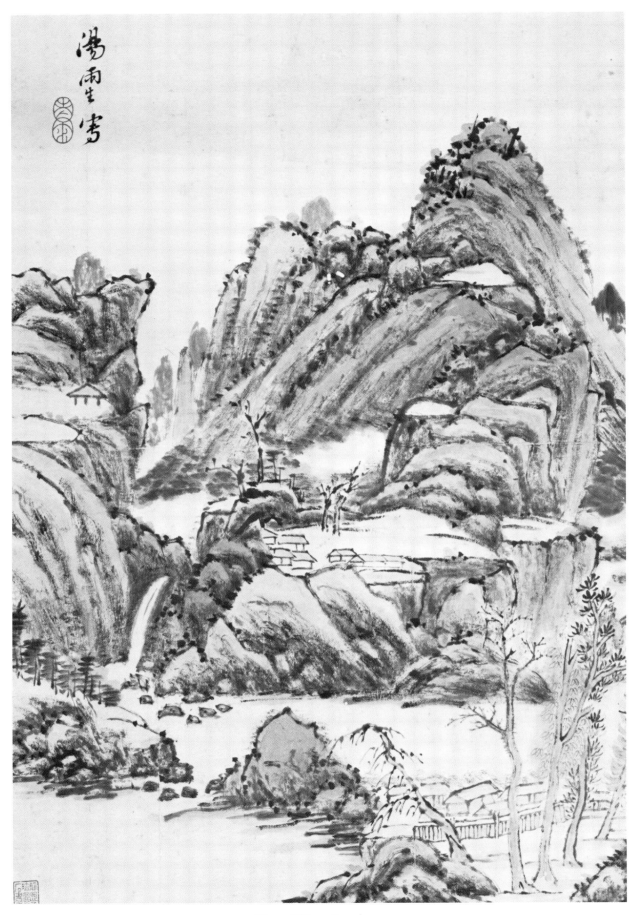

Tang Yifen. *Landscape.*

170

retired he returned to Nanjing where, in 1853, he committed suicide during an attack by the Taiping rebels.

The earliest recorded work by Tang Yifen is dated 1805. Adept in all the techniques of China's long painting history, he excelled in landscapes, figures, flowers, and birds. He was fond of painting plum blossoms and other flowering plants with subtle colors and often a minimum of brushstrokes. His depictions of pine trees and junipers are said to reveal the true mastery of the brush in the spirit of the ancients. His illustrations to a poem by his mother entitled "The Broken Hairpin" *(Duancai yin)* became famous throughout China. The ten-volume *Jiangshang huaquan* records his views on art.

In landscape painting, Tang Yifen embraced the Orthodox philosophy as set down by Dong Qichang and carried on by Wang Yuanqi (1642-1715) and Wang Hui (1632-1717). Dong Qichang had called for a synthesis of the techniques of past Literati artists for the purpose of developing a personal style that emphasized expressive brushwork and the abstraction of form. A century later, Wang Hui successfully fused all existing schools of painting in his work, dissolving the boundaries between what had been considered distinct traditions. Like Wang Hui, Tang Yifen drew upon each of the various styles that had evolved from the very beginnings of painting down to his own lifetime, ranging from Orthodox to Individualistic to Eccentric. As a resident of Nanjing, a center of Christian activity in China, he was even influenced by western art.

The composition of this landscape is basically a conventional arrangement of trees, rocks, a river, and mountains; it is through the sensitive brushwork and the use of color that Tang Yifen's creative expression is manifested. In a manner reminiscent of Wang Yuanqi and Zhu Da, the natural elements are contoured in strong calligraphic strokes. In fact, this painting displays a number of other significant references to the style of Wang Yuanqi. Generally, in Chinese landscapes prior to the 17th century, color was applied solely to fill in outlined forms and was thus subordinate to the ink line. But Wang Yuanqi, and later Tang Yifen, gave new weight to color that in essence balanced that of ink. So, though the hues used here are delicate compared to those of most "blue and green" landscapes of the past, the colors imbue the entire painting with an atmosphere of lush growth. In some cases patches of color pass outside the bounds of an outline, as in the large green stone in the central foreground, imparting a carefree feeling complementary to the liveliness and abstract aesthetic of the strokes themselves.

In other areas colors are applied independent of line, as in the waves on the river, the foliage of the trees, and the vegetation dots on the hills. This blurring effect, which again recalls Wang Yuanqi, suggests the movement, atmospheric moisture, depth, and other conditions that inevitably affect a viewer's perception of any natural setting. In one notably daring detail in the left middle ground, a waterfall issues out of a sheer stony wall. Having no apparent source (such as a crevice leading into deeper space or a flat stretch of land), the cascade is rendered in a manner that reflects the artist's informal attitude toward the traditional adherence to a certain logic in natural formations. This unrealistic touch is a by-product of Tang Yifen's overall schematic treatment of landscape elements. The rocky mountains are made to appear substantial through the buildup of layer upon layer of blue, green, pale brown, and multitoned ink.

Although the paintings of Wang Yuanqi have been likened to those of Cezanne, Tang Yifen comes even closer to this French artist with his solid forms, tilted ground planes, and reverberant surface textures. The alternation of solid and void moves rhythmically through the pictorial space, beginning with a tree-lined shore with cottages in the foreground and progressing across the river to a steep mountain range beyond. Now ascending, now receding, it culminates in a towering eminence on the right and finally descends once more to lightly washed peaks in the far distance.

Such a vast expanse with its abundance of elements might be expected to appear crowded or cluttered in this small format. On the contrary, the compelling unity, clarity, and depth of this landscape evoke all the simplicity and power seen in the larger works of Tang Yifen's Orthodox forefathers. Moreover, its forceful symbolism of a world microcosm is born of the imposing gravity of its conception and unaffected finesse of its execution. For an artist active during what is considered a low ebb in the course of Chinese painting, this alone is no small feat. But with this piece, Tang Yifen also takes a step into a new age. Updating the Orthodox tradition with his vigorous brushwork and venturesome color technique, he paves the way for such later landscapists as Huang Binhong (1864-1955).

Finally, the inviting inhabitability of this landscape by Tang Yifen allows the viewer to experience not only the pure beauty of nature, but the wonders of human society as well. From this standpoint, the art of Tang Yifen is a monument to the abiding spirit of humanism so fundamental to Chinese civilization.

**Landscape**

Hanging scroll, ink on paper
23 x 12½ inches

*Inscription:* I have seen a collaborative painting by Ni Zan and Wang Meng.[1] Though I have tried my utmost I have not wholly attained its profound subtlety. This I deeply regret. Second month, *xinchou* (1841), Tang Yifen.

*Artist's seals:* *Tang Yifen yin*, square, intaglio
*Yusheng*, square, relief

*Collectors' seals:*
(Lower right) *Kong*, round, relief
*Yuexuelou*, rectangular, intaglio
*Deyu shending*, square, relief
*Shaotang*, rectangular, relief
*Kong Guangtao*, rectangular, relief
*Shaotang yanyun guo yan zhi wu*, rectangular, relief
(Lower left) *Kong shi Yuexuelou shoucang*, rectangular, relief
*Pan Shicheng yin*, square, intaglio
*Zhou Fan guo yan*, rectangular, intaglio and relief

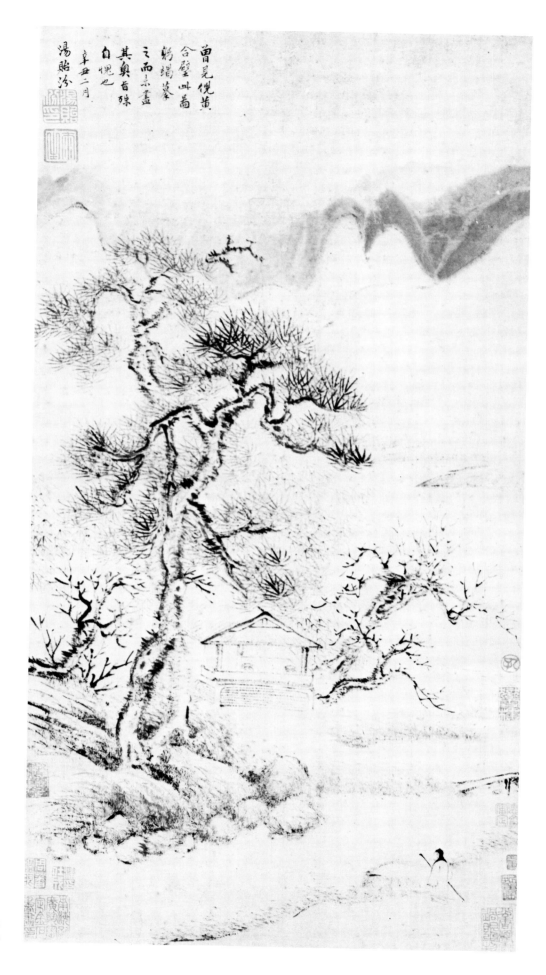

曾見倪黃
合璧四幅
鶴塌峯
之而未盡
其與旨殊
自愧也
辛丑二月
湯貽汾

Tang Yifen
*Landscape*

173

*Nanhai Kong Guangtao shending jinshishuhua yin*, square, relief

Collection of William Warren Bartley, III and Stephen Kresge, Oakland, California

On a more casual, intimate note, Tang Yifen painted this ink landscape based on a prototype by two of the Four Masters of the Yuan Dynasty, Ni Zan and Wang Meng. A comparison of the two paintings, however, shows the 19th century version to be a very loose interpretation of the Yuan original. Clearly, rather than duplicating the external image, Tang Yifen seeks to recreate the elusive yet resounding spirit of the older work. Although in his inscription he criticizes his failure to reproduce its "profound subtlety" *(ao)*, the painting itself evinces certain essential qualities associated with Ni Zan and Wang Meng. Tang Yifen demonstrates his deep understanding of the personal achievements of these two artists as well as his own creative powers, by distilling and transforming these qualities in a picture that is stylistically unified yet leisurely in manner.

Twin pines on a rising riverbank, viewed by a lone figure on the near shore in the lower right corner, refer to Wang Meng in the dotted, twisted configurations of their trunks and branches, and the bold upswept brushstrokes of their needles. This Yuan master's predilection for thick luxuriant growth is preserved here with the pale-toned and delicate pendant bamboo leaves issuing from unseen stalks behind a pavilion situated just beyond the pines. To either side of the structure, old, barren plum trees echo the front pine's rightward inclination. These aged trees, along with the dense grove of bamboo, call to mind the untranslatable phrase that is often used to describe Wang Meng's paintings, *cangmang*, connoting dark green, weathered, but flourishing vegetation covering a broad area. The rocks and sloped bank also follow his *pimacun* or "hemp fiber stroke" pattern.

If the foreground functions as a presentation of Wang Meng's style, the background, beginning half way up the picture plane with a barely visible third shoreline on the winding river, is Tang Yifen's tribute to Ni Zan. But instead of employing this "lofty scholar's" *zhedaicun* or "severed band stroke" to describe stratified encrustations, Tang Yifen taps his model's characteristic dependence on blank paper for atmospheric and spatial effects. The overall scheme of the painting is, in fact, a variation of Ni Zan's favorite "one river, two banks" mode. His sparing use of ink is adhered to in the suggestion of a row of mountains through the use of a single parched stroke as the contour of each peak. The unpainted face of these hills indicates their remoteness, while it also illuminates the rest of the picture with the mysterious glow of twilight. More distant peaks pose a striking contrast in their nonlinear, washed rendering, with successive rows eventually fading out into infinity. The sense of thin, cool, clean air emanating from these mountains captures the flavor of Ni Zan's immaculate landscapes. Although there is no visible bridge to link the nearby inhabited and vegetated land to the insubstantial heights far across the water, the two are visually connected by means of the superimposition of the top of the lanky pines over the left portion of the faraway mountains.

By combining the approaches of these two Yuan painters, Tang Yifen portrays a world that is at once lively and serene, enchanting and remote, personal and universal. But whereas the color landscape presented above is a well-planned, formal summing-up of the painter's artistic cultivation, this monochrome river scene

was produced in the spirit of scholarly diversion, as spontaneous "ink play" *(moxi)*, probably executed with a single brush. While the former work evokes a sense of solemn majesty, carrying the gravity of a major philosophical treatise, the latter is lighthearted and lyrical, like one or two lines of extemporized and heartfelt poetry. Yet the technical level of the two paintings is consistent, this one in ink featuring slow, deliberate brush movements with a broad spectrum of values and moistness. The calligraphic basis of the brushwork, an outstanding trait of Yuan art, is updated by Tang Yifen by means of the *beixue* aesthetic, especially apparent in the pine trees. The use of the *zhongfeng* method, in which the brush is held perpendicular to the painting surface, gives sharp visibility to even the tiny uppermost branches.

This example epitomizes the transition of Chinese painting from a venerable orthodoxy toward a modern approach to expression wherein even more ancient inspirational sources are utilized. Although its inventive aspects play a secondary role to its more obvious derivational content, careful analysis of this work discloses that Tang Yifen initiated significant strides in the transformation of Chinese painting during this crucial period.

## Plants and Rocks

Pair of hanging scrolls, ink and light color on paper
58½ x 15¼ inches each

Panel One: Banana Leaves, Flowers, and Rock

> *Inscription:* Covered with fur and tied in purple ribbons,
> surely of the royal house,
> Once painted, they blossom into fragrance,
> these flowers from the imperial palace.
> In the still solitude of night, behold them
> with pleasure,
> Under the bright moon, pure fog—a
> gossamer veil.
> I have seen Chen Daofu's work and casually
> imitate his style. Yusheng.

> *Artist's seal:* *Yifen*, square, intaglio

Panel Two: Pine Tree, Tiger Lilies, and Rock

> *Inscription:* After a snowfall, young shoots sprout
> beside a stone,
> Green tassels, like pendant ribbons,
> waft in the wind.
> The north window is always sunny without
> the heat of summer,
> It faces the "forget-your-sorrows" flowers,

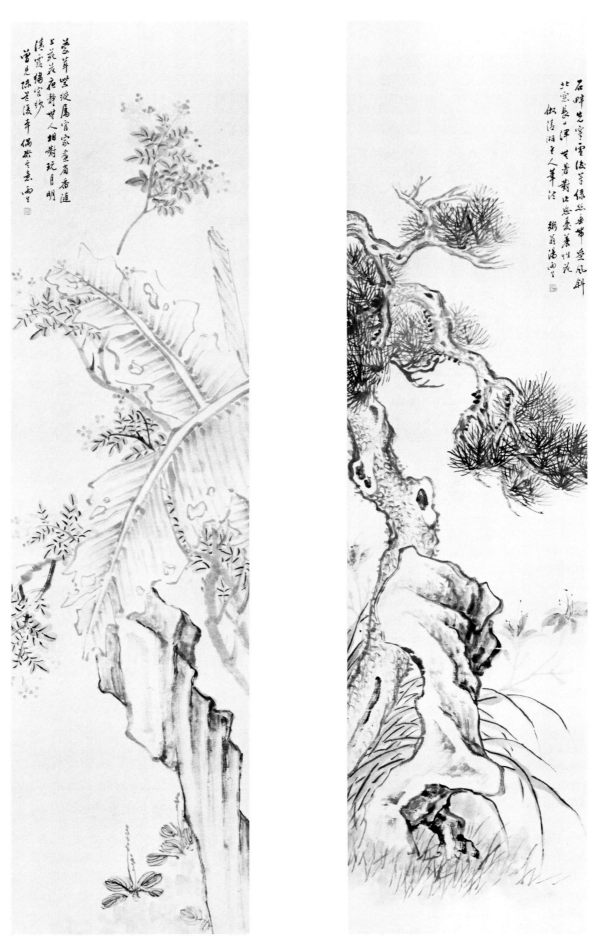

Tang Yifen. *Plants and Rocks:* Panels One and Two.

176

which cultivate one's character.

In the style of Qingxiangdaoren (Shitao).
Zhouweng, Tang Yusheng.

*Artist's seal:* *Longshanqinyin*, square, intaglio

Collection of Y. W. Shih, Tainan, Taiwan

Tang Yifen started painting flowers and birds in the *gongbi* or fine detail method, and only later developed facility in the *xieyi* mode. He was equally skilled in the outline and boneless techniques, using ink either alone or with colors. Chen Chun (Daofu, 1483-1544) and Shitao were the models for many of his works on this subject, including this pair of paintings, each depicting a tree, flowering plant, and rock.

The long, narrow format and one-sided compositions as well as the seasonal content of these pictures suggest that they were originally part of a set of four, eight, or even twelve hanging scrolls. Such large sets were popular as decoration for the airy halls of large residences in Shanghai and Nanjing in the early 19th century. Even so, either of these two panels may stand alone, satisfying the eye with a richness of visual and symbolic imagery and with an asymmetrical yet balanced schema.

In his inscription the artist states that he had Chen Chun in mind when he executed this picture of a banana tree and a bush with yellow blossoms growing beside a large stone. Powerful strokes of pale ink applied with the brush held upright *(zhongfeng)* delineate the broad banana leaves that enter the scene from the right. The playful meanderings and modulations in these lines bring the giant foliage to life, while perforations due to insects break down the repetition of the leaves' striated pattern. Just behind the banana tree, clusters of small blue leaves are depicted in the boneless technique, with a single ink stroke down the center of each. At the end of every brown branch, delicate yellow flowers are dotted with white anthers and complemented by reddish-brown buds. Like jewels adorning a beautiful woman's face, the floral sprays are distributed sparsely around and between the massive forms of the banana, providing contrasting accents of color and delicacy.

Instead of including the trunk or main stem of these two plants in the scope of this scene, Tang Yifen anchors them with the weight of a tall slender rock, thus adding spatial dimensionality as well as elemental and symbolic interest to the painting. The oddly-shaped stone thrusting diagonally from the lower right corner toward the upper left is composed of vertically disposed rectangular segments that repeat the straight lines of the banana leaves above. The rock derives its hard, solid appearance from coarse brushwork and shading through graded ink values. A few small plants around the base of the rock establish the ground plane for this garden view.

The second panel of this pair was inspired by Shitao, although the pine tree also relates to Mei Qing (1623-1697). Old and twisted, this evergreen's rough bark is textured by brief, curling brushstrokes of alternating dry and wet, light and dark values. The fanlike distribution of the foliage exhibits crisp needles, with depth achieved through variations in ink tones. Zhao Mengfu's tenet that for painting rocks one must know *feibai* technique and for trees, seal script calligraphy is

followed here. The contours of the pine move with the slow, persistent energy of engraved seal script, while the outline of the rock yields to *feibai*, that is, strokes showing streaks of white paper within the black ink.

Like a modern abstract sculpture, the stone stands upright in an S-shape, similar to the form of the tree. The tiger lilies that bloom from behind the rock and pine are rendered in simple color wash with fine-lined black pistils, yet convey a realistic tangibility. The long blue lily leaves, also boneless, depart from precedent in the rough irregularity of their profiles. *Xuancao* or tiger lily is also known in China as "forget-your-sorrows flower" *(wangyouhua)*; the choice of tiger lilies to accompany two emblems of longevity therefore invokes auspicious wishes for a long life free from care.

Depictions of two or three different plants alongside a rock were traditionally appreciated in China not only for the inherent beauty of their natural forms and such symbolism as is exemplified here, but also for their representation of the artist's taste and skill as reflected in his brushwork and arrangement. In these paintings Tang Yifen demonstrates his artistic and scholarly cultivation in the subtle expressive force of his masterful brushstrokes. The bold diagonal movements in these compositions imbue the inanimate subjects with a vital tension and recall the paintings of the Yangzhou masters. But the self-contained air and acute sensitivity in every stroke may be compared to the pictures of the Hangzhou artists.

By drawing on disparate approaches of previous masters and schools, Tang Yifen's oeuvre illustrates the preoccupation of the middle Qing period with the gamut of past cultural achievements. On the other hand, his borrowings from more recent developments and awareness of newly budding trends identify him as both a painter of uncommon independence and an important progressive force within the mainstream of China's artistic tradition.

*NOTES:*

1. National Palace Museum, Taipei, Taiwan.
2. Another *hao* or sobriquet of Tang Yifen.

# The Jiangxi School

In the central portion of eastern China, Jiangxi Province benefits from self-sufficiency in agriculture and a number of active ports on the Yangtze River. But above all, this province is known for its abundant deposits of *gaolin* clay, the raw material that made the name of China synonymous with the finest porcelain manufactured in the world. Jiangxi's ceramic industry in Jingdezhen was operating in Tang times, and by the Ming period it had grown to be the main center of porcelain in the country. The factories there attracted numerous artists to the area for employment in designing and decorating porcelain wares. Many of these artists continued in their spare time to cultivate their talents in painting on paper or silk. Whereas the painted decorations on porcelains of the Ming generally consisted of conventionalized motifs, in the Qing, Literati painting values were absorbed by ceramic art, which featured free-hand figures, plants, and landscapes. By the middle Qing period, the discrepancy between craft and fine art had thus grown smaller, and certain highly successful and scholarly painters (such as Hua Yan, 1682-1756) spent some of the early years of their careers working in the Jingdezhen porcelain industry.

Among renowned artists who led in Nanchang, the capital of Jiangxi, were Zhu Da (1624-ca. 1705) and Luo Mu (1622-1706). The latter, an admirer of Dong Qichang (1555-1636) and Huang Gongwang (1269-ca. 1354), is considered the father of the Jiangxi School of painting. Also a calligrapher, poet, and tea connoisseur, Luo Mu is remembered for the superb ink effects he obtained in his *pomo* ("splashed ink") landscapes. Although his style is related to that of Xie Shichen (1487-after 1567), it is inspired more directly by Dong Qichang's Orthodox approach. Later followers of Luo Mu carried on his methods, which were so suited to depicting the rainy weather of the Nanchang region.

*WAN SHANGLIN (Wanggang), 1739-1813*

*Landscapes*

Album of ten leaves, ink on silk
10½ x 9 inches each leaf

Leaf One: Scholar on a Riverbank

> *Inscription:*   Leisurely gazing at autumn waters,
>    my mind empty,
> Quietly listening to a universe in harmony,
>    my spirit is stirred.
>
> Wan Shanglin.
>
> *Artist's seals:*   *Wan Shanglin yin*, square, intaglio
> *Wanggang shuhua*, square, relief

Leaf Two: Temple by a River

> *Inscription:*   Dew wets my garments, but I take no notice.
> Gusts of wind blow through the willows and onto
>    my face, but I feel nothing.
>
> *Artist's seals:*   *Wan Shanglin yin*, square, intaglio
> *Wanggang shuhua*, square, relief

In the middle Qing period, Chinese landscape painting was dominated by the Orthodox School. Because of this, Wan Shanglin, who worked outside of Orthodox circles, has been overlooked by art historians. He was a native of Nanchang, Jiangxi Province, and a landscape painter whose work has been compared to that of the Ming masters Shen Zhou (1427-1509) and Xie Shichen.

Nanchang at that time was the center of a small group of artists, the Jiangxi School, led by Luo Mu. It is not certain whether Wan Shanglin is considered a member of the Jiangxi School or not, since no references on this school list his name. In terms of style, he painted in the Orthodox manner following the Wu School, as did Luo Mu. The ten leaves in this album are all landscapes in monochrome ink on silk, done in powerful free brushstrokes showing the influence of Shen Zhou. Even the calligraphy reveals that he was inspired by this 15th century master.

Painted in free wet strokes, Leaf One shows a gentleman seated on a knoll amid trees, lost in the enjoyment of nature. Opposite him is a rocky cliff whose angular lines counterbalance the long deft strokes of the tree trunks. Above are mountain peaks with a little village nestled among them. Only the roofs are visible, but they give the impression that the world of culture is very close to this wilderness area. In the far distance, peaks painted in light wash complement the dark and angular brushwork of the foreground and draw the painting to a gentle close. The artist has captured a feeling of clarity and freshness, and his skillful juxtaposition of light and

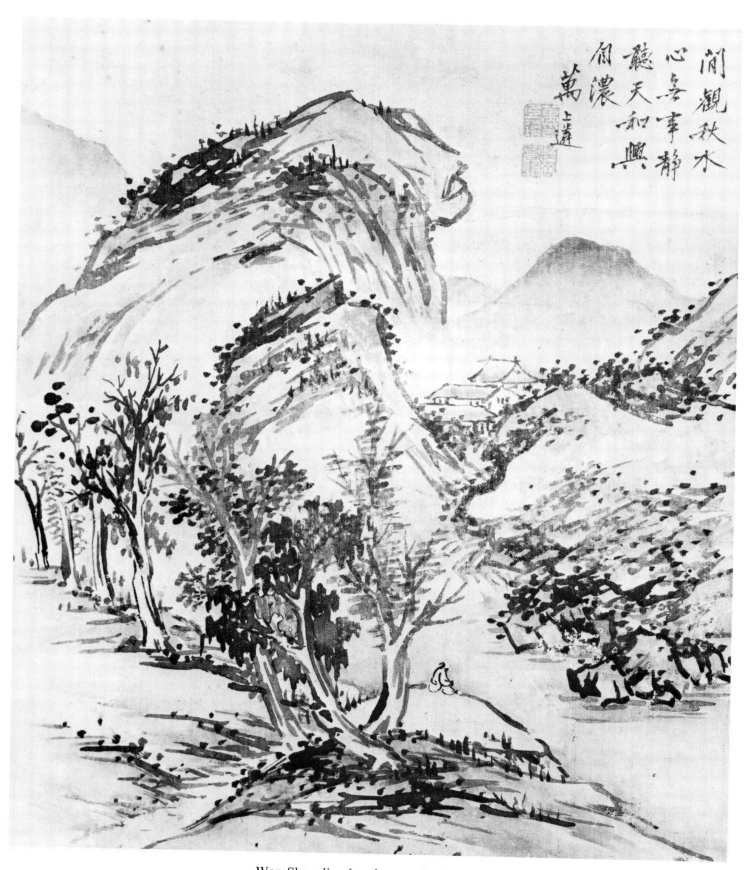

閒觀秋水心多事靜
聽天和興自濃
萬上遴

Wan Shanglin. *Landscapes:* Leaf One.

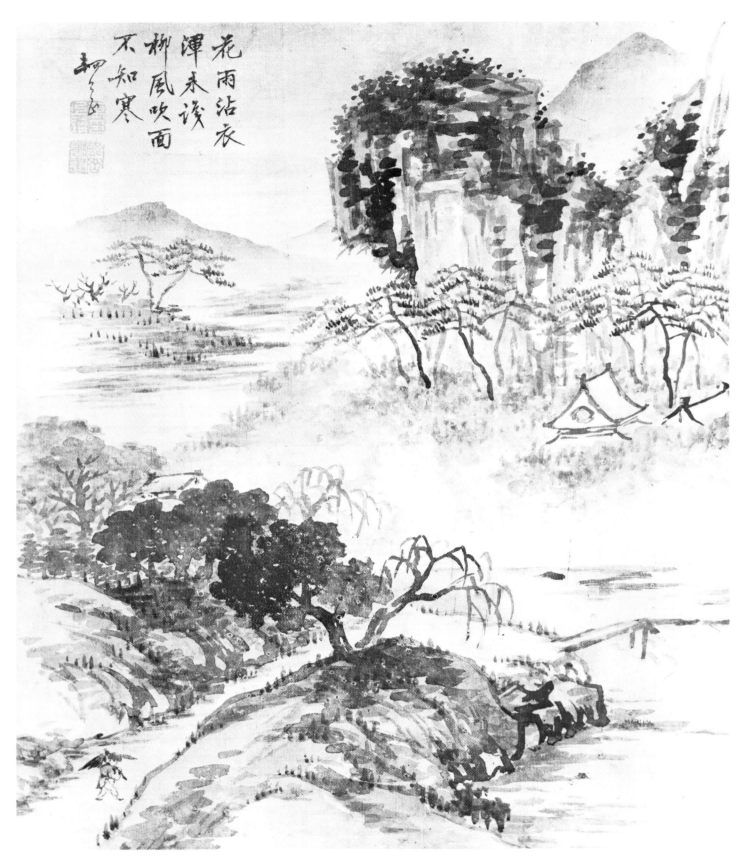

花雨沾衣
渾未覺
柳風吹面
不知寒

Wan Shanglin. *Landscapes:* Leaf Two.

182

dark tones creates a powerful image of a carefree scene. The painting was completed in a spontaneous outpouring, and so conveys fluid movement. In his sensitivity to atmosphere, the artist has attained the spirit of Xie Shichen. The whole scene conveys a poetic harmony with the natural world, restoring a calm balance between nature and the human spirit.

In the second leaf in this album, Wan Shanglin sketches a mist-filled mountain scene. The picture is similar in composition to the first leaf, with a river dividing the painting diagonally, but this time the banks are more clearly separated. In the foreground are trees drawn with large dark leaves, and willows with twisting branches. A figure stooped under an umbrella hurries along the path, reinforcing the feeling of moist air. The bridge over the river extends out of the picture and so suggests the vastness beyond the painting. On the other side of the river, surrounded by tall pines, the roofs of a temple rise from the river mist. The arrangement of the pines is most successful, unified in rhythm, each tree twisting in a unique way and varied in tone. Beyond, the river turns and continues till it disappears in a realistic recession into depth. All is moist and fresh, the effect of extensive use of wash, fluidly drawn brushstrokes, and dark rich tones of ink. The complete album seems to have been painted in one "breath" rather than with each leaf in a different style after certain old masters. Although there is a range of versatility, a pronounced continuity of style is also evident.

# Guangdong Artists

When Marco Polo visited the land of Cathay in the 13th century, he was struck with awe and admiration for its cultural splendor. Through his writings, Europeans were introduced to this mysterious world, but the Chinese remained in the dark about the West for centuries longer. In 1601, confronted by another Italian in the person of the Jesuit priest Matteo Ricci, the puzzled Ming court could only identify him vaguely as a "person from the Atlantic." Attempts to establish trade between China and Europe in the 16th century were initiated by the Portuguese, who were granted permission to stay in Macao. Following close behind them were traders from Spain, Holland, Great Britain and France. Moreover, European missionaries were making their way to China where they introduced western science, technology, and religion, mainly to court scholars. Fierce competition for the Chinese market led to the opening of four ports along the southern coast to foreign trade in 1685. Guangzhou (Canton), the one closest to the international ports of Southeast Asia, emerged as the most important, and it soon became the major door through which western culture poured into China.

Guangdong Province, of which Guangzhou is the capital, lies at the southeastern corner of China. Its warm climate, rich agricultural production, and relatively small population afford its residents a comfortable and prosperous life. The appreciation of fine art is an old tradition there, with the beginnings of its own unique painting style dating back to the Tang period. One of the greatest masters of bird painting, Lin Liang (active 1450-1500), was a native of Guangdong. Many other famous artistic names are associated with this locality. Shitao's (1641-ca. 1710) trip to Guangzhou had a significant effect on his art, and Cantonese connoisseurs are credited with being among the first to recognize the extraordinary genius of this painter's work.

During the 18th century, Guangzhou's commercial development gained momentum under the impact of foreign trade. As new wealth stimulated patronage of the arts, output by local painters increased in quantity and quality, budding into an assortment of expressive modes with a peculiarly regional flavor. Collecting was carried on to a degree not far behind that in Beijing (excluding the imperial

collection) and other major cities. While western techniques observed in imported European prints played a role in the formulation of new styles, Chinese citizens returning home after overseas sojourns brought with them fresh enthusiasm for their own culture. This augmented the interest in antique studies spawned by the middle Qing scholar's preferred pastime, textual research *(kaoju)*. Awakened to their national identity by the influx of outsiders into their midst, the custodians of classical learning plunged into a comprehensive reassessment of their own past; at the forefront of this movement were the scholarly and artistic circles of Guangdong. China's first art academy was founded in Guangzhou during this era, and a surge in the publication of magazines and books on art fed creative diversity. Eclectic and experimental throughout the 1800s, pictorial art in this province culminated in the first half of this century in the Lingnan School, which, despite extensive western influence (partly filtered through Japan), was deeply rooted in native aesthetic solutions. The gist of this school's objectives was to find a means of expression that spoke not just for times gone by but for a changing China in a modern world. This progressive tendency was already a moving force behind much of Guangdong painting in the middle Qing period.

*LI JIAN (Erqiao), 1747-1799*

**Landscape**

Hanging scroll, ink on paper
54 x 16 inches

> *Inscription:* Painting two days after the seventh month, seventh day in *jiyou* (1789) at Liubo Studio by Erqiao, Li Jian.[1]
>
> *Artist's seal:* *Xiaozikuang Jian,* square, relief and intaglio
>
> *Collectors' seals:* Four seals, all illegible

Because of its flourishing economy, the result of its role as a major port engaged in foreign trade, Guangzhou became a gathering place for intellectuals and artists in the mid-18th century. The region's topographical characteristics, as well as local customs and attitudes, contributed to the formulation of a unique artistic tradition. Perhaps the most outstanding painter who worked in this area during the middle Qing period was Li Jian, a native of Shunde District in Guangdong Province.

As a young boy, Li Jian showed considerable talent for painting, with his "splashed ink" impressions of the scenery he encountered during his travels with his merchant father. A bright youth, Li Jian was writing and reciting poetry at the age of ten, and also casting his own ancient-style bronze seals. At the age of about 16, after living in Guangxi Province for some time, he returned to Guangdong with his mother.

While he practiced the modes of the ancient masters Dong Yuan (ca. 900-962) and Juran (ca. late 10th century), Li Jian is heavily indebted for many aspects of his painting style to Wu Zhen (1280-1354). He was proficient in both meticulous *gongbi* techniques and the more freely expressive *xieyi* method; these he applied not only to landscapes but also to depictions of flowers, birds, and figures. Critics of his time praise him as a master of the "three sublimes" *(sanjue),* poetry, calligraphy, and painting. To these should be added a fourth: seal carving.

After Li Jian's marriage at the age of 20 to Liang Xue (Feisu), an artist in her own right, the two made their home and studio at Yaoyange.[2] This name, meaning "Pavilion of Medicinal Vapors," alludes to the frequent ill health of both husband and wife. They lived a quiet life, earning commissions for their art works; Li Jian also taught in a suburb west of Guangzhou. Such distinguished artists and scholars as Xi Gang and Weng Fanggang (1733-1818)[3] sought out his company to view his work and exchange ideas. The association of these worthy names with that of Li Jian enhanced his reputation and increased the demand for his paintings and writings. Those who requested them, however, were accommodated only if they found the artist in a favorable mood; not infrequently, no matter how high the price offered, potential clients were chased away from Yaoyange by a raving madman. Li Jian apparently reconciled himself to the notoriety that these outbursts earned for him, since he carved a seal for himself reading *Xiaozikuang Jian* or "Jian the Lunatic" (see the seal on the painting presented here). His distressed condition was aggravated by his wife's death in 1784, which prompted the inconsolable painter to

write over a hundred poems expressing his grief and longing for her.

That same year the renowned poet, artist, and high-ranking statesman Yuan Mei (1716-1797)[4] visited Guangzhou and courteously sent a calling card to Li Jian. Far from feeling honored by the recognition bestowed on him by this distinguished person, Li Jian not only refused to receive Yuan Mei, but went so far as to write a lengthy letter to the latter's son (an official serving in Guangzhou at the time) replete with insults addressed at his father. This instance of flagrantly offensive behavior toward a superior, along with his well-known indulgence in alcohol, redoubled Li Jian's disrepute throughout the country. Nonetheless, the popularity of his art was not diminished by his scandalous conduct; it is said that the couplets he wrote at the New Year were stolen off his own doorposts, so coveted were his creations. Three years before his death, twenty-five volumes of his poetry were published under the title *Wubaisifengtang shichao*, "Manuscript of Poems from the Hall of 504 Peaks."[5]

No signs of mental impairment or emotional instability are outwardly manifest in Li Jian's paintings. Although he took up the brush only when inspiration overtook him, he nevertheless painted with utmost discipline, observing natural appearances assiduously and applying ink and color only where they were essential to his design as a whole. These features hold true for both extremes of his landscape style: one somewhat cluttered with hills, rivers, boats, houses, and figures after the manner of Wu Zhen, the other in the spare mode of Ni Zan (1301-1374). The elements of local folk art in his pictures furnish them with a fresh, lively, somewhat naive quality and decorative flavor akin to those of scenes found on Coromandel screens made for export and on *kesi* tapestries of the Ming period. The murals of artists associated with the Taiping movement of the mid-19th century display an approach similar to Li Jian's.

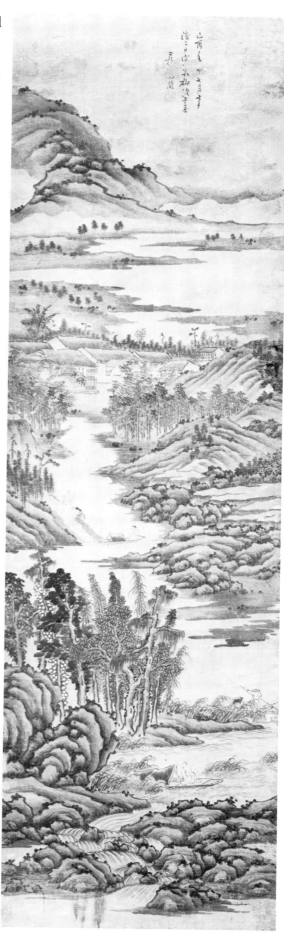

Li Jian
*Landscape*

187

This landscape illustrates Li Jian's inventive combination of mainstream Literati techniques and the folk tradition of his native region. The manner of the artist's inscription in running script, the pictorial theme of an idyllic fishing village, and the full composition with rounded hills receding into the distance—all these traits are traceable to Wu Zhen. Moreover, the leisurely pace of the brush movements and the loose, open structure of form, despite its multiplicity, also relate to this Yuan master. The spirit of Wu Zhen's approach to painting as a joyous, vivifying act permeates Li Jian's work.

Through both subject matter and style, this picture allures the eye with its images of gently rolling hills and quiet waters, of scholars taking in the scenery and boatmen contentedly going about their business, of the graceful swaying of grasses and trees in the light breeze, of rustic cottages nestled together on a wooded shore. This array of figures and objects, outlined in ink and colored in pale umber, deep green, and ink washes, is organized into a foreground, middle, and background, and is presented from the *pingyuan* viewpoint, that is, looking from a high point across a vast expanse of low hills. Despite the visibility of far distances afforded by this point of perspective, convention calls for the indication of spatial recession through the use of mist, fading hues, and blurring as well as the gradual diminution of pictorial elements. Although Li Jian uses the latter method, he virtually ignores the former devices. However, this must not be attributed to any deficiency in the artist's technical abilities, for the extreme tilting of the ground plane and the vertical piling up of the "three depths" are the means by which a moving focus, as opposed to a fixed angle of vision, is established. Just as in viewing a handscroll painting, the spectator "travels" through Li Jian's hanging scroll landscape and beholds each of its components from a different angle. Consistent with this format also is the lack of emphasis on any single portion of the composition. Each cluster of rocks and grove of trees, every turn of the river and the rise and fall of every slope, is to be savored individually. The picture thus does not represent a specific glimpse of nature as viewed through a window, but rather a journey within nature to be experienced through the dimension of time as well as of space.

The vertical sequence of the three sections of land is derived from folk art, and provides the decorative flavor of the painting. Not only the inviting subject matter, but also the apparent proximity of even its hindmost segments, accounts for the immediate accessibility of the landscape as a whole. But once "in" the painting, the discerning eye will observe sophisticated delineation. The group of trees on a nearby riverbank epitomizes Li Jian's versatile skill: eight or more species are depicted in distinct foliage patterns. The free energy in the strokes of the wind-blown grass and flowing water strikes harmonies with the easy meanderings of the contours defining the semicircular rock and hill conformations. Where ink appears in wash, as in the shoals and background mountains, it is masterfully applied in unmuddied patches without any trace of the brush. The rhythmic upsweep of these repeated stroke patterns and the vitality revealed in each individual touch of the brush are sources of the landscape's synthesis of decorative and scholarly appeal.

In this painting Li Jian does not aspire directly to Literati ideals, nor does he seek to impress the spectator with an overt demonstration of bravura brushwork or eccentric composition. As a poet, he used common words and a straightforward manner to voice his thoughts with a moving poignancy, and his pictorial work bespeaks this same unpretentiousness and honesty. Proud of his local heritage, he

veils a superior command of Literati technique within a primitivistic design. His success in achieving this unlikely union affirms his importance not just within the Cantonese School of painting, but also in the greater context of middle Qing period art throughout China.

*NOTES:*

1. The seventh month, seventh day is the festival of the Cowherd and the Spinning Maid.

2. Another name for Li Jian's residence was Baihuacun (Village of a Hundred Flowers).

3. *Jinshi* degree in 1752. Official, calligrapher, seal carver, and authority on *jinshi* (engraving) studies. Authored *Liang Han jinshi ji (Record of Engravings of the Two Han [Dynasties]).*

4. *Jinshi* degree in 1740.

5. Li Jian's *hao,* Erqiao, refers to two mountainous areas that he frequented near Guangzhou: Xiqiao (West Qiao) and Dongqiao (East Qiao). The latter is more commonly known as the Luofu Mountains. The total number of peaks of Xiqiao and Dongqiao is 504, hence the name of Li Jian's hall in the title of this poetic publication.

## *ZHANG WEIPING (Nanshan), 1780-1859*

### Landscapes

Album of eight leaves, ink on paper
10¼ x 11½ inches each leaf

Leaf One: Pines and Full Moon

| | |
|---|---|
| *Inscription:* | The lake a thousand feet deep,<br>The moon a wheel's fullness,<br>Transparent water under a bright moon of silver<br>A wind from Heaven stirs snow-white waves.<br>This remarkable feeling—indescribable.<br>Who knows this? Ask Old Iron.<br>Who is Old Iron?—the pine tree. Nanshan. |
| *Artist's seals:* | *Chen Weiping yin,* square, intaglio<br>*Pin,* square, relief<br>*Hai,* square, relief |
| *Collector's seal:* | (Lower right) *Shouting xinshang,* square, relief |

Leaf Eight: Mountain Studio

| | |
|---|---|
| *Inscription:* | Closing the door to write books,<br>Time passes easily.<br>Planting pines in my old age,<br>I make myself more noble. |

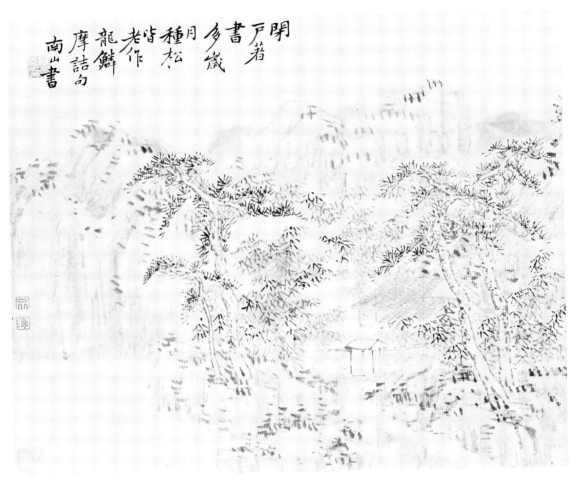

閉戶著書多歲月　種松皆作老龍鱗　摩詰句　南山書

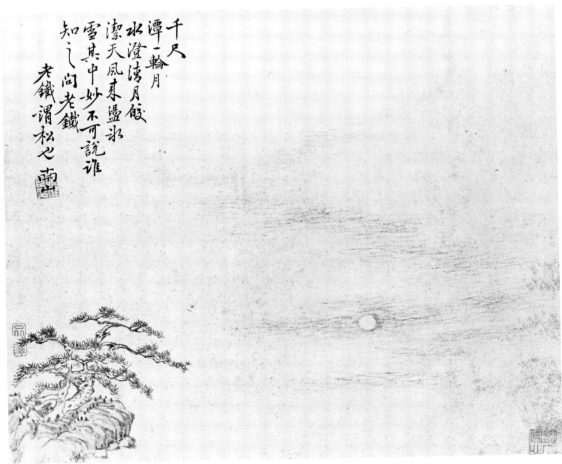

千尺潭一輪月　水澄灣月皎　潔天風來墨水　雪其中妙不可說誰　知之尚老鐵　老鐵渭松也

Zhang Weiping
*Landscapes:*
Leaves One
(above) and
Eight (below)

Moji's (Wang Wei, 699-759) verse. Written by Nanshan.

*Artist's seals:*   *Chen Weiping yin,* square, intaglio
                    *Pin,* square, relief
                    *Hai,* square, relief

*Collector's seal:*   (lower left) *Shouting xinshang,* square, relief

Zhang Weiping was a native of Panyu in Guangdong Province. A prosperous agricultural and fishing community, Panyu is noted for its scholars and artists, including the Gao brothers: Gao Lun (Jianfu, 1879-1951) and Gao Weng (Qifeng, 1889-1933). In 1822 Zhang Weiping passed the examination for the *jinshi* degree and was appointed magistrate of Huangmei District in Hubei province. He was a benevolent official, well-loved by the people of the region. The story is told that when a disastrous flood came, he worked with the residents trying to prevent the destruction of their homes and crops. In the process he nearly drowned, but was rescued by a floating log. It was said of him, "He saved the people and Heaven saved him." This incident reinforced his reputation for being a conscientious, upright official.

As a young man he was known for his calligraphy and poetry. He was influenced by Li Bo (701-762) and Su Dongpo (1036-1101), and demonstrated his admiration for them when he was posted in Nanchang, Jiangxi Province, by sponsoring the building of a shrine in their honor. The pine, time-honored symbol of longevity and constancy as well as of virtuous character, held great meaning for him. Thus he named his house "Listening-to-Pines Studio," and even called himself "Pine-Heart" (Songxin).

After withdrawing from official service, Zhang Weiping returned home and spent a leisurely retirement studying and painting, inspired by the beautiful scenery of Guangdong. Many books of his poetry were published, but his paintings have been overlooked, even though some bear colophons by noted scholars. His figurative works are said to be in the style of Chen Hongshou (1599-1652), while his landscapes follow Shitao.

This romantic painting showing the moon reflected on water is reminiscent of Ma Yuan (active ca. 1190-1224), called "One-Corner Ma" for his diagonal compositions. However, where the Song artist would have filled 40 to 60 percent of the picture with land, leaving an upper corner blank as an evocative void, the terrain in the lower left corner of Zhang Weiping's work occupies only about 10 percent of the picture plane. Although the rocky bank and two gnarled pines overlook a vast hazy expanse, the central purpose does not lie in the contrast of tangible terrestrial elements with the mysterious void beyond, as in Song art. Instead, Zhang Weiping's landscape is conceived as a tripartite design: a solid, clearly defined segment of land, a vague area in which water blends imperceptibly with sky, and finally the inscription, itself a combination of the visual art of calligraphy and the literary art of poetry. The three units are interdependent; ingeniously balanced to compose a unified whole, each draws equal attention in turn from the spectator.

If any single part is the focal point, it is the reflection of the moon on the mirrorlike surface of the water. Shitao employed a similar device by directing the focus

of a number of his paintings to a bird or to boat sails on wind-swept waves, but Zhang Weiping's night scene evokes a more calm, contemplative mood. This moon, nothing but a circle of unpainted paper, is the mere shadow of an unseen object located in the unfathomable depths of the sky. Just as the aged pines on the shore lean toward the fleeting image that dots the dark waters, so does the nebulous quality of the boundless space suggested here elicit the mental ponderings found in poetry. Indeed, Zhang Weiping's verse covers a portion of this "emptiness," yet to an eye accustomed to simultaneously separating and integrating the written text on a painting, it is simply another dimension in the aesthetic experience of this work of art.

The poem first reinforces the sense of wonder that the picture inspires, and then returns to the metaphor of the pine, symbol of wisdom as well as an allusion to the artist, "Pine-Heart," himself. Thus, despite the diminutive size of the three passages that make up this work, and despite the unassuming, even bland manner of their treatment, all are inextricably bound together by the "fullness" of the blank paper between them, and by an underlying ideational coherence. Such unity illustrates the close association of the arts of poetry, calligraphy, and painting during the middle Qing period.

Deliberately limiting the range of his ink tones and the scale of his landscape elements, Zhang Weiping presents a picture that is neither imposing nor dramatic. True to the Literati character of his time, he requires of the viewer a developed capacity for response to indirect expression and subtle suggestion. This approach of understatement is particularly appropriate for this painting's theme of evanescence. The calm, spare brushwork, and the lack of color or even ink modulations, imbue the image with serenity, but only through patient attentiveness and acute sensitivity on the part of the onlooker may this elusive feeling be grasped.

The largely unpainted surface and elevated, distant perspective of the first leaf differ from the full, close-up view in the final leaf. Tall pines border a path in the foreground that leads to a gate, beyond which can be seen a couple of rustic houses enclosing a yard. With a lake in front and a wall of mountains behind, the setting is an ideal retreat for a scholar. The Chinese have an adage: "In mountains, one sees benevolence; in water, wisdom." A scholar here would be in the best of company, surrounded by bamboo, pines, mountains and a lake.

Zhang Weiping's outstanding technical ability is demonstrated in the "severed band" strokes *(zhedaicun)* that contour the rocks and hills. Except for the washed ink representing remote peaks, form is defined by a dry brush and an exceedingly light touch. This lightness is sustained by the staccato effect of the loose network of dots and short strokes that animate the entire landscape. The swish of bamboo leaves and the bristling of pine needles in the soft breeze are almost audible. Although mountains and trees fill much of the paper, their presence is only implied by pale, sparse strokes of ink. With their substantiality essentially dissolved in this way, the blank masses signifying sky and water take on added visual impact.

Once again, Zhang Weiping's ink is even-toned, his brushwork placid and plain. Painted for the sophisticated sensibility, this work testifies to the artist's strong ties to the mainstream Literati tradition of painting as carried on during the early 19th century.

## SU RENSHAN (Changchun), 1814-1849

## Two Figures

Hanging scroll, ink on paper
47½ x 13¼ inches

| | |
|---|---|
| *Inscription:* | Portrait of the Qin physicians He and Yuan. Painted by a later follower, Su Changchun. |
| *Artist's seal:* | *Jingfu*, square, relief |
| *Colophon by Gao Lun (Jianfu, 1879-1951):* | He and Yuan were superior physicians of ancient times. Dr. Qifang[1] is a superior physician of today. Ancient techniques differ greatly from modern ones, but the principle of medicine is the same. Then, see how the physician (Dr. Li Qifang) treasures this painting. It is not a good sign? Jianfu. |
| *Seal accompanying colophon:* | *Panyu Gao Lun*, square, intaglio |
| *Collectors' seals:* | |
| (Lower right) | *Biliu zhencang*, square, intaglio |
| (Lower left) | *Youhuan buru xingyi shi Zhongshan xiansheng mian wo yu* ("To be an official is not as great as to be a physician; this is a point on which Mr. Zhongshan [Sun Yatsen] has encouraged me"; seal of Dr. Li Qifang), square, intaglio |
| | *Huiyang Li shi Qifang suocang shuhuajinshi jingji zhi yin* (seal of Dr. Li Qifang), square, relief |

Collection of Medical History Museum, Shanghai College of Traditional Chinese Medicine, Shanghai, People's Republic of China

One of the more fascinating but obscure artistic personalities in the middle Qing period was the ill-fated painter of Guangdong Province, Su Renshan. Legend mixes freely with fact concerning the circumstances of his brief life, which ended tragically in a prison cell where he had been placed, according to some accounts, by members of his own family. Even his technical and stylistic development in art remains a mystery, particularly since he attained an extremely high level of proficiency and a peculiarly individual vision at such a young age. His achievement is all the more awesome considering his geographical remoteness in relation to the active art centers of China at the time, for he evidently never traveled outside of Guangdong beyond Guangxi Province. Little attention is allotted to Su Renshan in art history texts, even in those focusing on the Lingnan School. Most of his paintings have been lost, while many that remain have not been preserved in good condition. This artist has been rediscovered only recently, mainly by Japanese and Cantonese collectors who have promoted the appreciation of his work through a number of exhibitions and publications.

Like Li Jian, Su Renshan's home district was Shunde. From an early age he followed a vegetarian diet and associated with few people except monks, living on

and off at monasteries. It is said that he liked to sit out in the open in the mountains, sometimes for days at a time, just watching the clouds go by. He studied in Guangzhou for several years, hoping to pursue a life in the civil service, but by his early twenties he had abandoned this idea and turned to calligraphy and painting.

The sources of Su Renshan's artistic training are unknown, although his father is said to have been a painter. His calligraphy is based on the running script of Yan Zhenqing (709-785), with the apparent influence also of Huang Tingjian (1045-1105). Capable in landscapes, flowers and birds, and figures, Su Renshan is known primarily for the latter subject, especially Buddhist beings and historical worthies. These he depicts in the linear *baimiao* (plain outline) method, using calligraphic brushwork, strikingly original composition, and touches of whimsy.

The two seated figures in this painting are identified in the title, written by the artist in *li* script, as Drs. He and Yuan, both of whom lived in the state of Qin during the Spring and Autumn Period (722-481 B.C.). Dr. He is noted for his theory of the six *qi*,[2] while Dr. Yuan's use of needles in treating patients dates the technology of acupuncture to this ancient era. The famous physicians sit on the ground opposite one another, their diagonal disposition within the painting allowing the face of only the farther one to be seen. Dressed in antique fashion, they appear with hair styled in a knot and covered with a kerchief, with two ribbons draping down over the shoulders. Their robes are described with dark, heavy ink in fluid lines executed in an easy-going manner. Wu Daozi (active ca. 720-762) is called to mind by the broken outline, the irregularity in breadth of individual strokes, and the dynamic force of the brush work. On the other hand, the relaxed movement and loose bearing of form are in keeping with the essence of Gu Kaizhi (ca. 344-ca. 406). Paring down his delineation to a minimum number of strokes, the artist sustains a unified composition devoid of any superfluous matter and so exploits the representative and expressive potential of every touch to the full. Series of fine parallel lines signify the gentlemen's hair and beard, providing contrasting accents to the bold black-and-white configurations of the drapery. The simply rendered features of the doctor's face manifest the dignity, wisdom, and lofty virtue associated with the character of both of these medical sages.

The brushstrokes depicting the figures proceed in unison with those of the calligraphy above, producing a compelling oneness of design in the work as a whole. The inscription on the right opens with seven characters in *li* script, revealing Su Renshan's mature accomplishment in this style. His use of stele inscriptions as models is apparent, with the loose-knit, casual quality probably inspired by the Zhangqianbei and the Shimensong. Han period *li* script found on bamboo slips may also be a source of this carefree feeling. Clearly, the same brush manipulations and rhythms enacted in producing the title as well as the running script signature were employed in creating the pictorial image below. Even the colophon filling the upper left portion of the paper and written by a 20th century Lingnan artist in his highly personal style complements the mood and cadence of the other elements in this work.

In the true spirit of the *xieyi* tradition, Su Renshan conveys the essential character of his subjects with supreme economy of means and subtlety of taste. Like the figure painters among the Yangzhou Masters of the 18th century, he transforms antique brush modes into a personal approach. In the case of Su Renshan, this

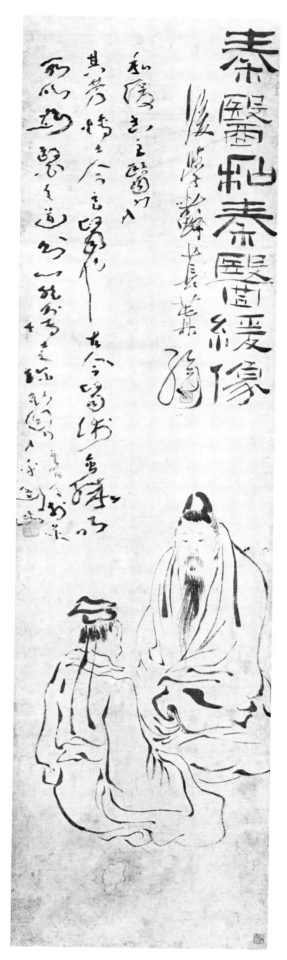

approach imbues his forms with substance and animation. Warm humanism, a keen wit, and a lively imagination along with remarkable mastery of the brush converge in the person of this man, a veritable phenomenon in art. As new verifiable information about his life is uncovered, and as additional examples of his paintings are studied, perhaps the genius of Su Renshan will become more clearly understood. The value of such an understanding will lie in a deeper appreciation not just of this artist's work alone, but also of Chinese art of the last hundred years, which Su Renshan, in his inexplicable way, anticipates.

## NOTES:

1. Dr. Li Qifang, Dr. Sun Yatsen's personal physician, and the former owner of this painting.

2. *Qi* may in this usage be translated as the vital forces within the human body.

Su Renshan
*Two Figures*

# Professional Artists

For centuries the distinction between professional and amateur painting has been a central issue in the study of Chinese art. Theoretically, a professional painter was anyone who made a living by selling his artistic creations, while an amateur artist was a scholar who painted as an avocation, inspired by the sheer love of art. Whether he held an official post or subsisted on inherited wealth, the amateur did not depend for his livelihood on accepting cash or other compensation for his paintings. For all lettered gentlemen, painting was an important ingredient in a social life that featured frequent gatherings where they not only discussed literature and art, but also engaged in extemporizing poetry and impromptu demonstrations of personal refinement in calligraphy and painting.

In contrast to the scholar, who was erudite, expert in calligraphy, and on easy familiarity with a wide selection of painting styles (as long as they were "Literati" styles), the professional artist was stereotypically less educated, something less of a calligrapher, and had acquired only a limited range of techniques through an apprenticeship to another vocational painter. The dissimilarity of these backgrounds supposedly resulted in fundamental stylistic differences between professional and nonprofessional painting.

Thanks to his broad education in the Confucian classics and literature, and his exposure to masterpieces of the past, the amateur was capable of pursuing spiritual values; that is, of manifesting the *dao* in his art. Trained technically but not philosophically, and also obligated to please a paying audience, the professional was presumably bound to paint pictures that were lacking in spiritual depth.

As actually practiced, however, these two categories overlapped to no small extent, since it was not unusual for a literatus to use his paintings as partial or total financial support at some point in his life. Indeed, many of the paragons of scholarly art are known to have relied on the sale of their painted works for income: the lofty-minded Northern Song master Mi Fei (1052-1107) and the Yuan scholar-recluse Wu Zhen (1280-1354) sold their own art; Zhao Mengfu (1254-1322) did so after he retired from government service. And even Dong Qichang (1555-1636), the

apotheosis of the amateur ideal, contradicted his own adamantly antiprofessional doctrine by accepting pay for his creations. It was, in fact, the latter artist who, at the close of the Ming Dynasty, rigidified the classification of art into professional (which he dubbed the Northern School) and scholar-amateur (the Southern School) through his analysis of historical schools and trends. The pervasive influence of his theories on subsequent art and art criticism perpetuated the myth of pure literati art undefiled by commercialism and clearly separate from professional art with its superficial attractions.

However, Dong Qichang is not to be blamed in full for the disparagement of paintings created with the intention of monetary gain, since this attitude springs from firmly entrenched social divisions that date back to the early stages of Chinese civilization. Traditionally, all types of vocations involving manual work or specialized skill were the occupations of the lower classes of society. In addition to laborers and soldiers these included musicians, physicians, and artisans. Populating the top of the social hierarchy was the educated man who exercised only his mind in his daily routine of study, writing, and ruling the country. As the model of moral behavior for the rest of society, his essential mission in life was to cultivate Confucian virtues in himself, and this necessitated his remaining aloof from material rewards for his accomplishments. But even within the framework of this ideal class structure, the practitioner of any skilled trade or craft could rise above the limits of his caste and gain acceptance by the intelligentsia if he approached his work with the non-materialistic goals of a scholar. Accordingly, a musician who was found to play music imbued with implications of the *dao* could win the respect of his social superiors and the admiration of generations to come.

But the conventional path toward entry to the intellectual stratum was a Confucian education and the passing of the civil examinations. A civil degree provided both a guarantee of employment in public administration, and automatic admission into the cultural elite. In the case of learned men who failed the examinations (or, because of their political convictions, refused to participate in the exam system), entry could be won through some other proof of their scholastic worth, such as published writings or requests from literati for essays or calligraphy. Like the musician who was elevated in status when a scholar recognized a certain profundity in his tunes, an artist who got his start as a vocational painter could cast off the derogatory label of "professional" if he were recommended by an influential member of the lettered class.

In reality, whether branded a professional or exalted as literati-amateur, any artist claiming a name in Chinese history has done so on the basis of some literati content in his work. In the art academy of the Song emperor Huizong, scholastic requirements were high and paintings were conceived as interpretations of poems. Art as mere decoration had long been rejected by all painters of historical consequence, and this was especially true as the possibilities of social mobility increased and the aspiration of more and more commoners was the acquisition of honor for themselves and their descendants through acceptance into the ranks of the literati. Consequently, by the 18th century art was divided only into "high art" and handicraft, the latter category encompassing ancestor portraits and pictures created for purely ornamental purposes. Now, anyone who painted for a living had to fulfill the prerequisites of the scholar-amateur artist: brush techniques had to be based on those of calligraphy and the conventions of ancient masterpieces; use of ink and

colors was to comply with certain standards of elegance and harmony; and choice of subject matter was mainly limited to traditional themes. For a talented and ambitious young painter without social advantages, the observance of these requirements was the only assurance of selling his works to a patronage that revered the Literati ideal.

The persistence of the distinction between amateur and professional through modern times was not based on artistic style so much as on social and economic consideration. The nine artists discussed below were typical "professional" painters of the middle Qing period. Making careers of art, most did not hold official posts and, even if they dabbled in poetry or other scholarly fields, their main activity and means of support was painting. Still, far from being simply skilled brush technicians, they were educated men whose works matched those of many of their Literati contemporaries in their attainment of an antique spirit and insights into the mysteries of the *dao*.

*SHEN QUAN (Nanping), 1682-1760 or later*

**Magnolias and Peonies (Honor and Prosperity)**

Hanging scroll, ink and color on silk
41 x 11¾ inches

|  |  |
|---|---|
| *Inscription:* | Study based on a model by Songxuelaoren (Zhao Mengfu). Early winter, *yichou* (1745), Nanping, Shen Quan. |
| *Artist's seals:* | *Shen Quan zhi yin*, square, intaglio<br>*Nanping,* square, relief |
| *Collectors' seals:* |  |
| (Lower right) | *Jingyouzhai zhencang jinshishuhua*, rectangular, relief |
| (Lower left) | *Yilantang shuhua yin*, rectangular, relief<br>*Bingren ? ?,* square, relief |

Collection of the Birmingham Museum of Art, Birmingham, Alabama

This painting was executed when the artist had achieved not only popular recognition but also the deeper experience of life that age brings. Thus, the painting embodies a philosophic understanding of nature. According to Chinese tradition the magnolia, along with the cherry-apple blossom, also shown here, symbolizes an honorable household, while the peony has long been an emblem of prosperity. Besides fulfilling its function of adorning the wall of its owner's home, then, this work bears a message of good wishes for honor and wealth.

To create an elegant floral composition, it is necessary to take the utmost care in the placement of the various flowers, branches, and leaves, as well as in the color harmonies. In this painting, each kind of flower is rendered with the visual and tactile characteristics and the freedom of movement it possesses in nature. The smooth, thick magnolia petals are gracefully curved and seem to grow naturally from their stems. The peony, in its rich profusion of delicate petals, obtains a vibrant quality through the clear definition of its form. A single twisted stroke delineates the curving stem in conformity to the processes of natural growth. The almost tangible, tender, semitransparent substance of the leaves is created in part by the inclusion of their red veins. This detail, and the establishment of depth through the arrangement of the peonies, the dense growth of foliage, and the suggestion of volume in the turning of the magnolia blooms, are influences from Dutch flower painting, which had been introduced to the East by missionaries in the 17th century. Some of the leaves in the painting are barely visible; their faint appearance is partly due to fading and to the darkening of the silk support, but also to the artist's intention of representing the tentative and frail sprouting of new foliage.

It must be remembered that Chinese painting does not afford the luxury of reworking that is inherent in the western technique of oil painting. Each stroke, each touch of the brush, must be correct the first time. Shen Quan applied his color gradations from light to dark in order to achieve a naturalistic effect. In this piece he exhibits all the facets of his skill: mastery of natural forms, densities, and textures,

and the elegant balance of hues that he had observed in Song art. Yet he has conveyed more than just the formal beauty of the flowers; he has transformed his subject matter into an expression of his personal cultural outlook.

Shen Quan was a native of Huzhou in Zhejiang Province, and was active there until his fame prompted the emperor of Japan to extend an invitation to visit his country. Shen Quan went to Nagasaki in 1729[1] and remained in Japan to teach and paint for about three years. His first recorded painting, "Hollyhock and Cat" (1731), was executed in Japan. In 1760 he painted "Wild Goose in Reeds." Although this is the last account of his activity offered in Japanese and Chinese records, paintings dated as late as 1778 have been attributed to him. However, these unlikely dates throw such works into doubt, and conclusive evidence of the year of Shen Quan's death remains to be uncovered.

A specialist in finely detailed and brightly colored paintings of flowers and birds with luxuriant plant growth, Shen Quan also painted landscapes and animals. He is said to have been strongly affected by European art, in particular Dutch animal and flower paintings. But, except for the few western aspects of his work discussed above, he seems rather to have absorbed the technical secrets of the Song masters. In the Qing period, when Orthodox landscape painting was in vogue, the Song tradition of careful workmanship was revived only by Yun Shouping (1633-1690), who painted "boneless" flowers and birds with great subtlety. Obviously, Shen Quan had to be an exceptional artist to achieve great fame and fortune in the face of prevailing trends. He had many students, both in China and in Japan, his legacy to the latter country being the impact his painting style brought to bear on the art of flower arranging. Upon his return to China he gave away to friends and to the poor the large sums of money that Japanese nobles and merchants had paid for his paintings.

Given the immense demand for his paintings in Japan and China, Shen Quan may have signed works of his students with his own name, and the question of whether certain pieces were executed with the help of assistants poses a problem. Nevertheless, it is certainly possible to determine the genuine status of paintings as skillfully executed as the one presented here.

**Monkey**

Album leaf mounted as a hanging scroll, ink and color on silk
11 x 10 inches

*Inscription:* Painted by Nanpinglaoren.

*Artist's seal:* *Shen Quan*, round, intaglio

Many Chinese artists excelled in painting animals, and their repertoires often included the monkey. As early as Song times, various kinds of apes were portrayed as lively, capricious creatures, their homely facial features deemphasized in favor of their lithe movements. This animal is associated with nobility because of the

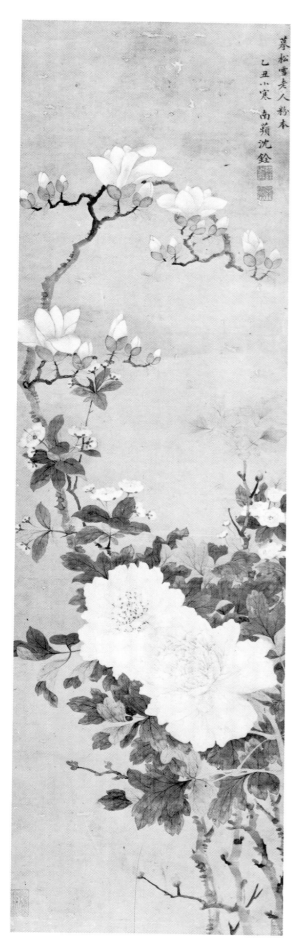

蓼松雪老人粉本
乙丑小寒 南蘋沈銓

homophony of the word for monkey with that for marquis (both pronounced *hou*). When monkeys are depicted along with wasps *(feng)*, homophonous with another term meaning "to confer (position or rank)," the painting serves as a kind of rebus offering wishes for the recipient's advancement in status.

Shen Quan's "Monkey" presents a unique setting of a cliff over the ocean with the rising sun. The animal, its fur described with fine ink strokes, clings to a vine growing from a sheer wall of rocky earth that protrudes out over a vast sea. The bluff's vertical disposition essentially divides the composition in half. A pale wash of mineral blue was applied first, followed by long fluid *cun* or "texture strokes" of malachite green. This boneless style (with no ink contours except a thin line along the edge of the mountainside) and the vivid mineral colors have their sources in late Tang murals and early Song painting. Such treatment brings the rocky forms into high relief and suggests a moist, moss-laden surface. The dots of deep crimson representing autumnal foliage on the tangled vine complete the rich, archaic color scheme.

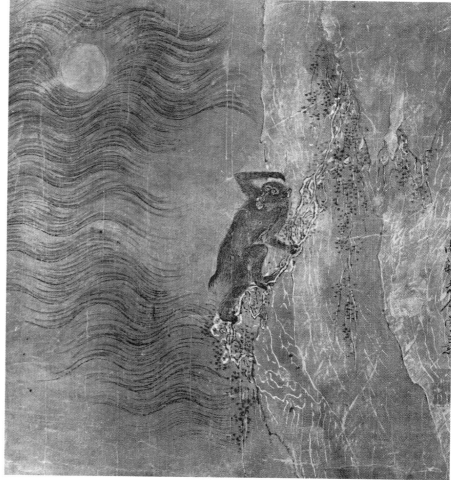

Shen Quan. *Magnolias and Peonies (Honor and Prosperity).*

Shen Quan. *Monkey.*

201

The scattered accents of red in the right half of the picture are counterbalanced by a blazing ball of cinnabar red in the upper left corner, the object of the monkey's intent gaze. The sun appears in a field of undulating ink lines that occupy nearly the entire left portion of the painting. The graceful sideward flow of these sea waves meets at a right angle with the land. Moreover, whereas the stoney wall is viewed from a close, frontal position, the sea extends into the depths of space, even past the sun rising above an unseen horizon. This element of fantasy raises questions about the pictorial content of the work. Whether Shen Quan is illustrating a fable or legend, or whether he is injecting his imagination into memories of his own travels across the sea, is not clear.

Despite its obvious references to antiquity, this painting discloses its 18th century origin in several respects. The strong ink outlines and heavy colors of the Song period are softened here for purposes of technical and chromatic harmonies. In addition, the Song artists' fidelity to natural appearances, as well as their masterful invocations of infinite space, are modified to suggest the illusion or supernatural phenomenon of the sun rising out of the sea. On the other hand, Shen Quan captures the poetic ambience and immediate charm of Song pictures. In fact, his superior command of this subject gave rise to rumors that he was the reincarnation of the famous 11th century painter of apes Yi Yuanji (died 1064). Considering the successful depiction of the monkey's inquisitive and playful character and the convincing reality of the fanciful scene, Shen Quan's contribution to animal painting may be considered among the most important of the Qing period.

*NOTE:*

1. This is the date given in *Guochao huashi*. Osvald Siren cites Shen Quan's dates in Japan as 1731-1733.

*WANG YUANXUN (Xiangzhou), 1728-1807*

**Three Immortals in a Forest Clearing**

Hanging scroll, ink and color on paper
35 x 61 inches

*Inscription:* Painted by Xiangzhou, Wang Yuanxun.

*Artist's seals:* *Wang Yuanxun yin*, square, intaglio
*Xiangzhou*, square, relief

Collection of Mr. and Mrs. William M. Spencer, III, Birmingham, Alabama

Wang Yuanxun, a native of Shanyin, Zhejiang, was a painter of figures, landscapes, and flower-and-bird compositions, but he was most noted for his portraits. It has been said that his portraits of gentlewomen surpassed even those of the Tang

Dynasty painter Zhou Fang (active ca. 780-810) in their nobility and refinement. Wang Yuanxun's portraits captured not only the likeness but the spirit of the sitter.

This painting portrays three of the Eight Immortals, the legendary beings of Daoism who attained immortality through their study of nature's secrets. However, despite the subject matter, this is not a religious painting; it would not be suitable for display in a temple or for use in religious ceremony. Even the choice of these particular three immortals is prompted not by tradition but for reasons of compositional arrangement and harmonious contrast: beauty and deformity, youth and age, male and female.

The lame beggar, Li Tieguai, often appears with a deer. Supposedly, even while Li Tieguai was alive, his magic powers were appreciated by the celestial world. In popular legend, he sometimes left his body behind in the care of a disciple in order to journey to heaven as pure spirit. Once, after an especially long heavenly sojourn, Li Tieguai returned to find his body burnt by the disciple. The only body available for his soul was that of a dead beggar. In this depiction, Li Tieguai carries a pilgrim's gourd with a curling wisp of smoke escaping from it to symbolize his power to set the spirit free from the body.

The lady is He Xiangu. A shopkeeper's daughter, she became a supernatural being after eating a charmed peach. Wandering in the hills, He Xiangu lived on powdered mother-of-pearl and moonbeams, which gave her immortality. Next to her stands a figure who is probably Lan Caihe, judging from the flower basket and the blue gown. However, this immortal is generally regarded as a woman. The only male immortal with similar attributes is Han Xiangzi, who has the power to make things grow, but his emblem, the flute, is absent here. He Xiangu and Lan Caihe both hold pieces of fungus or *lingzhi*, the plant of immortality. Deer are said to be the only animals capable of finding this sacred fungus. The pine tree also symbolizes long life.

The challenge in Chinese figure painting, always the most difficult genre, is to capture not only a human likeness (imaginary figures, like the Immortals, must look as though they could possibly exist), but also the underlying spiritual quality of the subject. Figures in Chinese painting must have a certain beauty reflective of their inner virtue. Wang Yuanxun's subjects are lively, believable types: the crookedly smiling cripple, the sweet and contented lady, the virtuous young man. They make a unified, harmonious group; deep in conversation with each other, they create their own atmosphere. The dreamlike, unworldly feeling of the scene is heightened by the smoke curling out of the gourd and vanishing into the blank, unpainted background. A slight breeze in the thin air wafts through the Immortals' robes and ruffles the ends of their belts. This is indeed the ethereal region where the Immortals gather.

Wang Yuanxun has combined two very different painting techniques in this work. The hair on the figures and the skin of the deer are rendered in very fine strokes that closely duplicate the texture of the real thing. On the other hand, the wrinkles on the robes (especially that of Li Tieguai), the twisting stem of the pine tree, and the rocks and waterfall (which are partially passages of unpainted paper) show exceptional freedom. This coupling of minute detail and spontaneous brushwork brings to mind the work of the 20th century artist Qi Baishi (1863-1957), who

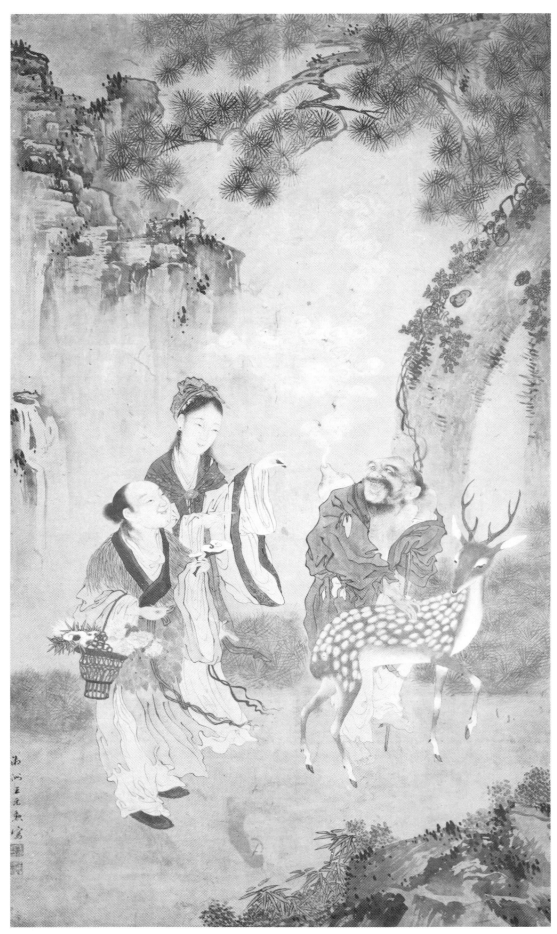

Wang Yuanxun. *Three Immortals in a Forest Clearing.*

could paint a tiny insect next to a tangle of boldly brushed vines. The evenly blended solid areas of color in Wang Yuanxun's painting—the light green wash of the ground, the flat areas of the robes—are particularly hard to achieve on paper. Unlike silk, paper tends to show every touch of the brush. Wang Yuanxun's skill as a colorist is also emphasized by this type of absorbent surface; clear, bright hues are much harder to achieve on paper. The painter has chosen subtle tones that harmonize well together. From the brushwork and the way in which Wang Yuanxun has executed the details, it seems possible that he was influenced by Tang Yin (1470-1523), a Ming artist with a Literati background who worked as a professional painter.

Traditionally, depictions of the gathered Immortals celebrating the birthday of Xiwangmu (Queen Mother of the West) were often given as birthday gifts. One might speculate that this painting was one of a set depicting all eight Immortals. However, certain details suggest that the painting is a complete work in itself. It does not represent a specific season, so it is unlikely to be one of a four seasons group showing all the Immortals. The signature in the lower left corner indicates that this picture is either a single piece or the final panel of a group. Finally, the large size of the painting would make it the center of attraction wherever it was hung.

After the great period of landscape painting in the 17th century, many artists turned to the human figure. The demand for this genre grew rapidly during the 18th century. Wang Yuanxun's superior skill, as exhibited in this work, gives concrete evidence of the high standards that distinguish figure painting of this era.

## FANG XUN (Lanchi), 1736-1799

### Landscapes

Album of ten leaves; ink, and ink and color on paper
14½ x 8¾ inches each leaf

Leaf Seven:

*Inscription:* House on a rocky shore in the woods, in the style of Ke Jingzhong.

*Artist's seal:* *Xun*, square, relief

Leaf Ten:

*Inscription:* Painted in *yiwei* (1775), midsummer. Fang Xun of Shimen.

*Artist's seals:* *Fang*, square, intaglio
*Xun*, square, intaglio
(Lower right) *Lanchi*, square, relief

Collection of Mr. and Mrs. Mitchell Hutchinson, Chicago, Illinois

Toward the end of the 18th century, two men from western Zhejiang Province who were famous for their poetry, calligraphy, painting, and classical learning were known as the Two Noble Scholars of Western Zhe. These esteemed personages were Fang Xun and Xi Gang, the latter ten years the junior of the former. By this time, the once-prevalent influence of the Four Wangs on landscape painting had begun to wane; moreover, most of the celebrated masters of Yangzhou had passed away, and artistic trends in the Jiangnan region had begun to shift. Even if they fell short of the provocative creativity of their forebears, painters such as these two in addition to Qian Du, Chen Hongshou, Huang Yi, and others ascended to preeminence not just on the merits of their calligraphy and painting but also for their excellence in the multifarious aspects of traditional scholarship. Besides this, Fang Xun was venerated for his personal integrity.

At a young age Fang Xun left his home in Shimen to travel with his father Fang Mei (Xueping) around the two provinces of Zhejiang and Jiangsu. He met noted scholars along the way and established a reputation for himself as a calligrapher and painter. When his father died, the youthful artist was left alone in the world with no means of support. Fortunately, a scholar named Jin Eyan of Tongxiang in Jiaxing District in Zhejiang took him in as a resident artist. Because Jin Eyan's mother was a devout Buddhist, Fang Xun was asked to copy sutras in his elegant *xiaokai* script and to paint Buddhist images for her. Jin Eyan himself took an interest in art and, as a distant relative of Xiang Yuanbian (1525-1602), he had the opportunity to purchase works of art from the heirs of this great collector. Gradually, Jin Eyan accumulated a sizable collection of ancient masterpieces, each of which he had Fang Xun copy. Thus the two passed years together, immersed in art day and night, the artist instructing his patron in historical painting methods and authentication. Fang Xun naturally reaped extensive benefits from constant exposure to this collection and from daily practice. He eventually acquired superior skill in painting landscapes, figures, and flowers, and it is said that his renditions of old pictures could hardly be distinguished from the originals.

Fang Xun did not marry until middle age, whereupon, as a man with no kin of his own, he moved in with his wife's family. Still, Jin Eyan wanted to continue his close association with the artist, to the point that he discouraged the now-famous Fang Xun from producing paintings for others, even for very high commissions, and from accepting teaching posts for handsome salaries. Finally, however, Fang Xun received an offer he dared not refuse, though he was unwilling. This came from the renowned poet and chancellor of the Grand Secretariat, Ruan Yuan (Yuntai, 1764-1849), who met Fang Xun on an official visit to Zhejiang. Impressed with his abilities, he asked the artist to go to Hangzhou to work with him. Failing health forced Fang Xun to retire after only about a year, and he died shortly thereafter.

Among Fang Xun's numerous books, some of which remain unpublished, *Shanjingju lunhua*, a two-volume study of art, is the best-known. Despite his notable literary and artistic accomplishments, he never sought personal advancement through the customary channel of the civil examinations and an official career, either because of lifelong poor health, a lack of self-confidence (apparently stemming from, or reflected by, stuttering problems), or both. Nevertheless, even with his steadfast loyalty to the possessive Jin Eyan, word of his lofty scholarship, artistic talent, and upright character spread far and wide during his lifetime. Later generations referred to him as one of the four leading artists of the middle Qing, along with

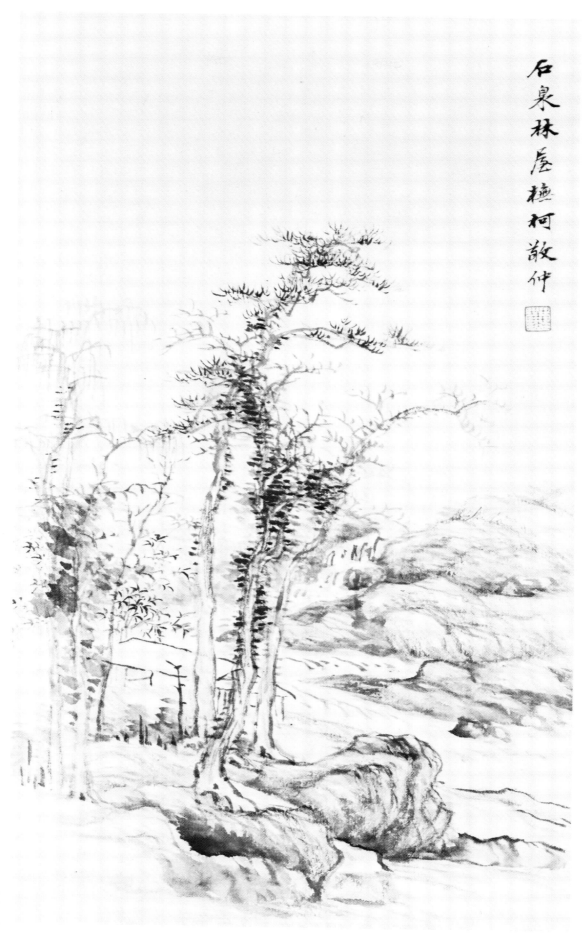

石泉林屋樓柯散仲

Fang Xun
*Landscapes:*
Leaf Seven

Xi Gang, Tang Yifen, and Dai Xi, together commonly called Fang Xi Tang Dai.

Due to Fang Xun's ample experience in copying and interpreting the works of the old masters, his paintings display more technical virtuosity than novelty of conception or design. In answer to a query from Xi Gang concerning the best way to practice in order to achieve a high artistic level, he answered: "Rather than complexity or simplicity, pursue a Literati quality. Follow the canons with discipline to attain the essence of painting *(huazhi).*" These comments and his paintings themselves demonstrate that Fang Xun embraced the artistic ideals of Dong Qichang. Like the latter artist, he admired Mi Fei, and in his *Shanjingju lunhua* praises this Song master's method of completing a painting in "one breath," that is, in one sitting under a single stream of inspiration.

This "one breath" execution may be observed in Fang Xun's landscapes, in which pictorial elements are often linked into a unified whole by contours and texture strokes that appear to be mutually connected. This feature is displayed in an album of ten landscapes, particularly in a leaf painted after the manner of Ke Jingzhong (Ke Jiusi, 1312-1365). Drawing on this Yuan master's preferred subjects, Fang Xun depicts a few wintry trees and bamboo growing on rocks. Just behind the plants a small hut is set on the bank of a river that tumbles down the side of a steeper bank in the background. The prominent foreground and gradual fading off of the far shore is in keeping with the style of Ke Jiusi, as is the crisp clarity of the pine needles against a cool, transparent sky. This effect is also reminiscent of Xin'an School artists. But Fang Xun's trees and other forms do not stand out with the compelling power of those of 17th century painters. Instead, they are quietly asserted as semiabstract components of a single cohesive structural unit. A model of the middle Qing predilection for refined brushwork, understated expression, and hidden force, Fang Xun nevertheless reveals his own persevering nature and spiritual vitality in the delicate yet tenacious twisting of branches and in the persistent weaving of a single strand of energy throughout this scene of varied elements.

Rather than following a certain Song or Yuan artist like the nine other leaves, the final leaf of this album sums up the styles of various past masters in an unusual composition of Fang Xun's own devising. *Pimacun,* or "hemp fiber strokes," are used for both the low shore and rounded rocks in the foreground, and the jagged peaks in the background. In his *Shanjingju lunhua*, Fang Xun theorizes that all of the conventional texture stroke patterns originate in the *pimacun*. Because of its primary importance and versatility, he relied heavily on this method for describing earth forms. The brevity and indefinite shape of his *pimacun* recall the manner of Fang Congyi (Fanghu, ca. 1301-1393), but here, as in Leaf Seven, Fang Xun applies these lines in series without lifting his brush.

The unpainted lower portion of this picture represents shallow water from which, farther up, weeds grow. On the riverbank jutting out from the right, two tall trees overhang a pavilion partly hidden by rocks. Beyond this bank, another stretch of water stops abruptly at a massive wall of stone consisting of a row of high slender encrustations leaning to the right in contrast to the foreground trees. Curving back into depth on the right, the eminence fades into a nebulous area of mist and wash, whereas on the left it opens up into a narrow, forested gorge from which a stream flows. Between the sheer slopes of this ravine, the mountain peaks continue for miles into the distance. A distinctive feature of this painting is the continuation of

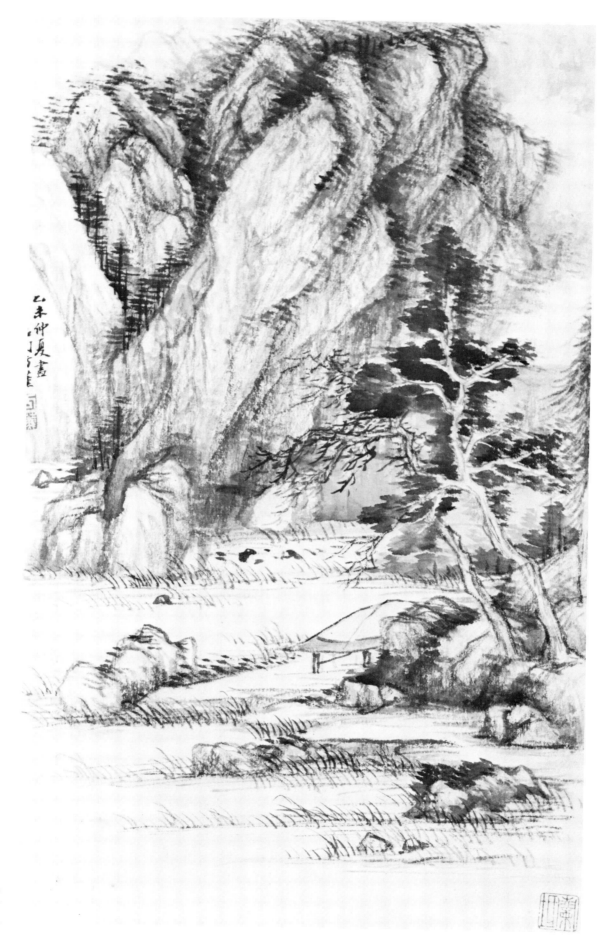

Fang Xun
*Landscapes:*
Leaf Ten

the mountains past the upper border of the paper; only a small corner at the top left is blank. Less obvious is the subtle yet convincing convexity and concavity of the crags and unexpected openings into deep space. Moreover, the frontal, massive buildup of cliffs, harking back to Fan Kuan (active ca. 990-1030), moves the viewer with its grandeur at the same time that it lures the eye with its sometimes ambiguous spatial relationships. Only patient, careful study discloses the full achievement of this small landscape. Its beauty, like the character of the artist, lies below the surface; but once discovered, it is rich in rewards.

The date of *yiwei* on the tenth leaf corresponds to the year 1775, indicating that Fang Xun was 39 when he painted his album. As an example of the artist's work done in middle age, the album exhibits both notable maturity of stylistic development and marked devotion to the Orthodox order of landscape painting. But Fang Xun's personal brand of orthodoxy differed from that of other painters of the time in that he ignored individualistic trends of the 17th century such as the art of Shitao (1641-ca. 1710) and Zhu Da (1626-ca. 1705), even though these masters significantly influenced numerous artists of the middle Qing era. And since he was not attached to either the Loudong or the Yushan School, Fang Xun was free to follow an independent course, rather than that of the Four Wangs, in his exploration of Song and Yuan modes and Dong Qichang's doctrine. Thus the present album is valuable on the one hand as evidence of Fang Xun's advanced artistic accomplishment at a relatively youthful age, and on the other as a representation of the continuing vitality of orthodoxy in landscape painting through the later 18th century.

## WU ZHAO (Qinghui), 1755-1811

### Bamboo and Orchids

Hanging scroll, ink on silk
20 x 13¾ inches

| | |
|---|---|
| *Inscription:* | In the style of the Yuan master Xu Youwen's (Xu Ben, died 1379 or 1380) deep, graceful brush. Dedicated to my fellow scholar Yiqing. Wu Zhao. |
| *Artist's seal:* | *Qinghui*, rectangular, relief |

*Collectors' seals:*
    (Top center)    *Guanhaidaoren*, square, relief
    (Lower right)    *Guanhaidaoren shending*, rectangular, relief
                     *Cui Keting jia zhencang*, rectangular, relief
    (Lower left)    Illegible, rectangular, relief
                     *Shou Peng guo yan*, rectangular, relief
                     *Hu Kuiwen shending shuhua zhi yin*, square, relief

Collection of William Warren Bartley, III and Stephen Kresge, Oakland, California

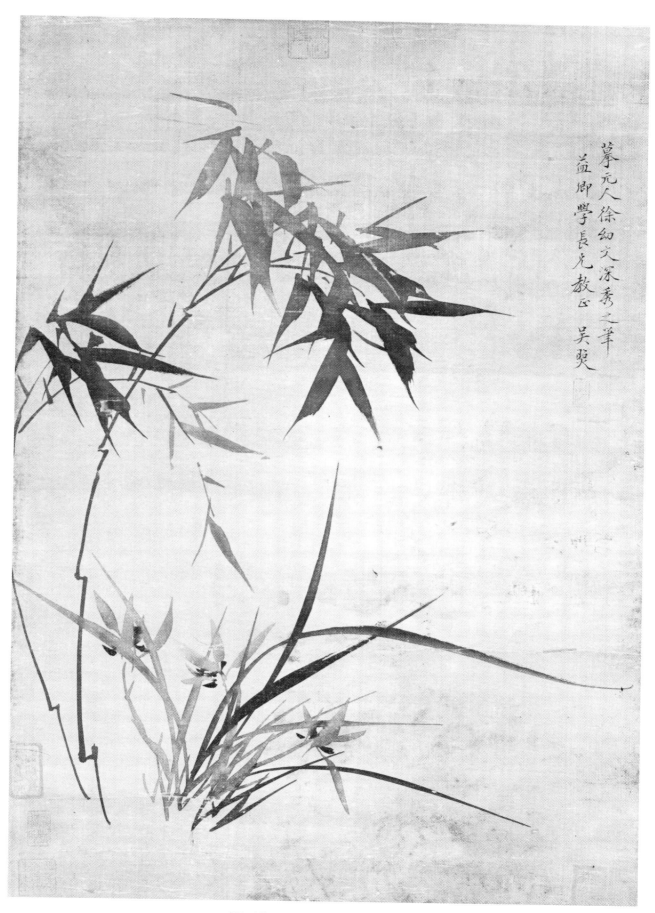

摹元人徐幼文深秀之筆
益卿學長兄教正 吳爽

Wu Zhao. *Bamboo and Orchids.*

211

A native of Nancheng in Jiangxi Province, Wu Zhao was awarded the degree of *bagong* in 1789 and subsequently held a position in the Administration of Education. Later he withdrew from public service to paint professionally. His father, Wu Xuan, was a noted artist in the early Qianlong period. A poet, calligrapher, and painter of landscapes, bamboo, and orchids, Wu Zhao is said to have been of a generous and easy-going nature. The Yangzhou artist Luo Ping once dedicated a painting to him, and the two friends exchanged poems and ideas on art. Wu Zhao mastered the six scripts and, true to the scholarly ideal, based his painting technique on the principles of calligraphy. His depictions of bamboo display the brush method known as *jincuodao*, characteristic of the writing of Liu Gongquan (778-865). This technique results in powerful strokes that almost appear to have been carved out with an iron chisel. In 1801 Wu Zhao completed a painting of orchids in ink, and a work of bamboo and rocks is recorded under the date 1804. He wrote several books, including *Shuowenziyuan kaolue (An Investigation of the Sources of Calligraphy), Laozi shuolue (A Brief Discussion of Laozi's Philosophy),* and *Tingyulou shiji (Selections of Poetry from the Listen-to-the-Rain Studio).*

This painting of bamboo and orchids represents the tradition of Literati art in two respects: thematic symbolism and brush technique. Bamboo is associated with the virtues of the scholar-gentleman; the exquisite fragrance of the orchid is said to evoke deep inspiration in man and so stands for refinement and purity. These two plants are part of the quartet of motifs known as the four gentlemen (with plum blossoms and chrysanthemums completing the group). Metaphors for the lofty-minded literatus, all of these subjects are readily executed with the materials and techniques of calligraphy. Zhao Mengfu, one of history's most revered painters of ink bamboo and orchids, advised mastery of the eight basic brush movements of calligraphy for portraying bamboo. In each element of his picture, Wu Zhao employs an appropriate style of writing to convey the spirit of the particular plant. For the bamboo stems in the *jincuodao* manner, cursive script *(caoshu)* is employed. The bamboo leaves display the regular script *(bafenshu* or *kaishu)*. The orchid leaves consist of strokes in the official style *(lishu)*, while the flower petals are based on running script *(xingshu)* and the flower stems on large seal *(dazhuan)* writing. In this way, the motifs of bamboo and orchids lend themselves to ink play with the subtle contrasts of light and dark, wet and dry, that Literati-artists so admired.

While calligraphy is the basis of Wu Zhao's technique and much of his painting's aesthetic interest, his brush never strays far from its close observance of his subjects' real forms in nature. This balanced tension between abstract and realistic contributes to the enduring quality of Literati art. Although completed with but a few brief strokes of the brush, this simple composition is the product of a lifetime of training and cultivation.

The silk on which this piece was painted is pinkish-orange in color and appears to date back to early Ming times. It was not uncommon for a patron to present an artist with antique silk for painting. Such a gesture was an expression of the patron's respect for the artist's skill. The collectors' seals appearing on this work represent a number of prominent scholars. They include Hu Kuiwen, a late 18th century literatus known for the fine brushes and ink that he made, and Shou Peng, a noted man of letters of the early 19th century.

# DONG FENGCHUN (Yuncha), active ca. 1791

## Autumn Landscape

Hanging scroll, ink and light color on silk
38½ x 20½ inches

> *Inscription:* Autumn, ninth month of *xin* (1791), in the style of the Song masters. Dedicated to Mr. Ximing; painted by Yuncha, Dong Fengchun, at Baoyang Guest House.
>
> *Artist's seals:* *Dong Fengchun yin*, square, intaglio
> *Yuncha*, square, relief
> (Lower left) *Xingtian luo bi*, oviform, relief

Collection of Mr. and Mrs. George T. McCoy, Hillsborough, California

The great distance from Dong Fengchun's native Henan Province to the artistic center of Jiangnan has forced this artist into historical obscurity, although he was an accomplished landscape painter of the late 18th century. Today, Dong Fengchun is better known as a teacher and friend of Wu Siye, a native of Jiangsu who achieved wider acclaim as an artist than his mentor. Wu Siye was already painting landscapes when he met Dong Fengchun in Henan. The active publication of art books in Jiangsu Province in this era assured a likely exposure for artists such as Wu Siye who were working there, while Dong Fengchun's fine efforts in a more remote location went unnoticed.

Therefore, little information has circulated on the life and work of Dong Fengchun, also known as Yuncha. No dates for his birth or death have been recorded. It is known that he was a scholar and calligrapher who took painting as his profession and who taught scholars at his studio, Baoyang Guest House. Much of his artistic individuality is indicated by his choice of models: Lan Ying (1585-ca. 1664), whom he particularly admired, and the Wu School masters Shen Zhou (1427-1509) and Tang Yin (1470-1523).

This painting, dated 1791, is very revealing of Dong Fengchun's artistic character and superior technical skill. The accord of his refined ink and brushwork, along with his personal aesthetic, impart an air-light ambience and inviting quality to the landscape. Display of his own talents supersedes allegiance to one tradition or school without the eccentricities of other individualists. This kind of exposure of the artist's knowledge and training and of his ease in producing a pleasing image, is peculiar to 18th century Chinese landscape painting.

For this artist, this priority produces a feeling of freedom and delight, evocative of a crisp autumn day. Without trying to precisely simulate nature, his fluid, alternately wet and dry brushstrokes engender the natural live qualities of the different elements: in the foreground, the hardness and wetness of rocks, the fragility of the flowers, the crooked configurations of the tree trunks, the paper-thin lightness of the autumn leaves, the sharp, bristling character of the pine needles, the softness of the river bank, the craggy rough surface of the rock mass. Together, the elements reside in an effervescent atmosphere. Ink and brush use is liberal and expressive,

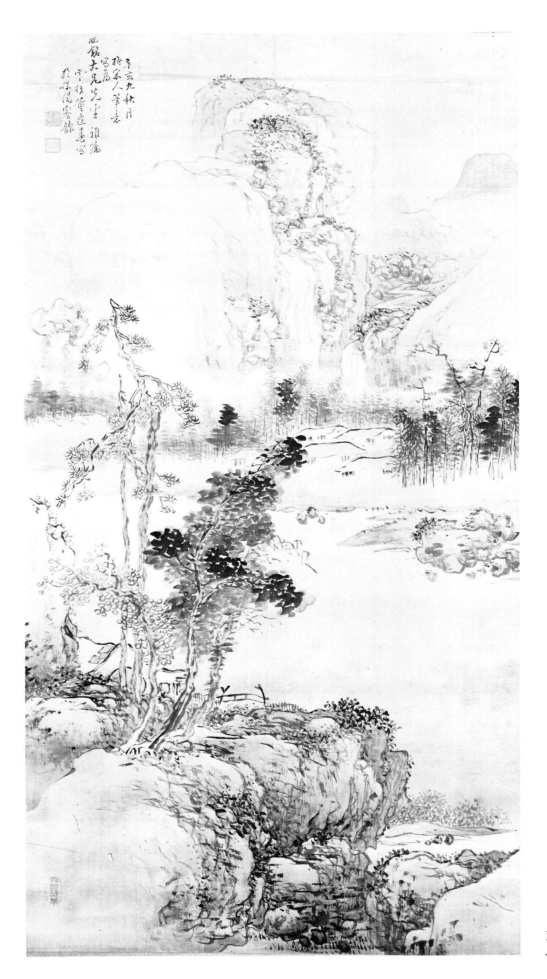

Dong Fengchun
*Autumn Landscape*

214

without undermining the cohesiveness of the composition.

Unity is achieved through techniques the artist may have studied from the works of Lan Ying, whose training was based on the tenets of the Zhe School. This late Ming master chose to juxtapose his numerous stylistic methods without modification in close proximity to one another, a step Dong Fengchun rejects here. What he does take up is Lan Ying's manner of suggesting Song majesty, but this is toned down to create intimacy. Also, instead of abruptly dividing the scene as Lan Ying often did, Dong Fengchun carries the viewer's eyes over a smooth progression from front to back, making the group of trees on the left a primary transition point. Although these trees are a strong unit, they are painted in a pale color wash that complements fine brushwork. Attention is eventually drawn to the massive mountain by the height of the pine and full leafy trees; they seem almost three-dimensional, and one can imagine peering past them into the distance. There, the dense forest gently ushers the eye to the impressive mountains, and down again to a cascade and low thatched houses along the shore.

Considering this example of Dong Fengchun's personal aesthetic and effortless, fluent brushwork, he deserves more attention than he has enjoyed in the past as a distinguished landscape painter of the middle Qing period.

### GAI QI (Qixiang, Yuhuwaishi), 1774-1829

#### Lady Holding a Covered Instrument

Hanging scroll, ink and color on paper
36 x 16½ inches

> *Inscription:*　Echoes of a new poem fill the empty hall,
> Tiny steps against the cold, revived after drink,
> Out in the snow, the imprint of a fur cloak is clear,
> Facing the wind, a lovely form—so graceful.
> When this doll smiles, her brows and cheeks bloom;
> She should pose with a single vase,
> And, with the rich hues of plum blossoms,
> 　be portrayed in a painting.
>
> Autumn, seventh month, fifth year of Daoguang (1825), Qixiang, Gai Qi.

> *Artist's seals:*　*Gai Qi zhi yin*, square, intaglio
> *Qixiang*, square, relief

> *Collector's seal:*　(Lower left) *Li Hao*, square, relief

Private Collection, La Puente, California

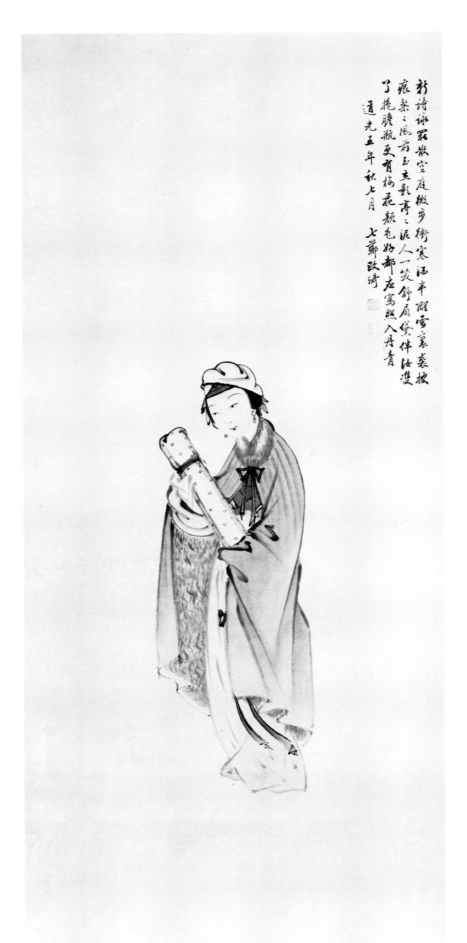

新詩詠罷散空庭微步衡寒澗半醒雪裹裹披
痕綦之風前玉立歌尊之泥人一笑鈿眉黛伴泊淮
了掩臙瓶更肖梅花顏毛野都應寫照入丹青
道光五年秋七月　七薌政壽

Gai Qi
*Lady Holding a
Covered Instrument*

216

The human figure had become a popular subject for painting by 1800. This was true not only in Yangzhou, where Huang Shen and Min Zheng had gained fame several decades earlier for their boldly brushed likenesses, but also in Hangzhou, and in the capital, where Yu Ji was known for his refined depictions of ladies and scholars. Demand for works in this genre reached such proportions in the later 18th century that an aphorism often quoted was, "Paint portraits for gold, paint flowers for silver; paint landscapes and become a beggar." This trend in part may account for the success of Gai Qi, whose portrayals of "beauties" as well as Buddhist and Daoist beings brought him wide reknown. His greatest achievement was his illustrations of *Dream of the Red Chamber (Hongloumeng)*, a project in which he was inspired by Tang Yin's pictures created to accompany the drama *The West Chamber (Xixiangji)*. Gai Qi's fifty-five figure paintings employing the *baimiao* (plain outline) method are faithful in every detail of appearance, manner, and temperament to the characters described in Cao Xueqin's classic novel. The illustrations were later transferred to woodblock form and, in 1879, printed as a book entitled *Hongloumeng tuyong*.

Gai Qi's family moved from their homeland near China's western border (probably modern-day Xinjiang Province) to Songjiang in Jiangsu when his grandfather was appointed to official service there.[1] Said to be a gifted youth, Gai Qi wrote poetry and excelled in writing small regular *(xiaokai)* script in the fluid manner of Yun Shouping. Seal carving was also one of his pastimes, though the quality of his work in this field never matched that of the other arts. Besides figures, he painted orchids and other flowers, bamboo, and landscapes. He mingled with prominent literary and artistic personalities of the day, among them Qian Du and Chen Hongshou (Mansheng). The latter once commissioned an Yixing teapot as a gift for Gai Qi, inscribing the body of the vessel with the dedication ". . . inscribed by Mansheng for Qixiang."

Each of this artist's depictions of ladies presents a unique character suggested by the subtlety of a pose or facial expression. Most of his early pictures were executed in thin lines of even width, based on the *baimiao* technique of Li Gonglin (1040-1106). Later, as in "Lady Holding a Covered Instrument," Gai Qi's brush loosened to produce a more spontaneous style in which lines vary in breadth and ink tones. In this painting, a woman dressed in a fur-lined cape over a long gown with her hair covered by a hat holds a musical instrument, undoubtedly a *qin*, wrapped in a cloth coverlet. This instrument, in addition to the woman's genteel deportment and fine apparel, indicates that she is well-bred, educated, and of some social standing.

During the middle Qing period, daughters of wealthy gentlemen were often given the opportunity to receive an education and to develop their artistic talents. Thus the figure shown here is representative of many women of the time. Her beauty, on the other hand, is idealized. Her sparkling eyes and high, slender eyebrows, the faint smile on her lips, her slight stature and graceful movement in tiny steps—all these features add up to an elegant, intelligent, feminine young maiden as conceived by the male imagination. Sensual beauty, however, is rejected altogether; to the Chinese eye, direct attention to physical aspects, including exposure of bound feet, would render the picture unworthy for consideration as a purely artistic creation. Rather, like the instrument tucked neatly within its cloth case and the fine fur that lines the inside of her cape, it is the woman's inner character that is of primary

217

importance here.

As an image of quiet nobility, of gentleness and grace, this lady is a model of the mystique of femininity that complemented that of the gentleman-scholar during Gai Qi's era. Yet even if she nears perfection, she is nevertheless human: amiability and warmth are generated not only by the softness of her eyes and the slight forward bend of her posture, but also by the curving lines and subdued colors that give her form. Moreover, although she is depicted alone on an otherwise unpainted field, her presence fills the painting, which would appear complete even if the artist's inscription were absent. This spaciousness reinforces the suggestion in the fall of her drapery that the lady is walking, while the sweeping strokes that define her clothing show the agile movements of the brush. With this work, Gai Qi demonstrates his mastery of vivid characterization in visual terms, and of the principles governing an aesthetic presentation of the human form.

### Lady Under a Banana Tree

Hanging scroll, ink and color on silk
32¼ x 13½ inches

>    *Inscription:*    Yuhuwaishi, Gai Qi.

>    *Artist's seal:*    *Gai Boyun shi*, square, relief

The decorative phase of Gai Qi's art is encountered in this painting of a young woman holding a cat and standing before a banana tree and yellow rose bush. The close-in focus includes only the upper half of the figure, a mode that gained popularity during the 18th century. The brilliant red of the lady's short coat is offset by the snow-white fur of her feline pet. Nearly filling the space around her, the banana tree grows up the left side of the scene, slightly to the rear of the figure. One of its leaves bends down to the right, forming an arch over the lady's head and echoing the downward slope of her shoulders. Establishing still deeper space, the tall rosebush blossoms behind the banana tree. The woman's hair, pulled loosely over her ears, is rendered with fine lines over light ink wash. Executed with exceptional control, these lines seem to grow and fall with the suppleness of natural hair. A tinge of pale blue in the white of the figure's eye further enlivens her face, and her hand is gracefully poised on the cat's head in a gesture of gentle affection.

Like the young maiden in the previous painting, this woman appears charming and mild, but her more casual manner, along with the bright hues of her clothing and the plants, and the comical countenance of the cat, endows the painting with a lighthearted, cheerful tone. Her form is integrated with the other pictorial elements by this mood, as well as by the consistency of the artist's linework. The fluid lines of her clothing are one with those defining the huge banana leaves and delicate roses.

A painting of this kind would have adorned the walls in the inner chambers of a

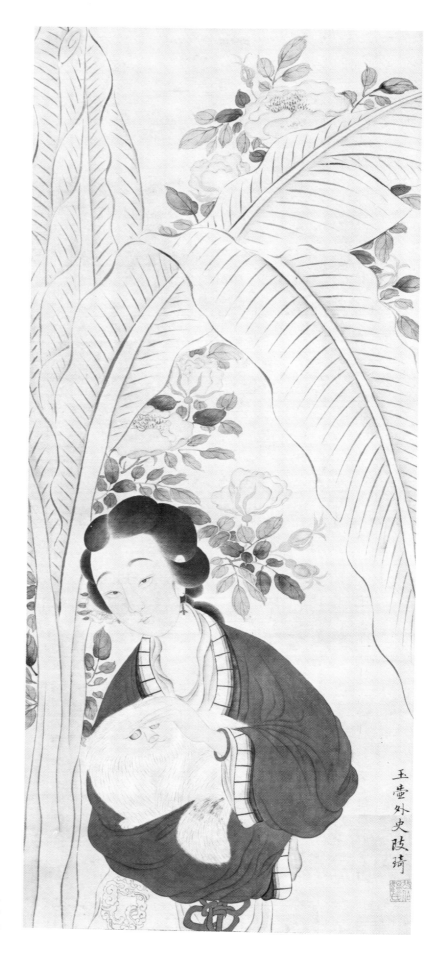

Gai Qi
*Lady Under a*
*Banana Tree*

219

19th century home, and would have been appreciated both for its artistic achievement and its didactic value as a portrait of feminine elegance and moral wholesomeness.

**Narcissus**

Hanging scroll, ink and light color on paper
23¼ x 12½ inches

*Inscription:*  Elegant flowers bloom under the hazy moon.
In plain attire, she gazes with bright eyes.
As dawn breaks one sees shadows amid heavy dew.
Outside the curtain, the breeze is light but fragrant.
At night the Jasper Terrace[2] is quiet; the royal crown
   is moist.
Deep within the little cave in spring, a cool jade pendant lies.
That glance is her most lovable feature.
Now, chanting poems brings memories of King Chen.[3]

Spring, *renwu* (1822), Yuhuwaishi. By Gai Qi.

*Artist's seals:*  *Gai Qi*, square, relief
*Yuhushanfang*, square, relief

Collection of Y. W. Shih, Tainan, Taiwan

In addition to modeling his calligraphy on the style of Yun Shouping, Gai Qi also followed this 17th century master in his depictions of flowers. This painting of narcissus exemplifies this influence at the same time that it typifies middle Qing views of art and nature. The Chinese word for narcissus, *shuixian*, means literally "aquatic immortal," for this bulb finds nourishment in plain water or even snow. Since it blooms in the bitter cold of the lunar New Year season, it shares with the blossoming plum the virtues of purity and perseverance, and symbolizes hopes for good fortune in the coming year. Gai Qi employs an ink outline technique in this work, coloring the leaves with pale bluish-green, the flower petals with pale yellow, and the coronas with golden yellow. The plants appear in empty space with only short weeds scattered around them. The absence of a groundplane asserts the ability of narcissus to grow without soil, while the expanse of unpainted paper above them suggests the flowers' ethereal quality and provides air in which their ambrosial perfume may circulate.

The delineation and spatial organization of the spear-shaped foliage indicate Gai Qi's advanced brush expertise. Each leaf is formed of long flowing lines, with color applied in two continuous strokes, leaving a thin strip between to represent the central vein. Although the leaves are interwoven in a complex yet tidy design, they turn and bend in all directions with graceful and relaxed movement. This subject lends itself to the artist's facility for linear elegance. Although this style is derived

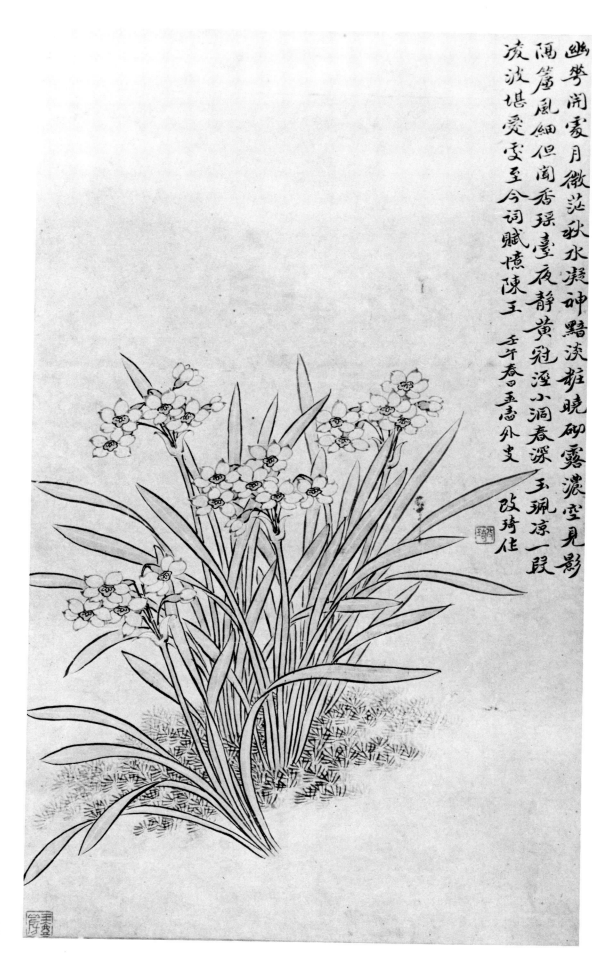

幽夢閒雲月微茫秋水凝神黯淡粧曉砌露濃空見影
隔簾風細但聞香琴臺夜靜黃冠涇小洞春深玉珮涼一段
凌波堪愛雲至今詞賦憶陳王 壬午春日玉壺外史
改琦作

Gai Qi
*Narcissus*

221

from Yun Shouping, Gai Qi replaces the awe-invoking splendor of this master's work with a more playful, intimate ambience. This subjective attitude is a salient feature of late 18th to early 19th century Chinese art.

The accomplished calligraphy along the upper right edge of the picture further characterizes this period in the choice of script (small regular) as well as brush manner and layout. The last is notable for the incorporation of the inscription into the painted image: the second and third lines accommodate the intrusion of a stray narcissus leaf. Moreover, the shorter length of the third line and placement of a seal to the left just above the final character breaks with traditional conventions of square or rectangular blocks of writing. The artist's addition of another seal in the lower left corner, signaling the bottom border of the intended pictorial space, shows Gai Qi's interest in the engraving aesthetic.

## Tao Yuanming's Peach Blossom Paradise

Hanging scroll, ink and light color on paper
23½ x 12¾ inches

*Inscription:* *Wuyan* (1818), *jiaping* (twelfth month), in the style of Liuru-jushi (Tang Yin). Qixiang.

*Artist's seal:* *Gai Qi*, square, relief

*Collector's seal:* *Likezhai yin*, square, relief

Collection of Bland Lane, Menlo Park, California

Despite Gai Qi's reputation for figure paintings, his landscapes were in considerable demand during his lifetime. The art critic Sheng Dashi (1771-?)[4] once commented that among the numerous fine-brush landscapes he had seen, none surpassed those of his friend Gai Qi, which "enter the realm of the Northern Song." It was most likely not Song paintings that nurtured Gai Qi's artistic development, but rather interpretations of such early modes by Qiu Ying (active 1506-1522) and Tang Yin. Aspects of both of these Ming masters' styles are present in this quiet landscape, although only the latter artist is named in the inscription. Thin, supple brush strokes with the tensile strength of steel wire are employed in land forms, trees, the figure, and his boat. Whereas this technique follows Qiu Ying, Gai Qi's colors are representative of middle Qing taste. Lightly washed and of subdued tones, the faint blue and orange hues merge with overall pale ink values to render individual elements elusive and the entire scene hazy and dreamy.

This atmosphere befits the narrative content of the picture, which illustrates "Peach Blossom Spring" *(Taohuayuan ji)*, by one of China's greatest poets, Tao Qian (Yuanming, 372-427). This famous essay relates the story of a fisherman who, rowing his boat up a river, finds that the water flows from within a cave. Once through the cave, he discovers a community of people living in perfect brotherhood

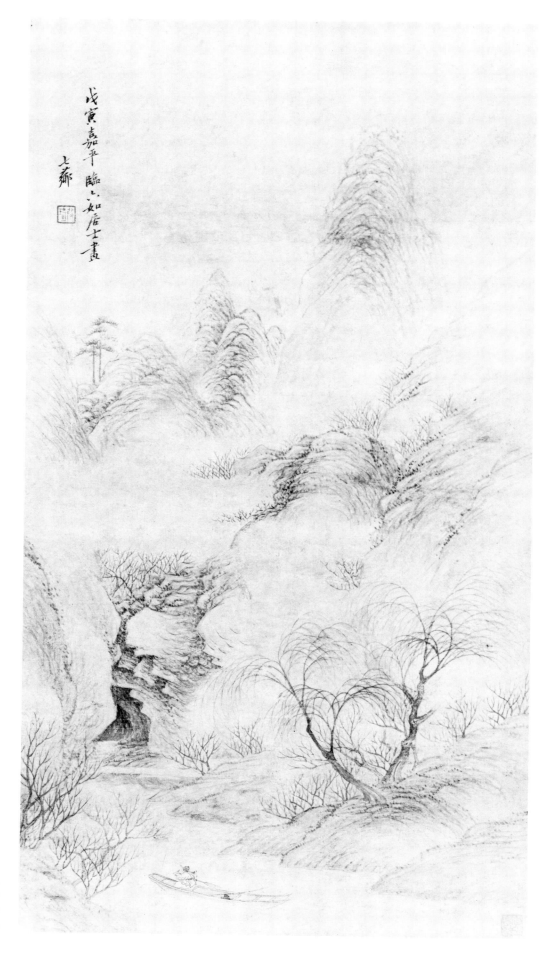

Gai Qi
*Tao Yuanming's
Peach Blossom
Paradise*

223

and peace with no awareness of the outside world. After returning home and telling others of his adventure, the fisherman rows up the same river, this time accompanied, to prove his fanciful tale. But the cave is nowhere to be found.

In Gai Qi's rendition of this story, the fisherman passes by peach trees in full bloom and approaches the cave carved out of a rocky edifice. Two tall weeping willow trees, their branches bare, exhibit finely brushed lines of fluent and lively movement. Just above the cave, jagged rock formations are constructed of parallel strokes after the manner of Tang Yin. Mountains branch off to either side and culminate in the distance in soaring peaks. The depiction of the hills, which, though built of delicate, pale lines, appear bulky, is interrupted by areas of unpainted paper suggestive of mist. This alternation of solid and void not only creates distance and monumentality, but also imbues the landscape with a sense of mystery. The viewer may easily be drawn into this fairyland, to sit beside the fisherman in his boat and to gaze up in wonder at the lofty splendor of the blossom-laden peaks.

## NOTES:

1. The name Gai is a sinicization of an originally non-Han Chinese surname.

2. Yaotai, the residence of Xiwangmu, Queen Mother of the West.

3. This type of poem, wherein a series of very loosely connected images consisting of worldly observations mixed freely with fantasy or mythological metaphor, was a popular accompaniment to paintings during the 18th and 19th centuries. Much is lost in the translation of such verses; in the original Chinese, however, they serve as embellishments to the pictorial image.

4. *Jinshi* degree 1800; Sheng Dashi was a poet, landscape painter, and art critic. A student of Wang Yuanqi, Sheng Dashi was considered a leading master of the Loudong School.

## WENG LUO (Xiaohai), 1790-1849

### Cat and Butterfly

Hanging scroll, ink and color on paper
52 x 20¾ inches

Inscription: *Xiaopenghaiwaishi*, Weng Luo.

Artist's seals: *Xiaohai*, square, relief
*Weng Luo siyin*, square, relief

According to the preface of his book *Xiaopenghai shiji (Selection of Poems by Weng Luo)*, Weng Luo was born in 1790 and died in 1849. He came from a noble family that claimed its origins in Wujiang (the present district of Wusong in Jiangsu Province). Weng Luo's father, Weng Guangping, was a noted scholar with a particular fondness for antiquity. He authored several books on classical studies and, though poor, lived the life of a pure-minded literatus. As a calligrapher and poet, he was respected in the intellectual circles of his time. Despite this fame, his artistic

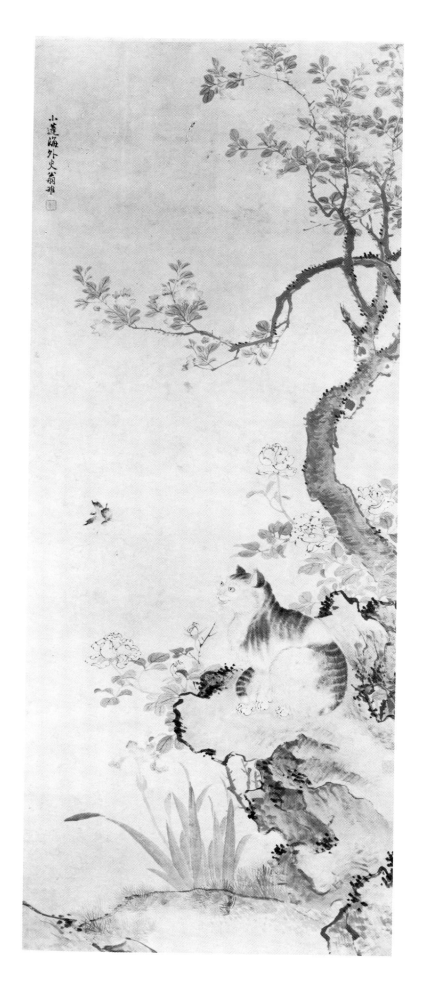

Weng Luo
*Cat and Butterfly*

225

talent was not widely known. Weng Guangping passed his talents on to his children, especially to his second son, Weng Luo.

It is said that Weng Luo was born with the love of art and antiquity. He showed genius in painting, particularly in portraits and figures, and received recognition before middle age. This artist excelled in depicting flowers and birds, insects and animals, but after his forties gave up figure painting. His family's collection of ancient masterpieces gave him the opportunity to study past achievements. As a friend of many famed artists of his time, he was able to exchange thoughts, opinions, and techniques with them. After practicing the methods of various schools, Weng Luo invented a personal style in the painting of flowers and birds, which he taught to his students. He was a highly respected artist during his own lifetime.

Except for a small sampling in Chinese and Japanese museums, not many paintings by Weng Luo exist today. In 1838, in collaboration with Qian Du and three other artists, Weng Luo painted a large work for the great scholar and teacher Jiang Shengming, entitled "Holding the Lantern and Teaching Children How to Read."

The painting presented here was probably conceived as a gift for a friend's birthday. Cats are favored subjects in Chinese paintings, but they are one of the most difficult animals to depict. In addition to achieving a representation that is true to nature, the painter must capture the creature's spirit and imbue the image with life. In China, cat and butterfly paintings *(maodietu)* are very popular because of the meaning that they convey. *Mao* is the word for "cat," but it is also the sound for a word meaning "over eighty years old." Similarly, "butterfly," *die*, is homophonous with a word for "over seventy." Such pictures involving puns abound in Chinese art: bats connote happiness; deer, emolument. Here a butterfly approaches a cat that sits on a rock, an emblem of longevity due to its hardness and resistance to decay. Above the cat are cherry-apple blossoms *(haitang)*, symbolic of a noble household. Beneath the tree and behind the cat are yellow roses, and an iris to stand for peace. Thus, the artist is wishing longevity and peace to the noble household of his friend.

Outstanding technical skill is displayed in this painting. The rock and tree branches are painted with strong ink outline. The delineation of the roses demonstrates the artist's mastery of the brush, just as the fine lines of the cat's fur testify to his aesthetic refinement. The iris and cherry-apple blossom are rendered in the boneless *(mugu)* style, without outline. Using pure and harmonious colors, Weng Luo has created a unified and lively composition out of many small components. It should be noted that color wash and fine strokes demand special discipline from the artist. The absorbent quality of paper often causes colors to run, so the correct amount of ink and water needed for each brush stroke must be accurately gauged. Moreover, the materials used in Chinese painting do not permit corrections or retouching after the initial movements of the brush. Within the framework of these restrictions, Weng Luo succeeds in capturing the inner nature of his subjects with admirable finesse.

# Scholar-Amateur Painters

In every period of China's history there have been artists who, for one reason or another, do not fall into any particular school or movement. Without inclusion in such convenient groupings, these painters usually won only limited fame during their lifetimes and so were often overlooked by writers of art history. While most have thus fallen into obscurity, a small number are survived by a few rare examples of their painting, as well as a scanty amount of recorded information about their lives and work.

One broad category of these nearly forgotten artists is the scholar-amateur painters, wealthy gentlemen of leisure who did not make careers of either painting or government service. For some of these men painting was only one of several genteel pastimes, for the ideal scholar was expected to excel not only in literature but also in the diverse disciplines of music, the game of go, calligraphy, and painting. Many made a name for themselves as poets or experts on classical learning. Textual research was the means by which three of the painters presented here made significant contributions to the field of classical studies. Xie Jin was additionally devoted to his religion, and Zhang Geng was an outstanding art historian. Bi Long, another of the artists discussed here, is best remembered today as an art collector and connoisseur; in fact, the presence of one of his collector's seals on a painting is considered reliable evidence of the work's authenticity.

As amateur painters, each of these individuals commanded the brush with superior facility, and their styles reflect orthodox Neo-Confucian thought as it had evolved through middle Qing times. They followed ancient models, as did most of their contemporaries, for the purpose of preserving their majestic artistic heritage. Painting was an integral part of their lives as literati. Expressing themselves in an indirect, plain manner that required a connoisseur's eye to appreciate, they found in their art a means of maintaining their special identity as members of a cultivated elite that existed above the more common segments of society.

227

*ZHANG GENG (Pushan, Guatianyishi; original name Zhang Tao), 1685-1760*

**Landscape with Figure**

Hanging scroll, ink and light color on paper
25½ x 13 inches

|  |  |
|---|---|
| *Inscription:* | The yard is not swept clean of autumn moss, |
|  | Little by little, the soughing wind scatters the red leaves. |
|  | Not one guest approaches my thatched cottage all day, |
|  | Only old trees, their heads bowed, listen as I read. |

Winter, *bingyin* (1746), (painted) in the style of Xuanzai (Dong Qichang, 1555-1636); poem composed by Zhang Geng of Xiushui.

*Artist's seal:*   *Guatianyishi,* square, intaglio
One illegible seal in lower left corner

Collection of Stanford University Art Museum, Stanford, California

This inviting landscape is the creation of an artist who is less known for his paintings than for his writings on art. As an impoverished youth, he did not take the civil examinations; nevertheless, he eventually made his mark as a distinguished scholar. Over ten thousand of his poems have been published in addition to numerous essays, and he was an authority on the classics and literature. His erudition secured him a recommendation, along with Jin Nong and Ding Jing (1695-1765), for the honored title of *boxuehongci*; only Zhang Geng, however, accepted. A calligrapher as well as a painter, his thorough research in art history and experience as a collector qualified him to author historical and critical studies on art. In an era abounding in publications on art, Zhang Geng's works, particularly *Pushan lunhua* and *Guochaohuazhenglu*, are among the most notable, and continue to be widely quoted today.

Zhang Geng is associated with two other painters: Qian Zai (1708-1793), who, like Zhang Geng, was a native of Xiushui (Jiaxing, Zhejiang); and Qian Weicheng, a relative of Zhang Geng. When young, all three studied under the lady painter Chen Shu (1660-1736). At the age of 27 Zhang Geng went to teach in Wujiang, where he became a student of the renowned landscapist Xu Rong. Because the latter was a pupil of Wang Hui (1632-1717), Zhang Geng is often placed in the Yushan School. However, since his poetry and art criticism are regarded to be more important than his paintings, he is presented here as a scholar-amateur artist. Inspired in his landscapes by Song and Yuan masters, Zhang Geng used the *baimiao* or fine-lined ink technique for his figure paintings.

This example of Zhang Geng's art is of special interest not only for its rarity, but also for its display of the artist's characteristically rich application of ink. A scholar sits in a studio that opens out onto a level yard. A rocky creek occupies the foreground of the painting, and the gate of a bamboo fence leads to a slope culminating in steep mountains set against a dark and cloudy sky. The areas of the sky that are devoid of clouds are filled in with ink wash; in combination with the

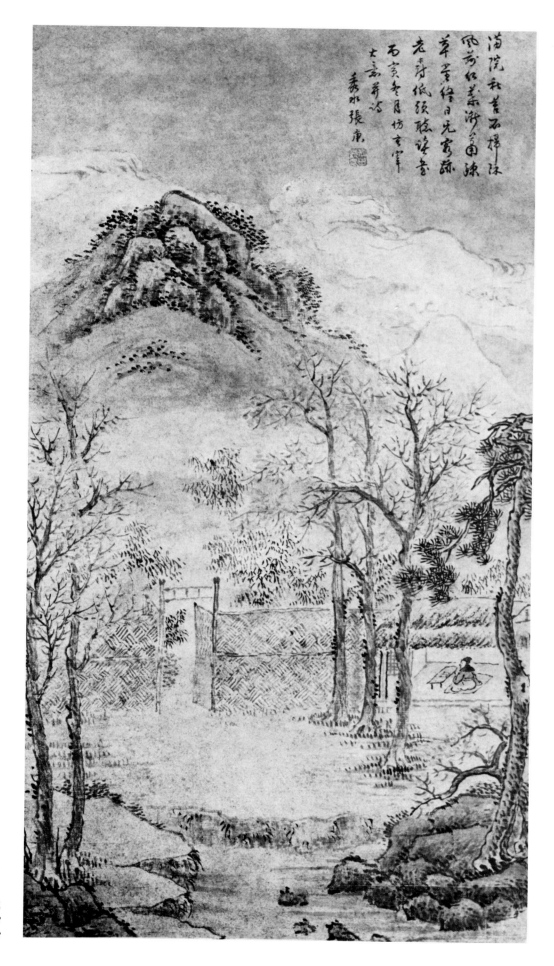

Zhang Geng
*Landscape
with Figure*

229

red-leafed trees in the yard, such a sky represents late autumn rather than winter. The edges of the individual strokes that make up the ink wash of the sky and define the clouds are concealed to retain a light, transparent feeling. The suggestion of a bamboo grove is achieved simply through clusters of dotlike strokes just beyond the fence.

Considering the intimate and tranquil atmosphere of this setting, Zhang Geng may have been describing an imagined secret paradise in this piece, as Tao Qian (372-427) did in his poetic essays. However, a mood of loneliness is betrayed in the lines inscribed by the artist in the upper right corner. This brief poem explains why the gentleman sits gazing in the direction of the open gate. It also provides additional narrative elements, as in the aural quality of the soughing wind and the personification of the trees, the scholar's only companions among the mountains.

## TUAN SHIGEN, active mid-18th century

### Two Figures

Hanging scroll, ink and color on paper
55½ x 17½ inches

> *Inscription:* Midwinter, *yiyou* (1765); painted by Tuan Shigen of Zhenzhou.
>
> *Artist's seals:* *Tuan Shisan*, square intaglio and relief
> Illegible, square, intaglio

Few facts are known about Tuan Shigen. Even the family name of Tuan is very rare in China. Taizhou, Jiangsu, is recorded as the artist's birthplace in certain sources, but reports of his origins in Zhenzhou, modern-day Yicheng District in Jiangsu, are corroborated by his inscription on this painting. Noted for his poetry and figure paintings, Tuan Shigen was the son (or possibly the brother) of Tuan Sheng, a famous calligrapher. The artist's one established date is the year he passed the *fubang* examination in 1720. At one point he joined the military service and was stationed in Tibet. There he practiced his art by painting the battle scenes that he witnessed. He died at the age of 88.

This picture of a scholar and his servant looking up in wonder and fear at a peculiarly shaped cloud is an unusual subject in the traditional sense. The slope on which the figures stand hardly qualifies as a full-fledged landscape, and the people are smaller than the standard size in figure painting. Rather, this is an image created to evoke a specific atmosphere. The layers of ink wash are carefully controlled to suggest the misty, humid air and the ominous presence of the dark, water-filled cloud. Great skill is necessary to make the starting and stopping points of the brush imperceptible and to unify the different tones and layers of wash into a seamless whole.

The painting is composed very simply of two wedges of sky and land, the latter suggested by clusters of fine, dark dots and a few brief brushstrokes. The postures of the two figures who stand on the hillside and look up at the sky serve to unify the two large areas. Even though their backs are toward the viewer, their concentration on the mysterious phenomenon can be read from the raised hands that shield their eyes. The young servant, leaning on an umbrella, seems to crouch forward in fear of the unknown forces of the universe. Tuan Shigen has rendered the outlines of the figures' garments with short strokes that swell and diminish in breadth. This technique aptly suggests the way drapery actually falls over the body, but it is primarily inspired by the new interest in ancient stone carving that is characteristic of art of this period.

Also typical of its time is the feeling of intimacy generated by this scene. After the great achievements in monumental landscape of the preceding epoch, 18th century artists turned to more personal themes of reduced scope. In this work the intimate, highly concentrated effect is the result of carefully orchestrated individual touches: the measured flow of ink, the very light watery blue of the scholar's robe, the balanced placement of the human subjects and the cloud mass. Two travelers pause to marvel at the wondrous power of nature; Tuan Shigen's expert handling of ink wash has captured the mood of this transitory moment.

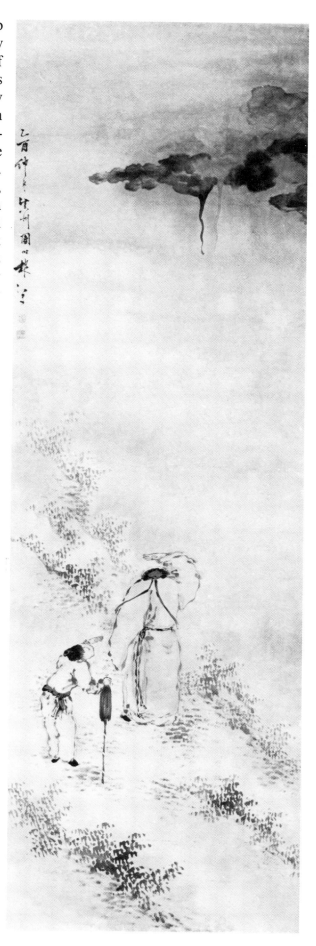

Tuan Shigen
*Two Figures*

231

## XIE JIN (Yunping), 1747-1819

### Lotus and Mandarin Ducks

Hanging scroll, ink and color on paper
66½ x 18½ inches

> *Inscription:* In the style of Baiyangshanren (Chen Chun, 1483-1544), trying out a *panyuenan* brush. Eighth month of *wuyin* (1818), Jiaqing (reign period). Xie Yunping.

> *Artist's seal:* *Meihuating zhang*, square, intaglio

Collection of Los Angeles County Museum of Art, Los Angeles, California

Xie Jin, from Zhenze (Wujiang, Jiangsu), was head priest of Qizhen ("Reside in Truth") Daoist Temple, and was also known for his scholarship on Buddhism, Confucianism, and the *Book of Changes (Yijing)*. Many schools and cultural societies invited him to lecture on these subjects. At first he accepted, but later in life he refused, preferring to concentrate his energies on calligraphy and painting. After studying flower-and-bird painting in the manner of Yun Shouping, he invented his own style with sweeping strokes and bold splashes of ink, combining both the "boneless" and outline modes. Like his good friend Xi Gang, Xie Jin sometimes painted landscapes. But his most famous piece is a long handscroll entitled "The Myriad Fragrances of Flowers."

The painting presented here displays the beauty of the harmony of opposites, an illustration of the Daoist philosophy of *yin* and *yang*. Since ancient times, *yin* has denoted elements that are female, dark, weak, passive, while *yang* signifies the male, bright, strong, active aspects of the universe. These two complementary forces are in a constant state of interaction, at once in opposition to and in unity with one another. The mandarin ducks in this painting, one female and one male, represent this theory of the universe. They are also traditionally symbolic of conjugal fidelity. To complement this pair, two full lotus blooms rise up out of the pond. While the ducks are quite colorful, the lotus blooms are pure white with a clearly defined black outline. The flowers themselves form a contrast: one has a very faint pink wash in the center, and the other opens to reveal a blue and green seed pod. The position of these blooms is termed *bingtoulian*, meaning "heads together lotus," another allusion to the ducks and a happily married couple. Above this floral arrangement, once again, is a pair; this time, two lotus buds. One, on the left, is barely beginning to open, the other is half unfurled.

The whiteness of all four flowers is emphasized by the black outline that forms them. In his article "Contour and Contrast" Dr. Floyd Ratliff[1] explicates the theory of this phenomenon, discovered by the Chinese as early as the Song Dynasty, in which a light color set directly beside a dark color, particularly one with a hard edge as in the outline here, will appear brighter than the identical shade next to a pale color. Here, then, is one more example of the *yin yang* principle.

To match the four flowers are four leaves; but whereas the blooms were painted in the *shuanggou* or outline technique, the quartet of leaves is an instance of Yun Shouping's "boneless" or *mugu* style. Curling gracefully in various directions, these

leaves consist of flat color washes; their veins, of blank white (unpainted) spaces.

All of these elements harmonize in a composition displaying both unity and diversity. Every segment of this painting is engaging in itself: the colorful mandarin ducks swimming together, the elegant, fresh lotus blooms rising out of the mud without even a speck of dust on them,[2] and the delicate leaves, twisting and curling about, their circularity contrasting with the stems and the reeds growing out of the water. All of these components are united here in a statement of purity, harmony, and beauty.

The inscription in the upper right corner indicates that the artist painted this piece in 1818, probably as a wedding gift for a friend. Since the artist died just a few months after that time, this painting may be his last recorded work.

### NOTES:

1. *Scientific American*, June, 1972, Vol. 226, No. 6, pp. 90-101.

2. For this reason, the lotus is a Buddhist and Daoist symbol of purity.

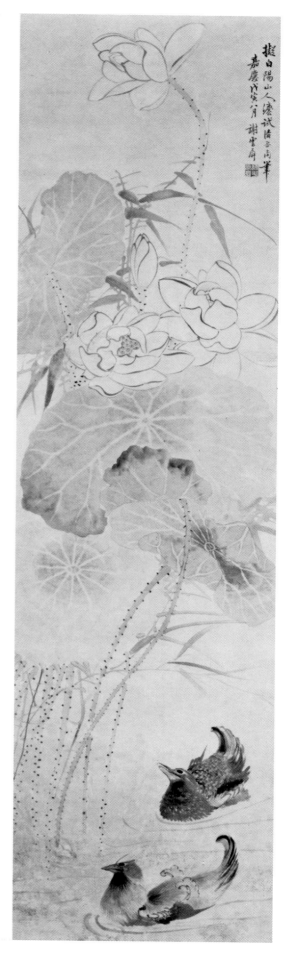

Xie Jin
*Lotus and Mandarin Ducks*

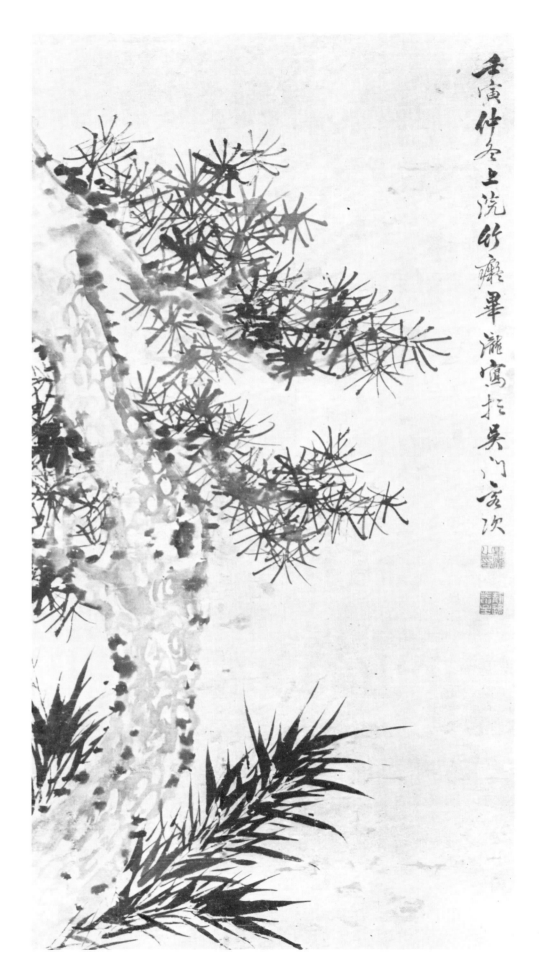

壬寅仲冬上浣竹廳畢瀧寫於吳門客次

Bi Long
*Pine Tree
and Bamboo*

*BI LONG (Jianfei, Zhuchi), active 1777-1782*

**Pine Tree and Bamboo**

Hanging scroll, ink on paper
39 x 20 inches

*Inscription:* Midwinter, *renyin* (1782), inscribed by Zhuchi, Bi Long of Shangyuan (Taicang) in Wumen (Suzhou).

*Artist's seals:* *Bi Long zhi yin*, square, relief
*Jingyianzhu*, square, intaglio

Collection of Dr. and Mrs. Felix Bongiorno, Oakland, California

Bi Long and his brother, Bi Yuan, were prominent art collectors of the Qianlong period. Bi Long himself owned important and rare pieces of the Song, Yuan, and Ming periods. Moreover, his collection of masterworks by the Six Masters of the Qing Dynasty[1] was the best of the time. A native of Zhenyang (present-day Taicang in Jiangsu Province), Bi Long was not only one of the best-known art connoisseurs of the 18th century, but a poet, calligrapher, and painter as well. His depictions of bamboo tend toward realism, and have been compared to those of the Yuan painter Wu Zhen (1280-1354). Bi Long called himself Jianfei or "Flying Torrent" and Zhuchi, "Crazy About Bamboo." The latter appellation originated in part in his aspirations to the virtues symbolized by this plant, and also in his love for objects made from it, particularly ancient bamboo tablets which, strung together, were the earliest form of books, originating in the Han Dynasty. As a scholar in the tradition of textual research *(kaoju)*, Bi Long treasured such tablets as prime sources of historical data.

This monochrome painting of a pine tree and bamboo displays the careful calligraphic brush strokes of the Literati approach to art. Bi Long chose to paint only the midsection of the tree, leaving the ground and the top of the tree to the viewer's imagination. The artist's expertise in both seal *(zhuan)* and official *(li)* script is demonstrated in the delineation of the pine. The juxtaposition of these two evergreens suggests the theme of purity. The "three purities" may in fact be the artist's intention here, with the presence of the third element, the moon, only implied by the other two.

*NOTE:*

1. Wang Shimin (1592-1680), Wang Jian (1598-1677), Wang Hui (1632-1717), Wang Yuanqi (1642-1715), Wu Li (1632-1718) and Yun Shouping (1633-1690).

*WU DONGFA (Kanshu, Yunfu), 1747-1803*

**Landscape**

Hanging scroll, ink and color on paper
38¼ x 16½ inches

> *Inscription:*   Painted in the style of Xie Xuecun, Kanshu, Wu Dongfa.

> *Artist's seals:*   *Wu Dongfa yin*, square, intaglio
> *Kanshu*, square, relief

Private Collection, La Puente, California

Wu Dongfa, a native of Haiyan, Zhejiang, was one of the foremost scholars of his time. An authority on classical learning, he engaged in *kaoju* (textual research) and *jinshixue* (study of ancient engravings). For these accomplishments, in addition to his talent in poetry and painting, he won the admiration of Ruan Yuan (Yuntai, 1764-1849), the respected poet and chancellor of the Grand Secretariat. Wu Dongfa painted monumental landscapes in the style of Wu Zhen and Shen Zhou (1427-1509), but was also acclaimed for his depictions of flowers and insects. Zhang Shuwei, a 19th century art critic and painter, commented on a four-panel landscape painted by Wu Dongfa when he was 32 years old, saying, "The subtle and powerful effect he created in this painting would take another artist many years to achieve." As well as he painted, Wu Dongfa was even better known for his carving technique. His style of engraving impressed Zhao Zhiqian (1829-1884), Wu Changshi (1844-1927), and other artists who developed the Jinshi ("Engraving") School.

Unfortunately, only a small number of Wu Dongfa's works are now in existence for the purpose of research and comparison. The rare remaining few, like those of many other 18th century artists, owe much to Song and Yuan period painters. An examination of Wu Dongfa's art reveals how he has recaptured the majestic strength of Northern Song landscapes such as those by Fan Kuan (active ca. 990-1030). There is much complexity and concentrated energy in the brushwork, especially in the trees on the cliff with houses nestled among them. The barrenness of the deciduous trees and the rich foliage of the conifers are clearly visible. An enormous rugged mountain in the background is so filled with contrasts of light and dark that it seems to be alive. A waterfall descending the right side of the eminence is balanced by several houses and cliffs on the left, the effect of which is almost overwhelming in its grandeur of conception. Despite the meticulous drawing, the whole impression is one of spontaneity. The brushwork in this painting displays a placid calligraphic technique typical of the Yuan literati-artist Xie Xuecun (14th century),[1] named by Wu Dongfa in his inscription.

*NOTE:*

1.  Xie Tingzhi, painter of landscapes and ink bamboo.

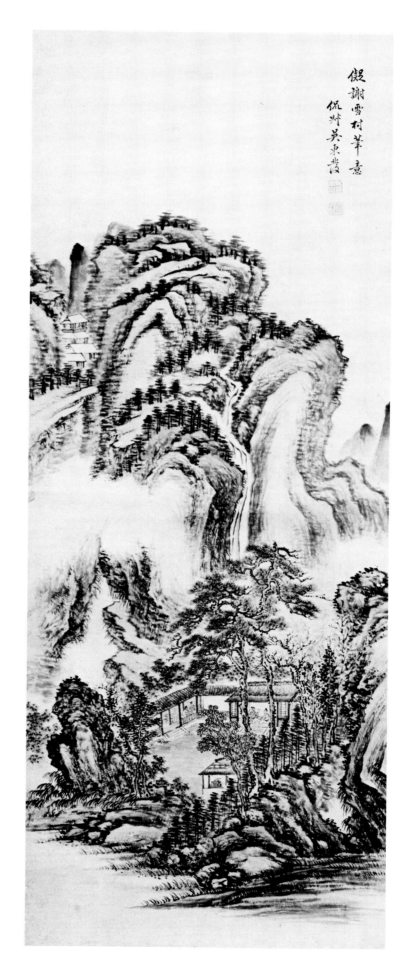

擬謝雪村筆意
倣州吳東發

Wu Dongfa
*Landscape*

237

# Official Artists

Since the civil examination system was instituted in the Sui Dynasty, scholars have enjoyed status and power as the administrators of China's immense bureaucracy. By the Ming period, intellectuals formed an elite class to whom the population at large rendered privilege, reverence, and obedience. For these advantages, the literatus was not only commissioned to carry on the business of governing, he was also expected to live up to an ideal code of conduct that perpetuated traditional moral standards and cultural refinements. In addition to thorough familiarity with the Confucian classics, which was necessary to pass the civil tests, the Literati way of life entailed facility in poetic composition, calligraphy, and painting. (To a lesser degree were included playing the *qin*, a musical instrument, and *weiqi* or the game of go.) In the gentleman-scholar's process of self-cultivation, nature was his ultimate guide as reflected in the adage "In mountains there is benevolence; in water, wisdom." Because of this, landscape was his preferred subject in painting, for in his renderings of hills and streams he could give voice to his inner moral character.

At the inception of the Qing Dynasty the Ming examination plan was maintained, and Manchu emperors and noblemen made a conscious effort to educate themselves in all aspects of Chinese civilization. This preserved the old order whereby scholars were rewarded with rank and honor for their literary and artistic achievements. However, despite their enthusiastic promotion of Chinese traditions, the Qing rulers' suspicion of anything not sanctified by precedent eventually locked those traditions into rigid patterns that tolerated no deviation. For the Chinese employed in public service, this meant severe restrictions on self-expression, a situation complicated by their feelings of guilt over participating in an administration under a foreign monarch.

It was undoubtedly no coincidence that the Qianlong emperor chose the calligraphy and painting style of Zhao Mengfu (1254-1322) as the model for artists holding official titles. This Yuan master used his position in the Mongol government to ensure the preservation of his native culture during a period of alien rule in China. Besides assuaging the guilt of the scholar-officials, Qianlong's homage to this oft-criticized artist also steered their creative instincts along a politically acceptable line.

But only certain aspects of Zhao Mengfu's complex stylistic repertoire were singled out for the imperial stamp of approval: it was his landscape style, featuring monochrome ink and a calm, reserved brush manner that was now held up as the ideal painting mode. However, lacking the extensive training that this ancient master had, as well as any freedom of expression, the official artist of the middle Qing was capable of arriving at little that was new or provocative in his pictures. Under the watchful eye of the throne, it behooved him to carefully follow Zhao Mengfu and certain other Yuan and Song masters, and to deliberately avoid eye-catching qualities in his work.

Based on Dong Qichang's (1555-1636) theories of Orthodox painting, this derivative approach, known in the Qing period as *fanggu*, was actually a late development of the Wu School, which had been diffused from Suzhou to various parts of the country. Originally intended to offer themes for free interpretation, the *fanggu* movement eventually evolved into the pursuit of antiquity for its own sake. By the 18th century, this long-term trend had turned into a formalized aesthetic comprising a narrow range of brush techniques and compositions that obscured the painter's own individuality from all except the most sensitive and cultivated viewers. Just as scholastic inquiry under imperial sponsorship had become bogged down in pedantic academicism, official art was now growing more and more rarified, its vital focus on the great *dao* virtually abandoned under the taxing demands of historic example and political constrictions.

Even while he pursued the amateur ideal of Yuan Literati painters, the scholar-official of the middle Qing could not engage in "ink play" in the same leisurely frame of mind as had his predecessors. Artistic accomplishment to him was an important method of procuring the emperor's favor, of impressing his personal cultivation upon his peers, and of winning the acceptance of the public. Moreover, as his art was used to enhance his own political and social standing, it also furthered the process of assimilating Manchu nobility into Han Chinese society. As patient, practical-minded men, official painters of the middle Qing saw this route as the most efficient way to maintain their own welfare and at the same time to secure the survival of their treasured artistic heritage for posterity.

# DONG BANGDA (Fucun, Dongshan), 1699-1769

## Landscape

Hanging scroll, ink on paper
20 x 11¾ inches

| | |
|---|---|
| *Inscription:* | Painted in the manner of Zhao Songxue's (Zhao Mengfu's) "Pavilion in the Shade of the Pines" *(Songyin tingzi)*, Dong Bangda. |
| *Artist's seals:* | *Shidaye*, square, intaglio<br>*Dongshan*, square, relief |

*Collectors' seals:*

| | |
|---|---|
| (Lower right) | *Baoshi Songxi jiancang zhi yin*, square, relief<br>*Xiuning Zhuzhichi zhencang tushu*, rectangular, relief<br>*You shi shoucang*, rectangular, relief |
| (Middle left) | *Zhuzhichi jianshang*, square, relief |
| (Lower left) | *Peizhi qingshang*, square, relief<br>*Wushiyitang jianshang*, rectangular, intaglio |

Private Collection, Indianapolis, Indiana

This ink landscape by the official painter Dong Bangda is a prime example of the formative role played by Zhao Mengfu's creative vision in the art of the middle and later 18th century. After earning a *jinshi* degree in 1733, Dong Bangda was appointed director of the Bureau of History. In this post he supervised the publication of the *Shiqubaoji*, the encyclopedic catalog of Qianlong's enormous art collection. Later he served as President of the Board of Rites. Recognized both as a scholar of stature and as an authority on art and antiques, Dong Bangda was also an artist in his own right. After his death, he was awarded the highest honors an official could receive.

Connoisseurs classify Dong Bangda as one of the "Three Dongs," along with Dong Yuan (ca. 900-1062) and Dong Qichang. This type of grouping of artists has long been a tradition in China, but usually the artists of a given group have in common either a period of time, such as the Four Masters of the Yuan Dynasty or the Four Wangs, or a location such as the Eight Jinling Masters. Although the Three Dongs lived many centuries apart, they shared the same surname, along with a common orthodoxy of approach in landscape painting. Dong Yuan is considered one of the forefathers of this doctrine, Dong Qichang was the key figure in articulating and synthesizing its theories, and Dong Bangda was a representative of the later phase of its development.

Paintings by Dong Bangda have been recorded for almost every year that he served in the court. Of these, few bear inscriptions other than the artist's signature, which he usually placed in an obscure corner of the picture in conformity with the rules of propriety for an artist painting for the emperor or a member of the court. Dong Bangda excelled in landscapes in the manner of the Yuan masters, for his use of a dry brush evoked a feeling of antiquity reminiscent of Huang Gongwang and

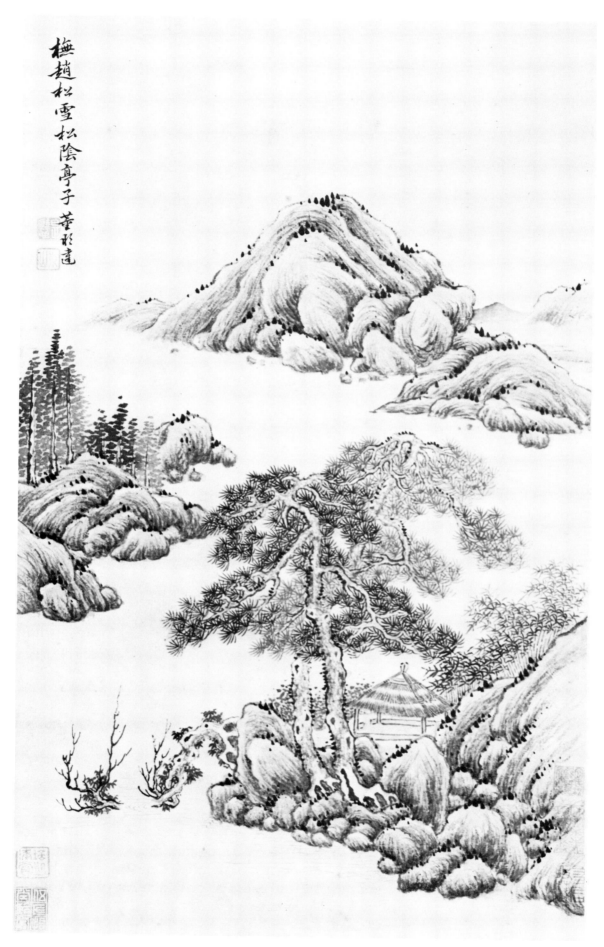

撫趙松雪松陰亭子 董邦達

Dong Bangda. *Landscape.*

241

Wang Meng, both of whom were students of Zhao Mengfu.

Zhao Mengfu's "Pavilion in the Shade of the Pines," the source of inspiration for this monochrome landscape, is not known to exist today, but valuable insights into the 18th century artist's approach may be provided by comparison of the present work to this Yuan artist's famous "Twin Pines Against a Flat Vista" *(Shuangsong pingyuan*, Metropolitan Museum of Art). In the scholarly "ink play" *(moxi)* spirit of Zhao Mengfu, Dong Bangda applied his dry brushstrokes with a slow, relaxed hand in a wholly linear technique. The aesthetic of calligraphy is the primary intent here; the fine, even, and densely arranged strokes suggest *xiaokai* (small regular) script. An orderly and rhythmic build-up of *pimacun* (hemp fiber texture strokes) renders the rounded bulgings of the rocks and mountains, with the distant peak claiming the most immediate attention for its clear contrasts of light and dark as well as the undulating movement of its concave and convex formations. The faraway highlands are clearly set apart from the foreground and middle bank of land on the left by unpainted areas representing water in a simple three-step spatial recession. Clarity and order also rule the description of plant life despite a limited range of ink values. The two pines on the near shore are distinguishable from one another by the use of dark ink for the foliage of the foremost tree and lighter ink for the one to the rear. To their right, radiating bamboo leaves are picked up by a mild breeze, while across the water, foliage consisting of masterful dotting gently shimmers in a thin haze.

In the shade of the pines, true to Zhao Mengfu's theme, is a simple thatched pavilion beside a grove of bamboo. To the left a tangled old tree bows down into the river and then tenaciously grows out again; the slightest suggestion of animation in the water around it is effected by a few pale, delicate, rippling brushstrokes. The sense of serene calm in which the whole image is suspended may be likened to that of Zhao Mengfu's "Autumn Colors on the Qiao and Hua Mountains" *(Qiao Hua qiuse,* National Palace Museum, Taiwan). It is for this quality, along with the artist's pursuit of a cultivated plainness in style, that Dong Bangda's painting may be assessed as a successful interpretation of his 13th century predecessor's artistic creations. At the same time, its emphasis on beauty in the individual brushstroke, its evenness of tone, and its note of intimacy are unmistakable characteristics of Dong Bangda's own time.

## QIAN WEICHENG (Chashan), 1720-1772

### Flowers and Fruits: "Prosperity and Peace"

Hanging scroll, ink and color on paper
42 x 20½ inches

*Inscription:* Humbly painted by Qian Weicheng, official.

*Artist's seals:* *Chen,* square, relief
*Weicheng,* square, relief

Collection of Dr. and Mrs. Felix Bongiorno, Oakland, California

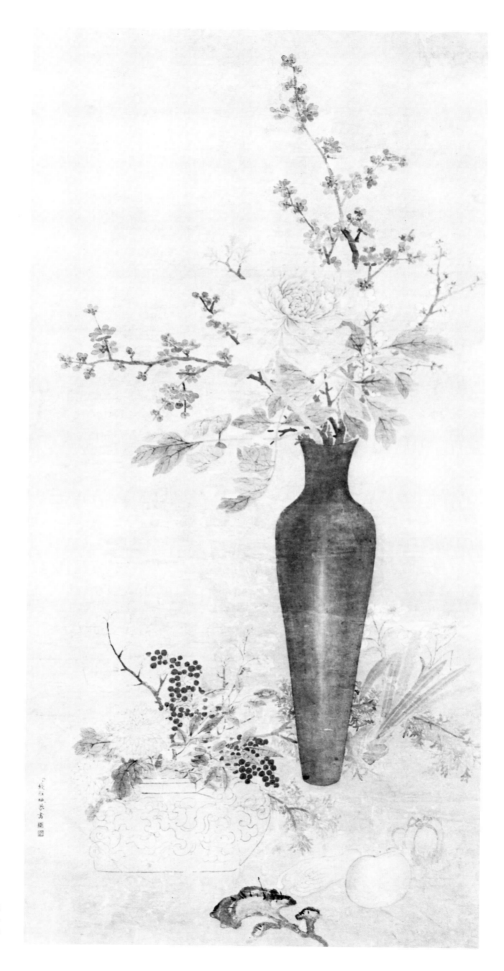

Qian Weicheng
*Flowers and Fruits:*
*"Prosperity and Peace"*

243

Qian Weicheng is a classic example of a highranking official of the Qianlong period who painted frequently at the behest of the court but who was not employed as an academy artist. His illustrious career began when, at the age of 25, he earned the title *zhuangyuan* for taking first place in the *jinshi* examination. Thereafter he rose to the position of Vice President of the Board of Works. Notwithstanding his broad learning as well as his accomplishment in poetry and calligraphy, he was best known for his paintings. He first studied art under his great-aunt, Chen Shu (Nanloulaoren, 1660-1736), who was widely acclaimed for her depictions of flowers and birds, and who was mother and painting teacher of a number of noted scholars of the day. With rigorous classical training not only in literature and art but also in the Confucian code of conduct, Qian Weicheng emerged as an artist whose paintings display impeccable technical command in a wide range of styles.

The diverse benefits of education and opportunity that were available to Qian Weicheng throughout his life are symbolized in the thematic variety and rich hues observable in this festive picture of floral arrangements and fruits. A tall, slender blue vase, emblem of peace, holds spring peonies (signifying wealth) and other blossoms; next to the vase bloom narcissus, associated with late winter. An autumnal spray of chrysanthemums is displayed in a squat jar to the left, with a sprig of winter berries and branches of foliage. In front of the vessels are fruits, including a Buddha's hand (a variety of citron) and *lingzhi* (fungus of immortality). Such an incongruous medley of seasonal vegetation is not unprecedented in Chinese art history, and Qian Weicheng's intent in transgressing nature's laws in his art is undoubtedly to offer perennial wishes of prosperity and peace to the beholder.

Rendering auspicious flowers in attractive compositions like this one was a common assignment for both academy painters and official-artists during the Qing period. From the stylistic and textual form of the signature, it is evident that this work was created either to satisfy an imperial order or for presentation to another official, probably superior to the artist in rank. The inscription appears in the script prescribed by the court for such paintings, *xiaokai*, written in an unobtrusive corner of the picture. It begins with the character *chen*, "your servant" or "official," set off slightly to the right, followed by the artist's name (given name; a *zi* or *hao* would not be appropriate), and concluding with the term *gonghui*, meaning "humbly painted." The seals also conform to the courtly model.

Because *gongbi* (the realistic style employing a fine brush, brilliant colors, and meticulous detail) requires extensive academic training, before the 18th century it was practiced almost exclusively by professional and court artists. Although scholars had traditionally embraced painting as an extension of literary cultivation, emphasis was placed on amateur "ink play" as opposed to the technical skill and accurate pictorial representation of professional art. By the middle Qing, however, lines drawn between styles previously attributed to literati and those practiced by professionals had become blurred; now, learned men were expected to develop expertise in a variety of approaches. Thus Qian Weicheng's use of *gongbi* is not anomalistic. Many Literati artists of his time shared his competence in this mode, although few could match the high quality of his achievement. In conjunction with the properties observed in the signature and seals on this painting, this formal style is the best suited for presentation to the emperor or a high-ranking personage as suggested above. Moreover, the formality of the composition and sumptuous, all-inclusive nature of the subject matter reflect the prevailing tenor of the Qianlong administration.

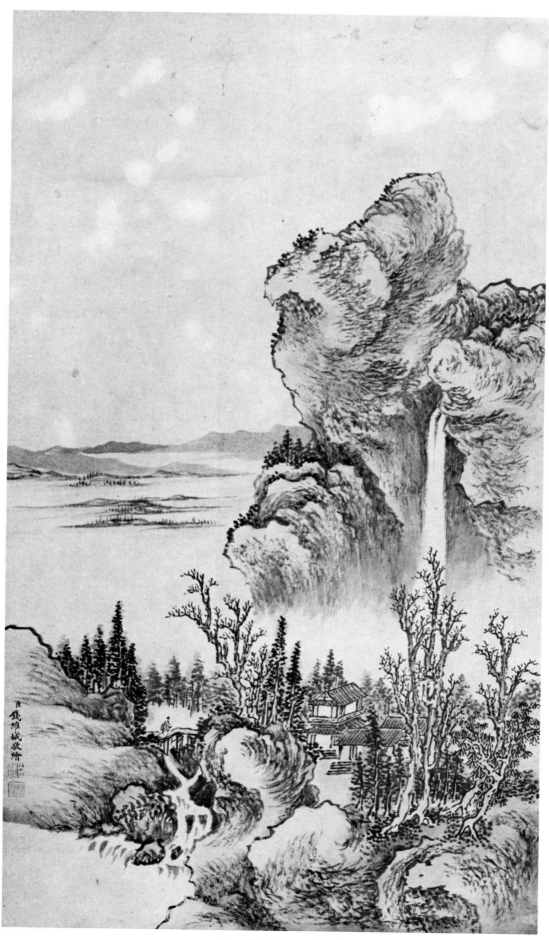

Qian Weicheng. *Landscape.*

# Landscape

Hanging scroll, ink and light color on paper
22¾ x 12¾ inches

>  *Inscription:* Respectfully painted by Qian Weicheng, Official.
>
>  *Artist's seals:* *Chen Weicheng*, square, intaglio
>  *Gonghui*, square, relief

Collection of Dr. and Mrs. Gregory A. Dahlen, Santa Barbara, California

After mastering the flower-and-bird genre, Qian Weicheng took up landscape, a subject that won him immediate and widespread fame. His paintings are often compared to those of Wang Yuanqi (1642-1715), but were also influenced by the contemporary official and noted landscapist Dong Bangda. However, like so many painters of his time, particularly those gathered around the court, Qian Weicheng was well-versed in the gamut of historical methods and could use any of them alone or in combination. Not just the theme but also the style of each of his paintings depended to a great extent on the circumstances that led to its creation. This may be noted both in the flower painting discussed above and in a small landscape bearing an inscription and seals that follow the same court-prescribed formula. The artist's signature on the landscape is identical to the one on the flower painting except for the substitution of the character *jing*, meaning "respectful," for *gong*, or "humble."

Wang Hui's (1632-1717) synthesis of disparate styles and the radiant clarity of his description of form play a role in Qian Weicheng's treatment of the natural elements in this painting. Rocky hills in the foreground are given a jagged, twisted appearance by means of dry texture strokes applied in brief semicircles with pale ocher washes in convex and ink washes in concave areas. Crossing a footbridge over a waterfall, a lone figure approaches a group of buildings partly hidden in the trees. The exquisite brush strokes of the dry branches of some of the taller trees are illuminated by the blank spaces—rising vapors—directly behind them. While these and other leafy trees are delineated in dark ink with light grayish-blue wash, the trees growing beyond the bridge and houses consist of pale ink, suggesting depth even within the limited scope of the foreground. A lofty bluff in the midground, with water cascading from a high cleft, is rendered in the same method, producing a notable three-dimensional effect of shadowy recesses and bulging projections.

To the left of the peaks a broad expanse of water stretches into the far distance, which is indicated by the diminutive size of a few islands and the pale blue coloration of the furthermost hills. The picture thus couples a monumental sense of nature with an intimate glimpse of a most inviting human habitation. As a small-scale image of a scholar's ideal retreat nestled in a protected corner of a vast, rugged landscape, this painting is typical of official-artists' production during the 18th century. Nostalgia for a simple existence in nature removed from the demands of public life gave this theme untiring appeal for bureaucrats of this time. Although the strain of Qian Weicheng's brushwork is reserved, orderly, even fastidious, a cheerful mood is engendered by the soft hues and the overall picturesque quality of the scenery.

**Landscape**

Hanging scroll, ink on paper
45½ x 16 inches

> *Inscription:*    At sunset there are few travelers among the peaks.
> With green moss everywhere, the road cannot be found.
> Thousands of planted bamboo stalks sway in the shadows of
>     pines.
> A mountain breeze blows clouds over to my window.
>
> I casually painted the idea of this Yuan poem for the enjoy-
> ment of Mr. Qishan. Chashan, Qian Weicheng.

> *Artist's seal:*    *Qian Weicheng yin*, square, intaglio

Private Collection, La Puente, California

The tone and style of this larger landscape are in marked contrast to those in the former work. Neither the character *chen* nor other terms of decorum are included in the signature, and the entire inscription is written in fluent running script. The artist "casually" quotes a Yuan period poem and paints (literally "writes") his vision of this literary piece. He may have done this at a leisurely gathering of scholars; perhaps Mr. Qishan, to whom the painting is dedicated, was the host. Executed in ink of a relatively narrow spectrum of values, this picture was obviously conceived for appreciation by a connoisseur's eye.

Here, Qian Weicheng gives freer rein to his brush, demonstrating his virtuoso capabilities with refreshing ease and spontaneity. Using generally dry strokes, he constructs a dense composition of a river separating a near shore from foothills, which are followed in depth by higher mountains and finally faint pinnacles in the remote distance. A figure in a boat appears on the water; houses line the far shore and its forested hills; a simple pavilion is perched on a flat spot of the peaks. This gradual build-up of a complex landscape is reminiscent of the Yuan artists Zhao Yuan (active ca. 1370) and Xu Ben (1335-1380). Like the Yuan masters, Qian Weicheng pursues expression through *bifa* or "brush method," investing each stroke with concentrated energy backed by prolonged training and a refined aesthetic sensibility. In some parts of the picture, one stroke pattern passes over a contour to merge with another pattern, resulting in interwoven layers of texturing, as in the paintings of Wang Yuanqi. The loose brush manner and evenness of ink tones suggest that this work was completed in one sitting in a sudden burst of inspiration. Nevertheless, sober discipline regulates every touch just as it guides the conduct of the proper Confucian gentleman.

The sum of these features is representative of a peculiarly 18th century brand of orthodoxy in art wherein plainness *(pingdan)* obscures individuality to all but highly cultivated minds. For the connoisseur, as Mr. Qishan surely was, this mode served as a visual metaphor for the essence of his country's cultural and moral heritage.

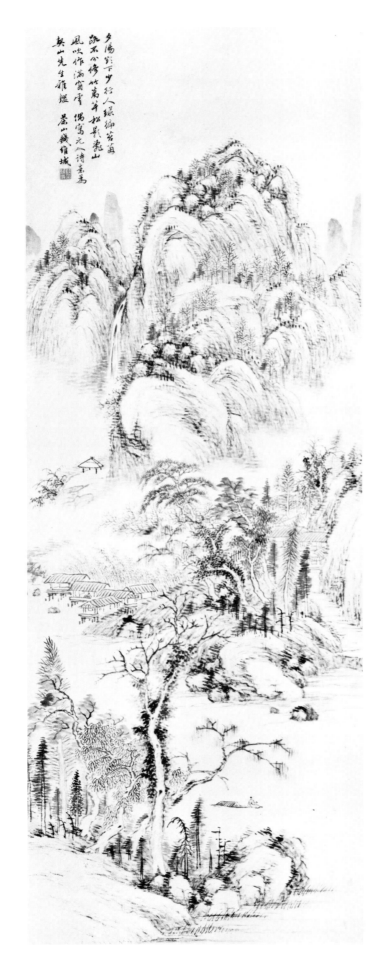

夕陽紅不少行人綠綿答再
弱石分修竹高年松影亂山
風吹作滿窗雪擬寫元人詩意為
英山先生雅鑑
茶山錢維城

Qian Weicheng
*Landscape*

248

## Cassia Flowers, Orchids, and Rock

Hanging scroll, ink and color on paper
44 x 16¾ inches

> *Inscription:* Painted on the 15th day of the third month of *wuxu* (1838) in the reign of Daoguang by Zhuyetingsheng, Yao Yuanzhi at (my) residence in the capital.

> *Artist's seal:* *Yuanzhi*, square, intaglio

Collection of Robin and Charles Goodstein, Rock Island, Illinois

For his outstanding achievements in the areas of classical scholarship, government service, calligraphy, and art, Yao Yuanzhi was a model of the Chinese literatus. Born in 1776,[1] he was awarded a *jinshi* degree in 1805 at the age of 29. Just two years later he became an editor in the imperial Department of Publications. He later served as Vice President of the Board of Punishments, and in 1841 became a member of the prime minister's cabinet. Despite his active official career and his devotion to the study of the ancient classics, Yao Yuanzhi produced a steady stream of calligraphic and pictorial art throughout his long life.

As an artist, Yao Yuanzhi was known for his calligraphy in the *li* (official), *zhuan* (seal), and *cao* (cursive) scripts, as well as his figures in the *baimaio* (plain outline) style. His copy of Zhao Mengfu's (1254-1322) "Sixteen Venerable Lohans" brought high praise from the 18th century connoisseur Huang Yue (Zuotian). Although familiar with many masterpieces of the past, Yao Yuanzhi was able to incorporate his knowledge into the spontaneous expression with which he depicted flowers, plants, fruits, and vegetables. His earliest recorded painting was a pine tree, completed in 1823. True to the amateur ideal, his works were given to friends and associates as gifts rather than sold professionally.

An awareness of the literary associations within "Cassia Flowers, Orchids, and Rock" is essential to an understanding of its significance. The cassia is an autumnal flower which, like the orchid, is admired for its fragrance. The orchid is a symbol of refinement, and thus an emblem of the perfect man; Confucius himself remarked on its exquisite characteristics. The quality of endurance represented by the rock in this painting complements the fleeting beauty of the flowers.

In this work, the artist demonstrates his mastery of the mode known as *xieyi* (literally, "to write the idea," a spontaneous and free painting method). Broad strokes of light ink form the thick but slightly curling cassia leaves distributed in clusters among several branches. The tiny flowers that grow beneath each foliage group are light orange dots of fragrance. Prior to the 18th century, the cassia was generally cast as a subordinate subject in relation to the chief theme of a painting. Here, however, towering over both the orchids and the stone, the cassia is equal in importance to the other two elements. The orchid plant, often painted as the main subject, is shown here growing from behind the rock. Placed at the front of the arrangement, the rock's strange contorted form and weighty solidity match the power

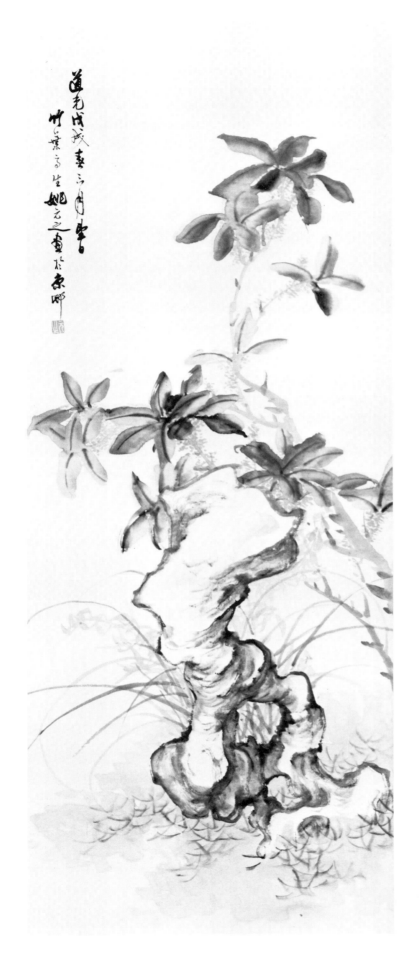

Yao Yuanzhi
*Cassia Flowers,*
*Orchids, and Rock*

of the distinctive features of the two plants.

Color is applied sparingly in order to focus attention on the calligraphic lines. As a master of calligraphy, Yao Yuanzhi tapped his writing skills in his paintings in order to imbue every stroke of his brush with resilience and strength. In particular, the outline of the rock and the leaves of the orchid reveal a highly trained hand that is at once controlled and relaxed. The result of this brush technique is the artist's personal statement of scholarly cultivation and exquisite taste.

Although the theme of plants with a stone harks back to the works of several Yuan and Ming masters, including Wen Zhengming (1470-1559) and Chen Chun (1483-1544), not until Yao Yuanzhi's era did calligraphic brush methods figure so prominently in such pictures. Two of his contemporaries, Qian Du and Tang Yifen, also excelled in painting these subjects in a similar manner. Later artists such as the Four Rens[2] developed this art form even further. Thus "Cassia Flowers, Orchids, and Rock" may be viewed as one link in a long artistic tradition. Ultimately, however, as an elucidation of the vital spirit in all things, Yao Yuanzhi's rendition of a small corner of the natural world surpasses all boundaries of time and even of culture.

*NOTES:*

1. Guo Weiqu, ed., *Song Yuan Ming Qing shuhuajia nianbiao (Almanac of Calligraphers and Artists of the Song, Yuan, Ming, and Qing Dynasties),* (Silver Culture Service, Hong Kong). According to the *Zhongguo lidai shuhuazhuankejia zihao suoyin (Index to Aliases of Chinese Artists in the Past Generations),* (The Chinese Calligraphy and Painting Institue, Hong Kong, 1968), Yao Yuanzhi was born in 1773.

2. Ren Xiong (1820-1857), Ren Xun (1835-1893), Ren Yi (Bonian, 1840-1896), and Ren Yu (1853-1901).

*YU JI (Qiushi), 1738-1823*

**Figure: Su Dongpo**

Hanging scroll, ink and color on silk
52½ x 26¼ inches

> *Inscription:*
> (title, top right): Posthumous Portrait of Su Wenzhong (Su Shi, Dongpo, 1036-1101).
> (top left): Like a flying immortal, this gentleman. He considered himself an average person, though he stood far above the common crowd. His vision was as broad as that of Fan Li[1] and Mencius. But such talent provoked jealousy in others, so that he could not live peacefully in Bian.[2] Since he wandered as an exile east of Guangdong, seven hundred years have passed. Yet one can still see him on White Crane Peak in Dunzhou.[3]

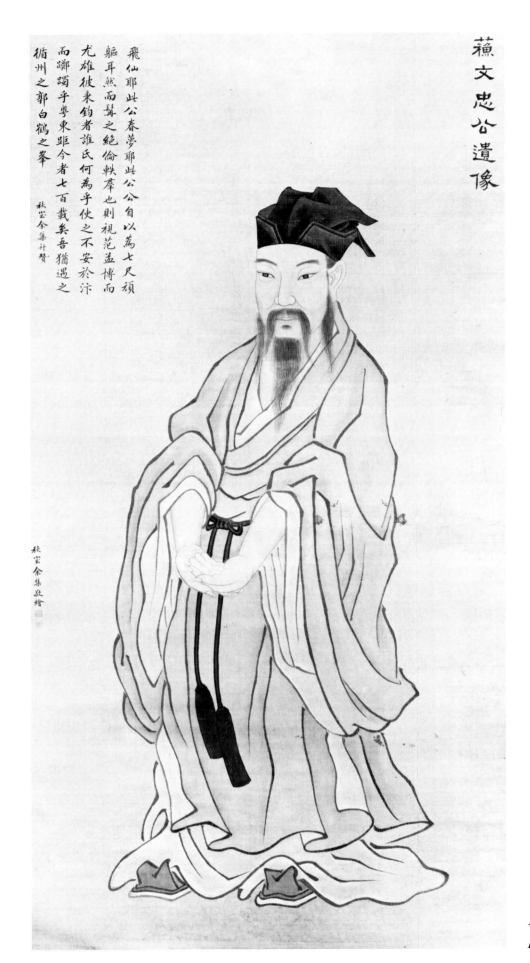

蘇文忠公遺像

飛仙耶此公春夢耶此公公自以為七尺頎
軀耳然而髯之絕倫軼羣也則視范孟博而
尤雄彼東釣者誰氏何為乎使之不安於汴
而躑躅乎粵東距今者七百載矣吾猶遇之
循州之郭白鶴之峯

秋室余集計贊

秋室余集敬繪

Yu Ji
*Figure: Su Dongpo*

252

Eulogized by Qiushi, Yu Ji.
(middle left):   Respectfully painted by Qiushi Yu Ji.

*Artist's seals:*  *Yu Ji,* square, intaglio
               *Qiushi,* square, relief

Collection of Sansu Si (Temple of the Three Su's), Mei Xian, Sichuan, People's Republic of China.

This nearly life-sized portrait of Su Dongpo, a literatus and statesman of the Song period revered for his poetry, calligraphy, and paintings, was rendered by a Qing scholar who was also renowned for his accomplishments in these three arts. Yu Ji, a native of Hangzhou, became a *jinshi* at the early age of 28. As a painter his depictions of landscapes, orchids, and bamboo were well-received in his own time, but above all he was famous for his figures. His pictures of ladies engaged in various activities earned him the appellation Yu Meiren, or "Yu the Beauty Painter." Numerous unverifiable anecdotes have been generated by his success with this subject, one being that the artistic work he performed in the audience of the emperor was awarded lavish praise from the throne and all those present in the court.

Representations of the human form are prominent among the most ancient examples of Chinese painting known today. By the Tang Dynasty, a full spectrum of styles had already reached maturity. Thus most of what followed afterward may be seen as variations of the classical achievements that came about before the beginning of the second millenium. Commencing with Song times, figures were relegated to a position subordinate to that of landscapes in scholarly circles. After brief flowerings of boldly brushed figures by Zen masters in the Song and florid technical displays by the Zhe School during the early Ming period, figure painting suffered a general decline in the 16th and 17th centuries. Exceptions to this trend were a few artists specializing in Buddhist themes, as well as Chen Hongshou (1599-1652) and Cui Zizhong (died 1644). The reign of Qianlong brought an upsurge in the production of portrayals of the human form. Throughout the 18th and 19th centuries, portraiture enjoyed a new importance, while the demand for depictions of historical and religious personalities, and of gentlewomen, increased.

Since this "posthumous portrait" of Su Dongpo is a creation of the artist's imagination, it cannot be considered a portrait in the strict sense of the word. Without the title or encomium at the top of the painting, identification of the subject would be impossible. (Although the style of the hat is alleged to have originated with Su Dongpo, it has been worn by scholars ever since Song times.) As in any Chinese visualization of such a personage when the physical appearance is unknown, the point is the transmittal of the superior character, or virtues, for which the subject is revered. A paragon of scholastic achievement, artistic sensibility, and moral integrity, Su Dongpo appears here as the exemplar of the middle Qing Literati class. His placid, self-contented expression hints at profound wisdom. His hands are folded in a relaxed manner with the palms up, a genteel gesture which, along with the fashion of his attire, the refined delineation of the facial features, and even such details as his long fingernails, distinguishes him as a man of rank and breeding. The slouching shoulders, slight bulging belly, and overall mildness of manner suggest a life devoted to nothing but artistic and literary pursuits. Rather than providing enlightenment as to the actual attributes of this famed individual, Yu Ji's painting offers valuable

insights into the qualities associated with the ideal gentleman-scholar of the middle Qing era. It also indicates continuing imperial patronage of the Song Neo-Confucianist doctrine.

This piece additionally holds clues to the mind of Yu Ji himself as a living aspirant to the scholarly ideal. Most of the personal expression here is reserved for the flowing lines of the robe, which, true to mainstream developments in Chinese figure painting, obscures the wearer's physique. From beginning to end, each long stroke of the brush shows sound training in traditional methods. The fluctuation in breadth, the precision and fluency evident in every line of the drapery, preserve the mode of Wu Daozi (active ca. 720-762), especially as interpreted by Cui Zizhong. In contrast to the quiescence of the man as revealed in his face and hands, his clothing seems to flutter in a gentle breeze, as though his lofty presence were accompanied by the ethereal vapors of immortality. Moreover, the deep indigo of his tasseled belt, the pale greenish-blue shade of the robe, and the orange-red coloring of his upturned shoes lend an archaic flavor to this picture in their suggestion of ancient cave paintings. The black hat of folded cloth exhibits masterful application of ink wash. Finally, the threadlike delicacy of the strokes making up the "five strand" beard and eyebrows brings every hair to life. The use of *li* script for the title and regular style for the eulogy and signature adds to the formal tone of the painting. Here, then, Yu Ji shows himself to be an artist who, in his advanced skill, choice of subject matter, and method of execution seeks to revive the glories of his country's cultural past.

### NOTES:

1. Spring and Autumn Period statesman who helped the state of Yue conquer the state of Wu.

2. Bianjing or Kaifeng, capital of the Northern Song Dynasty.

3. An allusion to "The Red Cliff" *(Chibifu)*, a poetic essay by Su Dongpo.

## DAI XI (Chunshi, Jingdongjushi), 1801-1860

### Landscape in the Style of Huang Gongwang

Hanging scroll, ink on paper
57½ x 16½ inches

|  |  |
|---|---|
| *Inscription:* | Misty Woods and Rainy Peaks, in imitation of the idea of Huang Zijiu's (Huang Gongwang) "Steep Cliffs and Thick Woods" *(Doubi milin)*. Painted for Xiyu in the eleventh month of *bingchen* (1856) by Chunshi, Dai Xi. |
| *Artist's seals:* | *Dai Xi,* square, intaglio<br>*Jingdongjushi,* square, intaglio |
| *Collectors' seals:* | |
| (Lower right) | *Penglai Sun Nangeng shi jiancang yin*, square, intaglio |
| (Lower left) | *Nangeng shending zhenji*, rectangular, relief |

*Shi Yanzai yin*, square, relief
*Penglai Sun shi mo ? ancang*, rectangular, relief

Collection of Y. W. Shih, Tainan, Taiwan

The life and art of Dai Xi, the latest among the artists represented in this collection, bridges early through middle Qing orthodoxy with modern developments in painting, the most important being the technical innovations of the Jinshi movement. His death by suicide when his beloved city of Hangzhou fell into the hands of the Taiping rebels in 1860 marks a turning point in the course of Chinese art. Having witnessed during his lifetime the dissolution of the rigid classification of styles into schools based on teachers and geography, Dai Xi illustrates in his work a new synthesis, not only of ancient modes, but also of more recent approaches to painting.

An exemplar of the literatus-official-amateur artist, a status still highly respected in the 19th century, Dai Xi was born into a family of scholars and became a *jinshi* in 1832. His government career included such posts as Vice President of the Board of Punishments and, at the time of his death, leader of the imperial defense against the Taiping army in Hangzhou. Shortly after his passing, the Xianfeng emperor awarded him with the posthumous title of *Wenjie*.

A seal that Dai Xi used (see following painting) reading "(I have the) same name as Xu (Xi [10th century]) of Jiangnan and Guo (Xi [active 1068-1078]) of Hoyang" indicates his strong sense of identity with ancient masters, a trait that shows up in his depictions of landscapes as well as of flowers and trees with rocks. In flower painting, Xu Xi's methods made their mark on Dai Xi, although they were filtered through the elegant renderings of Yun Shouping (1633-1690). Implicit in all of Dai Xi's paintings are the sober, balanced judgment required of an administrator of justice, and a self-effacing allegiance to time-honored aesthetic concepts analogous to his self-sacrificing loyalty to the throne. His work is also characterized by comprehensive training in calligraphy, particularly the styles of Mi Fei (1051-1107), Zhao Mengfu, and Yun Shouping, thorough familiarity with every phase of art history, a deep regard for the splendors of natural scenery, and highly sophisticated taste.

However, these features may easily be overlooked by the undiscerning eye due to this artist's unassuming manner of presentation. As a proper Confucian gentleman, he subordinated personal expression to the emulation of past models. Moreover, for the most part he adhered to convention in his construction of pictorial elements and overall schema. But unique to his style is an underlying rationality of conception and a combination of bold simplification of form with clarity of individual brushstrokes in a usually diminutive format. It is the consummate discipline and subtle force of each touch of the brush that transforms Dai Xi's paintings from common reworkings of standard modes into lucid expositions of Literati values during the early 19th century.

Dai Xi names Huang Gongwang as the source of this rare large-size landscape. In actuality, centuries of variations on the theme of this Yuan master's work are disclosed here. But Dai Xi contributes his own advancements to this mode, with a general paring down of the schematic complexity characteristic of 17th and 18th century versions and with the illusion of close proximity to both the low hills of the

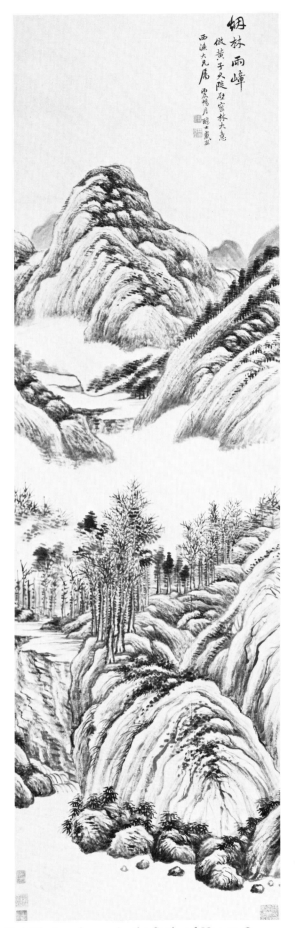

foreground and the higher peaks in the distance. These effects are achieved through the establishment of an independent entity in every line and dot. The long, narrow shape of the picture focuses on a thin "slice" of what might be the panoramic view seen in a handscroll such as Huang Gongwang's "Dwelling in Fuchun Mountains," yet even this section manifests an integrated structural power and natural grandeur akin to this Yuan masterpiece.

Although a massive fog bank obliterates any physical connection between the foremost mountains and those in the rear (rather than the more usual body of water, here appearing at the very bottom of the painting), front and background are linked with a shared pattern of texturing, matched in scale of tonality and moistness, along with the convincing tangibility of the mist itself. Somewhat darker tones of wash and strokes are applied on the hills at the point where they meet with the fog to suggest the volume and rising motion of the vaporous mass. The progression into depth of the trees along the foreground ridge is rendered by means of gradual blurring and fading of the foliage.

Dai Xi's undulating texture strokes, of the "hemp fiber" variety, are broad and strong in relation to the forms they describe. These dynamically vigorous lines, executed with the brush held upright in the *zhongfeng* position, bear an abstracting influence on the mountains and take on a life of their own. Later artists such as He Weipu (1842-1922) and Wu Tao (1840-1895) took up this approach, which fulfills Dong Qichang's Orthodox theories advocating the interpretation of ancient models through personalized "handwriting" and semi-abstracted form. The impressive presentation and masterful brush technique of this composition are more than sufficient to dispel any doubts about Dai Xi's ability to work in anything other than small-scale formats.

Dai Xi. *Landscape in the Style of Huang Gongwang.*

## Landscape in the Style of Dong Yuan

Hanging scroll, ink on satin
60 x 15½ inches

| | |
|---|---|
| *Inscription:* | Spring River and Light Rain, in the style of Beiyuan (Dong Yuan). Late spring, *bingchen* (1856). Wulin, Dai Xi. |
| *Artist's seals:* | *Dai Xi,* square, intaglio<br>*Chunshi,* square, relief |
| (To right of inscription) | *Banchuang cao yu manchuang shu,* rectangular, intaglio |
| (Lower right) | *Qiuca,* square, relief |

Collection of Senator Jack Faxon, Detroit, Michigan

Immediately recognizable in this painting are the "Mi dots," which give shape and surface texture to the mountains. Derived from the famous father and son painters Mi Fei and Mi Youren (1072-1151), and also associated with Gao Kegong (1248-1310), these "dots" are applied over a layer of light wash to indicate a moisture-laden atmosphere or rain-drenched earth. The styles of these three artists were widely imitated during the 16th and 17th centuries, but whereas such works perpetuated the round or oval spotlike technique of the original Mi dots, after around 1800 a tendency to stretch the spots out into short blunt strokes became prevalent. Dai Xi uses this newer method with rich modulations of ink tones and stroke formation. A lone fisherman paddles a boat past a thatched pavilion and a grove of trees, while a path ascends the hill along the right edge of the scene to a simple house. The waterfall on the left is backed by woods and then a misty void, which winds its way back along the side of the mountains to distant peaks of wash against a clear sky. Once again, Dai Xi offers a well-designed landscape of substantial dimensions representative of his superior artistic skill and rational world view.

Mention of Dong Yuan in the inscription refers to the inner spirit that Dai Xi attempts to capture in this painting rather than to the techniques he employed. Along with the inclusion of Wulin (the former name of Hangzhou) in his signature, it also alludes to his high respect for the remote past.

## Frosty Branches, Bamboo, and Rock

Hanging scroll, ink on paper
38½ x 12 inches

| | |
|---|---|
| *Inscription:* | Frosty Branches, Bamboo and Rock. Chunshi, Dai Xi. |
| *Artist's seals:* | *Dai Xi,* square, intaglio<br>*Chunshi,* square, relief |

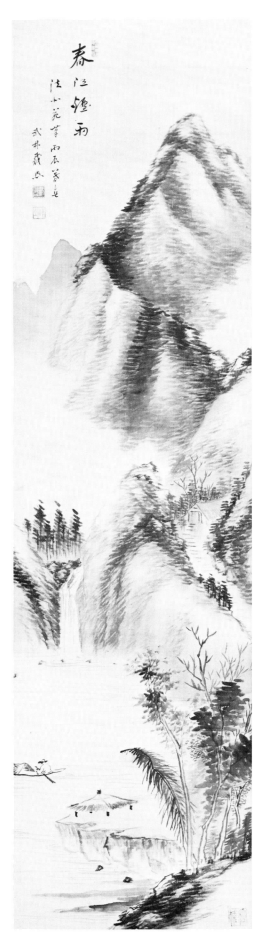

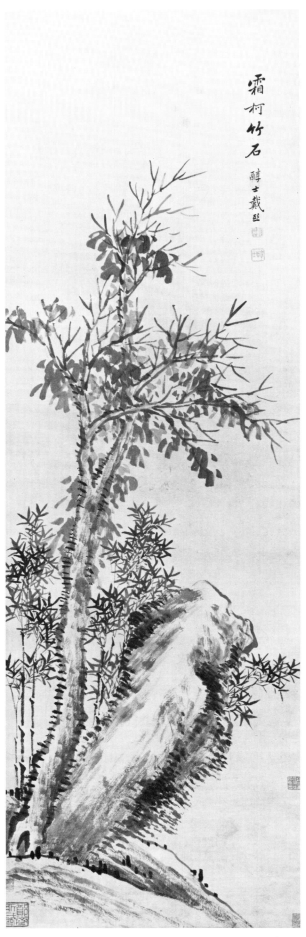

Dai Xi. *Landscape in the
Style of Dong Yuan.*

Dai Xi. *Frosty Branches, Bamboo and Rock.*

258

(Lower right)  *Yu Jiangnan Xu Heyang Guo tongming*, square, intaglio

*Collectors' seals:*  *Shao shi Miwan*, rectangular, relief
*Qihuai canghua*, rectangular, intaglio
*Zhengzhai*, square, relief

The image of an aged tree enduring the bitter cold of winter alongside a moss-encrusted rock has been a favorite theme among artists and poets since the 10th century. Signifying fortitude and strength of moral character, these two elements are often complemented by the potent symbol of gentlemanly virtue, bamboo. It was Zhao Mengfu who firmly established this combination as a subject for leisurely ink play in the scholar's painting repertoire. While Dai Xi preserves tradition by demonstrating the cool reserve of a lofty state of mind and unadorned beauty of Literati taste, he shifts the main emphasis of his expression to an exhibition of technical virtuosity. No contorted configurations in either plant or stone distract from this prominent feature; instead, it is the shape, speed, thrust, and resilience of the individual stroke that provide the moving force of this picture. The painting thus appeals to the trained and sensitive eye of the connoisseur. Every twig and leaf on the half-withered tree stands out with artistic meaning, exerting a power which, at first glance obscure, with extended study proves to be compelling. Smaller moss "dots" along the trunk and rock edges and on the ground are in fact not dots but short lines, ensuring consistent movement and verve throughout the composition. Delicate sprays of fresh bamboo leaves grow from low thin stalks behind the tree and rock, adding depth to the scene and a gentle accent to the solid and weathered qualities of the other two subjects. The work is a study of formal balance as well as an attempt to convey certain atmospheric conditions and the essential vitality inherent in plants and even in rocks.

A verse by Zhao Mengfu describes his prescribed method of painting the three subjects depicted in this work:

> Stones with "flying white, trees with seal script,
> Painting bamboo requires mastery of the eight
> stroke method (of calligraphy)."[1]

Dai Xi follows this approach, but develops it one step further by injecting an element of *beixue* into each brush stroke. This affinity to engraved stone tablets places Dai Xi among the forerunners of the Jinshi School, which was to flower not long after his death.

*NOTE:*

1. In *Chinese Calligraphy*, p. 151, Chiang Yee interprets *yongzi bafa* as "the eight components of the character *yong*."

# CHINESE NAMES

Abahai 阿巴噶

Aisin Gioro 愛新覺羅

Anhui
Anhwei 安徽

Aodaoren
Ao-tao-jen 澳道人

Badashanren
Pa-ta-shan-jen 八大山人

Baihuacun
Pai-hua-ts'un 百花村

Baiyangshanren
Pai-yang-shan-jen 白洋山人

Banqiao
Pan-ch'iao 板橋

Bao Shichen
Pao Shih-ch'en 包世臣

Baoya
Pao-ya 寶厓

Baoyang keguan
Pao-yang k'e-kuan 保陽客館

Beijing
Peking 北京

Beiyuan
Pei-yuan 北苑

Bi Long
Pi Lung 畢瀧

Bi Yuan
Pi Yüan 畢沅

Bian
Pien 汴

Biyanxiaoshi
Pi-yen-hsiao-shih 畢岩蕭史

Bo'erdu
Po-erh-tu 博爾都

Bonian
Po-nien 伯年

Buyisheng
Pu-i-sheng 布衣生

Cai Jia
Ts'ai Chia 蔡嘉

Cao (District)
Ts'ao 巢縣

Cao Ba
Ts'ao Pa 曹霸

Cao Xueqin
Ts'ao Hsüeh-ch'in 曹雪芹

Cao Zhibo
Ts'ao Chih-po 曹知白

Caoyisheng
Ts'ao-i-sheng 草衣生

Cha'nan
Ch'a-nan 槎南

Changchun
Ch'ang-ch'un 長春

Changshu
Ch'ang-shu 常熟

Changzhou
Ch'ang-chou 常州

Chashan
Ch'a-shan 茶山

Chen Chun
Ch'en Ch'un 陳淳

Chen Daofu
Ch'en Tao-fu 陳道復

Chen Hongshou
Ch'en Hung-shou 陳洪綬

Chen Hongshou
Ch'en Hung-shou 陳鴻壽

Chen Shu
Ch'en Shu 陳書

Cheng Jiasui
Ch'eng Chia-sui 程嘉燧

*Chibifu*
*Ch'ih-pi-fu* 赤壁賦

Chongzhen
Ch'ung-chen 崇禎

Chu Kuangzu
Ch'u K'uang-tsu 鄰壙祖

*Chuci*
*Ch'u-tz'u* 楚詞

Chunshi
Ch'un-shih 醇士

Cifeng
Tz'u-feng 次峯

Cui Zizhong
Ts'ui Tzu-chung 崔子忠

261

Dachi 大癡
Ta-ch'ih

Dai Jin 戴進
Tai Chin

Dai Xi 戴熙
Tai Hsi

*Daiyan fanggu riji* 岱若訪古日記
*Tai-yen fang-ku jih-chi*

Danfu 遯夫
Tan-fu

Danshi 憺士
Tan-shih

Dantu 丹徒
Tan-t'u

Danyang 丹陽
Tan-yang

Daoguang 道光
Tao-kuang

Daoji 道濟
Tao-chi

Dayi 大易
Ta-i

Deng Shiru 鄧石如
Teng Shih-ju

Ding Guanpeng 丁觀鵬
Ting Kuan-p'eng

Ding Jing 丁敬
Ting Ching

Ding Yunpeng 丁雲鵬
Ting Yün-p'eng

Dong Bangda 董邦達
Tung Pang-ta

Dong Fengchun 董逢椿
Tung Feng-ch'un

Dong Qichang 董其昌
Tung Ch'i-ch'ang

Dong Yuan 董源
Tung Yüan

Dongqiao 東樵
Tung-ch'iao

Dongshan 東山
Tung-shan

Dongxin 冬心
Tung-hsin

Dorgon 多爾袞
Doubi milin 徒壁靡林
*Tou-pi mi-lin*

*Duancai yin* 斷釵吟
*Tuan-ts'ai yin*

Dunhuang 敦煌
Tun-huang

Dunzhou 循州
Tun-chou

Duwangke 獨往客
Tu-wang-k'e

Erchi 二癡
Erh-ch'ih

Erqiao 二樵
Erh-ch'iao

Fan (District) 潍縣
Fan

Fan Kuan 范寬
Fan K'uan

Fan Li 范蠡
Fan Li

Fan Qi 樊圻
Fan Ch'i

Fang Congyi 方從義
Fang Ts'ung-i

Fang Fanghu 方方壺
Fang Fang-hu

Fang Mei 方楳
Fang Mei

Fang Shishu 方士庶
Fang Shih-shu

Fang Xi Tang Dai 方奚湯戴
Fang Hsi T'ang Tai

Fang Xueping 方雪屏
Fang Hsüeh-p'ing

Fang Xun 方薰
Fang Hsün

Fang Yizhi 方以智
Fang I-chih

Feilaifeng 飛來峯
Fei-lai-feng

Fenglong 豐隆
Feng-lung

Fuchun 富春
Fu-ch'un

Fucun 孚存
Fu-ts'un

Fujian 福建
Fukien

Futang 復堂
Fu-t'ang

Gai Qi
Kai Ch'i
改琦

Gan Jing
Kan Ching
干旌

Gao Fenghan
Kao Feng-han
高鳳翰

Gao Jianfu
Kao Chien-fu
高劍父

Gao Kegong
Kao K'o-kung
高克恭

Gao Lun
Kao Lun
高崙

Gao Qifeng
Kao Ch'i-feng
高奇峯

Gao Qipei
Kao Ch'i-p'ei
高其佩

Gao Weng
Kao Weng
高嵱

Gao Xiang
Kao Hsiang
高翔

Gaoyou (District)
Kao-Yu
高郵縣

Gengyan
Keng-yen
耕煙

Gengzhitu
Keng-chih-t'u
耕織圖

Gong Xian
Kung Hsien
龔賢

Gongmou
Kung-mou
恭懋

Gu Kaizhi
Ku K'ai-chih
顧愷之

Gu Yanwu
Ku Yen-wu
顧炎武

Guan Zhongji
Kuan Chung-chi
管仲姬

Guangdong
Kwangtung
廣東

Guangling
Kuang-ling
廣陵

Guangxi
Kwangsi
廣西

Guangzhou
Kuang-chou (Canton)
廣州

Guanxiu
Kuan-hsiu
貫休

Guanyin
Kuan-yin
觀音

Guatianyishi
Kua-t'ien-i-shih
瓜田逸史

Guiyan
Kuei-yen
桂岩

*Gumuhanquan*
*Ku-mu han-ch'üan*
古木寒泉

Guo Zhongshu
Kuo Chung-shu
郭忠恕

*Guochaohuashi*
*Kuo-ch'ao hua-shih*
國朝畫史

*Guochaohuazhenglu*
*Kuo-ch'ao hua-cheng-lu*
國朝畫徵錄

Gushe
Ku-she
姑射

Guyuan
Ku-yüan
縠原

Hainan
Hai-nan
海南

Haining
Hai-ning
海寧

Haiyan
Hai-yen
海塩

Haiyu
Hai-yü
海虞

Han
Han
漢

Han Gan
Han Kan
韓幹

Han Xiangzi
Han Hsiang-tsu
韓湘子

Hangzhou
Hang-chou (Hangchow)
杭州

Hankou
Hankou (Hankow)
漢口

Hanshan (Temple)
Han-shan
寒山寺

He
Ho
和

He Weipu
Ho Wei-p'u
何維樸

He Xiangu
Ho Hsien-ku
何仙姑

Hebei
Hopei
河北

Henan
Honan
河南

Heshen
Ho-shen
和珅

| | | | |
|---|---|---|---|
| Heyi<br>Ho-i | 赫奕 | Huanghaoshanqiao<br>Huang-hao-shan-ch'iao | 黃鶴山樵 |
| Hezhou<br>Ho-chou | 和州 | *Huanghuayinguan*<br>*Huang-hua-yin-kuan* | 黃花吟館 |
| *Hongloumeng*<br>*Hung-lou-meng* | 紅樓夢 | Huangmei (District)<br>Huang-mei | 黃梅 |
| *Hongloumeng tuyong*<br>*Hung-lou-meng-t'u-yung* | 紅樓夢圖詠 | Huangshan<br>Huang-shan | 黃山 |
| Hongren<br>Hung-jen | 弘仁 | Huazhisi Seng<br>Hua-chi-szu Seng | 花之寺僧 |
| Hongwu<br>Hung-wu | 弘旿 | Hubei<br>Hupei | 湖北 |
| Hu Kuiwen<br>Hu K'uei-wen | 胡夔文 | Huizong<br>Hui-tsung | 徽宗 |
| Hu Yuan<br>Hu Yüan | 胡遠 | Hunan<br>Hunan | 湖南 |
| Hua Yan<br>Hua Yen | 華嵒 | Huzhou<br>Hu-chou | 徽州 |
| Huaisu<br>Huai-su | 懷素 | Ji Jun<br>Chi Chün | 紀昀 |
| Huaixi<br>Huai-hsi | 懷西 | Ji Xiaolan<br>Chi Hsiao-lan | 紀曉嵐 |
| Huang Binhong<br>Huang Pin-hung | 黃賓虹 | Jinan<br>Chi-nan | 濟南 |
| Huang Ding<br>Huang Ting | 黃鼎 | Jiading<br>Chia-ting | 嘉定 |
| Huang Gongwang<br>Huang Kung-wang | 黃公望 | Jianfei<br>Chien-fei | 澗飛 |
| Huang Jun<br>Huang Chün | 黃均 | Jiang Can<br>Chiang Ts'an | 江參 |
| Huang Shen<br>Huang Shen | 黃慎 | Jiang Guandao<br>Chiang Kuan-tao | 江貫道 |
| Huang Shugu<br>Huang Shu-ku | 黃樹穀 | Jiang Tingxi<br>Chiang T'ing-hsi | 蔣廷錫 |
| Huang Tingjian<br>Huang T'ing-chien | 黃庭堅 | Jiangnan<br>Chiang-nan | 江南 |
| Huang Yi<br>Huang I | 黃易 | *Jiangshan huaquan*<br>*Chiang-shan hua-ch'üan* | 江上畫筌 |
| Huang Yue<br>Huang Yüeh | 黃鉞 | Jiangsu<br>Kiangsu | 江蘇 |
| Huang Zijiu<br>Huang Tzu-chiu | 黃子久 | Jiangxi<br>Kiangsi | 江西 |
| Huang Zongxi<br>Huang Tsung-hsi | 黃宗羲 | Jiangyin<br>Chiang-yin | 江陰 |
| Huang Zuotian<br>Huang Tso-t'ien | 黃左田 | Jiao Binzheng<br>Chiao Pin-cheng | 焦秉貞 |
| Huangcun<br>Huang-ts'un | 篁村 | Jiaozhou<br>Chiao-chou | 膠州 |

| | | | | |
|---|---|---|---|---|
| Jiaqing<br>Chia-ch'ing | 嘉慶 | | Kaifeng<br>K'ai-feng | 開封 |
| Jiaxiang (District)<br>Chia-hsiang | 嘉祥縣 | | Kangxi<br>K'ang-hsi | 康熙 |
| Jiaxing (District)<br>Chia-hsing | 嘉興 | | Kanshu<br>K'an-shu | 侃叔 |
| *Jietaoguan shiji*<br>*Chieh-t'ao-kuan-shih-chi* | 解弢館詩集 | | Ke Danqiu<br>K'o Tan-ch'iu | 柯丹丘 |
| *Jieziyuan huazhuan*<br>*Chieh-tzu-yüan hua-chuan* | 芥子園畫傳 | | Ke Jingzhong<br>K'o Ching-chung | 柯敬仲 |
| Jifang<br>Chi-fang | 李方 | | Ke Jiusi<br>K'o Chiu-szu | 柯九思 |
| Jiliushanmin<br>Chi-liu-shan-min | 稽留山民 | | Kerou<br>K'o-jou | 克柔 |
| Jin<br>Chin | 金 | | Kuiyan<br>K'uei-yüan | 葵園 |
| Jin<br>Chin | 晉 | | Kunming<br>K'un-ming | 昆明 |
| Jin Eyan<br>Chin O-yen | 金鄂岩 | | Lü Liuliang<br>Lü Liu-liang | 呂留良 |
| Jin Nong<br>Chin Nung | 金農 | | Lan Caihe<br>Lan Ts'ai-ho | 藍采和 |
| Jin Ruli<br>Chin Ju-li | 金汝礪 | | Lan Ying<br>Lan Ying | 藍瑛 |
| Jin Xiangyu<br>Chin Hsiang-yü | 金香雨 | | Lanchi<br>Lan-ch'ih | 蘭坻 |
| Jingdezhen<br>Ching-te-chen | 景德鎮 | | Lang Shining<br>Lang Shih-ning | 郎世寧 |
| Jingdongjushi<br>Ching-tung-chü-shih | 井東居士 | | *Laozi shuolüe*<br>*Lao-tzu shuo-lüeh* | 老子説略 |
| Jingjiang<br>Ching-chiang | 京江 | | Lengyan (Sutra)<br>Leng-yen | 楞嚴經 |
| Jingui<br>Chin-kuei | 金匱 | | Li Bo<br>Li Po | 李白 |
| Jinling<br>Chin-ling | 金陵 | | Li Gonglin<br>Li Kung-lin | 李公麟 |
| Jinshi<br>Chin-shih | 金石 | | Li Jian<br>Li Chien | 黎簡 |
| Jinshi<br>Chin-shih | 進士 | | Li Longmian<br>Li Lung-mien | 李龍眠 |
| *Jiuge*<br>*Chiu-ko* | 九歌 | | Li Qifang<br>Li Ch'i-fang | 李其芳 |
| *Jiusitang shichao*<br>*Chiu-szu-t'ang shih-ch'ao* | 九思堂詩鈔 | | Li Shan<br>Li Shan | 李鱓 |
| Jiusizhuren<br>Chiu-szu-chu-jen | 九思主人 | | Li Sixun<br>Li Szu-hsün | 李思訓 |
| Juran<br>Chü-jan | 巨然 | | Li Tieguai<br>Li T'ieh-kuai | 李鐵拐 |

Li Xiguang
Li Hsi-kuang
李錫光

Li Zicheng
Li Tzu-ch'eng
李自成

Liang Feisu
Liang Fei-su
梁飛素

*Liang Han jinshi ji*
*Liang Han chin-shih chi*
兩漢金石記

Liang Xue
Liang Hsüeh
梁雪

Liangfeng
Liangfeng
兩峯

Lianchao
Lien-ch'ao
蓮巢

*Lidai renwu nianli beizhuan zongbiao*
*Li-tai jen-wu nien-li pei-chuan tsung-piao*
歷代人物年里碑傳綜表

Lin Chun
Lin Ch'un
林椿

Lin Liang
Lin Liang
林良

Lin'an
Lin-an
臨安

Linding
Lin-ting
臨汀

Lingnan
Ling-nan
嶺南

Liu Gongquan
Liu Kung-ch'üan
柳公權

Liu Songnian
Liu Sung-nien
劉松年

Liu Zhaoji
Liu Chao-chi
劉肇基

Liubo
Liu-po
柳波

Liurujushi
Liu-ju-chü-shih
六如居士

Liyang
Li-yang
溧陽

Longshanqinyin
Lung-shan-ch'in-yin
龍山琴隱

Lou
Lou
婁

Loudong
Lou-tung
婁東

Loujin
Lou-chin
露筋

Lu Zhi
Lu Chih
陸治

Luo Mu
Lo Mu
羅牧

Luo Ping
Lo P'ing
羅聘

Luofu
Lo-fu
羅浮

Luting
Lu-t'ing
魯亭

Ma Hezhi
Ma Ho-chih
馬和之

Ma Yuan
Ma Yuan
馬遠

Ma-Xia
Ma-Hsia
馬夏

Mansheng
Man-sheng
曼生

Mei Qing
Mei Ch'ing
梅清

*Meipu*
*Mei-p'u*
梅譜

Menglao
Meng-lao
蒙老

Menglou
Meng-lou
夢樓

Mengquanwaishi
Meng-ch'üan-wai-shih
蒙泉外史

Mi Fei
Mi Fei
米芾

Mi Youren
Mi Yu-jen
米友仁

Miao Bingtai
Miao Ping-t'ai
繆炳泰

Min Xiaozi
Min Hsiao-tzu
閔孝子

Min Zheng
Min Cheng
閔貞

Ming
Ming
明

Minghuang
Ming-huang
明皇

Mingzhu
Ming-chu
明珠

Mocun
Mo-ts'un
默存

Moji
Mo-chi
摩詰

| | | | | |
|---|---|---|---|---|
| Moling<br>Mo-ling | 秣陵 | | Putuoluojia<br>P'u-t'o-lo-chia | 普陀洛伽 |
| Mu Wang<br>Mu Wang | 穆王 | | Qi Baishi<br>Ch'i Pai-shih | 齊白石 |
| Nalanxingde<br>Na-lan-hsing-te | 納蘭性德 | | Qian Du<br>Ch'ien Tu | 錢杜 |
| Nanchang<br>Nan-ch'ang | 南昌 | | Qian Feng<br>Ch'ien Feng | 錢灃 |
| Nancheng<br>Nan-ch'eng | 南城 | | Qian Li<br>Ch'ien Li | 錢灃 |
| Nancun<br>Nan-ts'un | 南邨 | | Qian Qi<br>Ch'ien Ch'i | 錢起 |
| Nanfulaoren<br>Nan-fu-lao-jen | 南阜老人 | | Qian Weicheng<br>Ch'ien Wei-ch'eng | 錢維城 |
| Nanjing<br>Nanking | 南京 | | Qian Xuan<br>Ch'ien Hsüan | 錢選 |
| Nankang<br>Nan-k'ang | 南康 | | Qian Zai<br>Ch'ien Tsai | 錢載 |
| Nanloulaoren<br>Nan-lou-lao-jen | 南樓老人 | | Qian Zhuding<br>Ch'ien Chu-ting | 錢竹汀 |
| Nanping<br>Nan-p'ing | 南蘋 | | Qianlong<br>Ch'ien-lung | 乾隆 |
| Nanshan<br>Nan-shan | 南山 | | Qiantang<br>Ch'ien-t'ang | 錢塘 |
| Nantian<br>Nan-t'ien | 南田 | | *Qiao Hua qiuse*<br>Ch'iao Hua Ch'iu-se | 鵲華秋色 |
| Nanyuan<br>Nan-yüan | 南園 | | Qifang<br>Ch'i-fang | 其芳 |
| Ni Can<br>Ni Ts'an | 倪璨 | | Qin<br>Ch'in | 秦 |
| Ni Gaoshi<br>Ni Kao-shih | 倪高士 | | Qing<br>Ch'ing | 清 |
| Ni Zan<br>Ni Tsan | 倪瓚 | | *Qingdai huashi*<br>Ch'ing-tai hua-shih | 清代畫史 |
| Ningbo<br>Ning-po | 寧波 | | Qinghui<br>Ch'ing-hui | 清暉 |
| Nurhaci | 努爾哈赤 | | Qingxiangdaoren<br>Ch'ing-hsiang tao-jen | 清湘道人 |
| Pan Gongshou<br>P'an Kung-shou | 潘恭壽 | | Qishan<br>Ch'i-shan | 契山 |
| Panyu<br>P'an-yü | 番禺 | | Qitang<br>Ch'i-t'ang | 霽堂 |
| Pengxin<br>P'eng-hsin | 蓬心 | | Qiu Sui<br>Ch'iu Sui | 求穟 |
| Pushan<br>P'u-shan | 浦山 | | Qiu Ying<br>Ch'iu Ying | 仇英 |
| *Pushan lunhua*<br>P'u-shan lun-hua | 浦山論畫 | | Qiu Yuan<br>Ch'iu Yüan | 丘園 |

| | | | |
|---|---|---|---|
| Qiu'an<br>Ch'iu-an | 秋盦 | Shanting<br>Shan-t'ing | 杉亭 |
| Qiucha<br>Ch'iu-ch'a | 秋槎 | Shanyin<br>Shan-yin | 山陰 |
| Qiushi<br>Ch'iu-shih | 秋室 | She (District)<br>She | 歙縣 |
| Qiuyue<br>Ch'iu-yüeh | 秋岳 | Shen Quan<br>Shen Ch'üan | 沈銓 |
| Qixiang<br>Ch'i-hsiang | 七薌 | Shen Zhou<br>Shen Chou | 沈周 |
| Qizhen<br>Ch'i-chen | 棲真 | Shenfu<br>Shen-fu | 慎夫 |
| Quantang<br>Ch'üan-t'ang | 泉唐 | Sheng Dashi<br>Sheng Ta-shih | 盛大士 |
| Ren Renfa<br>Jen Jen-fa | 任仁發 | Shengzu<br>Sheng-tzu | 睴祖 |
| Ren Xiong<br>Jen Hsiung | 任熊 | Shi Kefa<br>Shih K'o-fa | 史可法 |
| Ren Xun<br>Jen Hsün | 任薰 | Shimen<br>Shih-men | 石門 |
| Ren Yi<br>Jen I | 任頤 | Shimensong<br>Shih-men-sung | 石門頌 |
| Ren Yu<br>Jen Yü | 任預 | *Shiqubaoji*<br>*Shih-ch'ü-pao-chi* | 石渠寶笈 |
| *Rizhilu*<br>*Jih-chih-lu* | 日知錄 | Shisanfengcaotang<br>Shih-san-feng ts'ao-t'ang | 十三峯草堂 |
| Roquan<br>Jo-ch'üan | 若泉 | *Shisanfengcaotang shichao*<br>*Shih-san-feng ts'ao-t'ang shih-ch'ao* | 十三峯草堂詩鈔 |
| Ruan Yuan<br>Juan Yüan | 阮元 | Shitao<br>Shih-t'ao | 石濤 |
| Ruan Yuntai<br>Juan Yün-t'ai | 阮芸臺 | Shitian<br>Shih-t'ien | 石田 |
| Ruyiguan<br>Ju-i-kuan | 如意館 | *Shizhuzhai huapu*<br>*Shih-chu-chai hua-p'u* | 十竹齋畫譜 |
| *Sanglianliguan zhuketu*<br>*Sang-lien-li-kuan chu-k'o-t'u* | 桑蓮理館主客圖 | Shou Peng<br>Shou P'eng | 壽彭 |
| Shandong<br>Shantung | 山東 | Shoumen<br>Shou-men | 壽門 |
| Shang<br>Shang | 商 | *Shuangsong pingyuan*<br>*Shuang-sung p'ing-yüan* | 雙松平遠 |
| Shangqiu<br>Shang-ch'iu | 商丘 | Shuiyunjingshe<br>Shui-yün-ching-she | 水雲精舍 |
| Shangyuan<br>Shang-yüan | 上沅 | Shumei<br>Shu-mei | 叔美 |
| *Shanhaijing*<br>*Shan-hai-ching* | 山海經 | Shunde<br>Shun-te | 順德 |
| *Shanjingju lunhua*<br>*Shan-ching-chü lun-hua* | 山靜居論畫 | Shunzhi<br>Shun-chih | 順治 |

| | |
|---|---|
| *Shuowen* 說文<br>Shuo-wen | Taiping Tianguo 太平天國<br>T'ai-p'ing Tien-kuo |
| *Shuowenziyuan kaolue* 說文字原考略<br>Shuo-wen-tzu-yüan k'ao-lüeh | Taizhou 泰州<br>T'ai-chou |
| Sichuan 四川<br>Szechwan | Taizong 太宗<br>T'ai-tsung |
| *Sikuquanshu* 四庫全書<br>Szu-k'u-ch'üan-shu | Tang 唐<br>T'ang |
| Sima Xiangru 司馬相如<br>Szu-ma Hsiang-ju | Tang Bin 湯斌<br>T'ang Pin |
| Song 宋<br>Sung | Tang Yifen 湯貽汾<br>T'ang I-fen |
| *Song Luo fangbei riji* 嵩洛訪碑日記<br>Sung Lo fang-pei jih-chi | Tang Yin 唐寅<br>T'ang Yin |
| *Song Yuan Ming Qing shuhuajia nianbiao* 宋元明清書畫家年表<br>Sung Yüan Ming Ch'ing shu-hua-chia nien-piao | Tao Qian 陶潛<br>T'ao Ch'ien |
| Songhu 松壺<br>Sung-hu | Tao Yuanming 陶淵明<br>T'ao Yüan-ming |
| Songjiang 松江<br>Sung-chiang | *Taohuayuan ji* 桃花源記<br>T'ao-hua-yüan chi |
| Songxin 松心<br>Sung-hsin | Teng (District) 滕縣<br>T'eng |
| Songxuelaoren 松雪老人<br>Sung-hsüeh lao-jen | Tianning 天寧<br>T'ien-ning |
| *Songyin tingzi* 松陰亭子<br>Sung-yin t'ing-tzu | Tiesheng 鐵生<br>T'ieh-sheng |
| Songyuan 松原<br>Sung-yüan | *Tingyulou shiji* 聽雨樓詩集<br>T'ing-yü-lou shih-chi |
| Su Dongpo 蘇東坡<br>Su Tung-p'o | Tongxiang 桐鄉<br>T'ung-hsiang |
| Su Renshan 蘇仁山<br>Su Jen-shan | Tuan Sheng 團升<br>T'uan Sheng |
| Su Shi 蘇軾<br>Su Shih | Tuan Shigen 團時根<br>T'uan Shih-ken |
| Su Wenzhong 蘇文忠<br>Su Wen-chung | Wan Shanglin 萬上遴<br>Wan Shang-lin |
| Su Wu 蘇武<br>Su Wu | Wang Chen 王宸<br>Wang Ch'en |
| Sui 隋<br>Sui | Wang Fuzhi 王夫之<br>Wang Fu-chih |
| Suzhou 蘇州<br>Su-chou (Soochow) | Wang Hui 王翬<br>Wang Hui |
| Taicang 太倉<br>T'ai-ts'ang | Wang Jian 王鑑<br>Wang Chien |
| Taihu 太湖<br>T'ai-hu | Wang Jiu 王玖<br>Wang Chiu |
| | Wang Meng 王蒙<br>Wang Meng |

| | | | | |
|---|---|---|---|---|
| Wang Mian<br>Wang Mien | 王冕 | | Weng Luo<br>Weng Lo | 翁雒 |
| Wang Shimin<br>Wang Shih-min | 王時敏 | | Wenjie<br>Wen-chieh | 文節 |
| Wang Shishen<br>Wang Shih-shen | 汪士慎 | | Wenzhao<br>Wen-chao | 文招 |
| Wang Shizhen<br>Wang Shih-chen | 王士禎 | | Wu<br>Wu | 吳 |
| Wang Su<br>Wang Su | 王憮 | | Wu Bin<br>Wu Pin | 吳彬 |
| Wang Wei<br>Wang Wei | 王維 | | Wu Changshi<br>Wu Ch'ang-shih | 吳昌碩 |
| Wang Wenzhi<br>Wang Wen-chih | 王文治 | | Wu Daozi<br>Wu Tao-tzu | 吳道子 |
| Wang Wu<br>Wang Wu | 王武 | | Wu Dongfa<br>Wu Tung-fa | 吳東發 |
| Wang Xizhi<br>Wang Hsi-chih | 王羲之 | | Wu Li<br>Wu Li | 吳歷 |
| Wang Yu<br>Wang Yü | 王昱 | | Wu Liang Ci<br>Wu Liang Tz'u | 武梁祠 |
| Wang Yuanqi<br>Wang Yüan-ch'i | 王原祁 | | Wu Qi<br>Wu Ch'i | 吳祺 |
| Wang Yuanting<br>Wang Yüan-t'ing | 王阮亭 | | Wu Sangui<br>Wu San-kuei | 吳三桂 |
| Wang Yuanxun<br>Wang Yüan-hsün | 王元勳 | | Wu Siye<br>Wu Szu-yeh | 吳思業 |
| Wang Zhenpeng<br>Wang Chen-p'eng | 王振鵬 | | Wu Tao<br>Wu T'ao | 吳滔 |
| Wang'anlaoren<br>Wang-an lao-jen | 忘庵老人 | | Wu Xizai<br>Wu Hsi-tsai | 吳熙載 |
| Wangcheng<br>Wang-ch'eng | 望誠堂 | | Wu Xuan<br>Wu Hsüan | 吳煊 |
| Wanggang<br>Wang-kang | 輞岡 | | Wu Yunlai<br>Wu Yün-lai | 吳允徠 |
| Wei (District)<br>Wei | 濰縣 | | Wu Zhao<br>Wu Chao | 吳照 |
| Wei<br>Wei | 魏 | | Wu Zhen<br>Wu Chen | 吳鎮 |
| Weisan<br>Wei-san | 惟三 | | *Wubaisifengtang shichao*<br>*Wu-pai-szu-feng-t'ang shih-ch'ao* | 五百四峰堂詩鈔 |
| Wen Tong<br>Wen T'ung | 文同 | | Wujiang<br>Wu-chiang | 吳江 |
| Wen Zhengming<br>Wen Cheng-ming | 文徵明 | | Wujin<br>Wu-chin | 武進 |
| Weng Fanggang<br>Weng Fang-kang | 翁方綱 | | Wulin<br>Wu-lin | 武林 |
| Weng Guangping<br>Weng Kuang-p'ing | 翁廣平 | | Wumen<br>Wu-men | 吳門 |

| | |
|---|---|
| Wusong<br>Wu-sung<br>吳淞 | Xiashanyan'ai<br>*Hsia-shan-yen-ai*<br>夏山煙靄 |
| Wuxi<br>Wu-hsi<br>無錫 | Xie Jin<br>Hsieh Chin<br>謝晉 |
| Xi Gang<br>Hsi Kang<br>奚岡 | Xie Shichen<br>Hsieh Shih-ch'en<br>謝時臣 |
| Xia Chang<br>Hsia Ch'ang<br>夏昶 | Xie Tingzhi<br>Hsieh T'ing-chih<br>謝庭芝 |
| Xia Gui<br>Hsia Kuei<br>夏珪 | Xie Xuecun<br>Hsieh Hsüeh-ts'un<br>謝雪村 |
| Xia Zhouyang<br>Hsia Chou-yang<br>夏州楊 | Xileng<br>Hsi-leng<br>西冷 |
| Xi'an<br>Hsi-an<br>夕庵 | Ximing<br>Hsi-ming<br>西銘 |
| *Xi'an riji*<br>*Hsi-an jih-chi*<br>夕庵日記 | Xin'an<br>Hsin-an<br>新安 |
| Xianfeng<br>Hsien-feng<br>咸豐 | Xinghua<br>Hsing-hua<br>興化 |
| Xiang Yuanbian<br>Hsiang Yüan-pien<br>項元汴 | Xingzhai<br>Hsing-chai<br>惺齋 |
| Xiangxian<br>Hsiang-hsien<br>象賢 | Xinjiang<br>Sinkiang<br>新疆 |
| Xiangyu<br>Hsiang-yü<br>香雨 | Xinluoshanren<br>Hsin-lo-shan-jen<br>新羅山人 |
| Xiangzhou<br>Hsiang-chou<br>湘洲 | Xiqiao<br>Hsi-ch'iao<br>西樵 |
| Xianwu<br>Hsien-wu<br>顯吳 | Xiting<br>Hsi-t'ing<br>西亭 |
| Xiao Banbian<br>Hsiao Pan-pien<br>蕭半邊 | Xiujiang<br>Hsiu-chiang<br>秀江 |
| Xiao Hehua<br>Hsiao ho-hua<br>蕭荷花 | Xiushui<br>Hsiu-shui<br>秀水 |
| Xiao Junxian<br>Hsiao Chün-hsien<br>蕭俊賢 | Xiwangmu<br>Hsi-wang-mu<br>西王母 |
| Xiao Xun<br>Hsiao Hsün<br>蕭遜 | *Xixiangji*<br>*Hsi-hsiang chi*<br>西廂記 |
| Xiao Zhao<br>Hsiao Chao<br>蕭照 | Xiyu<br>Hsi-yü<br>西漁 |
| Xiaohai<br>Hsiao-hai<br>小海 | Xiyuan<br>Hsi-yüan<br>西園 |
| *Xiaopenghai shiji*<br>*Hsiao-p'eng-hai shih-chi*<br>小蓬海詩集 | Xu Ben<br>Hsü Pen<br>徐賁 |
| *Xiaopenglaige jinshiwenzi*<br>*Hsiao-p'eng-lai-ko chin-shih wen-tzu*<br>小蓬萊閣金石文字 | Xu Chongsi<br>Hsü Ch'ung-szu<br>徐崇嗣 |
| Xiaoshidaoren<br>Hsiao-shi tao-jen<br>小獅道人 | Xu Daoning<br>Hsü Tao-ning<br>徐道寧 |
| Xiaosong<br>Hsiao-sung<br>小松 | Xu Jiaju<br>Hsü Chia-chü<br>徐家駒 |

| Pinyin | Wade-Giles | Chinese |
|---|---|---|
| Xu Rong | Hsü Jung | 徐溶 |
| Xu Wei | Hsü Wei | 徐渭 |
| Xu Xi | Hsü Hsi | 徐熙 |
| Xu Youwen | Hsü Yu-wen | 徐幼文 |
| Xu Yuting | Hsü Yü-t'ing | 徐雨亭 |
| Xuantong | Hsüan-t'ung | 宣統 |
| Xuanzai | Hsüan-tsai | 玄宰 |
| Xuanzong | Hsüan-tsung | 玄宗 |
| Xueyai | Hsüeh-yai | 雪崖 |
| Xugu | Hsü-ku | 虛谷 |
| Xunyang | Hsün-yang | 潯陽 |
| Xunyuan | Hsün-yüan | 洵遠 |
| Yan Zhenqing | Yen Chen-ch'ing | 顏真卿 |
| Yangeng | Yen-keng | 硯耕 |
| Yang Jin | Yang Chin | 楊晉 |
| Yangshao | Yang-shao | 仰韶 |
| Yangzhou | Yang-chou | 楊州 |
| *Yangzhou huafanglu* | Yang-chou hua-fang-lu | 楊州畫舫錄 |
| *Yanshi* | Yen-shih | 硯史 |
| Yanshichufu | Yen-shih-ch'u-fu | 研石鉏夫 |
| Yao Yuanzhi | Yao Yüan-chih | 姚元之 |
| Yaohuadaoren | Yao-hua tao-jen | 瑤華道人 |
| Yaori | Yao-jih | 堯日 |
| Yaotai | Yao-t'ai | 瑤臺 |
| Yaoyange | Yao-yen-ke | 藥煙閣 |
| Yi Bingshou | I Ping-shou | 伊秉綬 |
| Yi Yuanji | I Yüan-chi | 易元吉 |
| Yicheng (District) | I-ch'eng | 儀徵縣 |
| Yichun | I-ch'un | 宜春 |
| *Yijing* | I-ching | 易經 |
| Yiju | I-chü | 以拒 |
| Ying Yujian | Ying Yü-chien | 瑩玉澗 |
| Yingpiao | Ying-p'iao | 癭瓢 |
| Yiqing | I-ch'ing | 益卿 |
| Yixing | I-hsing | 宜興 |
| Yizhoushuangji | I-chou shuang-chi | 藝舟雙楫 |
| Yongrong | Yung-jung | 永瑢 |
| Yongzheng | Yung-cheng | 雍正 |
| Yongzhou | Yung-chou | 永州 |
| Yu Ji | Yü Chi | 余集 |
| Yu Meiren | Yü Mei-jen | 余美人 |
| Yu Sheng | Yü Sheng | 余省 |
| Yu Shinan | Yü Shih-nan | 虞世南 |
| Yu Xun | Yü Hsün | 余珣 |
| Yuan | Yüan | 元 |
| Yuan | Yüan | 緩 |
| Yuan Jiang | Yüan Chiang | 袁江 |
| Yuan Mei | Yüan Mei | 袁牧 |

| | |
|---|---|
| Yuan Yao<br>*Yüan Yao*　袁耀 | Zhang Zongcang<br>*Chang Tsung-ts'ang*　張宗蒼 |
| Yuanjiang<br>*Yüan-chiang*　袁江 | Zhangqianbei<br>*Chang-ch'ien-pei*　張遷碑 |
| Yuanting<br>*Yüan-t'ing*　阮亭 | Zhangzhou<br>*Chang-chou*　漳州 |
| Yueshan<br>*Yüeh-shan*　越山 | Zhao Boju<br>*Chao Po-chü*　趙伯駒 |
| *Yufojie*<br>*Yü-fo-chieh*　浴佛節 | Zhao Danian<br>*Chao Ta-nien*　趙大年 |
| Yuhuwaishi<br>*Yü-hu-wai-shih*　玉壺外史 | Zhao Mengfu<br>*Chao Meng-fu*　趙孟頫 |
| Yun Shouping<br>*Yün Shou-p'ing*　惲壽平 | Zhao Xiao<br>*Chao Hsiao*　趙曉 |
| Yuncha<br>*Yün-ch'a*　雲槎 | Zhao Yong<br>*Chao Yung*　趙雍 |
| Yunfu<br>*Yün-fu*　芸父 | Zhao Yuan<br>*Chao Yüan*　趙原 |
| Yunlin<br>*Yün-lin*　雲林 | Zhao Zhiqian<br>*Chao Chih-ch'ien*　趙之謙 |
| Yunnan<br>*Yünnan*　雲南 | Zhao Zhongmu<br>*Chao Chung-mu*　趙仲穆 |
| Yunping<br>*Yün-p'ing*　雲屏 | Zhe<br>*Che*　浙 |
| Yuqing<br>*Yü-ch'ing*　禹卿 | Zhejiang<br>*Chekiang*　浙江 |
| Yushan<br>*Yü-shan*　虞山 | Zheng Xie<br>*Cheng Hsieh*　鄭燮 |
| Yusheng<br>*Yü-sheng*　雨生 | Zheng Zhiben<br>*Cheng Chih-pen*　鄭之本 |
| Yuyang<br>*Yü-yang*　漁洋 | Zhengzhai<br>*Cheng-chai*　正齋 |
| Zengsan<br>*Tseng-san*　曾三 | Zhenjiang<br>*Chen-chiang*　鎮江 |
| Zhang Geng<br>*Chang Keng*　張庚 | Zhenyang<br>*Chen-yang*　鎮洋 |
| Zhang Shining<br>*Chang Shih-ning*　張賜寧 | Zhenze<br>*Chen-tse*　震澤 |
| Zhang Shuwei<br>*Chang Shu-wei*　張叔未 | Zhenzhou<br>*Chen-chou*　真州 |
| Zhang Tao<br>*Chang T'ao*　張燾 | Zhiyan<br>*Chih-yen*　芝岩 |
| Zhang Weiping<br>*Chang Wei-p'ing*　張維屏 | Zhizhuangqinwang<br>*Chih-chuang-ch'in-wang*　質莊親王 |
| *Zhang Xi'an xiansheng nianpu*<br>*Chang Hsi-an hsien-sheng nien-p'u*　張夕庵先生年譜 | *Zhongguo hua*<br>*Chung-kuo hua*　中國畫 |
| Zhang Yin<br>*Chang Yin*　張崟 | *Zhongguo huajia<br>renming dazidian*<br>*Chung-kuo hua-chia jen-ming ta-tzu-tien*　中國畫家人名大字典 |

273

*Zhongguo lidai shuhuazhuankejia*
*zihao suoyin*
*Chung-kuo li-tai shu-hua-chuan-k'o-chia*
*tzu-hao suo-yin*

中國歷代書畫篆刻家字號索引

Zhongju
Chung-chü
仲駒

Zhongyuan
Chung-yüan
仲遠

Zhou
Chou
周

Zhou Chen
Chou Ch'en
周臣

Zhou Fang
Chou Fang
周昉

Zhou Gao
Chou Kao
周鎬

Zhou Hao
Chou Hao
周灝

Zhouweng
Chou-weng
粥翁

Zhu Da
Chu Ta
朱耷

Zhu Suiliang
Chu Sui-liang
褚遂良

Zhu Wenzhen
Chu Wen-chen
朱文震

Zhu Xi
Chu Hsi
朱熹

Zhu Yunming
Chu Yün-ming
祝允明

Zhuchi
Chu-ch'ih
竹痴

*Zhupu*
*Chu-p'u*
竹譜

Zhuyetingsheng
Chu-yeh-t'ing-sheng
竹葉亭生

Zigong
Tzu-kung
子恭

Zihao
Tzu-hao
子鶴

Zijing
Tzu-ching
子京

Zining
Tzu-ning
子凝

Zongyang
Tsung-yang
宗揚

Zungu
Tsun-ku
尊古

Zuo Wenjun
Tso Wen-chün
卓文君